Saint Cecilia in the Renaissance

Saint Cecilia in the Renaissance

The Emergence of a Musical Icon

JOHN A. RICE

The University of Chicago Press CHICAGO AND LONDON

The University of Chicago Press, Chicago 60637

The University of Chicago Press, Ltd., London

© 2022 by The University of Chicago

All rights reserved. No part of this book may be used or reproduced in any manner whatsoever without written permission, except in the case of brief quotations in critical articles and reviews. For more information, contact the University of Chicago Press, 1427 E. 60th St., Chicago, IL 60637.

Published 2022

Printed in the United States of America

31 30 29 28 27 26 25 24 23 22 1 2 3 4 5

ISBN-13: 978-0-226-81710-1 (cloth)

ISBN-13: 978-0-226-81734-7 (e-book)

DOI: https://doi.org/10.7208/chicago/9780226817347.001.0001

Publication of this book has been aided by the Claire and Barry Brook Fund of the American Musicological Society, supported in part by the National Endowment for the Humanities and the Andrew W. Mellon Foundation.

Library of Congress Cataloging-in-Publication Data

Names: Rice, John A., author.

Title: Saint Cecilia in the Renaissance : the emergence of a musical icon / John A. Rice.

Description: Chicago : London : The University of Chicago Press, 2022. | Includes bibliographical references and index.

Identifiers: LCCN 2021040662 | ISBN 9780226817101 (cloth) | ISBN 9780226817347 (ebook)

Subjects: LCSH: Cecilia, Saint. | Cecilia, Saint—Songs and music—History and criticism. | Cecilia, Saint—In art. | Cecilia, Saint—Cult. | Music—15th century—History and criticism. | Music—16th century—History and criticism. | Motets—History and criticism. | Church music. | Christian saints in art. | Art, Renaissance.

Classification: LCC ML190 .R53 2022 BX4700.C5 | DDC 782.26—dc23

LC record available at https://lccn.loc.gov/2021040662

♾ This paper meets the requirements of ANSI/NISO Z39.48-1992 (Permanence of Paper).

PARA MARIZA,
MAIS UMA VEZ

Contents

Illustrations

FIGURES

Musical Examples

Tables

Bibliographic Abbreviations and Library Sigla

BIBLIOGRAPHIC ABBREVIATIONS

CM	*Current Musicology*
CMM	*Corpus mensurabilis musicae*
DRM	*Denkmäler rheinischer Musik*
DTÖ	*Denkmäler der Tonkunst in Österreich*
FM	*Early Music*
EMH	*Early Music History*
JAMS	*Journal of the American Musicological Society*
JM	*Journal of Musicology*
JRMA	*Journal of the Royal Musical Association*
MB	*Musica Britannica*
MD	*Musica Disciplina*
RBM	*Revue belge de musicologie*
RISM	*Répertoire International des Sources Musicales*
RRMR	*Recent Researches in Music of the Renaissance*
SCJ	*Sixteenth Century Journal*
SCM	*Sixteenth-Century Motet*
SM	*Studi musicali*
TVNM	*Tijdschrift van de Vereniging voor Nederlandse Muziekgeschiedenis*

LIBRARY SIGLA

A-Wn	Vienna, Österreichische Nationalbibliothek, Musiksammlung
B-Bc	Brussels, Conservatoire Royal, Bibliothèque
B-Br	Brussels, Bibliothèque Royale
B-Gu	Ghent, Universiteitsbibliotheek
B-LVu	Leuven, Katholieke Universiteit, Bibliotheek
CH-E	Einsiedeln, Kloster, Musikbibliothek
CH-Zz	Zürich, Zentralbibliothek
D-Mbs	Munich, Bayerische Staatsbibliothek
F-Pn	Paris, Bibliothèque Nationale de France
F-VAL	Valenciennes, Bibliothèque Municipale
GB-Cu	Cambridge, University Library
GB-Lbl	London, British Library
GB-Ob	Oxford, Bodleian Library
GB-WA	Whalley, Stonyhurst College Library
I-Bc	Bologna, Museo Internazionale e Biblioteca della Musica
I-Nbn	Naples, Biblioteca Nazionale
I-Rsg	Rome, San Giovanni in Laterano, Archivio musicale
I-Rvat	Rome, Biblioteca Apostolica Vaticana
I-TVd	Treviso, Biblioteca capitolare del Duomo
I-VIM	Vimercate, Archivio Plebano
NL-L	Leiden, Gemeentearchief
NL-SH	's-Hertogenbosch, Archief van de Illustre Lieve Vrouwe Broederschap
NL-Uu	Utrecht, Universiteitsbibliotheek
US-BAw	Baltimore, Walters Art Museum

A Note on Spelling, Terminology, Musical Examples, and Translations

In quoting from texts in languages other than English, I have preserved the spelling, punctuation, and capitalization used in the cited source, with the following exceptions:

1. I have tacitly expanded (spelled out) Latin abbreviations.
2. I have transcribed the Latin ligatures œ and æ as *oe* and *ae*.
3. I have regularized the use of the letters *U* (as a vowel) and *V* (as a consonant).
4. In transcribing the words of motets, I have standardized punctuation, capitalization, and orthography, to facilitate alphabetization of incipits and comparison of multiple settings of identical or similar texts. I have followed the spelling used in Lewis and Short, *A Latin Dictionary* (Oxford, 1879), except for the name of Cecilia herself. Although this name was spelled with a diphthong in ancient Rome (Caecilia), in the Latin of the Middle Ages and Renaissance the spelling "Cecilia" was common. In quoting motet texts, I have adopted the latter spelling throughout. I have also enclosed in quotation marks (never found in the original sources) statements by Cecilia in texts that shift from narrative to direct quotation.

Throughout this book, "the Netherlands" refers to territory corresponding roughly to the present-day Netherlands and Belgium. As a corresponding adjective, I prefer "Flemish" to the cumbersome "Netherlandish." References to persons as "Flemish" mean that they were born in the Netherlands (as understood here) and have no bearing on what language or languages they spoke or wrote.
Composers in the Renaissance often wrote motets in two or more move-

ments, which they called *prima pars*, *secunda pars*, and so forth. In referring to these movements, I have used the words *partes* (plural of *pars*), "parts," and "movements" interchangeably.

The musical examples are not intended as critical editions. In examples based on original sources, I have tacitly adjusted text underlay and occasionally corrected (without comment) what I perceive as mistakes in the sources. To the words in musical examples, whether based on original sources or modern editions, I have applied the editorial policies described above. All examples preserve (or, in the case of some examples based on modern editions, restore) the original note values.

The predominance in the sixteenth-century motet of *tempus imperfectum*—a kind of duple meter in which the breve serves as a basic metrical unit—makes the breve a convenient unit of measurement for the length of motets, of individual movements, and indeed of any musical passages. In dealing with the *longa* of indeterminant length with which most sixteenth-century motet movements end, I have followed the practice of many modern editors and have counted a movement's final *longa* as its final breve. In motets with more than one movement, I have counted the breves in each movement separately.

All translations into English are my own unless otherwise indicated. Most translations are accompanied by the text in its original language. Among the few exceptions are some of the long quotations derived from sources easily accessible on Google Books.

Introduction

Pierre de Sainte-Catherine, describing in 1669 the liturgical practices of the Royal Convent of Montmartre in Paris, explained why the nuns celebrated St. Cecilia's Day with exceptional solemnity:

> Although her Office is only semidouble, nevertheless the Mass will be sung in polyphony, and with the organ, in honor of this saint. Her story holds that, among her life's innocent activities, every day she spent several hours singing divine praises, mingling her voice with the pleasant sounds of the organ, and asking God to keep her heart and her body always pure in his sacred presence.[1]

Alban Butler, in the vast collection of hagiographic lore he assembled in the second third of the eighteenth century, wrote of Cecilia's "assiduity in singing the divine praises (in which, according to her Acts, she often joined instrumental music with vocal)."[2]

It is not surprising that Pierre and Butler should believe that Cecilia devoted much of her life to music. They published their books during a long period when artists depicted her playing a wide variety of musical instruments or singing, and poets such as Dryden and musicians such as Purcell and Handel honored her as the patron saint of music.

Yet during this same period a skepticism characteristic of the Enlightenment began to raise doubts. Already in 1732 the historian Jean Lebeuf published a learned discourse on Cecilia's inappropriateness as a musical icon:

> Since everything on earth is subject to change, and every day we make progress in our knowledge of history, we have discovered that the choice of St. Cecilia as

patron of musicians rests on a crumbling foundation: in other words, on authors who attribute to this saint deeds that it pleases them in their piety to imagine, or on a historical text that—even if it were authentic—they have misunderstood or misinterpreted.[3]

Fifty years later the music historian Charles Burney (another voice of the Enlightenment, but apparently unaware of Lebeuf's article) remarked again on the lack of evidence of Cecilia's musical activities. To Burney, writing at the end of a century in which she had been the subject of many musical tributes in England, that lack of evidence seemed remarkable:

> It was natural to expect, in the life of this titular and pious patroness of Music, that some farther mention would be made of her own performance, or at least protection of the art; but neither in Chaucer, nor in any of the Histories or legendary accounts of this saint which I have been able to consult, does any thing appear that can authorise the religious veneration which the votaries of Music have so long paid to her; nor is it easy to discover when it has arisen.[4]

Lebeuf and Burney were right. The late Roman account of Cecilia's life known as the *Passio sanctae Caeciliae* says nothing about daily musical activities. No evidence supports the claim that she spent several hours a day making music or that in her performances "she often joined instrumental music with vocal." But the *Passio* does contain—as Lebeuf pointed out—a passage that gave the initial impetus to a process of cultural evolution that transformed her image into that of a musician and a patron of music.

At the beginning of the fifteenth century, Christians perceived Cecilia as one of many virgin martyrs, without musical skills or interests. During the next two centuries, while maintaining her status as a virgin martyr, she became a patron saint of musicians and of music, inspiring more than one hundred motets in her honor and paintings that depicted her singing or playing the organ, virginal, clavichord, violin, bass viol, or lute.

How did an originally unmusical saint come to be portrayed as a musician? Why did so many composers of the sixteenth, seventeenth, and eighteenth centuries write music that honored her as their patron? Several scholars have traced the iconographic record in manuscript illuminations, frescoes, and altarpieces, following the evolution of visual elements (Cecilia as an organist, as a player of other instruments, as a singer) over time.[5] This book takes a more interdisciplinary approach, arguing that her association with music arose out of interactions between the Christian liturgy, the visual arts, music, and musical institutions; and between artists, musicians, and their patrons. This is a story not only of the influence of the visual arts on music and vice versa, but also of the transfer of visual and musical traditions from northern Europe to Italy. Although much of the story takes place in the Netherlands and northern France, in the last two chapters the scene shifts to Italy, and the astonishing discovery, in 1599, of Cecilia's body under the church in Rome that bears her name.

A LEGENDARY VIRGIN AND HER MUSICAL WEDDING

We know nothing for sure about Cecilia's life—or even if she existed at all. By the middle of the fifth century, a cult had grown up around tales of a young Roman woman who, devoted to Christ, lived in chastity with her husband and converted him and many others to Christianity before being martyred. Around AD 450 Arnobius the Younger, a monk living near Rome, assembled these stories in the *Passio sanctae Caeciliae*.[6] Arnobius's account circulated in manuscript during the next several centuries, spreading the legend of Cecilia to every corner of Europe.

By the later Middle Ages, two texts had displaced the *Passio* as sources for the legend: the liturgy for Cecilia's Day, spoken and sung in Europe's churches and monasteries on 22 November, and the *Legenda aurea*, or *Golden Legend*, a collection of saints' lives compiled by Jacobus de Voragine in the 1260s. Although the *Passio* served as the principal source for both the Cecilian liturgy and Voragine's biographical sketch, the Renaissance came to know Cecilia primarily through the liturgy and the *Golden Legend*.

Cecilia's association with music can be traced to a short passage near the beginning of the *Passio*. A young Christian woman of noble birth, she devoted herself to God and decided to remain a virgin. An arranged marriage brought her to a state of crisis. During the wedding festivities, "while the instruments sang, she sang in her heart to the Lord alone, saying: 'Let my body and my heart be made pure, that I may not be confounded.'" Compilers of the Cecilia's Day liturgy quoted this passage repeatedly. Writers who retold her story, including Voragine, referred to the music at her wedding; and artists who depicted the wedding in illuminated manuscripts and frescoes included musicians in their images. These writers and artists understood that Cecilia herself was no musician; yet their work laid the conceptual foundation for the decision by later artists to place a small organ in her hands or at her feet.

THE ORGAN AS EMBLEM IN THE VISUAL ARTS

In the late Middle Ages and early Renaissance, patrons demanded paintings of the Virgin and Child surrounded by saints, and they frequently specified that those saints be virgin martyrs, including Cecilia. Artists faced a new challenge: to differentiate her from other virgins. Easily identifiable when surrounded by musicians at a wedding banquet, she suddenly became anonymous when depicted with a martyr's palm, surrounded by other women with palms.

Looking for an attribute to distinguish Cecilia from the other female saints, Flemish artists found it in Arnobius's phrase "while the instruments sang" ("cantantibus organis") and in the illuminations inspired by it. Despite the obvious meaning of the passage as a whole, the phrase led artists to adopt the organ as her emblem. In some of the earliest depictions of her with an organ, she holds it,

or sits or stands next to it, but does not play it. It seems to have been only in the early sixteenth century that artists in the Netherlands consistently brought her fingers into contact with the keys.

Artists' use of the organ as Cecilia's attribute, and her subsequent transformation into a musician, involved the same kind of linguistic-visual sleight of hand that resulted in another virgin martyr, Agnes, being depicted with a lamb (Latin: *agnus*). Artists found the lamb an attractive and convenient emblem even though they knew that Agnes was no shepherdess and had no lamb as a pet. St. Jerome's lion belongs in the same category. By the beginning of the sixteenth century, most artists were aware that no evidence supported the story (borrowed from the life of another saint) that a tame lion lived with Jerome in the desert; yet they continued to depict the lion, refusing to give up an attribute that they and their patrons knew and loved.[7]

FROM THE VIRGIN MARY TO CECILIA: SINGERS DISCOVER A SAINT OF THEIR OWN

Flemish artists' depiction of Cecilia with an organ led to her correspondingly early adoption as a patron of musicians in the Netherlands. In 1502 instrumentalists in Leuven organized a guild under her protection. A document dated 1515, from Antwerp, is the first suggesting that singers of church music considered her feast as an occasion for celebration and marked it with food and drink. In a later development, first documented in Rouen in 1539, professional musicians established confraternities under her protection, with the goal of observing her feast with religious services and banquets.

Professional singers of sacred music served as a mouthpiece for clergy and congregation alike. When a composer of the late Middle Ages set to music the words "we" and "us" and a choir sang them, they could usually be understood as referring to all Christians—or, at the very least, to all those who could hear the music and who paid for it.[8] But as singers grew increasingly aware of their status as artists—as masters of a difficult and highly valued craft—and as more of them organized themselves into professional groups such as guilds, they increasingly used "we" to refer to themselves. Jane Hatter has called attention to this transformation, which gave rise in the late fifteenth century to the composition of works intended primarily "for the spiritual and professional benefit of living composers"[9]—and, we might add, living singers.

Almost all of those works are addressed to the Virgin Mary. Loyset Compère's *Omnium bonorum plena*, as Rob Wegman has explained, is a prayer by the singers who performed it, imploring the Virgin for intercession on their behalf: "offer prayers to [thy] son, for the salvation of those who sing." Wegman points to this and similar works as evidence that professional singers and composers of the late fifteenth century regarded Mary as their patron saint. The banquet that the singers of St. Donation in Bruges held on the Feast of the Assumption of Our Lady in

1484, in honor of the visiting Johannes Ockeghem, likewise suggests the Virgin held a special place in the spiritual life of singers. The singers of Bruges had no officially sanctioned guild; but everything about the event reminds us of the banquets with which guilds and confraternities celebrated their patronal days.[10]

The fifteenth-century trends that Wegman and Hatter have analyzed continued to shape musical life in the sixteenth century. But now Franco-Flemish musicians seeking saintly intercession and an opportunity for a banquet found an alternative to Mary. With the establishment of musicians' guilds under Cecilia's patronage and the composition of music in her honor, singers in France and the Netherlands entrusted to her a role—as a saint who was theirs alone—that Mary could never play. In the words "Sancta Cecilia, ora pro nobis" that musicians sang at the end of several motets, we can recognize one of the "self-referential features"[11] found in Marian music of the previous century, but with Cecilia, rather than Mary, as the object of the singers' devotion and the recipient of their appeals.

CECILIA AS THE SUBJECT OF MOTETS

We know vastly more about sixteenth-century music than we did in 1972, when Richard Luckett called Palestrina's *Cantantibus organis* (published in 1575) "possibly the earliest attributable and dateable composition in [Cecilia's] honour."[12] At least forty-eight motets preceded Palestrina's. Heinrich Hüschen was one of the first scholars to call attention to the proliferation of music for Cecilia in the sixteenth century.[13] Homer Rudolf discussed the topic in more detail in his dissertation on Cornelius Canis (1977) and explored it further in two unpublished papers.[14] My own work on the music began in 1981, with a paper that formed the basis for one read at a conference that took place in the town of Palestrina in October 1994, in commemoration of the four-hundredth anniversary of the composer's death; it was published many years later.[15] In the meantime Martin Ham, in his dissertation on Thomas Crecquillon (1998), and Mary Tiffany Ferer, in a paper given in 2003, drew scholarly attention to Crecquillon's five Cecilian motets.[16] More recently Gerald Hoekstra has expanded our knowledge of Cecilian music and of the culture that fostered it in his edition of the motets of Andreas Pevernage, and Megan K. Eagen has discussed several Cecilian motets in her dissertation on sacred music published in Augsburg between 1540 and 1585.[17]

The trend started in the north: until the 1560s, composers of Cecilian music worked almost exclusively in northern France and the Netherlands. Most of their motets are settings of liturgical texts for Cecilia's Day, but a few are non-liturgical, and their texts raise the possibility that some of them were written for and sung during observances of the feast by professional musical associations under her protection.

Certain texts from the Cecilia's Day liturgy, such as *Cantantibus organis* and *Dum aurora finem daret*, offered composers stimulating opportunities for dra-

matic musical moments. Both shift from narration to Cecilia's words in direct quotation. In setting them to music, composers often signaled the beginning of the quotation by a prominent change in texture and register. *Cantantibus organis* ends with the words "ut non confundar" (that I may not be confounded), to which composers usually responded with music of exciting rhythmic and contrapuntal complexity. Toward the end of the sixteenth century, the opening word "Cantantibus" inspired composers to write long melismas on the second syllable: musical depictions or evocations of the act of singing itself.

Composers rarely used existing plainchants as structural elements in Cecilian works, but they did incorporate Litany formulas in settings of texts that included words from the Litany of the Saints ("Sancta Cecilia, ora pro nobis"). Occasionally they paraphrased the beginnings of Cecilian chants as *soggetti* for the points of imitation that dominate these works. Only in works explicitly liturgical in function (for example, the polyphonic settings of Vesper antiphons by the Venetian Girolamo Lambardi, published in 1597) do we find Cecilia's Day chants being used as *cantus firmi*.

CECILIA RETURNS TO ROME

The music in honor of Cecilia by composers in the Netherlands and northern France does not seem to have had an immediate effect in Italy, where her cult (to judge from both iconographic and musical evidence) did not attract much attention between 1520 and 1580. The fame of Raphael's *Ecstasy of St. Cecilia* (painted around 1515) has obscured the lack of interest that artists in Italy showed in her as a musician or patron of musicians before the last quarter of the sixteenth century. Italian painters followed Raphael in adopting the Flemish use of a small organ as an identifying attribute. But they rarely took the next step that some Flemish artists took: having Cecilia *play* the organ. Indeed, some of the organs depicted by Italian artists are so small as to be unplayable, and sometimes they lack bellows, a keyboard, or both.

Quite exceptional in this context is Bernardino Campi's altarpiece for the chapel of St. Cecilia in the church of S. Sigismondo in Cremona: a mid-sixteenth-century Italian depiction of Cecilia playing a splendidly decorated positive organ with evident pleasure. Campi's painting suggests that the Franco-Flemish conception of her as a performer, music lover, and patron of musicians was spreading to Italy, albeit slowly, in the cinquecento. That process, shifting to Rome, accelerated in the last quarter of the century.

The eagerness of Roman musicians to embrace Franco-Flemish Cecilian traditions surely had something to do with her having lived and died in Rome. Their interest was also related to the encouragement of the cult by Cardinal Paolo Sfondrato, whose titular church from 1590 was S. Cecilia in Trastevere. Sfondrato's campaign to enhance the saint's prestige—and by extension his own—included the engaging of papal singers to perform at S. Cecilia on her feast day.

His efforts culminated in 1599 in his discovery under the church of a body he believed to be that of Cecilia herself. Her solemnly celebrated reburial later that year, attended by many of Rome's most distinguished clerics and involving some of the city's finest musicians, made Rome the epicenter of her cult and ushered in a period (to be briefly surveyed in the epilogue) in which painters depicted her playing an unprecedented variety of musical instruments and Italian composers dominated the production of Cecilian music.

BOSIO, GUÉRANGER, CONNOLLY, AND CECILIA'S "MELODY OF THE SOUL"

Antonio Bosio, a Roman scholar closely associated with Cardinal Sfondrato, was possibly the first to assert that Cecilia's association with the organ grew out of the passage beginning "cantantibus organis." He explained that in classical Latin the plural noun *organa* could mean musical instruments in general, but it could also refer more specifically to the organ. "From this [narrower understanding of the word] the custom has entered the Church of an organ being painted in her hands."[18]

Bosio's explanation—together with his tacit acknowledgment of the absence of other reasons to think of Cecilia as a musician—has been repeated and elaborated over the centuries. But it is important to note that his main concern was the meaning of *organis*, not artists' use of a musical instrument as an iconographic attribute—the reason for which he probably regarded as self-evident. He ignored depictions of Cecilia *playing* the organ, her adoption as a patron of musicians, and the ninety or so motets written for her before 1600. Bosio, in other words, referred to only one step in the more complicated process, lasting more than a century, from which she emerged as a musician whom seventeenth-century painters depicted playing various instruments and who, according to Pierre de Sainte-Catherine, spent several hours a day singing to the accompaniment of an organ.

In the middle of the nineteenth century, Prosper Guéranger, abbot of Solesmes and a leader in the movement that promised a restoration of plainchant to its medieval roots, published a detailed account of Cecilia's life and legacy that accepted her as a historical figure and accepted the *Passio* as a statement of facts. He presented an explanation for her association with music that has nothing to do with the instruments played at her wedding, and everything to do with her silent prayer:

> During these profane concerts, Cecilia also sang in the depth of her heart, and her melody was united to that of the angels. She repeated that verse of the Psalmist, so well adapted to her situation: "May my heart and my senses remain always pure, O, my God! and may my chastity be preserved inviolable." The Church has faithfully preserved these words of the virgin. They are recited each

year, on the day of her triumph; and to honor the sublime concert, in which she sang with the celestial spirits, and which surpassed all the melodies of earth, she has been styled "Queen of Harmony."[19]

Cecilia's singing was "that melody of the soul which ascends to the Divine fountain of all harmony, and sings to its Creator, even amidst the profane concerts of earth."[20]

Guéranger's interpretation of Cecilia's music as silent prayer, a spiritual communion with the divine, caused him mostly to ignore the depictions of her, from the thirteenth century onward, with male musicians playing the organ and other instruments at her wedding, and the depictions of her as a performing musician that dominated her iconography during the seventeenth and eighteenth centuries. He focused his attention almost exclusively on images with no musical content and on Raphael's *Ecstasy of St. Cecilia*. That famous altarpiece shows her holding a portative organ upside down, allowing the pipes to slide out; at her feet are strewn other instruments in disrepair. She looks up to heaven, her silent prayer corresponding to the "melody of the soul" solely responsible for her status as "queen of harmony."

Guéranger's emphasis on Cecilia's "melody of the soul" and his lack of interest in depictions of her as a performing musician found resonance in the work of Thomas Connolly, the most accomplished and influential living student of her cult. Starting with two pathbreaking articles and continuing with a learned and fervently argued book, Connolly has encouraged scholars to rethink our assumptions about the cult and the process through which Cecilia became identified with music.[21] At the same time, his particular interests led him to focus on certain areas and to leave others untouched. This book is largely devoted to the latter; its aim is to complement Connelly's, not to compete with it.

Like Guéranger, Connolly said little about the medieval images of musicians at Cecilia's wedding; and he too found in Raphael's painting an embodiment of the idea of her prayer as a "melody of the soul." Raphael served as Connolly's chronological terminus as well. He left largely uncovered the Cecilian guilds and confraternities founded by professional musicians and the motets in praise of Cecilia; he discussed only briefly the events that unfolded in Rome in 1599.

Instead, looking back to late imperial Rome, Connolly explicated the archaeological and documentary evidence for the early history of Cecilia's cult, suggesting that it was related to the pagan cult of the Bona Dea, whose temple lay close to where the church of S. Cecilia eventually rose in Rome's Trastevere district. His ingenious argument traced an association between the saint and music back to the origins of her cult and found support in the works of the late medieval mystic Jean Gerson. Building on intensive analysis of Christian spirituality and the biblical theme—exemplified in the story of David—of a transformation from mourning into joy, which he described as "a musical motion of the heart,"[22] Connolly developed Guéranger's concept of Cecilia's silent music as a kind of prayer.

Connolly presented his explanation for Cecilia's association with music as an

alternative to the idea, stated by some twentieth-century scholars,[23] that artists who first depicted her with an organ did so because they misinterpreted a version of the sentence beginning "Cantantibus organis" to mean that she played the organ herself and sang out loud at her wedding: "It is precisely this willingness to attribute little beyond 'misunderstanding' to medieval thinkers, to proceed oblivious to their categories of thought, and to impose modern categories on their works, that has led to ignorance about why Cecilia is associated with music and to a simplistic and unmedieval contrast, in discussing her cult, between earthly and heavenly music."[24] Thus Connolly positioned his book as a defense of the intelligence and intellectual integrity of medieval artists and writers.

This is a worthy cause, and Connolly is certainly right that the artists who first used the organ as Cecilia's identifying emblem did so in full awareness that she did not actually make music (in a conventional sense) at her wedding. But in the passage just quoted, he set up a straw man. We do not need to posit the misunderstanding of a passage whose meaning is as clear to us as it was to medieval artists in order to agree with Bosio that the words "Cantantibus organis" suggested to those artists the idea of the organ as Cecilia's emblem.

Connolly's emphasis on theology left him with little room to consider the pleasures that men and women of the Middle Ages and Renaissance enjoyed, and that motivated them as much as spiritual matters. Artists delighted in depicting a musical instrument in Cecilia's hands as much as viewers delighted in seeing it. Worshippers at St. Johanniskirche in Lüneburg probably took a furtive pleasure in glancing at Hinrik Funhof's depiction of the naked saint standing in a tub of boiling water. Singers and listeners alike must have enjoyed the musical fireworks inspired by the phrase "ut non confundar" at the end of many motets. Musicians anticipated Cecilia's Day not only because of the musical and devotional opportunities it offered, but also because of the food and wine they enjoyed during the banquet. One of my goals in writing this book has been to restore to the scholarly discourse on Cecilia the idea that an appetite for life's less intellectual pleasures played a crucial role in the process by which she became indelibly identified with music.

COXCIE VS. RAPHAEL: TWO COMPETING IMAGES

Connolly, like Guéranger, gives pride of place to *The Ecstasy of St. Cecilia*. Raphael's painting is extraordinary and exceptional, in its beauty, iconography, and place of origin. I will argue that it falls outside the main historical trends in the evolution of Cecilia's cult, in which most of the important developments were taking place in and near the Netherlands when Raphael made his altarpiece. Because of this, and because Connolly served Raphael's painting so well, I will devote relatively little attention to it here.

If I had to choose a single image—an alternative to Raphael's—to represent my view of Cecilia in the Renaissance, it would be Michiel Coxcie's picture of

the saint making music with three angels—a painting mentioned by neither Guéranger nor Connolly. Like her transformation into a musician and patron of musicians, this painting is a product of the Netherlands, by an artist closely associated with the Habsburg court. Unlike the organ that Raphael's saint allows to fall apart, Coxcie's virginal appears to be in perfect order. We see Cecilia not as a virgin martyr, a celibate spouse, or a bride of Christ, but as a musician, performing with pleasure. She participates in the performance of *Cecilia virgo gloriosa*, a ravishing motet by a Flemish composer, Jacobus Clemens non Papa. A setting of texts from the Cecilia's Day liturgy, the motet identifies the performance as part of an observance of Cecilia's Day and testifies to the importance of music in that celebration. In showing Cecilia performing a motet, the painting alludes to a genre crucial to the spread of her cult and the transformation of her image.

Wedding Music: Retelling the Passio in Medieval and Early Renaissance Liturgy, Literature, and Art

Medieval Europe cultivated a special reverence for virgin martyrs: young women who, during the early centuries of Christianity, abstained from sexual activity and gave up their lives, often suffering great pain and bodily disfigurement, in defense of their virginity and faith in Christ. Their stories, few of which have any historical or archaeological basis, present a series of closely related narratives that Karen A. Winstead has summarized in an influential book:

> What distinguishes the legends of most female martyrs from those of their male counterparts is a preoccupation with gender and sexuality. Almost all virgin martyr legends dramatize some threat to the saint's virginity. Usually that threat is directly linked to religious persecution. For example, in many of the most popular legends, including those of Margaret, Juliana, Agnes, and Agatha, a pagan falls in love with the saint, woos her, then persecutes her when he finds that she will have nothing to do with him. In other cases, the official presiding over the trial of a beautiful Christian offers to marry her and is rejected, as in most legends of Martina, Euphemia, and Katherine of Alexandria. Somewhat less frequently, the saint's resistance to sexual advances forms a major episode in her legend, though it is not causally related to her martyrdom. For example, in the legends of Ursula, Cecilia, Justine, and Lucy of Rome, the saint successfully overcomes a threat to her chastity by converting her spouse or suitor; these legends generally conclude with the martyrdom of both the saint and her admirer.[1]

Since the publication of Winstead's book, the medieval cult of virgin martyrs has been the subject of much scholarly investigation, with Catherine of Alexandria drawing much of the attention.[2]

Cecilia differed from most virgin martyrs, including Catherine, in maintaining her virginity within marriage and converting her husband to Christianity. Her legend, as Arnobius the Younger recorded it in his *Passio sanctae Caeciliae*, thus constitutes a hybrid of two hagiographic narratives admired in the Middle Ages: those of the virgin martyr and the celibate marriage.[3]

After a prologue, the *Passio* quickly takes us to the event that would eventually lead to Cecilia's association with music. This young Roman woman's hitherto placid life, devoted to Christian prayer, is interrupted and transformed by an arranged marriage:

> Huius vocem audiens caecilia virgo clarissima, absconditum semper evangelium Christi gerebat in pectore. et non diebus, non noctibus a conloquiis divinis et orationibus cessebat. Haec valerianum quendam iuvenem habebat sponsum, qui iuvenis in amore virginis perurgens animum, diem constituit nuptiarum. Caecilia vero subtus ad carnem cilicio induta, desuper auratis vestibus tegebatur. Parentum enim tanta vis et sponsi circa illam erat exestuans ut non possit ardorem sui cordis ostendere. et quod solum Christum diligeret indiciis evidentibus aperire. Quid multa? Venit dies, in qua thalamus conlocatus est, et cantantibus organis, illa in corde suo soli domino decantabat dicens: Fiat corpus meum et cor meum immaculatum, ut non confundar, et biduanis ieiuniis orans, commendabat domino quod timebat.[4]

> *Hearing his [Christ's] voice, Cecilia the most noble virgin always bore the Gospel of Christ hidden in her heart, and neither day nor night did she cease sacred conversation and prayers. She was betrothed to a certain youth, Valerian. This youth, moved by his love for the virgin, established the day of the wedding. But Cecilia wore rough cloth over her flesh, beneath her gold-embroidered gown. For her parents and spouse exerted so much pressure that she could not reveal her heart's desire and show openly that she loved Christ alone. In short, the day when the marriage was to take place arrived; and while the instruments sang, she sang in her heart to the Lord alone, saying: "Let my body and my heart be made pure, that I may not be confounded." In prayer, and with two days of fasting, she commended herself to the Lord, because she was afraid.*

After the wedding she told her husband that she had a guardian angel who would kill anyone who threatened her virginity, persuading Valerian to become a Christian and to live with her in chastity. She went on to convert many others and to engage in a spirited debate with the pagan prefect Almachius, who sentenced her to death. After she survived an attempt to kill her in the scalding water or steam of a Roman bath, a soldier tried unsuccessfully to cut off her head with his sword, but the wound he inflicted did eventually lead to her death.

Arnobius's juxtaposition of festive wedding music and Cecilia's silent prayer—her silent "song" to God alone, paraphrasing Psalm 118, verse 80[5]—and the phrase "cantantibus organis," with its poetic evocation of musical instru-

ments that sing, evidently fascinated the medieval mind. Compilers of the liturgy repeated this sentence, giving it a prominent place in the prayers and readings of the Divine Office for Cecilia's Day, 22 November. Writers who retold her life in prose or poetry rarely omitted a reference to the wedding music. Some of the artists who illustrated liturgical manuscripts and other accounts of her life with pictures of the wedding included in their illuminations a musician playing the organ, or several musicians playing the organ and other instruments. But neither the writers nor the artists made Cecilia herself into a musician.

CECILIA'S DAY IN CONTEXT

Within the Sanctorale, the liturgical cycle of fixed feasts with which medieval Christians organized the year, Cecilia was one of hundreds of saints: some honored throughout the continent, others the objects of regional or local cults. These feasts were ranked according to an elaborate system of classification. Cecilia's Day, in most places, occupied a place in the middle of the rankings. Three sixteenth-century liturgical calendars, from different kinds of institutions in different parts of Europe, all show that Cecilia's Day was observed more grandly than some feasts, but not with the solemnity accorded the highest holidays.

In the use of York, the liturgical tradition of the cathedral of York, which prevailed in the north of England until it was suppressed under King Henry VIII, Cecilia's Day was one of eighty-nine "Feasts of Nine Lessons" (with a full nine readings during Matins), which also included the feasts of other virgin martyrs (Agnes, Agatha, Margaret, Catherine, Lucy, and the Eleven Thousand Virgins of Cologne) and other women (Anne, Martha, Mary Magdalene, and the regionally venerated Everilda). Below these were many lesser feasts, celebrated with three lessons. But half of the Feasts of Nine Lessons belonged in two categories of higher status than that of Cecilia's Day, the Principal Doubles and the Minor Doubles. These included the feasts of twenty-seven saints: all, except the Virgin Mary, were male, consisting mostly of apostles, evangelists, and church fathers.[6]

At the Church of Our Lady in Breda (also known as the Grote Kerk), in the Netherlands, Cecilia's Day was likewise a Feast of Nine Lessons, along with the feasts of Agnes, Agatha, and the Eleven Thousand Virgins; but several female saints (including two virgin martyrs) outranked them: Anne and Barbara as Triplex feasts (corresponding to the Principal Doubles in York) and Mary Magdalene and Catherine as Duplex feasts (corresponding to the Minor Doubles).[7]

Cecilia's Day was even further from the top of the liturgical hierarchy at the Benedictine monastery of St. Emmeram in Regensburg; it yielded to the celebration of locally prominent saints such as Emmeram and Wolfgang, and also to a feast that became increasingly important during the sixteenth century, that of the Presentation of the Virgin Mary (21 November, just a day before Cecilia's Day). A breviary published in 1571 designates All Saints' Day as the highest feast in November (*in summis*). Below it were thirteen feasts ranked according

to the number of candles (*lumina*) burning. The monks lit fifteen candles for the Translation of Emmeram and the Presentation of the Virgin; seven for Andrew, Catherine, Martin of Tours, and the octave of Wolfgang; five for Leonard and Elizabeth of Hungary; but only three for Brice, Cecilia, Clement, Othmar, and Virgilius. At the bottom of the hierarchy were seven feasts classified as "commemorations," which required no specific number of candles.[8]

Hundreds of books of hours copied during the later Middle Ages and Renaissance give us a wider view of Cecilia's place in the cult of saints. The calendars in these prayerbooks for private use, as collected and transcribed by Aaron Macks, divide feasts into several categories, the two main ones defined by him as "normal" (with the name of the feast typically written in black ink) and "high" (in red ink).[9] Of the 312 calendars in his database that include Cecilia's Day, 258 rank it normal while only 31 rank it high. These calendars often rank the feasts of several other virgin martyrs higher than Cecilia's Day. Most conspicuous in this respect is Catherine, whose feast, 25 November, ranks high in 263 calendars. Only three days after Cecilia's Day, its "popularity" may have negatively affected that of Cecilia's feast. (In the following chapters, I will return occasionally to Catherine, treated very differently from Cecilia not only by those who compiled liturgical calendars but also by artists and musicians.)

Typical of Cecilia's place in books of hours is her treatment in the Hours of Isabelle of Castile (ca. 1500), which divides feast days into two tiers using black and red ink, and implicitly adds a third tier, lower than the others, by simply omitting the names of lesser feasts. In November, nine feasts in black, including Cecilia's Day, are outranked by six feasts in red: All Saints, All Souls, Martin, Clement, Catherine, and Andrew.[10]

A book of hours made in France in the mid- to late fifteenth century contains a more dramatic demonstration of Cecilia's secondary status (plate 1). The names of most feasts are written in red or blue ink in alternation, while the names of the highest feasts are written in gold. The calendar for the last eleven days of November has two names in gold (Catherine and Andrew) and eight names (plus the vigil of St. Andrew) in blue or red. The colors convey a two-tier hierarchy, with Cecilia in the lower tier. But the miniatures that embellish the page present a different ranking. The largest picture is of St. Geneviève, testifying to her special importance in France, where a feast in her honor was celebrated on 26 November.[11] Leaving aside the image of Sagittarius (which the sun entered on or about 17 November in the later Middle Ages[12]), smaller images (on the left) show Andrew, Catherine, and Clement. And the smallest images of all, at the top, depict two prelates and a woman reading a book. Since only three female saints are named on this page, this woman must be Cecilia. The artist clearly considered her of lesser importance than Geneviève and Catherine; but even this small image places her above the several saints listed in the calendar who are not depicted at all.

THE WEDDING IN THE LITURGY: THE OFFICE IN WORDS AND MUSIC

It was thus within a succession of greater, equal, and lesser feasts that Christians observed Cecilia's Day with prayers and readings. At Mass, those prayers mostly praised virgin martyrs in general, not Cecilia specifically. But during the Divine Office, a series of ceremonies extending from Vespers on Cecilia's Eve to Vespers twenty-four hours later, believers had an opportunity to retell and rehear her story in some detail—much of it in music.[13]

The Office was dominated by the declaiming of psalms and canticles (the Magnificat at Vespers, the Benedictus at Lauds), and the reading or chanting of lessons (*lectiones*). The psalms and canticles required antiphons, framing chants that differed every day according to the feast.[14]

By far the longest and most elaborate ceremony of the Office was Matins, celebrated during the night or early morning.[15] Matins consisted of large sections called nocturns, each of which began with a series of psalms preceded and followed by antiphons; it continued with a lesson. A responsory, often subject to rich musical elaboration, followed each lesson. The responsory had a distinctive form that can be represented as AB/CB. It began with a respond, which typically consisted of two phrases or sentences (AB); it continued with a verse (C), followed by the *repetendum*—a repetition (both verbal and musical) of the respond's second phrase (B).

Liturgical practices of pre-Tridentine Christianity varied, changing over time and differing from place to place and from institution to institution.[16] But these variations generally occurred within a fairly standardized framework. This is as true for the Office on 21–22 November as for any other part of the liturgy. Consider, for example, two manuscripts that record the Office, one with music and the other without. One is an antiphonary: a compilation of chants for the whole annual cycle of the Office. The other is a breviary: a compilation of the texts for the Office, without music. The Beaupré Antiphonary was completed in 1290 in the southern Netherlands for the Cistercian convent of Beaupré, near Geraardsbergen in Flanders. It was used for five centuries, subject to alterations as liturgical practices and musical tastes evolved.[17] The Breviary of Marie de Saint Pol was made in Paris between 1330 and 1340 for a wealthy noblewoman who commissioned it for her private devotions; the rubrics are in French. Marie founded a Franciscan convent (Denny, near Cambridge); not surprisingly, her prayerbook conforms to the Franciscan use.[18]

In both manuscripts the Cecilian Office begins with First Vespers and proceeds to Matins; but they differ in the text of the Magnificat antiphon (declaimed before and after the Magnificat). The nuns of Beaupré sang "Virgo gloriosa semper evangelium Christi gerebat in pectore suo" (Cantus ID 005451,[19] paraphrased from the passage in the *Passio* quoted above): a chant widely used in this liturgical context, in many institutions in many parts of Europe. Marie de

Saint Pol, in contrast, read words that, according to Arnobius, Cecilia said to her husband on their wedding night: "Est secretum Valeriane quod tibi volo dicere: angelum Dei habeo amatorem qui nimio zelo custodit corpus meum" (I want to tell you a secret, Valerian: I have an angel of God as my lover, who guards my body with great zeal; Cantus ID 002680). The use of this text as a Magnificat antiphon was traditional in the Franciscan order.

In what follows, when I cite a particular document as evidence for a liturgical practice, I never mean to imply that this practice was followed everywhere and always.

Many of the antiphons, lessons, and responsories for Cecilia's Day consisted of excerpts from or paraphrases of Arnobius, including his account of the wedding.[20] As an example of how the wedding narrative pervaded the Office, here are some texts that refer to the wedding and what directly preceded it. I quote from the use of York.[21] But in its frequent allusions to the wedding, it was typical of the Office as declaimed throughout Europe in the Middle Ages and Renaissance. The words "cantantibus organis" (in boldface below) were sung four times, Cecilia's prayer "Fiat Domine cor meum" (or "Fiat cor meum") no less than six times, in various liturgical contexts.

FIRST VESPERS

Antiphon for the Magnificat

> Virgo gloriosa semper evangelium Christi gerebat in pectore suo: non diebus neque noctibus a colloquiis divinis et oratione vacabat [Cantus ID 005451]

> *The glorious virgin always bore the Gospel of Christ in her heart, and neither day nor night did she cease sacred conversation and prayer.*

MATINS

Nocturn 1

Antiphon 3

> Cilicio cecilia membra domabat: deum gemitibus exorabat [Cantus ID 001804]

> *Cecilia tamed her limbs with rough cloth; groaning, she prayed to God.*

Lesson 1

> In diebus illis: Cecilia virgo clarissima evangelium Christi gerebat in pectore suo et non diebus neque noctibus a colloquiis divinis et oratione cessebat. Hec valerianum quendam juvenem habebat sponsum: quique diem constituit nuptiarum. Cecilia vero subtus ad carnem cilicio induta: desuper deauratis vestibus tegebatur. Quid multa? Venit dies in qua thalamus collo-

catus est: et **cantantibus organis** cecilia domino decantabat dicens: Fiat cor meum et corpus meum immaculatum: ut non confundar.

In those days, Cecilia the most noble virgin bore the Gospel of Christ in her heart, and neither day nor night did she cease sacred conversation and prayer. She was betrothed to a certain youth, Valerian, who established the day of the wedding. But Cecilia wore rough cloth over her flesh, under her gold-embroidered gown. In short, the day when the marriage was to take place arrived; and while the instruments sang, Cecilia sang to the Lord, saying: "Let my heart and my body be made pure, that I may not be confounded."

Responsory after Lesson 1

[Respond:] **Cantantibus organis** cecilia virgo in corde suo soli domino decantabat dicens: Fiat domine cor meum et corpus meum immaculatum: ut non confundar. [Verse:] Biduanis ac triduanis jejuniis orans commendabat domino quod timebat dicens [*Repetendum:*] Fiat domine cor meum (Cantus ID 006267, 006267a).

[Respond:] While the instruments sang, Cecilia the virgin sang in her heart to the Lord alone, saying: "Lord, let my heart and my body be made pure, that I may not be confounded." [Verse:] In prayer, and with two and three days of fasting, she commended herself to the Lord, because she was afraid, saying: [Repetendum:] "Lord, let my heart . . ."

Responsory after Lesson 3

[Respond:] Virgo gloriosa semper evangelium Christi gerebat in pectore. Et non diebus neque noctibus vacabat a colloquiis divinis et oratione. [Verse:] Cilicio cecilia membra domabat deum gemitibus exorabat. [*Repetendum:*] Et non diebus (Cantus ID 007902, 007902b).

[Respond:] The glorious virgin always bore the Gospel of Christ in her heart, and neither day nor night did she cease sacred conversation and prayer. [Verse.] Cecilia tamed her limbs with rough cloth; groaning, she prayed to God. [Repetendum:] And neither day . . .

Nocturn 2

Antiphon 3

Fiat domine cor meum et corpus meum immaculatum ut non confundar (Cantus ID 002863)

Lord, let my heart and my body be made pure, that I may not be confounded.

Responsory after Lesson 4

[Respond]: Cilicio cecilia membra domabat deum gemitibus exorabat. Almachium exuperabat tyburtium et valerianum ad coronas vocabat. [Verse:]

Non diebus neque noctibus vacabat a colloquiis divinis et oratione. [*Repeten-dum:*] Almachium (Cantus ID 006284, 006284a).

[*Respond:*] *Cecilia tamed her limbs with rough cloth; groaning, she prayed to God. Almachius she defeated and Tiburtius and Valerian she summoned to crowns [of martyrdom]. [Verse:] Neither day nor night did she cease sacred conversation and prayer. [Repetendum:] Almachius . . .*

LAUDS

Antiphon 1

Cantantibus organis cecilia domino decantabat dicens: fiat cor meum im-maculatum: ut non confundar (Cantus ID 001761).

While the instruments sang, Cecilia sang to the Lord, saying: "Let my heart be made pure, that I may not be confounded."

SECOND VESPERS

Antiphon 1

Cantantibus [organis cecilia domino decantabat dicens: fiat cor meum im-maculatum: ut non confundar] (Cantus ID 001761).

While the instruments sang, Cecilia sang to the Lord, saying: "Let my heart be made pure, that I may not be confounded."

Most of these texts were sung to melodies that probably existed (or resembled melodies that existed) before the invention of a system of notation that recorded relative pitch more or less exactly. In manuscripts made during that system's evolution, we can see the melodies emerge with gradually increasing precision. An early stage in that emergence is recorded in the famous Hartker Antiphonary, made at the end of the tenth century for the monks of St. Gallen, in what is now northern Switzerland (plate 2). Many of them had sung the responsory *Cantantibus organis* since youth and probably knew it by heart. The staffless neumes in this manuscript served them as an aide-mémoire as they sang a familiar chant. For us they serve another purpose, revealing something of the responsory's melodic contour as it sounded at St. Gallen in the tenth century.

The responsory's pitch content comes more clearly into focus in a manuscript made in the twelfth century for the Augustinian monastery at Klosterneuburg, near Vienna (plate 3). A red horizontal line indicates the location of the pitch F, and letters arranged vertically at the beginning of each line give the approximate location of A and C above F and of D below F.

By the time the Beaupré Antiphonary was made, near the end of the thirteenth century, the system of pitch notation that we still use today—in which

EXAMPLE 1.1. Responsory *Cantantibus organis* (Cantus ID 006267) in the Beaupré Antiphonary, pp. 355–56.

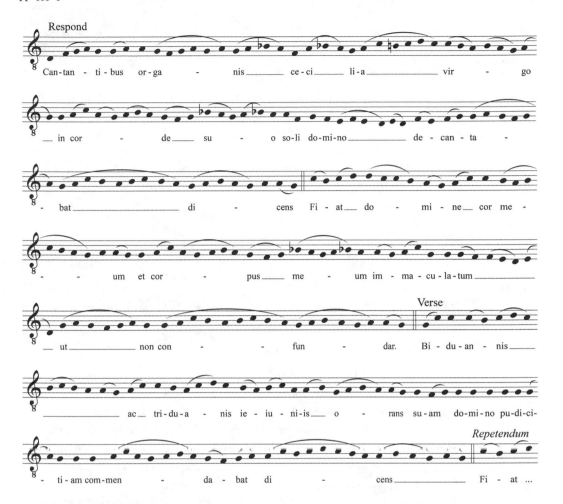

parallel horizontal lines and the spaces between them represent individual pitches—was close to full implementation (plate 4). The staff consists of four red lines, with clefs that indicate the location of F or C, and the notes are marked with square notation.

The Beaupré manuscript records, on eight sheets of parchment, the music of the Cecilian Office with unusual fullness. It includes chants not only for First and Second Vespers, Matins, and Lauds, but also for Prime, Terce, Sext, and None. At Beaupré the sentence beginning "Cantantibus organis," in whole or in part, took on four melodic guises, corresponding to four liturgical functions: as a responsory, a responsory verse, an antiphon in Matins, and an antiphon in Lauds.

The responsory *Cantantibus organis* (ex. 1.1) exemplifies the characteristic AB/CB form of responsories (which in this case required the repetition of Cecilia's prayer "Fiat Domine cor meum") and their typically exuberant melismatic style. Notice that the Beaupré manuscript transmits a version of the verse (with

EXAMPLE 1.2. Verse *Cantantibus organis* (Cantus ID 007902zb) in the responsory *Virgo gloriosa semper Evangelium Christi* in the Beaupré Antiphonary, pp. 357–58.

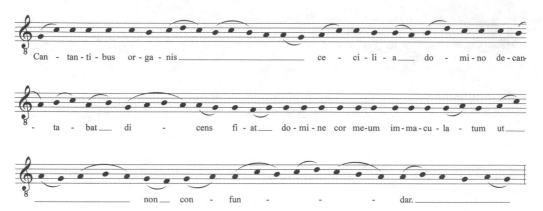

EXAMPLE 1.3. Antiphon *Fiat Domine cor meum* (Cantus ID 002863) in the Beaupré Antiphonary, p. 359.

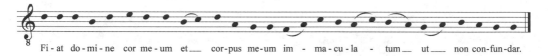

the words "suam Domino pudicitiam commendabat") different from the version associated with the use of York and recorded in the Klosterneuburg manuscript (with the words "commendabat Domino quod timebat"). And the Hartker Antiphonary records yet another variant: "commendabat se Domino quem timebat."

The verse *Biduanis ac triduanis* begins with a melody that we might describe as "generic." Many responsory verses—including one later in the Beaupré version of the Cecilian liturgy—were sung to this same melody.

Later in Nocturn 1, the words "Cantantibus organis" return, but with an abbreviated text and a different melody serving as the verse in the responsory *Virgo gloriosa semper Evangelium Christi* (ex. 1.2). The tune is the one we already encountered in the verse *Biduanis ac triduanis*; yet it fits here. The repeated notes on "fiat domine cor meum immaculatum"—as if these words were being declaimed on the reciting tone G—remind us that Cecilia's prayer is paraphrased from a psalm verse.

In Nocturn 2 Cecilia's prayer, removed from the sentence to which it originally belonged, serves as a brief, mostly syllabic antiphon (ex. 1.3).

The words "Cantantibus organis" return later in yet another liturgical context: as the first antiphon in Lauds (ex. 1.4). Not only is the text abbreviated (in relation to the responsory that begins with the same words), but the music is also less elaborate, with mostly one note per syllable.

Chants similar to these in text and melody were sung in Cecilia's honor in many parts of Europe for many centuries—indeed throughout the entire period

EXAMPLE 1.4. Antiphon *Cantantibus organis* (Cantus ID 001761) in the Beaupré Antiphonary, pp. 365–66.

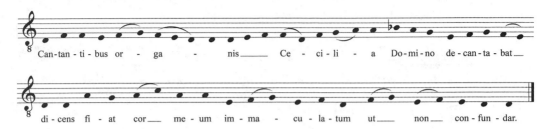

covered by this book and beyond. At the same time, the Beaupré Antiphonary also contains notable divergences from common practice, some associated with the Cistercian order to which the nuns of Beaupré belonged. The text "Cantantibus organis" as the verse of the responsory *Virgo gloriosa* (see ex. 1.2) is found mostly in a few widely scattered Cistercian manuscripts.[22] In many parts of Europe the antiphon *Cantantibus organis* was sung not only at Lauds but also at the beginning of Second Vespers—for example, in the use of York, as documented in the excerpts quoted above. But those who sang from the Beaupré Antiphonary followed the Cistercian tradition of beginning Second Vespers with a different antiphon, *Cecilia virgo Almachium exsuperabat* (Cantus ID 001749).

"CANTANTIBUS ORGANIS" IN THE MASS

The Proper of the Mass is the part of the rite that changes every day, in an annual cycle. It recognizes and takes account of the Sanctorale, but generally it is less closely identified with particular fixed feasts than is the Office, mainly because the readings during Mass are normally taken from the Bible, which refers to relatively few saints. While many versions of the Mass for Cecilia's Day mention her several times, most of the texts are biblical passages appropriate for the feast of any virgin martyr; and extracts from the *Passio*—including the sentence beginning "Cantantibus organis"—are absent. For example, in a missal that records the liturgy in Augsburg, published in 1510, the texts for the Cecilian Mass refer to her by name three times, but without saying anything about her except that she was a virgin martyr.[23]

Yet the words referring to music at Cecilia's wedding were not entirely absent from some versions of the Mass of 22 November. The Ambrosian Rite (used in most of the Archdiocese of Milan and some surrounding areas) called for an antiphon to be sung immediately after the reading from the Gospel ("antiphona post Evangelium"). On Cecilia's Day that antiphon was *Cantantibus organis*.[24] In both text and music it was identical to the *psallenda* (a processional antiphon in the Ambrosian Office) sung near the end of Vespers on Cecilia's Eve (ex. 1.5).[25] The chant shares with the responsory verse transcribed in example 1.2 repeated

EXAMPLE 1.5. Psallenda (processional antiphon) *Cantantibus organis*, which also served as the "antiphona post Evangelium" during Cecilia's Day Mass in the Ambrosian Rite. Source: I-VIM B, fol. 6r, as transcribed in *Psallendae: The Ambrosian Processional Antiphons*, ed. Terence Bailey, Kitchener, 2018, 23 (editorial flat added by author)

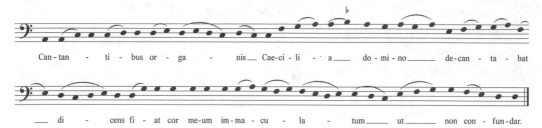

Can - tan - ti - bus or - ga - nis__ Cae-ci - li - ' a__ do - mi - no__ de-can - ta - bat

__ di - cens fi - at cor me-um im-ma - cu - la - tum__ ut__ non con - fun - dar.

notes (indeed the same G) on "Fiat cor meum immaculatum," again pointing to the origin of the words in Psalm 118.

The Alleluia, traditionally sung as a highly florid chant that precedes the Gospel reading, begins and ends with the Hebrew exclamation meaning "Praise the Lord." At its center is a verse: a text proper to the day on which the Mass is said. On Cecilia's Day, in most of pre-Reformation Europe, that text was one of the biblical passages in praise of virginity or in reference to a royal wedding—passages also sung on the feasts of other virgin martyrs such as Agatha, Agnes, and Lucy. But liturgical traditions in a few widely scattered regions preserved an Alleluia verse beginning "Cantantibus organis."[26] The text can be found in a manuscript missal according to the use of Béziers, an ancient city near the Mediterranean coast,[27] and the music in graduals (compilations of plainchant for the Mass) that record the uses of two other cities in the South of France, Narbonne and Albi.

Shortly after the reconquest of the city of Toledo from the Muslims in 1085, the victorious King Alfonso VI of Castile restored Christian worship in the cathedral by installing French monks and priests in positions of authority. They adopted a liturgy heavily influenced by the traditions of southern France.[28] Thus the Cecilia's Day Mass in Toledo included *Alleluia Cantantibus organis*.[29]

Less easy to understand is the presence of *Alleluia Cantantibus organis* in regions distant from each other and from southern France and Spain: the liturgies of Cambrai, Vannes (in Brittany), and York preserved this prayer as well.[30] With the destruction in the sixteenth century of many of the manuscripts and printed books documenting the use of York, we are fortunate that a manuscript containing *Alleluia Cantantibus organis*, notated with square notation on a four-line staff, survives (ex. 1.6).[31] The same chant is found in manuscripts from even further afield, suggesting that it was widely sung in the Middle Ages—or at least at the extremities of Christendom. One manuscript was almost certainly copied in Ireland; another is from Acre, a port on the Mediterranean in what is now northern Israel.[32]

While all these manuscripts record closely related melodies, a sixteenth-century codex preserved in Cambrai suggests that *Alleluia Cantantibus organis*

EXAMPLE 1.6. *Alleluia Cantantibus organis* (Schlager No. 221). Source: The York Gradual, GB-Ob MS Lat. liturg. b. 5, facsimile, ed. David Hiley (Ottawa, 1995)

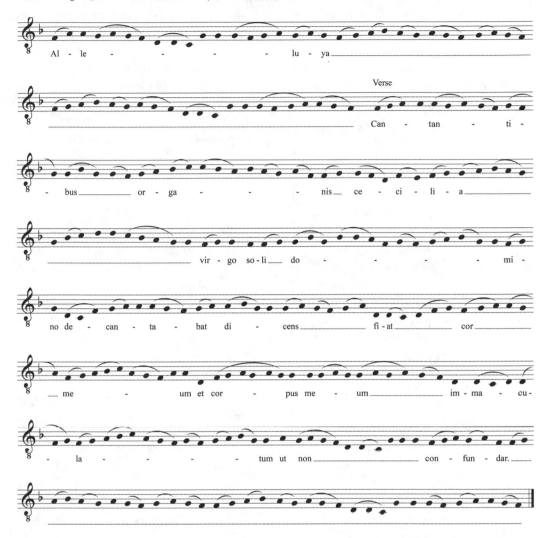

was sung there to a different (much shorter) melody. Another manuscript, from the nearby city of Lille, records yet another short melody for the *Alleluia Cantantibus organis*.[33]

The sequence—a hymn sung, in some liturgical traditions, between the Alleluia and the Gospel reading—offered another opportunity for those saying Mass to connect it more concretely to a particular feast day. *Exultent filiae Sion in rege suo*, a sequence for the feast of any virgin saint, was sometimes sung on Cecilia's Day (in Augsburg, for example[34]). But other sequences have texts devoted to Cecilia alone. *Benedicta es, virgo Cecilia* closely resembles the familiar Marian sequence *Benedicta es, caelorum regina*, to whose tune it was probably sung.[35] The text, preserved in a few missals published in the first half of the sixteenth century, recounts her legend, but without mentioning the music at her wedding.

Another Cecilian sequence, *Eructemus cum iocundo*, refers explicitly to music, adjusting the phrase "cantantibus organis" to fit the rhyme scheme and meter. A missal that records the liturgy of the cathedral of Vannes (mentioned above for its use of the *Alleluia Cantantibus organis*) preserves the text of this sequence as well:

Eructemus cum iocundo	*Let us announce with a joyful song*
cantu corde simul mundo	*and a pure heart the virgin's*
virginis martyrium.	*martyrdom.*
Victis hoste carne mundo	*The enemy and the flesh having been*
Cecilia de profundo	*conquered, Cecilia climbs from the*
scandit ad palatium:	*depths of the world to the palace:*
virgo prudens exors sordis	*the wise virgin, without filth,*
in arcano semper cordis	*always keeping the Gospel in a*
servans Evangelium.	*secret place near her heart.*
Foris nitens indumentis,	*Dressed splendidly on the outside, but*
subtus cultum parans mentis	*underneath, preparing for the adornment*
gerebat cilicium.	*of her mind, she wore a hairshirt.*
Cantantibus organistis	*While the musicians sang, she*
commutare non pro istis	*did not wish to give up, in exchange for*
vult Christi connubium,	*them, her marriage to Christ,*
fructum ventris virginalis,	*fruit of a virginal womb,*
rogans ne sponsi carnalis	*asking that she not feel the*
sentiat contagium.	*infection of a carnal spouse.*
Stupentem Valerianum:	*She sent her astonished husband*
sponsum mitit ad Urbanum	*Valerian to Urban, leader of the*
presulem fidelium,	*faithful,*
quem in fide reddit sanum,	*who sent him back, firm in his faith,*
cui Deus et germanum	*and God joined with him his brother*
sociat Tyburtium.	*Tiburtius.*
Currunt fratres ad certamen:	*The brothers quickly join the struggle;*
quibus virgo dat solamen	*to them the virgin gives comfort,*
ut vincant supplicium.	*that they might overcome torture.*
Cadit corpus vincunt tamen:	*The body falls, yet they conquer,*
nec pavent mortis gravamen	*nor do they fear the pain of death,*
propter vite premium.	*because of the reward of life.*

Sponsa sponso reddens vicem	*The bride, returning to the bridegroom,*
feriendam dat cervicem	*gives her neck to be struck, nor*
neque timet gladium.	*does she fear the sword.*
Sponsus sponsam pugnatricem:	*The bridegroom introduced his*
introduxit in felicem	*combative bride into the happy*
thalamum celestium.	*wedding chamber of heaven.*
Cecilia nos exaudi:	*Hear us, Cecilia,*
ut resistas semper fraudi	*that you might always resist the deceptions*
nobis adversantium.	*of our enemies.*
Sancto fine fac nos claudi	*With a holy end, may we—weak and*
et vacantes tue laudi	*inattentive in your praise—be led*
duc ad regni solium. Amen[36]	*to the throne of the kingdom. Amen*

Eructemus cum iocundo has the same meter as the *Stabat Mater*, and a similar rhyme scheme; perhaps it was sung to one of the melodies associated with that famous sequence.

ALDHELM'S PRAISE OF VIRGINITY

Medieval retellings of Cecilia's wedding were not limited to the liturgy of 22 November. Of the writers of prose and poetry who found inspiration in her legend, few could resist the temptation to repeat the phrase "cantantibus organis"; some used it as an excuse to describe an imagined musical performance in some detail.

Anglo-Saxon England seems to have been particularly fond of the Cecilia legend.[37] One of the earliest surviving accounts of her wedding is also one of the few that specifies the number of singers who entertained the guests. St. Aldhelm (ca. 639–709), a poet and scholar who served as abbot of Malmesbury Abbey and Bishop of Sherborne, wrote of her in *De laude virginitatis*, a treatise in praise of virginity, and in another treatment of the same theme in dactylic hexameter.[38]

In his characteristically ornate Latin prose, Aldhelm emphasized the vehemence with which Cecilia rejected the sexual part of her marriage; but he showed just as much interest in the music that helped celebrate it. He described it as being performed by "twice fifty and thrice five voices of sounds" (115 singers?), in addition to instrumentalists. (In dividing the musicians into singers and players, he may have been trying to explicate the phrase "cantantibus organis," which, however, he did not use.) Alluding to the literature of pagan antiquity, he likened the wedding music to that of the sirens whose seductive voices brought Ulysses close to shipwreck:

. . . Caecilia, virgo sacratissima, indultae iugalitatis consortia ac pacta proci
sponsalia obtentu castitatis refutans velut spurca latrinarum purgamenta lauda-
bili spiritus fervore contempserit, despexerit, respuerit; quae, licet organica bis
quinquagenis et ter quinis sonorum vocibus concreparet armonia, acsi letiferos
Sirinarum concentus, cum inexpertos quosque ad vitae pericula pellexerint,
sub praetextu integritatis surdis auribus auscultabat.[39]

*Cecilia the most holy virgin, having given herself up to marriage, and refusing the
agreed-upon wedding in order to maintain her chastity, with praiseworthy fer-
vor of the soul despised it, turned away from it, and rejected it as the filth of a
brothel. Instrumental harmony clashed with twice fifty and thrice five voices of
sounds, and under the pretext of [preserving] her virginity she heard with deaf ears
the deadly songs of the sirens, which would have seduced the inexperienced to mortal
dangers.*

The wedding music also plays a role in Aldhelm's epic poem on virginity,
showing again that he enjoyed describing the dangerous charms of instrumental
and vocal music:

Porro Caeciliae vivacem condere laudem
Quae valeat digne metrorum pagina versu?
. . .
Quamvis armoniis praesultent organa multis
Musica Pierio resonent et carmina cantu,
Non tamen inflexit fallax praecordia mentis
Pompa profanorum, quae nectit retia sanctis,
Ne forte properet paradisi ad gaudia miles.[40]

*What pages of poetry are worthy
of vigorously praising Cecilia?
. . .
Although organs vibrated with many harmonies,
and music and songs resounded with melodious singing;
yet the false pomp of the profane,
which sets traps for the virtuous, did not entice her
from rushing like a soldier to the joys of paradise.*

THE *SPECULUM HISTORIALE* AND THE *LEGENDA AUREA*

Two Dominican monks active in the thirteenth century, Vincent de Beauvais and
Jacobus de Voragine, stood out among the most prolific and influential scholars
of their time. Vincent was about a generation older; he was born in the 1180s
or 1190s and died around 1264, while Jacobus was born around 1230 and died

in 1298. Both were tireless compilers and editors of the manuscripts in which knowledge of the past had been preserved up to their day.

Vincent's fame rests on his *Speculum maius* (Greater Mirror), a vast compendium of which one part, the *Speculum historiale*, a précis of all of human history, includes a brief retelling of Cecilia's life. Although based, ultimately, on Arnobius, this version of the legend has some original touches. One detail that may have originated with Vincent (it is in any case absent from the *Passio* and from many forms of the liturgy) is the statement that she imbibed Christianity "from the cradle" ("ab ipsis cunabilis"). Most remarkable, he entirely omitted the wedding, and thus he left out the sentence beginning "Cantantibus organis":

> Cecilia hec nata preclaro genere romanorum ab ipsis cunabulis in fide christi nutrita: diebus ac noctibus virginitatem suam conservari a domino precabatur. Desponsata autem cuidam iuveni valeriano: dum dies nuptiarum instaret: biduanis et triduanis ieiuniis orans: se sanctis omnibus commendabat: ut eorum precibus suam pudicitiam custodiret.[41]

> *Cecilia, born of a noble family of Romans, was nourished from the cradle with faith in Christ; day and night she prayed to the Lord to preserve her virginity. But she was betrothed to a certain youth, Valerian. As the day of the wedding approached, she prayed with two days and three days of fasting, commending herself to all the saints, that through their prayers she might guard her chastity.*

Had Vincent's retelling of Cecilia's life not been largely superseded by that of his younger contemporary, the history of her association with music might have been very different.

Jacobus de Voragine, archbishop of Genoa, assembled and edited a collection of saints' lives that, under the title *Legenda aurea* (*Golden Legend*), became one of the most widely read books in the late Middle Ages.[42] Faced with the challenge of retelling the lives of hundreds of saints, Jacobus copied directly from many existing accounts. Although we do not know exactly when Vincent and Jacobus turned their attention to Cecilia, Vincent, the older, probably did so first. Jacobus's account of her wedding is an abridged edition of the *Passio* (including the sentence beginning "Cantantibus organis"), with several words and phrases that he appears to have lifted from the *Speculum*:

> Caecilia virgo praeclarissima ex nobili Romanorum genere exorta et ab ipsis cunabilis in fide Christi nutrita absconditum semper evangelium Christi gerebat in pectore et non diebus neque noctibus a colloquiis divinis et oratione cessabat suamque virginitatem conservari a domino exorabat. Cum autem cuidam iuveni, nomine Valeriano, desponsata fuisset et dies nuptiarum instituta esset, illa subtus ad carnem cilicio erat induta et desuper deauratis vestibus tegebatur et cantantibus organis illa in corde soli domino decantabat dicens: fiat, domine,

cor meum et corpus meum immaculatum, ut non confundar, et biduanis et triduanis jejuniis orans commendabat domino, quod timebat.[43]

The illustrious virgin Cecilia, who came from a noble Roman lineage and was nourished from the cradle in the Christian faith, always carried the gospel of Christ hidden in her breast. She was always occupied with divine conversations and prayers, both by day and by night, and entreated God to preserve her virginity. When she was betrothed to a young man named Valerian and the wedding date was set, she wore a hair shirt next to her flesh, beneath her clothes of gold. And while the musical instruments played, she sang in her heart to God alone, saying, "O Lord, keep my heart and my body undefiled, lest I be overcome." And she fasted for two or three days at a time, always praying, and entrusting to God what she feared.

The *Golden Legend* has special importance for the emergence of Cecilia as a musical icon, because its popularity made the phrase "cantantibus organis" even more familiar than it already was. Through the many vernacular translations that circulated in manuscript and print during the fifteenth and sixteenth centuries, the phrase became known in Dutch ("Ende doemen daer op organen speelde, soe sanck si allene"[44]), French ("et quant les instrumens chantoient elle chantoit a nostre seigneur en son cueur"[45]), English ("and she heeryng the organes making melodye she sang in hir herte onelye tu god"[46]), Italian ("& mentre che sonavano gli organi, cantava nel cuore suo al Signore solo"[47]), and Castilian ("Y cantando ay juglares, ella cantava en su coraçon solamente diziendo a Dios"[48]).

The German *Der Heiligen Leben* offered not just a translation, but an expansion of Voragine's life, including an identification of the kind of musicians who played at the wedding: they were *spilleüt*, or minstrels (like the Castilian *juglares*):

Nun kamen vil spilleüt und hofierer da dar die triben ir spyl uff der junckfrauwen hochzeyt das verdroß sie gar seer und gedaucht sie ein zergenckliche wunne oder traum und was die spilleüt triben so was ir herz doch stetigs bey gott / unnd begeret daß er ir keüscheit behute.[49]

Now came many minstrels and courtiers, who were playing their music for the young woman's wedding. That annoyed her very much and she thought of it as a momentary pleasure or a dream; and as the minstrels played her heart was always with God, and she desired that he preserve her virginity.

Early publications of the *Golden Legend* in the vernacular also played a crucial role in the consolidation of the organ as one of Cecilia's identifying attributes. As we will see in chapter 2, late fifteenth-century editions of French and Dutch translations contain some of the earliest dateable images of her holding an organ or standing next to one.

CHAUCER'S SECOND NUN RECOUNTS THE WEDDING

The vogue of the *Golden Legend* extended to England, where (in whole or in part) it circulated in manuscripts both in the original Latin and in translations into Middle English.[50] Although the Cecilia legend had been known in England since Aldhelm wrote of her in the seventh century, the *Golden Legend* made her better known than ever. When Geoffrey Chaucer wrote *The Canterbury Tales* between 1387 and 1400, he could be confident that his intended readers, already familiar with the legend, would welcome a setting of it in rhymed iambic pentameter, as narrated by a nun on the pilgrimage to Canterbury.

Scholars have intensively investigated Chaucer's sources—which were many, in Latin, English, and French.[51] But clearly the *Golden Legend* was the primary source, directly and indirectly, for the account of Cecilia's wedding. Here it is, in Chaucer's late Middle English and modernized:

This mayden, bright Cecilie, as hir lyf seith,
Was comen of Romayns and of noble kynde,
And from hir cradel up fostred in the feith
Of Crist, and bar his gospel in hir mynde.
She nevere cessed, as I writen fynde,
Of hir preyere, and God to love and drede,
Bisekynge hym to kepe hir maydenhede.

And when this mayden sholde unto a man
Ywedded be, that was ful yong of age,
Which that ycleped was Valerian,
And day was comen of hir marriage,
She, ful devout and humble in hir corage,
Under hir robe of gold, that sat ful faire,
Hadde next hir flessh yclad hir in an haire.

And whil that the organs made melodie,
To God allone in herte thus sang she:
"O Lord my soule and eek my body gye
Unwemmed, lest that I confounded be."
And, for his love that dyde upon a tree
Every seconde and thridde day she faste,
Ay biddynge in hir orisons ful faste.

This maiden bright, Cecilia, her life[52] *saith,*
Was Roman born and of a noble kind,
And from the cradle tutored in the faith

Of Christ, and bore His gospel in her mind;
She never ceased, as written do I find,
To pray to God, and love Him, and to dread,
Beseeching him to keep her maidenhead.

And when this maiden must unto a man
Be wedded, who was a young man in age,
And who had to his name Valerian,
And when the day was come for her marriage,
She, meek of heart, devout, and ever sage,
Under her robe of gold, well-made and fair,
Had next her body placed a shirt of hair.

And while the organ made its melody,
To God alone within her heart sang she:
"O Lord, my soul and body guide to Thee
Unsoiled, lest I in spirit ruined be."
And for his love who died upon a tree,
Each second and third day she used to fast,
And ever prayed she till the day was past.[53]

HUMANIST TRIBUTES: MANTUANUS AND CLICHTOVE

The scholars, poets, and theologians of the fifteenth and sixteenth centuries known today as humanists tried to reconcile their Christian faith with their deep knowledge and appreciation of ancient Greek and Roman literature and their ambition to recapture some of its beauty in their own writing. Some of them rejected on aesthetic grounds much of the Christian literature of previous centuries, including the *Legenda aurea*, which Juan Luis Vives famously denounced in 1531: "How unworthy of the saints and of Christian men is that account of the saints called the *Golden Legend*. I do not know why they call it 'Golden' since it was written by a man with a mouth of iron and a heart of lead."[54] Humanists who hoped to clothe hagiography in Ciceronian prose or Virgilian poetry found in Cecilia an attractive subject. On the one hand she offered a model of Christian virtue; on the other, she was a Roman noblewoman whose life invited retelling in words inspired by the best of pagan literature.

Baptista Mantuanus (1447–1516), a Carmelite friar and poet, praised virginity in a series of epic poems in the style of Virgil. His poem on Cecilia (in 811 dactylic hexameters) was published in Paris in 1509 under the title *The incomparable struggle of Cecilia the Roman heroine, of her chastity by merit, and of her fortitude in martyrdom, as told by Friar Baptista Mantuanus, Carmelite theologian and most learned poet, in heroic verses.* The title exudes humanist values.

Although it refers to Cecilia's chastity, it begins by describing her not as a virgin but as a Roman heroine (*virago*, not *virgo*); the author is both a theologian and a "most learned poet."

In mellifluous verse Mantuanus described the wedding as a festivity that gave all the senses pleasing stimulation:

> Iamque dies aderat genialis, et atria multo
> Strata thymo vernant postes redolentibus herbis
> Hic Amaranthe rubes; hic Myrtus et innuba laurus
> Halat, et aulaeis splendet domus alta superbis.
> Dumque lyrae lydosque modos phrygiosque sonarent,
> Dum streperent Citharae, dum mollibus organa cannis
> Concinerent, facibus late lucentibus inter
> Noctis opacae umbras, virgo psallebat ad aures
> Coelituum, Christi annales ad pectora clausos
> Veste tegens, Christumque arcano in corde volutans.[55]

> *And now the wedding day arrived, and the wide halls,*
> *decked with much thyme, and the doorways blossom with fragrant herbs:*
> *here, Amaranth, you blush; there Myrtle, and there virginal Laurel*
> *exhales, and the high walls glow with splendid tapestries.*
> *And while the lyres resounded with the Lydian and Phrygian modes,*
> *while citharas reverberated and the sweet organ pipes played,*
> *and bright torches shone in the shadows of dark night,*
> *the virgin sang psalms to celestial ears,*
> *holding to her breast, covered with her cloak, the gospel of Christ,*
> *and meditating on Christ in her secret heart.*

Without recourse to the phrase "cantantibus organis"—unusable in dactylic hexameter[56]—Mantuanus alluded colorfully to the wedding music. For this "poeta cultissimus" *lyra* and *cithara* carried the flavor of antiquity; and with them he reminded readers that *organum* in classical Latin could refer to any musical instrument. With the phrase "the Lydian and Phrygian modes," he displayed his knowledge of ancient music. And instead of referring to Cecilia's singing with the verb "decantabat" (as in Arnobius, Voragine, and the liturgy), he used "psallabat"—probably counting on readers to know that in praying she paraphrased a line from Psalm 118.

The Flemish theologian Josse van Clichtove (1472–1543) published another retelling of the Cecilia legend, this time in prose. A disciple and collaborator of Jacques Lefèvre d'Étaples, Clichtove studied at Leuven and Paris, served as librarian of the Sorbonne, and engaged in polemics with Erasmus and Luther.[57] He may have had personal reasons for praising Cecilia. He endowed the saying of Vespers and Mass on Cecilia's Day, leaving the impression that

he felt a special devotion for her. (We will return to these endowments in chapter 4.)

Clichtove's account of Cecilia's wedding goes beyond that of Mantuanus in its use of words associated with the music of classical antiquity, such as *symphonia* and *harmonia*. While Mantuanus was particularly interested in the sweet fragrances that wafted through the wedding, Clichtove thought of dance:

> Rursum in ipso nuptiarum die novae sponsae nunc pedibus plaudunt choreas et carmina ducunt: nunc vero alios spectant ducendis choreis intentos et dulci capiuntur organorum cithararumque symphonia. At vero Caecilia in publico illo suarum nuptiarum festo: animum suum ab oratione non relaxabat. Quandoquidem cantantibus organis: ipsa in corde suo soli domino psallebat dicens. Fiat cor meum domine et corpus meum immaculatum in iustificationibus tuis: ut non confundar. Demulcebat aures hominum suavis illa harmonia: quam aedebant citharaeque lyraeque. Aures autem dei longe gratius demulcebat intentissima Caeciliae oratio: coelos penetrans et mira dulcedine divinum oblectans auditum. Magno certe fervebat amore dei haec inclyta virgo: quae inter psallentium et tripudiantium strepitum cor habuit ad coelos devota oratione elevatum.[58]

> *On their wedding day new brides stamp dances with their feet and sing songs; now they see others eager to dance and they are captured by the sweet sonority of the organs and citharas. But Cecilia, even in the public celebration of her wedding, did not allow her mind to cease from prayer. While the instruments sang, in her heart she sang to the Lord alone, saying: "Let my heart, Lord, and my body be undefiled in thy justifications, that I may not be confounded." The sweet harmony of the cithara and the lyre pleased the ears of men; but Cecilia's earnest prayer pleased the ears of God far more, piercing the heavens and delighting the divine audience with its miraculous sweetness. This famous virgin certainly served with a great love of God: amid the noises of singing and dancing, she kept her heart focused on heaven with devout prayer.*

THE WEDDING IN THE VISUAL ARTS

Many of the visual representations of Cecilia's wedding in the Middle Ages and early Renaissance parallel its treatment by writers of prose and poetry. Artists too found inspiration in the phrase "cantantibus organis," depicting an organist or several musicians (usually but not always including an organist) at the wedding. These artists generally respected the distinction that musicians maintained between quiet instruments (in French *bas instruments*, making up an ensemble known as the *basse musique*) and loud instruments (*hauts instruments, haute musique*). They showed instruments of both types being played at the wedding, but rarely at the same time.[59] Neither Arnobius nor the liturgy for 22 November mentioned a banquet; yet "cantantibus organis" seems to have caused medieval

artists automatically to think of wedding guests eating and drinking as well as listening to music.

In the Beaupré Antiphonary, whose verbal and musical response to the wedding we have already considered, the initial letter *C* in the responsory *Cantantibus organis* is decorated with a picture of a banquet (plate 5; for the whole page, see plate 4). Cecilia and Valerian sit at the center of a long table: the bride, with hands crossed in front of her, signals her wish to remain a virgin. Servants bring food while musicians play a psaltery, a fiddle, and a very large portative organ—together making a *basse musique*—while another person (a singer or a dancer?) entertains the wedding party. With this arresting image, the artist called attention not only to the importance of *Cantantibus organis* in the Cecilia's Day liturgy as the first responsory in Matins, but also to the special role that the wedding music played in the medieval understanding of the legend.

Cecilia's wedding—food as well as music—plays an equally important role in a different kind of image made about a century later. Possibly the work of Lippo d'Andrea, active in Florence during the first half of the fifteenth century, the frescoes in the sacristy of S. Maria del Carmine in Florence depict the wedding feast as one of the episodes in Cecilia's life (plate 6); but the artist gave it special prominence by making it much larger than some of the other images (such as that of the newlyweds in their bedroom, to the right of the banquet scene).

In contrast to the portative organ on the left, the two shawms (double-reed instruments, ancestors of the oboe) on the right offered a brilliant and festive, even a raucous sound. These *hauts instruments* would probably not have sounded at the same time as the organ. The artist placed the musicians at opposite sides of the banquet, probably to suggest that they played in alternation.

For the high altar of the Johanniskirche in the northern German city of Lüneburg, several artists collaborated between 1480 and 1485 on a retable, with four hinged wooden panels, each painted on the front and back. On one panel Hinrik Funhof (active in Hamburg until his death in 1485) depicted five episodes in Cecilia's legend, integrating them within a painted architectural framework that allows us to understand the episodes as taking place inside and outside a single building (plate 7).[60] Reading Funhof's panel from left to right, and from foreground to background (in other words, from bottom to top), we begin with the wedding banquet. A column separates this scene from the next, in which Pope Urban baptizes Valerian while his wife looks on. In the third scene (background, upper left), an angel crowns husband and wife with garlands of flowers. The fourth scene shows the unsuccessful attempt to kill the virgin with boiling water, with conspicuously ugly men (and one figure whose features are completely hidden by a hood) surrounding her as she stands naked in a cauldron. In the fifth and last scene, which takes place outside, an executioner tries to behead the kneeling woman.

The banquet is the panel's principal image, much larger than the others. The couple (Valerian a strikingly long-haired blond) and a regally attired guest enjoy the feast, while a servant offers a drink and, on the left, three musicians play.

With her downward glance, the bride projects modesty; her hands in front of her body express her desire to preserve her virginity.

Unlike the two earlier depictions of musicians at the wedding, there is no organist here, but instead a *haute musique* playing woodwinds and brass. The player in the back points his trumpet up, projecting the sound as strongly as possible, while the dark-haired musician to the right holds what appears to be a short but unidentifiable brass instrument, or possibly a shawm; he looks at the third musician, who plays a shawm or cornetto.

We noticed earlier the absence of any mention by Vincent de Beauvais, in his retelling of the Cecilia legend, of wedding music. His silence makes the prominence of musicians in an illustration of a French translation of Vincent's *Speculum historiale* in a fifteenth-century manuscript all the more extraordinary (plate 8), suggesting that wedding music had become, by the late Middle Ages, a crucial part of the legend. The players do not entertain banqueters: instead, they accompany the procession of the bride (her hands once again crossed in front of her) and groom, with their guests, to the matrimonial bed.[61]

CECILIA AS "ANTI-MUSICIAN"

In none of the wedding pictures seen so far does the bride react to the music; she shows no particular interest in it, but she does not try to avoid it either. This lack of an emotional connection—positive or negative—between Cecilia and music is in keeping with the decorative, narrative role of musicians in these images. Other illustrators of the wedding, in contrast, direct the viewer's attention to the precise moment when she "sang in her heart to the Lord alone" with images in which her relation to conventional music is a crucial element.[62]

A Franciscan antiphonary copied in Emilia-Romagna in the second half of the thirteenth century contains the responsory *Cantantibus organis* with the initial *C* illustrating the text: Cecilia prays for the preservation of her virginity while a male organist plays a positive organ and another man pumps the bellows (plate 9). Although the image makes no explicit reference to the wedding, the context is clear from the words.[63] A very different illumination for the same initial *C*, made in the second half of the fourteenth century, tells the same story: while a man entertains the wedding guests with a portative organ, the kneeling bride looks away and prays (plate 10).[64] In yet a third illumination for the *C* in *Cantantibus organis*, this one from an early fifteenth-century breviary (not illustrated here), Cecilia ignores the wedding music, looking up to starry heaven with an expression of fascination and adoration.[65]

A miniature made much later, when (as we will see in the following chapter) artists were already often portraying Cecilia holding an organ, and occasionally even playing it, offers an unusual depiction of the bride absorbed in prayer and spurning the wedding music (plate 11). A historiated initial *C* of *Cantantibus organis* in an antiphonary made in the southern Netherlands between 1500 and 1502

draws our attention to a male organist at a large positive organ, while off to the side, in another room, the bride kneels at an altar, her hands on a prayerbook.

Cecilia actively turns away from the music in these illuminations and directs all her attention to heaven—a gesture dramatized by the artists' omission of all aspects of the wedding except the music. We might describe her as an "anti-musician"—her rejection of music being the central point of the images, which we can understand, following Connolly, as conceptual ancestors of Raphael's *Ecstasy of St. Cecilia*.

THE WEDDING WITHOUT MUSIC

Just as a few written accounts of Cecilia's life say nothing about music at her wedding, so a few visual depictions lack musicians and musical instruments. These tend to be parts of large-scale groups of images documenting many episodes in the legend. The patrons who commissioned complicated compound works and the artists who executed them, forced to keep many details in mind, may have considered the musical component of the wedding less important than other aspects of the life that needed to be depicted.

Probably the most familiar multi-image illustration of the legend is an altarpiece believed to have been made (by an anonymous artist known, after this painting, as the Master of St. Cecilia) in Florence at the beginning of the fourteenth century: about a hundred years before the frescoes in S. Maria del Carmine. Around a woman whose halo and palm leaflet identify her as a martyred saint are depictions of eight episodes in the legend, to be read from left to right, starting with the block of four panels on the left (plate 12). Above, the wedding banquet and the newlyweds in their bedroom; below, Valerian crowned by an angel and Cecilia converting Tiburtius, Valerian's brother, to Christianity. The story continues and concludes with the four panels on the right. Above, Cecilia and Valerian witness a baptism and she makes more converts with her preaching; below, she engages in a disputation with Almachius, by whose orders the Romans try to put her to death in a vat of boiling water while a soldier prepares to strike her with his sword.[66]

In the picture of the banquet at the upper left (fig. 1.1), Cecilia, identified by a halo, wears a dark gray gown. A servant sets down platters of what appears to be roast chicken, while two servants on the left bring more food. Unlike the banquet depicted in fresco in S. Maria del Carmine, this one appears to be without music.

No medium in the visual arts of medieval Europe involved more expense and time, or more dramatically and conspicuously displayed the wealth of an individual or an institution, than tapestry. Since tapestries could be hung and taken down at will, their display constituted an event in itself, in a way that a stained-glass window or a ceiling fresco did not. Tapestries were often hung in church choirs to solemnize important days in the liturgical calendar, as Laura Weigert explains:

FIGURE 1.1 Master of St. Cecilia, *St. Cecilia Altarpiece*, ca. 1304. Uffizi, Florence. Detail showing the wedding banquet. Photo: Alinari / Art Resource, NY

These tapestries were reserved for the celebration of high feast days, which were dramatic visual, aural, and olfactory events. On these days, the chapter of clerics and its officials took their assigned places in the choir. Textiles, golden reliquaries, and candles transformed this space by colors and lights . . . In many churches, the preparations for these days included unrolling and hanging immense scrolls of tapestry along the rows of stalls that lined the sides of the choir.[67]

The commissioning, designing, and manufacturing of a series of tapestries required many people to make difficult decisions and complicated plans. The documentation of those plans has, in most cases, disappeared. But for one projected series, which happens to involve Cecilia, detailed instructions about the design and iconographic content of the tapestries survive. Although the tapestries themselves were apparently never made, the instructions constitute priceless evidence about how someone familiar with the Cecilian liturgy and the literature associated with her thought about representing her visually. Scholars have known of this document since the middle of the nineteenth century, but it has only recently been made available in an annotated English translation by Tina Kane.[68]

In the late fifteenth century the church of St. Urban in Troyes, about 160 kilo-

meters southeast of Paris, commissioned a suite of six choir tapestries depicting the life of its patron saint. Since Urban served as pope, according to Arnobius, during Cecilia's life, she was to play an important role in the tapestries.

Kane argues persuasively (in line with earlier scholars, but with stronger evidence) that what she calls the "Troyes Mémoire" was written by Pierre Desrey (ca. 1450–1514), a resident of Troyes and a literary figure of some importance in the town. She identifies Vincent de Beauvais's *Speculum historiale* as Desrey's main literary source; but he was undoubtedly also familiar with the *Passio*, the *Golden Legend*, and the Cecilia's Day Office.

Desrey imagined the six tapestries as a kind of graphic novel in richly colored cloth. Of these six, he envisioned three (the second, third, and fourth) to be devoted, in part, to Cecilia. Each tapestry would contain three or four *histoires* (stories), for a total of eight on the legend (*histoires* 5–8 and 11–14). Each *histoire* would contain several *mystères* (images), including one *principal mystère*. A few of these *mystères* would depict a person speaking by means of a *rosleau* (speech scroll, serving the same purpose as today's speech bubble or speech balloon) emerging from his or her mouth. Under each *histoire*, a short poem would retell the story in verse. *Tabernacles* (architectural elements, presumably in the Gothic style, to match that of the church) would separate some adjacent *mystères*.

In keeping with the brevity of Vincent's account of Cecilia's wedding, Desrey passed over the wedding quickly, and with no mention of music. The fifth *histoire*—that is, the first *histoire* in the second tapestry—would consist of three *mystères*. His instructions for the first *mystère* begin as follows:

> sera faict [et portraict] ung honneste tabernacle, en forme d'ung domesticque palaciel, dedans lequel et au dessus en ung lieu eslongné sera Saincte Cécile honnestement vestue et habituée, comme une noble fille [et de noble estat yssue]; laquelle soit prosternée à deux genoulx et les mains joinctes [et les yeulx eslevez au ciel], pour [perfaire et] acomplir le narré [et contenu] de ce qui est escript [et récité ès volumes et livres hystoriaux des souverains préaléguez hystoriographes et] en la légende de la dicte saincte Cécile, disant: *"Cecilia nata ex preclaro genere Romanorum, in fide Cristi nutrita, diebus ac noctibus virginitatem suam conservari a Domino precabatur."* [Et de la bouche d'icelle saincte Cécile sortira ung grand rosleau auquel sera escript: *Fiat, Domine, cor meum et corpus meum immaculatum, et non confundar.*]

> *a fine tabernacle will be represented, like a palatial home. St. Cecilia will be here, above, in a separate place, becomingly dressed, like a girl of the nobility. She will be kneeling, hands joined [and eyes looking up to heaven], to fully illustrate the narrative written . . . in the legend of St. Cecilia, which says: "Cecilia, born of a noble Roman family and nurtured in the faith of Christ, prayed day and night for the Lord to preserve her virginity." [From St. Cecilia's mouth will emerge a large speech scroll on which will be written: "Lord, let my heart and my body be unstained, and let me not be confounded."]* [69]

Then Desrey turns to the second *mystère*:

> Item, et en ce mesmes tabernacle, au principal mistère, sera faict et protraict commant elle fut épousée à Valérian [son espoux]. Parquoy, la dicte saincte Cécile et Valérian son [dict] espoux seront honnestement vestus et habituez comme [il appartient à] espoux et espousée, et ung évesque [revestu et aorné de son pontificat] qui fera manière [et contenance] de les espouser; [et seront] iceulx [evesques, espoux et espousée] acompagnez de personages, comme appartient à ung mistère d'espousailes.

> *In this same tabernacle, in the principal mystère, will be her marriage to Valerian. For this, St. Cecilia and Valerian, her husband, will be becomingly dressed as husband and wife. With them will be a bishop, shown to be marrying them by his gesture, along with others as befits a wedding ceremony.*[70]

After instructions for the third and last *mystère* (the conversation of the newlyweds in their wedding chamber), Desrey provided a poem to be placed below the fifth *histoire* as a whole:

Saincte Cécile incessemment	*St. Cecilia ceaselessly*
Prioit pour sa virginité:	*Prayed for her virginity.*
Mais Valérian noblement	*But Valerian, honorably,*
Fut son espoux pour vérité.	*Was her husband truly.*
De par elle fut enhorté	*She exhorted him*
Ne la toucher charnellement;	*Not to touch her carnally,*
Car l'ange, pour sa chasteté	*Because the angel with her*
La gardoit singulièrement.	*Guarded her chastity singularly.*[71]

Although the Troyes Mémoire never came to fruition—as far as we know—in the form of what promised to be a magnificent series of tapestries, another collaborative visualization of the Cecilia legend gives us some idea of what Desrey might have had in mind when he wrote his instructions. Around 1505 (just a few years after the period to which scholars have assigned the Troyes Mémoire), artists including Francesco Francia, Lorenzo Costa, and Amico Aspertini depicted Cecilia's life in a series of frescoes in the Oratory of Saints Cecilia and Valerian in Bologna.[72] They painted ten frescoes: five on each side of the choirlike hall. In their shape, size, and placement (plate 13), they resemble a set of choir tapestries so closely that they tempt us to speculate that they originated in the hope of reproducing the effect of a suite like that commissioned by the church of St. Urban in Troyes. Francesco Francia's depiction of the wedding (plate 14), within an architectural frame that brings to mind Desrey's word *tabernacle*, might have been painted in response to instructions similar to those in the Troyes Mémoire. Here is another wedding—rare in the Cecilian iconography—in which the words "cantantibus organis" left no trace.

Beyond the Legend and Liturgy: The Organ as Emblem

Images of Cecilia in chapter 1 show that when medieval and Renaissance artists depicted her within the context of her legend (in which she is the only important woman), they did not need an emblem that allowed viewers to distinguish her from other women. But when they showed her alone—even in contexts (such as manuscripts recording the Cecilia's Day liturgy) where her identity was obvious—they rarely did so without identifying emblems such as a palm, a book, a crown of roses and lilies, a falcon, or a sword. All of these, except possibly the sword, preceded the use of yet another emblem that eventually replaced them all: the organ. Indeed, the organ is noticeably absent from pictures of the saint made before the late fifteenth century—with the important exception of depictions of her wedding, which often show a musician (but not Cecilia) playing an organ. In adopting the organ as her attribute near the end of the fifteenth century, artists took it out of the context of the wedding. It no longer illustrated an episode in her life, but instead helped viewers distinguish her from other virgin martyrs.

BEFORE THE ORGAN

A historiated initial *C* in an antiphonary believed to have been made at the Benedictine monastery at Melk shows a young woman in prayer (plate 15). We know she is Cecilia only because this *C* is the first letter in the antiphon *Cantantibus organis*, sung at Lauds on Cecilia's Day. Equally free of identifying emblems is a woman in the Stowe Breviary, made in Norwich between 1322 and 1325. We rec-

ognize her because this *S* is the first letter in the rubric "Sancte Cecilie virginis," announcing the Cecilian Office.[1] The lack of attributes allowed the illuminator to decorate the Offices of several female saints with similar heads.[2] These images are unusual. More often illuminators of liturgical manuscripts portrayed Cecilia with one or more of the identifying attributes listed above.

The artist who depicted Cecilia in the historiated *C* at the beginning of the lessons for Matins in a monastic lectionary (a collection of readings) made in the second half of the twelfth century in southwestern Germany gave her only one emblem (plate 16). The palm, an ancient symbol of military victory, became associated among Christians with martyrdom. Other artists used another single emblem: the book (plates 1, 17, and 18) symbolized wisdom and, more specifically, illustrated Arnobius's statement (paraphrased several times in the liturgy, including the lesson shown in plate 16) that she constantly kept the Gospel close to her heart.

The Master of St. Cecilia, working in Florence at the beginning of the fourteenth century, combined the palm (reduced to a single leaflet) and the book (plate 12). The artist thus helped establish these two emblems as an identifying pair that artists relied on through the fourteenth and fifteenth centuries. The illuminator of the Breviary of Marie de Saint Pol, probably active in Paris between 1330 and 1340, had Cecilia hold the same two emblems in a miniature showing the book's commissioner praying to her. (We know this is Cecilia because the illumination decorates the Cecilia's Day Office; see plate 19.)

Yet another attribute that artists used to identify Cecilia was a crown of red roses and white lilies (plate 20). As depicted by Funhof (see plate 7), an angel crowned her and Valerian with garlands of flowers after he became a Christian and agreed to live with her in celibacy.

In the fifteenth and sixteenth centuries, patrons often ordered paintings—small devotional pictures or larger altarpieces—in which two or more saints are arranged symmetrically around a central figure or group of figures, such as the Virgin and Child, or biblical events, such as the Crucifixion. When those saints included Cecilia, artists faced a challenge: how to differentiate her from the other virgin martyrs. Easily identifiable when surrounded by musicians at her own wedding feast, or when depicted alone in illuminations embellishing the text of her liturgy, she became potentially unrecognizable when taken out of those contexts and surrounded by other saints. Artists associated the palm with all martyrs, the book and the floral crown with several saints. Even in combination, these attributes lack the specificity that would have led viewers to the immediate recognition that artists usually aimed for.

The Ghent Altarpiece, completed by the van Eyck brothers in 1432, presents an early example of the problem. In the crowd of female martyrs with palms and floral crowns, we can easily identify a few saints, including Agnes (with a lamb) and Barbara (with a tower). Cecilia must be present, but she is hidden among the anonymous majority.[3] No easier to identify is the female martyr that Stefan Lochner placed between the church fathers Ambrose and Augustine in a painting from around the middle of the fifteenth century (plate 21). She might be

Cecilia, but the book and palm leave her identity in doubt.[4] Since Ambrose and Augustine far outranked Cecilia in the liturgical hierarchy, Lochner might have intended the woman as representative of all virgin martyrs—a visual counterpart of the Mass, known as "Commune unius virginis et martyris," to be said in honor of any virgin martyr.

One foolproof way to differentiate Cecilia from other female saints was to identify her in writing: on her crown (*The Virgin Surrounded by Saints*, attributed to the Master of St. Veronica and believed to have been made in Cologne around 1410[5]) or her halo (an anonymous *Virgin and Child with Virgin Martyrs*[6]). In a painting attributed to the Master of the St. Lucy Legend, probably made sometime before 1483 in Bruges (which the artist depicted in the background), Cecilia is one of four virgin martyrs who surround the Virgin and Child; the others are Catherine of Alexandria, to whom Christ gives a ring in recognition of their mystic marriage, Barbara, and Ursula (plate 22).[7] Dressed in white, Cecilia keeps her place in a book with one hand and holds a red object (her crown?) in the other (plate 23). She and Ursula (on the left, with arrows at her feet) play a secondary role in the painting, farthest from the center and not touching the child.

This is but one of several paintings from the fifteenth and sixteenth centuries showing Cecilia witnessing Catherine's mystic marriage. Probably Cecilia's own celibate marriage led artists to associate her with Catherine and her equally chaste relations with Christ. Cecilia's supporting role in these paintings corresponds to the tendency of books of hours to designate her feast as less important than Catherine's.

Another way to help viewers identify Cecilia was to invent a new emblem. Probably inspired by the *Legenda aurea*, which described her at the very beginning of its account as "ex nobili Romanorum genere," Flemish artists of the fifteenth century sometimes portrayed her with a falcon, a symbol of nobility. Nowhere does the falcon appear more memorably than in the Hours of Catherine of Cleves (plate 24).[8] Cecilia feeds the bird with a morsel at the end of a stick, and avian imagery pervades the page. Cecilia stands in front of a backdrop featuring a repeated motif that combines an outstretched wing, a child's head, and an arm holding a falcon. The page is framed with feathers of different colors, decorated with the initials C. D. (perhaps standing for *Catherina Duxissa*, Duchess Catherine) and with little pairs of wings.

The falcon never earned wide acceptance as an attribute, probably because Arnobius, the liturgy, and the Golden Legend do not mention it. I have not found any examples of its use by Italian artists.

THE ORGAN AS EMBLEM

Artists looking for yet another attribute for Cecilia found it in the organ—an object both visually arresting and already closely associated with her, thanks to Arnobius's phrase "cantantibus organis." That phrase, as we saw in chapter 1,

recurs in several medieval retellings of Cecilia's wedding, including the *Legenda aurea*. In some versions of the liturgy, the passage beginning "Cantantibus organis" might be spoken and sung as many as four or five times, in both the Office and the Mass, making it probably the single most familiar sentence in the Cecilian liturgy. Artists had, in addition, a purely visual reason for associating Cecilia with the organ: the many depictions of her wedding that showed a musician playing the organ.

In using the organ as an identifying attribute, artists did not automatically make Cecilia a performing musician. In the majority of the earliest depictions of her with an organ, she stands next to it or holds it without actually playing it.

When did artists add the organ to Cecilia's portfolio of emblems? The answer is uncertain because the identity of some of the women holding organs in late medieval and early Renaissance art is itself uncertain. Consider, for example, the statue of a woman holding an organ in the Museo del Castelvecchio in Verona, who has traditionally been identified as Cecilia.[9] This is part of a group of sculptures in the museum attributed to a fourteenth-century Veronese craftsman known as the Master of S. Anastasia, after the church in Verona in which some of his work is preserved. If she is indeed Cecilia, it would constitute a remarkably early use of the organ as her attribute, anticipating its widespread adoption by a century and a half. But how can we be sure who this statue represents, given that its sculptor, date, and original location and function are all open to doubt? Much stronger evidence suggests that artists' use of the organ as one of Cecilia's emblems greatly expanded in the last decade of the fifteenth century and that the growth took place primarily in the Netherlands.

Among the earliest datable images of Cecilia with an organ are woodcuts illustrating her story in editions and translations of the *Legenda aurea* printed in the 1480s and 1490s.[10] A Dutch translation, published in Delft in 1487 and reprinted in 1489 and 1499, shows her holding a sword and a falcon, with an organ at her feet (plate 25).[11] A French translation, published in Paris in 1490, shows her with an organ in her hands, while a sword hangs grotesquely from the back of her neck.[12] She may be playing the organ, but the image's lack of clarity leaves this in doubt. These woodcuts, and others published in later editions of the *Legenda aurea*, did more to disseminate Cecilia's new attribute than any single sculpture, altarpiece, or manuscript illumination.

We have an exceptionally early *terminus ante quem* for the image of Cecilia with an organ in the Breviary of Marguerite de Houchin-Longastre (plate 26). The original owner, identified by a coat of arms in this manuscript, served as abbess of Nivelles, one of the oldest and wealthiest abbeys of the southern Netherlands, from 1474 until her death in 1489.[13] The text of the Cecilian Matins is illustrated with a miniature of the saint sitting next to an organ. She holds a book in her left hand and extends her right hand toward the keyboard. Is she about to play? If so, why is she holding a book? And who is pumping the bellows? Or is she rejecting the organ's seductive sounds in favor of the "silent music" offered by her Bible or prayerbook? The image is ambiguous, and its ambiguity speaks

eloquently about the choices faced by late fifteenth- and early sixteenth-century artists in dealing with Cecilia.

The picture of Cecilia holding an organ in the Breviary of Queen Isabelle of Castile can be dated with some certainty to the years around 1497.[14] As in the Breviary of Marguerite de Houchin-Longastre, she seems reluctant to put down the book, even when it forces her to hold the organ, rather awkwardly, in one hand.

The illuminations in the two breviaries just mentioned are among several early images of Cecilia with the organ as an attribute that we know or suspect (on the basis of artistic style) to have been produced in Bruges. Although artists working in other cities in or near the Netherlands (including Delft, Leiden, and Cologne) and in Paris quickly realized the emblematic value of the organ, it was perhaps first in Bruges that artists used the organ as one of Cecilia's attributes on a large scale.

The organ, at first, supplemented Cecilia's other emblems, and gradually replaced them. Its adoption initiated a period of transition, from the late 1480s to around 1530, when many images show her with two or more emblems, usually including the organ. During this period another attribute also rose to prominence—the sword, the instrument of Cecilia's martyrdom. All these attributes led, in some cases, to an emblematic excess that Flemish artists and patrons of the late fifteenth and early sixteenth centuries evidently enjoyed.

That excess is perhaps best illustrated in a painting attributed to the Master of Alkmaar in which the Virgin and Child and St. Anne are surrounded by other saints (fig. 2.1). Cecilia, sitting next to an organ, holds a sword in one hand and a falcon in the other. In her lap is a book, and on her head a floral crown. She sits opposite John the Baptist; the symmetrical placement encourages viewers to think of them as equals. In the liturgy they were of course far from equal, John being one of Christianity's most revered figures and his feast day of 24 June celebrated with great splendor throughout Europe. But the adoption of the organ as Cecilia's emblem seems to have encouraged painters to raise her profile in relation to the other saints shown with her. They evidently perceived the organ as an object that offered a pleasing visual counterpoint to John's lamb, Catherine's wheel, and Barbara's tower.

Organ builders of the fifteenth century made instruments in many sizes, ranging in a continuous spectrum from those that could be held by the player, who played the keyboard with one hand and pumped the bellows with the other (portative organs), to those that stood on a table or floor and were played with two hands while another person worked the bellows (positive organs), to massive instruments built permanently into architectural settings. To identify Cecilia, late fifteenth- and early sixteenth-century artists generally limited themselves to portative organs. Close in size to the emblems of the other saints with whom she appeared in altarpieces, the organ stands next to her in some images; in others she holds it in her hands, as in a book of hours made in Bruges in the first two decades of the sixteenth century (plate 27) and in the more luxurious Mayer van

FIGURE 2.1. Master of Alkmaar, *Virgin, Child, and St. Anne Surrounded by Saints and Donors*, ca. 1490–1520. Royal Museums of Fine Arts of Belgium. Cecilia (at upper right), opposite John the Baptist, with book, falcon, sword, and organ. Photo: Bibliothèque Nationale de France

den Bergh Breviary, made in Ghent or Bruges around 1500, perhaps for Queen Mary of Portugal (plate 28).[15]

The anonymous artist known as the Master of the Virgo inter Virgines made an unusual use of the organ to identify Cecilia, while making sure viewers did not think of her as a performing musician. In a painting of the Virgin and Child

surrounded by four female martyrs, the artist gave each saint a golden ornament: a wheel and sword for Catherine (again celebrating her mystic marriage), an organ for Cecilia, a tower for Barbara, and an arrow for Ursula (plates 29 and 30).[16]

Cornelis Engebrechtsz (Leiden, ca. 1462–Leiden, 1527) learned much from the woodcuts in the *Golden Legend*. His work is remarkable for the frequency with which Cecilia appears with other saints.[17] Occasionally he relied on the emblems of sword and falcon alone (as in *Saints Cecilia and Valerian* in the Museum of Fine Arts, Budapest);[18] much more often he placed an organ, viewed from its end, at Cecilia's feet. But he never gave up the older emblems. In his altarpieces he often included Cecilia among the saints who, standing on the left or right, witness the events depicted in the center of the painting, or in the central panel of a triptych. He usually depicted these saints in pairs. In *The Crowning of Thorns*, Cecilia stands on the right, next to St. Agnes.[19] Witnessing the Lamentation of Christ, she stands on the left, next to Mary Magdalene;[20] witnessing the Crucifixion, next to Barbara (plates 31 and 32). With the emblematic overload typical of Engebrechtsz and his workshop, she holds a massive sword in one hand and a falcon in the other, and at her feet stands a portative organ. In a *Virgin and Child* (Prague, Národní Galerie), she stands on the right, opposite St. Thomas. In all these paintings the organ, severely foreshortened, is inconspicuous and silent but unmistakable in its function and meaning. Engebrechtsz's death in 1527 coincided, more or less, with the end of the period of transition when artists treated the silent organ as one of several equally effective attributes.

CECILIA BECOMES AN ORGANIST

Artists' use of the organ as an identifying attribute led them, inevitably it seems, to depict Cecilia actually playing it. In making this transition, they were probably inspired by two well-established iconographical precedents: the playing of portative organs by angels and by Musica, the personification of music. Some of the angelic organists of the van Eycks and Hans Memling look like beautiful young women, with long flowing hair, and without wings. An Italian manuscript in the Bibliothèque Nationale, copied in the early fifteenth century and an important of source of trecento music, depicts Musica as a woman with a portative organ on her lap (plate 33).[21] For a Flemish artist familiar with such images, it would not have taken much of an imaginative leap to place Cecilia's right hand on the keyboard of the organ that already served as her emblem.[22]

Three depictions of the mystic marriage of St. Catherine, all attributed to Memling, and all believed to have been painted between 1470 and his death in 1494, show how the leap might have taken place. Though born and trained in Germany, Memling spent much of his adult life in the Netherlands, and his later works convey Flemish values both aesthetic and iconographic. The order in which I discuss the paintings here may not follow the order in which Memling

made them, but it does suggest how an organ-playing angel might have evolved, in the minds of artists and patrons, into an organ-playing virgin martyr.

In one version of the mystic marriage (plate 34), the Christ child gives a wedding ring to Catherine while Barbara witnesses the ceremony. Two winged angels, one playing a portative organ and one playing a harp, provide wedding music.[23] That painting is closely related to the central panel of the Triptych of John the Baptist and John the Evangelist (also known as the Saint John Altarpiece, plate 35): a larger painting, completed in 1479, in which Catherine and Barbara are joined by two male saints, John the Baptist and John the Evangelist.[24] The organist has no wings. We might be tempted to identify this long-haired, sexually ambiguous figure as Cecilia, but the organist is much smaller than the surrounding saints and lacks the martyr's crown worn by Catherine and Barbara. Moreover, the symmetrical organization of the painting encourages us to see the organist as a counterpart to the equally small and androgynous figure on the other side of the Virgin, who holds a book from which Mary reads the wedding liturgy. The organist and the acolyte are probably wingless angels like the musicians in the Ghent Altarpiece, completed forty-seven years earlier.

A third depiction of the mystic wedding attributed to Memling, one of a pair of small paintings known as the Diptych of Jean de Cellier, shows the Virgin and Child surrounded by six symmetrically placed women (plate 36). They are all virgin martyrs, each with an emblem: in addition to Catherine and Barbara, we can identify Margaret, Lucy, Cecilia, and Agnes. Occupying the same place in the image that the organists occupy in the other paintings by Memling, Cecilia herself plays the organ. She has taken over the role of musician, but the angels have not stopped making music. Memling placed them in heaven, where they accompany her organ with wind or brass instruments, or some combination of them.[25]

Another early example of Cecilia playing the organ while sitting with other saints is a stunning intercession image (*Fürbittebild*) attributed to an anonymous artist known as the Master of the Holy Kinship the Younger, thought to have been active in Cologne between 1480 and 1520.[26] God the Father, the Virgin Mary, and Christ are surrounded by the two St. Johns, the donor, St. Columba of Sens, and Cecilia (plate 37). She sits with a portative organ on her left thigh, pumping the bellows with her left hand and playing with her right hand, exactly like the organists in plates 33–36.

Artists also depicted Cecilia standing up while she played the portative organ. The Master of the Holy Kinship included her among four female saints on an outer panel of the Altarpiece of the Holy Kinship (the work after which the artist is named). Cecilia works the bellows with one hand and touches the keyboard with the other (plate 38). In a French prayerbook from the early sixteenth century, we see only one of Cecilia's hands, but we can assume the other is pumping the bellows (plate 39). A single leaf from a devotional book, with miniatures probably painted in Ghent or Bruges between 1500 and 1510, shows Cecilia playing the organ while standing.[27] So does the Tsgrooten Antiphonary

(1522), but with her left hand on the keyboard.[28] In all these images, an unseen strap must be holding the instrument up against her body.

The first stage in the evolution of Cecilia's depiction as a practicing musician, represented by plates 36–39, involves an extension of the use of the portative organ as her emblem. The little organ continues to serve a primarily identificatory purpose. To play the organ, she needed both hands, one for the keyboard and one for the bellows. Thus her transformation into a musician coincided with the abandonment of the emblems that artists had earlier placed in her hands: the book and the palm. Cecilia the organist had hands for only one attribute: the organ itself.

Having supplanted a musical angel in Memling's Paris diptych, Cecilia the musician soon became inseparable from angels. Their presence not only reminded viewers that her music was divine, but it also solved a practical problem. The portative organ, although it was lighter than other organs, still presented a challenge to the standing saint.

The artist known as the Master of the Bartholomew Altarpiece depicted Cecilia at least twice: in a Crucifixion Altarpiece painted in the 1490s (plate 40) and in the altarpiece from which art historians derived his *Notname* (painted between 1505 and 1510 for the church of St. Columba in Cologne, and now in the Alte Pinakothek, Munich).[29] In both images an angel makes it physically possible for her to play the organ standing up and at the same time raises her music to the heavenly realm. The angel holds up the organ by means of a blue ribbon threaded through handles at both ends of the instrument and extending over his shoulders, leaving Cecilia's hands free to pump the bellows and to play. The angel in the Bartholomew Altarpiece is a miniature version of the long-haired winged youths so common in fifteenth-century Flemish art. The angel depicted with Cecilia on one of the hinged panels of the Crucifixion Altarpiece is an early example of the baby angel, or *putto*: an iconographical element whose popularity had only quite recently spread from Italy to the Netherlands.[30] In making Cecilia and John the Baptist a pair, apparently in conversation, the painter showed these saints as equals, just as the Master of Alkmaar did by placing them opposite one another (see fig. 2.1).

Art historians believe that the Master of the Bartholomew Altarpiece, although primarily active in Cologne, was trained in the Netherlands.[31] Thus his depiction of Cecilia as a performing musician for a church in Cologne is consistent with evidence suggesting that her association with music developed earlier and more strongly in the Netherlands than elsewhere. This was not the only artwork depicting her as a musician in St. Columba, which also owned the intercession image illustrated in plate 37. The concentration of Cecilian imagery at St. Columba suggests that this church played some yet unknown role in encouraging or reinforcing the association between Cecilia and music.[32]

During the rest of the sixteenth century, as Cecilia moved from the portative to larger organs and other instruments, angels continued to collaborate with her, pumping the bellows or singing. But even when not actively participating in

her musical activities, at least one angel is rarely absent from depictions of her making music. The putto—often holding musical notation—was to become a common companion of Cecilia the musician in the seventeenth century.

In 1514 the Flemish artist Jean Massy painted miniatures in a gradual for the Benedictine abbey of Gembloux, in the southern Netherlands. One of his illuminations depicts a woman sitting at the keyboard of a positive organ: a big, heavy instrument with about forty pipes and two pairs of bellows, pumped by an angel (plate 41). Unlike most earlier manuscript illuminations depicting Cecilia, Massy's does not adorn the Cecilia's Day liturgy; it appears instead among the chants of the Mass Ordinary. Furthermore, the organist wears a turban, not a crown of roses and lilies. Yet Connolly is surely right to identify her as Cecilia: "It is perhaps the first example of Cecilia seated at a keyboard, the first time in fact that she plays anything except her little portative organ."[33]

In moving Cecilia away from the portative organ to a larger, louder, and visually more impressive instrument; in giving her an angelic musical collaborator; in focusing the viewer's attention on the act of making music; and—most important—in taking her away from the liturgy of her feast so as to serve more widely as a symbol of sacred music, Massy's miniature constitutes an early manifestation of trends that would dominate Cecilian iconography for the rest of the sixteenth century and into the seventeenth. Raphael's *Ecstasy of St. Cecilia*, painted a few years later, is a masterpiece but something of a cul-de-sac in Cecilia's evolution into a musician who played and sang out loud, and with pleasure. Massy's illumination, in contrast, is an aesthetically minor work that exemplifies the way patrons, artists, and musicians perceived Cecilia for decades to come.

The Celebration of Cecilia's Day by Musical Organizations and Singers in the Netherlands and France

Two kinds of organizations that arose in the Middle Ages played important roles in the lives and professional activities of musicians in the Netherlands and France, including their adoption of Cecilia as a patron saint and their observance of her feast. Confraternities and guilds had much in common, and the words for them are often used interchangeably. But it is worth the effort to distinguish them. For the purposes of this book (and at the risk of overgeneralization and oversimplification), by "confraternity" I mean a group of laypersons of various professions who joined together with members of the clergy for the primary purpose of religious devotion. Most of their activities took place in a church, where they maintained a chapel dedicated to their patron saints and founded services in their honor.[1] By "guild" I mean a group of people belonging to a single trade, profession, or craft who joined together to regulate their professional activities. They too chose patron saints, maintaining a chapel or altar and founding services; but their primary interests were commercial, professional, and social.[2]

Paul Trio and Barbara Haggh put the difference in a nutshell: "Guilds . . . served the living, whereas confraternities . . . served the dead: their activities were thought to benefit the souls of deceased members, above all."[3] Members of confraternities believed that through their prayers and through the intercession of their patron saints they might shorten the time that the souls of their dead brethren would spend in Purgatory. While many confraternities adopted the Virgin Mary as their patron, guilds often dedicated themselves to male saints, reflecting memberships consisting predominantly or entirely of men.[4]

Confraternities and guilds in the Netherlands typically marked their patronal feasts not only with solemn religious services but also with a *maaltijd* or ban-

quet, and in this respect differences between confraternities and guilds disappeared: they all "served the living." In 1549 a *susterschap*—a confraternity for women—was founded in Zaltbommel (between Utrecht and 's-Hertogenbosch) under the patronage of St. Cecilia; but to judge from the founding statutes it had nothing to do with music. Its main *raison d'être* was a Cecilia's Day banquet, the remarkably detailed description of which in the bylaws vividly demonstrates the importance of food and drink in sixteenth-century confraternities and guilds in the Netherlands. The meal was to consist of several courses, with dishes including (but not limited to) ham, beef, mutton, duck, chicken, and "three bowls of stew" (*drie schottelen huystspot*), accompanied by wine and beer. When Cecilia's Day fell on a *vijssdach* (fish day, presumably Friday), the menu was to include two kinds of fish and rice pudding (the combination of rice, milk, sugar, and spices evidently making this dish more of a luxury than it is today). For dessert: butter, cheese, roast apples, and chestnuts.[5]

Banquets typically included large amounts of wine. Indeed, drunkenness seems to have played a crucial role in the social life of many confraternities and guilds. The city governments that authorized the founding of these organizations and oversaw their operations used alcohol as a way of maintaining their influence and control; some confraternities and guilds came to depend on regular "wine gifts" (*presentwijnen*) from city councils.[6]

The observance of a saint's feast typically took place over three days, beginning with Vespers on the eve of the feast day, continuing with Mass and a banquet on the day itself, and ending with a Requiem Mass for the deceased members on the day after.

CONFRATERNITIES AND GUILDS AS PATRONS OF MUSIC

Many confraternities included musicians among their members; but their primary contribution to musical life was the patronage of the professional musicians who composed and performed music for their sacred rituals. Members thought of music as a way to amplify their prayers; by engaging famous composers they also enhanced their own status, conspicuously displaying their wealth and good taste. Prosperous confraternities might pay for music as part of daily services, but the largest expenses supported the musical elaborations of a few special events on the confraternity's liturgical calendar, including the feast days of its patron saints. The banquet might also involve music, which offered audible sustenance as rich and satisfying as the food and wine. Many of the greatest musical achievements of the later Middle Ages and Renaissance can be credited to the patronage of confraternities.[7]

Confraternities played an especially important role in the history of one musical genre in particular. They encouraged composers to write motets by commissioning them and providing prestigious venues for their performance. Julie E. Cumming has suggested that they were also major consumers of printed

editions of motets, after Ottaviano Petrucci and others started publishing them in the early sixteenth century: "The confraternities, combining as they do sacred and secular, lay and clerical, amateur and professional, inhabit a space in society very similar to that of the motet in the musical genre hierarchy: sitting between secular music and the Mass, the motet can refer to and incorporate generic features from both ends of the spectrum."[8]

Guilds likewise acted as consumers of music, especially for the celebration of their patron saints. For example, in the early sixteenth century several of the twenty-seven incorporated guilds of Antwerp sponsored elaborate services with polyphonic music in their chapels or at their altars.[9] The stevedores, with over 500 members the city's largest guild, observed the feast of St. Andrew with singers, an organist, and a bell ringer; the schoolteachers sponsored the performance of a polyphonic Mass on the feast days of their patron saints Ambrose and Martha. The peat carriers had their altar in the church of St. James, where, on All Saints' Day and St. Hubert's Day, they solemnized Mass with singers and organ.[10] In Bruges the barber-surgeons sponsored a service in honor of their patrons Cosmas and Damian.[11]

Confraternities and guilds—and also individuals—paid for these services, including the music, primarily out of endowments: donations that came with specific instructions on how they were to be used. Invested, money produced income that—ideally—supported the service in perpetuity.[12] In Bruges foundations and endowments greatly increased the amount of polyphony being performed in the church (later cathedral) of St. Donatian.[13] Farther north, in Leiden, foundations and endowments from individuals had an equally powerful effect on musical repertory, making it possible for a non-collegiate church, St. Peter's, to celebrate with polyphony the Office throughout the day.[14]

In another church whose polyphonic repertory was strongly influenced by foundations and endowments made by individuals, the cathedral of Cambrai, donors who enriched the soundscape with their bequests included the famous composer Guillaume du Fay. He established a foundation at the chapel of St. Stephen, where he was to be buried, with funds for a polyphonic Mass to be sung on the feasts of saints who otherwise played no significant role in the cathedral's liturgical traditions.[15]

MUSICIANS' GUILDS IN PARIS AND THE NETHERLANDS

Of the professional freelance musicians of the Middle Ages, Kay Brainerd Slocum has written: "These *jongleurs*, or minstrels, earned a precarious living by travelling alone or in small groups from village to village and castle to castle, singing, playing, dancing, performing magic tricks and exhibiting trained animals. These itinerant performers were often viewed as social outcasts and were frequently denied legal protection as well as the sacraments of the church."[16] In the twelfth century, minstrels took the first steps in integrating themselves into

medieval society. They came together in associations with some of the features that, over the next few centuries, would become characteristic of musicians' guilds: "By forming corporations and thus voluntarily placing themselves under the power of rulers and civic authorities, the musicians could achieve a modicum of social acceptance and legal protection."[17]

The first musical organization that Slocum recognizes as a "trade guild"—in other words, an organization "founded to further the professional interests of musicians"—is the Parisian Confrérie of Saint-Julien-des-Ménestriers, founded in 1321. Under the protection of Saints Julian the Hospitaller and Genesius, this guild regulated the activities of minstrels in Paris and sponsored liturgical events at its chapel of St. Julian.[18] "A central thrust of guild regulation," Howard Mayer Brown and Keith Polk have written, "was to protect members by reducing competition. They strictly limited the number of apprentices a master player could train, for example, as a way of controlling the number of professional instrumentalists available in any one locality. All members were required to be citizens of the town, and the guild leadership would usually obtain the concession from the city council that only guild members could practise the profession within the walls."[19]

The musicians' guild in Paris probably inspired similar guilds in Bruges, Ghent, and Antwerp. Bruges hosted the first known musical guild in the Netherlands, established in 1421 or 1431.[20] An instrumentalists' guild under the patronage of Saints Job and Gummarus was founded in Ghent in 1478. From 1499 it maintained an altar dedicated to St. Gummarus in St. Nicholas's church.[21]

The Old Testament's long-suffering Job was widely venerated as a saint in medieval Europe, and a particularly intense devotion to him arose in the Netherlands.[22] Painters, manuscript illuminators, and printmakers showed the naked Job, covered in sores, being serenaded by musicians (plate 42). According to legend, he paid the musicians with scabs that he peeled from his skin, which then turned to gold. These images and stories led instrumentalists to choose him as a patron saint.[23] (Their devotion may have led, in turn, to the composition by Pierre de la Rue of an unusual Mass, the *Missa de Sancto Job*, in which parts of the text of the Ordinary are replaced with words and phrases inspired by the story of Job.[24]) But images of Job also gave him the reputation of a saint whose intercession might cure syphilis and other disfiguring diseases. It was probably that reputation that drew pilgrims to the church of St. Martin in Wezemaal (a village eleven kilometers north of Leuven), where during the late fifteenth and early sixteenth centuries St. Job's Day (10 May) was celebrated with much éclat, including music performed by a chorus that from 1514 consisted of nine or ten priests, some lay singers, and six boys (forces sometimes augmented by musicians from neighboring towns).[25]

The founders of a musicians' guild in Antwerp, active from about 1500, chose Job as their patron; members adopted a second patron, Mary Magdalene, in 1535. From its altar in St. James's Church it supervised a system of musical education in which master instrumentalists guided the training of young appren-

tices.[26] The guild's statutes, as revised in 1555, restricted admission to citizens of Antwerp. Those who wished to join had to demonstrate their musical abilities and pay an entrance fee. Non-members were forbidden from performing for fees, on pain of a fine and confiscation of their instruments. Members had to pay the guild a fee whenever they performed. Other statutes defined standards of professional behavior, forbidding members from accepting engagements that required them to be in two places at the same time, and requiring band leaders to engage a sufficient number of players, all of whom had to be members of the guild, and to pay them promptly.[27]

INSTRUMENTALISTS ADOPT CECILIA AS THEIR PATRON: MUSICIANS' GUILDS IN LEUVEN AND MONS

The sixteenth-century musicians who turned to Cecilia as a patron saint must have known as well as anyone that, as depicted in the *Passio*, *The Golden Legend*, and the lessons of Matins, she neither sang nor played the organ at her wedding. Yet they found her attractive as a patron and her feast appropriate for celebration for at least three reasons, all having to do with the way visual artists had depicted her. First, artists who had responded to the phrase "cantantibus organis" by showing players of the portative organ, shawm, fiddle, or psaltery at Cecilia's wedding (see plates 5–11) might have encouraged instrumentalists in search of a patron saint to choose her. Second, pictures of Cecilia's wedding banquet may have led viewers to associate her with the pleasures of food and wine. Since members of guilds and other professional organizations were accustomed to celebrate their patronal day with an alcohol-infused *maaltijd*, musicians who belonged to these organizations may have thought of her as a fitting patron. And third, images of her standing next to or holding an organ that started to appear in the late fifteenth century and were becoming more frequent in the early sixteenth century (see plates 25–32 and 36–41), even when they did not show her actually playing an organ, caused viewers to associate her with music.

What appears to have been the first musical guild dedicated to Cecilia was founded in Leuven in 1502. But she was not the first choice of the male musicians who organized the guild, probably influenced by the preference for male saints of many guilds during the fifteenth century. If they looked more specifically at existing musicians' guilds for precedents, they might have considered the male saints who served as protectors. From a document that records the founding of the guild, we learn that the musicians initially proposed Job as their patron. But the city council preferred Cecilia, and it prevailed.

The document consists of two parts: a petition submitted to the city council by six instrumentalists, requesting permission to establish an organization of musical instrument players, and the council's decree that grants the request. In the petition the founding musicians present a list of suggested statutes under which the organization might be run; in the decree the council presents its

own statutes, largely corresponding to those suggested by the musicians, but differing from them in a few respects (including, most noticeably, the requirement that the guild be dedicated to Cecilia).

The document refers to the organization as a *bruederscap*, a term that can refer to both a guild and a confraternity. But this was clearly a guild, with the principal goals of limiting the number of professional instrumentalists working in Leuven and regulating their professional behavior. Although the document mentions the organization's altar in St. Peter's church, it says nothing about religious services to be sponsored by it or attended by its members, suggesting that religious devotion was of secondary importance.

But this guild had at least one feature more characteristic of confraternities, with their typical mix of laypersons and clerics. It was open to those who were not professional players, but who might join, the document implies, out of their love of music and for the pleasure of social interaction.

Although this document, in Dutch, has been published several times,[28] as far as I know it has never appeared in English. Here is the first part, presenting the recommendations of the founding musicians:[29]

> The brotherhood of players of musical instruments, Peeter Faye, the brothers Claes and Jan Van Helen, Jan Van Hoegaarden, Raes De Smet, Gylys Coppens, as players of the harp, lute, viol, trumpet, and flute, native and resident citizens of this city of Leuven, in their own name and on behalf of their fellow players of the aforenamed musical instruments, residents of the same city, have come to the council of the said city, revealing and declaring:
>
> That they would like to set up, order, and regulate a brotherhood and have thereto a patron or patroness, whether it be Job, God's holy friend, or another as should best please the city;
>
> And that anyone might enter the said brotherhood, on payment of such an entry fee as the city council should ordain;
>
> And that the said brothers might choose yearly a leader who might govern them, in honor of their patron or patroness, so that the said brotherhood might be maintained in good order;
>
> And that each player of the aforementioned instruments from inside and outside [the city] for his entry fee should give and pay the aforementioned brotherhood six *rinsguldens* worth twenty *stuivers* each, to wit: one *rinsgulden* at the time of the entry fee, and from then on each year a *rinsgulden*, to be paid until the aforementioned other five *rinsgulden* should be paid in full, for the help and maintenance of the altar and brotherhood, [which] will have the power to execute the loaning-out of goods of those in arrears, with fair warning, and after they [i.e., the fees] have been demanded at least twice;
>
> And that all other persons, whether clerics or otherwise, who love the aforementioned musical instruments but are not masters of the same, and therefore not part of the above-mentioned brotherhood, shall be allowed to come to wine for four *stuivers*, thus to make and maintain friendly relations [with the instru-

mentalists], and each of them is to give every year a *colve*, just as the good men of the Chamber of Rhetoric of De Roose and others have their annual *colve*;[30]

And that the leader should always have the ability to summon the aforementioned players to their chamber, which they shall take on if these are in need, for a certain fee, to be ordained by you gentlemen, and if it is very necessary at double fee;

And that no player of any kind of instrument living outside the city of Leuven and coming to the said city for a time, in order to work in the said city, shall either work or help himself except at the Leuven fair, unless he shall first have applied to the aforementioned brotherhood, and be received therein, and received the citizenship of the city, and set a security for the fulfilling of the entrance-fee or set a pledge in the hands of the council, the brotherhood being warranty, or holding the same coins ready to pay for maintenance of the altar in the church of St. Peter that the aforementioned players will obtain.

And the aforementioned supplicants undertake to pay anyone to whom they shall owe money, so that no-one will have any reason to complain of them, and each player shall pay whatever annual fees that shall be ordained, before he will be employed in the said arts, on pain of penalties to be ordained, [including] the confiscation of their instruments, the proceeds to be directed to the needs of the aforementioned altar.

And here is the city council's response:

So it is ordained and decreed by the said council that men shall from now on, to the glory of God and His blessed Mother the Virgin Mary and the pure virgin Saint Cecilia, have a brotherhood to which the aforementioned players shall be admitted, and the said virgin Cecilia shall be its patroness;

And anyone living permanently and steadily in the city shall be allowed to enter, giving for his entry a pound of wax[31] or four *stuivers* beforehand;

And that the said brothers along with most of the followers shall be allowed to choose a leader whom they shall be bound to obey, and to appear at his summons, on pain of a fine of one *plecken* and a double fine of two *plecken*, and that as often and frequently as necessary the brothers shall gather for the needs of the brotherhood and welfare of the same;

And that each resident of the said city, being a musical instrument player, who does not enter the said brotherhood within this first year, and who wishes to enter after the year is ended, shall pay for his entry-fee one *ringsulden*;

And each player from outside shall owe for his entry-fee four *ringsuldens*, to wit: at first one *ringsulden*, then the other three, the first of them within the following year, the second within a year following that, and the third within the year after that, and setting good securities or pledges and warranties for the same;

And all other persons who are not musicians shall be allowed to enter this brotherhood, for a pound of wax or four *stuivers*;

And each brother shall owe the patroness one silver penny for his year's fees and the brotherhood four *stuivers*, and additionally a *colve* of two and a half *stuivers*;

And so that none of the brothers should abuse those whom they serve in this city, it is also ordained that each shall charge six *stuivers* per day in addition to the three *stuivers* he shall charge for performances in church, and each shall be required to be ready for any weddings, feasts and suchlike, for a fee of six Dutch *gulden*, and not be allowed to request more, on pain of the said fine.

The city pipers are exempted, who now and in the future are not and shall not be subject to the above; likewise those who come from outside to the afore-mentioned brotherhood as it is described shall not be obliged to take on the citizenship of the city, unless they wish to do so as an act of goodwill.

[Signed] Coram Berghe, mayor, Hovene, deputy, Borch Ledeleere, aldermen, and other members of the council. 3 December 1502.

For musicians whose main interest in forming a guild was hardly religious, the disagreement over the patron saint may not have mattered much. Their altar in St. Peter's would be dedicated to Cecilia, not Job; they would celebrate their patronal day on 22 November, not 10 May. But for us the disagreement is significant. It shows, on the one hand, that for professional instrumentalists looking for a patron at the beginning of the sixteenth century Cecilia was not yet the obvious choice; and, on the other hand, that the council felt strongly enough about her aptness as the musicians' patron, despite her gender, that it imposed its choice on the guild. Evidently the understanding of her relationship with music was in a state of transition in the Netherlands at the beginning of the sixteenth century, as images of her standing next to, holding, and even playing an organ became increasingly common and widespread. Perhaps members of the city council were more aware of these new images than the instrumentalists. Or perhaps they wanted to avoid the difficulties that the guild might encounter in observing St. Job's Day in Leuven at the same time as the feast was being celebrated in nearby Wezemaal.[32]

It may have been with some reluctance, initially, that the founding members of the musical guild in Leuven observed Cecilia's Day at their altar in St. Peter's. Yet with each passing year the musicians probably felt increasingly comfortable with her as their patron. The little victory that she enjoyed in Leuven over her rival Job anticipated the future. By the end of the sixteenth century, she had completely replaced Job as the first choice of musicians seeking a patron.

The statutes approved in 1502 remained in force for only two decades. On 19 January 1522, the city council of Louvain issued another decree:

On this 19th of January year 21 in the Brabantian style [i.e., 1522] this ordi-nance and charter of the council of this city, following Pieter Freye and certain others of the regiment of musicians, who for certain reasons so appealed to the

council, is abolished and annulled, and it is agreed that from now on anyone shall be allowed to play, paying St. Cecilia yearly on her day a silver penny.

Paul Trio and Barbara Haggh have stated that this decree did not necessarily spell the end of the musicians' guild in Leuven,[33] but I have found no evidence that it continued to exist. Whether the guild survived or not, the council, by mentioning Cecilia's Day as the day on which instrumentalists in Leuven were to pay an annual fee, made sure that she would continue to be associated with professional musicians.

Mons, a city in the French-speaking part of the southern Netherlands, has a claim to musical fame as the birthplace of Orlande de Lassus. But it also played a small role in Cecilia's emergence as a musical icon. In 1588 a group of local instrumentalists organized themselves under her patronage as the *Connestablie des Joueurs d'Instruments* (guild of players of musical instruments). The founding members took responsibility for the maintenance of a chapel dedicated to Cecilia in the church of St. Germain. In their statutes they agreed to sponsor services on her feast day and a Mass every month, "to pray to God and St. Cecilia for the souls of deceased members of this organization."[34] On Cecilia's Eve the members were to assemble "in the residence of one of the masters, or elsewhere, as instructed, to proceed in an orderly fashion to the church, to hear Vespers and *Salus*"; and the following day, Cecilia's Day, they were "likewise to assemble at the designated place to go to Mass and offertory, on pain of a fine of two *sous*, to be used to defray the expenses of the said chapel and divine office."[35] The bylaws say nothing about the musical component of these services. Correspondingly low-key was the meal that the musicians enjoyed after Mass: "at the end of the said Office, those who wish to accompany the masters to dinner may do so, without obligation however, and all paying for their meal equally."[36]

The statutes make clear that religious services played a larger role in the guild's activities than in Leuven. But it had even more important goals: to limit the number of professional instrumentalists in Mons, and to keep the quality of music-making as high as possible.

To achieve the first goal, the guild required that all professional instrumentalists in Mons be members, limited the number of members to forty, and required that players from out of town pay a fee for the privilege of performing in Mons: "When some group of foreign musicians comes to play for a wedding or banquet in the town, they must pay a fee of four *livres* each, and if they fail to do so their instruments may be confiscated; two-thirds of the said four *livres* to go to the chapel, and the rest to the poor of the said town."[37] Those who drew up the statutes did not consider organists to be *jouers d'instruments*; they, and singers as well, were welcome to join the guild, but they did not have to join.

To achieve the second goal (and contributing to the first goal as well), the guild instituted a system of apprenticeship that required young musicians to train for two years with a master and to learn to play four instruments:

Item, that all players who are presently residents of the said city will be able to live here the rest of their lives, without being subject to the master's exam. But all those who from now on wish to earn their living with the playing of instruments must be able to play four kinds of instruments, to wit, shawm, cornetto, flute, and viol, and to attain the status of master they must be able to play two pieces of music on each of the above-mentioned instruments, from whatever songs the masters might choose, paying for the privilege, for the benefit of the chapel, eight *livres* of Tournai, and to each of the above mentioned masters, for their trouble, twenty *sous* of Tournai.[38]

The statutes restricted the musical activities of the apprentices: "All the apprentice players, before being eligible to pass the master's exam or to play with a master, must be apprenticed to a master for two years, except that they may play at banquets before passing the master's exam, as long as they pay a fine of sixty *solz tournois* each time, for the benefit of the said chapel."[39]

ANTWERP'S SINGERS OBSERVE CECILIA'S DAY WITH FOOD AND WINE

In Antwerp, the biggest and richest city in the Netherlands, and one of the biggest cities in sixteenth-century Europe, Cecilia seems to have been mostly associated with singers of sacred music. Instrumentalists had their own guild, as we have seen, named after Job and Mary Magdalene. Church singers, in contrast, did not apparently belong to a guild; but they did acknowledge Cecilia's Day, in a way suggesting that they recognized her as their patron, or at least as a saint whose feast day gave them a good excuse to enjoy themselves.

The most important church in Antwerp (musically as well as architecturally and institutionally) was the Church (from 1559 the Cathedral) of Our Lady, Onze-Lieve Vrouwekathedraal (plate 43). It greatly impressed Albrecht Dürer when he visited the city in 1520: "Our Lady's Church at Antwerp is so vast that many masses may be sung there at one time without interfering one with another. The altars are richly endowed; the best musicians that can be had are employed; the Church has many devout services and much stonework, and in particular a beautiful tower."[40] In the church were the altars and chapels of many of Antwerp's confraternities and guilds—including the Confraternity of Our Lady (the Gilde van de Onze-Lieve-Vrouwe-Lof), one of the city's wealthiest and most active in the production of music.[41]

The pioneering archival work of Léon de Burbure and Édouard Gregoir in the 1850s and 1860s revealed that the choirboys and adult singers of the cathedral received gratuities and wine on Cecilia's Day from the Confraternity of Our Lady and from the city council.[42] More recently Kristine K. Forney and Godelieve Spiessens have studied more deeply the published documents and discovered

TABLE 3.1. Gifts of money, wine, and food for the singers of the Church (later the Cathedral) of Our Lady from the Confraternity of Our Lady (ca. 1550) and the city council of Antwerp (1530–1681)

Feast day	Gifts from the Confraternity of Our Lady*	Gifts from the city council (with dates of first and last gift)**
Epiphany (6 January)	Wine for choirboys	Wine or money for singers (1542–78)
Monday in Epiphany	Wine for choirboys	
Shrove Tuesday	Wine for choirboys	
Maundy Thursday	Wine and food for choirboys	
Pentecost	Gratuity for singers and choirboys	
Transfiguration (6 August)	Wine for choirboys	Wine for choirboys (1542–60)
Assumption (15 August)	Wine for singers	
All Saints (1 November)	Wine for choirboys	
St. Martin (11 November)	Wine for choirboys	
St. Cecilia (22 November)	Feast and gratuity for singers	Wine for choirmaster and singers (1530–1681)
Feasts of O (18–24 December)		Wine for singers (1551–59)
Holy Innocents (28 December)		Money or wine for choirboys and singers (1530–60)

*Forney, "Music, Ritual, and Patronage," table 6 on pp. 30–31.
**Spiessens, "Zingende kelen."

many others, enhancing our knowledge of how the singers in the cathedral observed Cecilia's Day.[43]

Cecilia's feast was one of several for which the cathedral's singers received confraternal or civic sponsorship during various parts of the sixteenth century, as listed in table 3.1. The documents tell us the year of the first and last gift from the city council on particular days; its donation of wine on Cecilia's Day lasted much longer than its other gifts. The Confraternity of Our Lady (to judge by the number of donations that the choirboys and adult singers received around 1550) was more generous than the city council. Not only did it give the singers wine more often than the city, but it sometimes helped them celebrate Cecilia's Day by paying for a banquet.

The earliest documented gift to the cathedral singers came from the confraternity, whose archive preserves the following statement, dated 1515: "Paid to the choirboys and [adult] singers, for their wine for the feast of St. Cecilia, 7 *escalins*, 10 *deniers*, Flemish coin."[44] As Forney's research has revealed, the confraternity continued to reward the singers on Cecilia's Day during the next few decades, sometimes with wine and sometimes with what the confraternity's records refer to as the *maltyt*—the banquet, which emerged around the middle of the century as the most frequent form of gratuity (table 3.2).[45] Sometimes the

TABLE 3.2. Payments by the Confraternity of Our Lady to the singers and choirmaster of the Church (later the Cathedral) of Our Lady on Cecilia's Day, 1549–1562

Year	Recipient and purpose of payment
1549	aende sangers op sinte cecielien dach alsse haer feest samen nae doude costuyme (to the singers on St. Cecilia's Day for their feast, according to the old custom)
1550	aen dye sangers doen sy haer maltyt hyelle van st. cecilia (to the singers for their banquet on St. Cecilia's Day)
1551, 1552, 1553	Betaelt den sangers op sinte cecilleen dach als sy haer maltyt houden nae doude costume (Paid to the singers on St. Cecilia's Day when they held their banquet, according to the old custom)
1554	Betaelt den sangers op sint cesillien dach als sy haer maltyt houden date men Mr. Antone Barbe betaelt heeft naer doude coustume (Paid to the singers on St. Cecilia's Day when they held their banquet; paid to M. Antoine Barbe, according to the old custom)
1555, 1556	Betaelt voer de sangers op Ste cecillien dach in handen van Mr. Antonis Barbe sangmeester (Paid for the singers on St. Cecilia's Day, into the hands of M. Antoine Barbe, choirmaster)
1557	Betaelt op sinte cecilien dach in handen van Mr. ant. Barbe voor de sangers nae doude costuyme (Paid on St. Cecilia's Day into the hands of M. Antoine Barbe, for the singers, according to the old custom)
1558	Betaelt aen heer Jan sangmeester sone voer die sangers voer hueren cicilien dach na doude coustuyme (Paid to herr Jan [Barbe], choirmaster, for the singers for their Cecilia's Day, according to the old custom)
1559	Betaelt meester antonis voer de maltyt van sinte cecylien voer een gratie toe behoef vanden sangers (Paid to Master Antoine [Barbe] for the banquet for St. Cecilia and for a gratuity for the singers)
1561	Betaelt aen gillis [?] om de maltyt op sinte cecelien dach op de sangers (Paid to Gillis [?] for the singers' St. Cecilia's Day banquet)
1562	Betaelt den selven om de maeltyt sinte cecelyen (Paid to the same [Geert van Turnhout, choirmaster] for the St. Cecilia banquet)

Source: Transcribed by Kristine K. Forney from payment records in the Katedraalarchief, Antwerp, Gilde van de Onze-Lieve-Vrouwe-Lof.

payments went directly to the singers; sometimes the choirmaster served as an intermediary.

The documents are not always clear whether the donations (in cash, wine, food) were meant to compensate the singers for their extra work during services on Cecilia's Day or to help them observe the day with a banquet. They probably did both. (A rare case of an explicit quid pro quo in connection with a Cecilia's Day payment is documented in a set of rules for the singers in the church of Saint-Pierre in Valenciennes dated 1623, according to which the city council sponsored the performance of a Mass in music ["la messe en musicque"] on

Cecilia's Day: "For the Mass of St. Cecilia the singers are paid 15 *livres tournois* and they receive five *cannes* of wine, which makes them happy to celebrate it."[46])

Cecilia's Day gifts from the Antwerp city council often came in the form of wine (usually specified as Rhine wine), the amount of which depended on whether the gift was for the choirboys, the adult singers, or both; but they generally ranged from seven *stoopen* (in 1530 and 1531; about seventeen liters) to twelve *stoopen* (in 1550).[47] Further obscuring how much wine the singers received is the city's occasional practice of combining donations for Cecilia's Day and for "the feasts of O," which took place about a month later.[48]

To judge from the years in which the city discontinued its gifts on most of these occasions, 1559–1581, some of the donations fell victim to the tumultuous political and religious events that occurred in the Netherlands in the second half of the sixteenth century: the outburst of iconoclasm known as the *Beeldenstorm* (1566), when Calvinist zealots invaded churches (including the cathedral in Antwerp) and destroyed paintings, tapestries, sculptures, and musical manuscripts, the outbreak of the rebellion against King Philip II (1568, the so-called Dutch Revolt), and the rise of the Calvinists to power in Antwerp (1581).[49] Of all the city's donations to the cathedral singers, only one returned after the retaking of the city by Spanish troops in 1585: its gift for Cecilia's Day, which lasted another century, until 1681.[50]

Although the city council resumed its *presentwijn* to the cathedral's singers for Cecilia's Day, even this gift required special interventions on at least two occasions. Séverin Cornet served as choirmaster in the cathedral from 1572 to 1585. In 1578, when Calvinists were increasing their political power in Antwerp but had not yet taken over the city, he pleaded on behalf of his singers for a Cecilia's Day present. He had to persuade the city council that the festivity was basically secular. Although Cecilia was "the musicians' patroness," her feast day was—Cornet implied—mostly an opportunity for the singers to drink together and enjoy themselves. He also characterized himself and the singers as willing to cooperate across denominational lines. He reminded the city council that a year earlier, when William, Prince of Orange, leader of the Protestant forces, had entered Antwerp, the cathedral singers had provided the music for a banquet in the prince's honor—a service, he added, for which the singers had not been rewarded:

> Aen mynen Eerw. Heeren Burghermeesteren ende Scepenen der stadt van Antwerpen. Gheven in alder ootmoet te kennen uwe onderdanige meester Severijn Cornet, sangmeestere, metten musiciens ende sanghers der cathedrale kercke van Onser Liever Vrouwen binnen deser stadt hoedat sy supplianten ende heure voorsaten van alle oude tijden sijn jaerlycx van der voors. stadt weghen op Ste Cecilien avont beghift ende beschoncken geweest met neghen stadtstoopen Rinschen wijn om daermede met malcanderen naer ouder costumen minnelijck ende vrolyck te vergaderen ende celebreren de feeste van Sinte Cecilia der musiciens patronersse Dat oock de supplianten omtrent een

jaer geleden naer de compste van der Excellentie des heeren prince van Orai-
gnen op 't bancquet, dwelck denselven heere Prince van der stadt weghen op 't
stadthuijs gegeven is geweest, hebben gedaen da musicque tot verhueghinge
desselffs syner excellentie ende Uwen Eerw. ende synen geselschappe ten be-
vele van denselven Uwen Eerweerden sonder dat de supplianten daeraff tot
noch toe syn vernuecht oft gherecompenseert geweest. Biddende daeromme
de supplianten dat Uwen Eerweerden believen wille den conchierge deser stadt
t'ordonneren dat hy den supplianten late volgen (des versocht synde) de voors.
neghen stadtstoopen wyns opdat de supplanten moghen daermede onderhou-
den heure oude loffelycke feeste van Ste Cecilia. Ende voorts dat den tresorier
ende rentmeestere deser stadt sal wordden geordonneert den supplianten te
gevene alsulcken redelycken contentement ende gracieusen recompensie als
Uwen Eerweerden bevinden selen by der supplanten (by heurlieder voors. mu-
sicke op 't voorseyde bancquet gedaen) verdient te syne. Dwelck doende selen
de supplianten hen des te meer t'allen tyden bevinden bereet ende gedienstich
tot Uwen Eerweerden des versocht synde.

<div align="right">Severyn Cornet[51]</div>

To my Honorable Lords Mayor and Aldermen of the city of Antwerp.

*Your servant Master Severijn Cornet, choirmaster, together with the musicians and
singers of the cathedral church of Our Blessed Lady in this city, most humbly brings to
your attention that the supplicants and their predecessors, according to long custom,
were yearly rewarded and bestowed by the aforesaid city with nine stadtstoopen of
Rhenish wine on St. Cecilia's Eve, so that they might, according to the old custom,
gather therewith with one another in a friendly and joyful manner to celebrate the
feast of St. Cecilia, the musicians' patroness.*

*Moreover, [they wish to point out] that about a year ago, at the entry of his Excel-
lence the Lord Prince of Orange, the supplicants played music at the banquet given at
city hall for the same prince, to the pleasure of His Excellency himself as well as Your
Honors and the prince's company, as directed by Your Honors yourselves, without the
supplicants ever having been rewarded or compensated from then until now.*

*Therefore the supplicants ask that Your Honors will be pleased to direct the quar-
termaster of this city to supply the supplicants (as requested) the aforesaid nine
stadtstoopen of wine, so that the supplicants might maintain therewith their tradi-
tional praiseworthy feast of St. Cecilia. And furthermore [they request] that the trea-
surer and stewards of this city will be directed to give the supplicants such reasonable
reward and gracious compensation as Your Honors shall deem the supplicants to have
earned (through having made their aforementioned music at the aforesaid banquet).
This having been done, the supplicants shall, all the more and at all times, be found
ready and amenable to Your Honors' requests.*

<div align="right">*Severyn Cornet[52]*</div>

The city council responded favorably to Cornet's memorandum, offering the singers nine *stoopen* of wine (about twenty-two liters) and six gulden in cash. But a year later, in 1579, Calvinists gained control of the council, and two years after that they made the public exercise of Catholicism illegal—effectively banning the observance of Cecilia's Day. Yet even as late as 1581, Cornet may have hoped to persuade the council to change its mind. In that year he published in Antwerp a book of motets, with a title page that boasts of his position at the Cathedral of Our Lady: *Cantiones musicae 5. 6. et 8 vocum Auctore Severino Cornet Valencenate Ecclesiae diuae Virginis Mariae Antuerpiensis Phonasco* (Musical Songs in 5, 6, and 8 voices, composed by Séverin Cornet of Valenciennes, Music Master of the Church of St. Mary the Virgin of Antwerp). It contains works both in honor of Cecilia (*Cantantibus organis*) and addressed to the city council (*Ad Magistratum*). The latter refers again to wine, this time in elegiac couplets:

> Qui varium regitis populum, qui frena tenetis,
>> vivite festivi, tempus et hora iubent.
> Atque epulas inter geniales libera vina,
>> cantio delectet, quam mea vena dedit.

> *You who govern a varied people, who hold the reins,*
>> *be joyful: the time and the hour demand it.*
> *And may the song that my talent has produced enhance the pleasure*
>> *of the free-flowing wine amid the joyful banquets.*

"You politicians deserve food and drink," the motet declares, with the subtext: "but so do we musicians."

After the reconquest of Antwerp by the Spanish in 1585, a new choirmaster, Andreas Pevernage, was installed in the cathedral; and he too may have felt the need to remind the city council of a tradition that his singers evidently treasured. Pervernage himself had long personal experience with Cecilia's Day festivities. Before taking up his position in Antwerp, he had served for about two decades as chapelmaster at the church of Our Lady in Kortrijk. There he had participated in the life of the city's Confraternity of St. Cecilia (to be discussed in the following chapter), writing motets to recognize the annual installation of the confraternity's prince.

Yet it was not Pevernage but unnamed "music lovers" ("lieffhebbers van der musicquen") who wrote to the city council in November 1585 (just three months after Alessandro Farnese had recaptured the city and restored Catholicism to its privileged status), to judge from a decree by the city council in response to the petition:

> Alsoo de lieffhebbers van der musicquen mijne heeren Borgemeesteren ende Schepenen verthoont hadden hoedat van allen ouden tyden mijne voors. heeren

de feeste van Sinte-Cecilien hadden jaerlijcx beschoncken ghehadt met tweelff stadtstoopen wijns. Ende ghemerct sylieden mits de reductie deser stadt hadden doen vergaderen meesteren Andriesen Peveraige [sic] van Cortrycke, alhier gheroepen omme te wesen sangmeester van Onser-Liever-Vrouwenkercke, met alle de sangers ende andere ghoede beminders van der musicquen omme nae ouder ghewoonten op Sinte-Ceciliensdach met malcanderen vrolyck te wesen. Biddende ten insiene van de jegenwoordige dierte ende besundere oyck dat sylieden in seven oft acht jaren van der stadtswegen mits de voorleden troublen nijet en hebben beschoncken gheweest dat daeromme mijne voors. heeren soude believen hen te gunnen een ame wyns. Soo hebben myne heeren mits den redenen boven verhaelt ende andere hen daertoe moverende den verthoonderen voor dese reyse ende sonder tselve te trecken in consequentien in plaetse van den voors. ordinarise jaerlycxe XII stadtstoopen wyns gegunt ende gheschoncken drij ende tsestich guldens eens, ordonnerende den tresoriers ende rentmeestere deser stadt de voors. LXIII gl. uuyt te reycken ende te betalen. Actum XXIa novembris 1585.[53]

Whereas the music lovers had shown my lords mayor and aldermen how from olden times my aforesaid lords had yearly bestowed the feast of St. Cecilia with twelve stadtstoopen *of wine; and they remarked that since the reconquest of this city Andriesen Peveraige [sic] of Kortrijk, called here to be choirmaster of the Church of Our Lady, had met together with all the singers and other good music lovers in order to make merry with one another on St. Cecilia's day, according to ancient custom; [and] in view of the present high cost of living and also the extraordinary situation that, for the last seven or eight years, with the preceding troubles, they had not been rewarded with anything at all by the city, they request that my aforesaid lords might be pleased to give them one* ame *of wine;*

 Therefore my lords decided, in view of the reasons related above and others moving them thereto, to give and grant the requesting parties—only for this instance and without setting a precedent for the same—a single payment of 63 gulden in place of the aforementioned usual yearly 12 stadtstoopen *of wine, directing the treasurer and stewards of this city to extend and pay the aforementioned 63 gulden. Enacted 21 November 1585.*[54]

Who were the music lovers to whom the city council was responding in this decree? Members of the cathedral choir or those who wished to enjoy the music as listeners? If the latter, this would be an early instance of Cecilia's Day being referred to as a source of musical pleasure for listeners, anticipating the evolution of Cecilian celebrations in the seventeenth century into what we might think of as public concerts.

Whoever these music lovers were, they had argued in their petition that the newly arrived *sangmeester* Pevernage and his musicians deserved to be rewarded on Cecilia's Day. The reward they proposed—one *aam* of wine (64 *stoopen*, or roughly 154 liters)—was much higher than those of the past, to make up for

the previous years under the Calvinists, when they received no wine at all. The city's counteroffer of 63 gulden in cash was worth considerably less, according to Godelieve Spiessens; but it was an auspicious gesture nevertheless, because henceforth, for almost a century, the city of Antwerp helped the cathedral singers observe Cecilia's Day with an uninterrupted series of annual donations.

FOLLOWING ANTWERP'S LEAD: SINGERS IN THE NETHERLANDS ENJOYING FOOD, DRINK, AND MUSIC ON CECILIA'S DAY

Evidence that professional singers in cities other than Antwerp received gifts or enjoyed a banquet on 22 November suggests that the custom was widespread in Dutch-speaking areas (table 3.3). These singers, like those in the cathedral of Antwerp, did not necessarily belong to a guild or confraternity: many of them celebrated Cecilia's Day as members of a choir. They did so despite the absence (already noted in chapter 1) of Cecilia from lists of major feasts. Her feast day, in contrast to Catherine's, three days later, was theirs alone.[55]

The city council of Mechelen (twenty-two kilometers south of Antwerp) bestowed one of the earliest documented Cecilia's Day gifts in 1516, on the singers of the church (later the cathedral) of St. Rumbold: two *stoopen* (about five liters) of Rhein wine. By 1566 the city had extended its annual generosity to the singers of the Church of Our Lady beyond the Dyle.[56]

TABLE 3.3. Cities in the Netherlands where singers of sacred music received gifts on Cecilia's Day, 1515–1570

Earliest documented date	City
1515	Antwerp
1516	Mechelen
1530	Delft
1532	The Hague
1539	's-Hertogenbosch
1548	Roeselare
1552	Gouda
1557	Oudenaarde
1559	Zoutleeuw
1560	Bruges
1560	Geraardsbergen
1563	Wesemaal
1570	Kortrijk

The custom also took hold farther north. During the second tenure of Gheer-kin de Hondt as choral director at the New Church in Delft (1530–1532), Ceci-lia's Day was one of four feasts (the others being Easter, Pentecost, and Christ-mas) on which the singers received a gratuity of three *stuivers*.[57] Nearby, in The Hague, singers also received money on or around 22 November—though not all the documents recording those payments (dating from 1532 to 1561) actu-ally mention Cecilia.[58] The singers at St. John's church in Gouda, thirty-five ki-lometers to the east of Delft, received presents on Cecilia's Day between 1552 and 1554.[59]

When Gheerkin moved from Delft to 's-Hertogenbosch in 1539, to take up a position at the Illustrious Confraternity of Our Lady, he found a Cecilian tradi-tion that benefited both the choirboys and the adult male singers. Three times a year, including Cecilia's Day, the boys enjoyed a special treat (something like the "cream and white bread" they received on another festive occasion?), while the men received a gratuity—sometimes in cash and sometimes in the form of food or wine.[60] At the same time, the Presentation of the Blessed Virgin Mary (21 November) became an increasingly important feast in 's-Hertogenbosch. Its celebration overlapped with Cecilia's Day, in that the Second Vespers took place on Cecilia's Eve, and a Requiem Mass was celebrated on the day after the Presentation—Cecilia's Day itself.[61] Perhaps the gifts and gratuities that the mu-sicians received on Cecilia's Day were intended—at least in part—as a reward for their contribution to the celebration of the Marian feast. It was probably to help celebrate Cecilia's Day that Gheerkin wrote his *Missa Ceciliam can-tate pii*, based on a motet by Nicolas Gombert and preserved in a manuscript in 's-Hertogenbosch.[62]

On 20 November 1560, two days before Cecilia's Day, the Chapter of St. Do-natian in Bruges approved a request from the singers for money to help them mark the day with a banquet. The minutes, in Latin, refer to the meal being prepared "ut moris est" ("as is customary," corresponding to Dutch expressions in the documents cited earlier). The phrase might mean that this was not the first Cecilia's Day banquet that the singers at St. Donatian had enjoyed. But per-haps the custom to which the Chapter referred was that of the cities mentioned above. The document goes on to say that the Chapter granted the request "by special dispensation" and in recognition not only of Cecilia's feast but also of the installation of a new *succentor*, Guillaume Rocourt:

> Audita lectura supplicationis pro parte clericorum installatorum hujus ecclesie exhibite, gratuitatem pecuniariam humiliter petentium, in subsidium prandii per eos in proximo festo dive Cecilie ad sese honeste recreandum ut moris est preparandi, et habita desuper matura deliberatione, tandem DD. Dictos clericos ad suum officium posthac in choro diligentius solito exercendum, per hoc alli-cere et animare sperantes, necnon in novi succentoris adventus congratulatio-nem, eisdem clericis in dicti prandii sublevamen, ex gratia speciali annuerunt X s. gr. ex obedientia.[63]

Heard: the reading of a petition on the part of the appointed choristers of this church, humbly seeking a monetary grant to subsidize a banquet for them on the next feast of St. Cecilia, being prepared, as is customary, for their honest enjoyment. After careful deliberation, hoping by this means to encourage and inspire the said clerics to be more diligent in the future exercise of their duties in the chorus, as well as to celebrate the installation of the new succentor, [the Chapter] granted for the said banquet, as a special dispensation, a subsidy of 10 s. gr.

The musicians of smaller cities and towns in the Dutch-speaking part of the southern Netherlands also found Cecilia's feast to be a good opportunity to celebrate, especially in the 1550s and 1560s. Already in 1548 Roeselare's musicians had received a present on Cecilia's Day from the city council.[64] In Oudenaarde the council gave five pounds in cash to a newly appointed choirmaster and his musicians for their "recreation" on Cecilia's Day, 1557.[65] Although the document mentions neither food nor drink, we can safely assume the city fathers had that kind of recreation in mind. From 1559 the singers in the church of St. Leonard in Zoutleeuw (about halfway between Leuven and Maastricht) received fifteen to twenty *stuivers* on Cecilia's Day.[66] Musicians in Geraardsbergen who called themselves *Cecilianisten* made annual requests to the city council for two kegs of beer for Cecilia's Day from 1560.[67] In 1574 the council referred to this organization as a guild when granting it seven pounds for its *recreatie*.[68] A document from Geraardsbergen dated 1591 states: "Paid to the musicians on St. Cecilia's Day, their feast day, that they might enjoy themselves together with the priests."[69] Even in the village of Wezemaal, mentioned earlier as the site of an important celebration of St. Job's Day, Cecilia's Day gained recognition as an occasion for rewarding singers. By 1563 it was already an "old custom" to give the singers of St. Martin's church twenty two *stuivers* on Cecilia's Day.[70] In 1570 the city council of Kortrijk gave wine to the Confraternity of St. Cecilia, making a further contribution of wine in 1590.[71]

CONVIVIUM CANTORUM: CECILIA'S DAY CELEBRATIONS IN HUMANIST POETRY

At least one of the many monasteries and convents in the southern Netherlands promoted the musical observance of Cecilia's Day. Joannes van Loo, the abbot of Eversam (also spelled Eversham: a monastery in western Flanders, between Ypres and Veurne), alluded to such a celebration in his *Carmen Caecilianicum*, a poem printed in 1575. In elegiac couplets, it consists of four parts: the first addressed to the dedicatee, Jacob Sluperius, a humanist poet whom van Loo considered "an extraordinary friend and an exceptional patron of musicians"; the second part to Musica, the personification of music; the third "to any musician"; and the fourth to Cecilia herself.[72]

In the first part, after praising Sluperius, van Loo referred to Cecilia's Day

at Eversam as the occasion for which he had written the poem. The event apparently involved a full day of music, instrumental and vocal. Inspired by the dedicatee's humanist credentials, the abbot thought less about Cecilia as a virgin martyr and a model of Christian virtue than about the musical icons of Greco-Roman antiquity:

> Caeciliae ob festum contendit nostra iuventus
> Hunc totum cantu concelebrare diem:
> Regia nunc omnis numerisque modisque sonoris
> Perstrepit, ac toto musica in orbe sonat.
> Hoc agedum festo, modulantis Arionis instar
> Iam resonent voces, organa, plectra, chelys.
> Prodeat artis opus Musis et Apolline dignum,
> Huc dulces numeri, Musica dulcis ades.
> Huc Orpheus pariter cantu celeberrimus adsit,
> Ut liceat digitis increpuisse lyram:
> Progredere Amphion docti certamine cantus,
> Carpe fides etiam Phoebe, canantque Deae,
> Nulla quidem organicis vacua est iam pulsibus hora,
> Ista dies fautrix artibus una bonis.

> *Because of the feast of Cecilia, our youth compete*
> *to celebrate this whole day with singing;*
> *now the whole monastery echoes with sonorous melodies and songs,*
> *and music sounds throughout the world.*
> *The feast having arrived, let the voices (like that of singing Arion),*
> *the organ, the plectra, the lyre resound.*
> *Let the work of art come forth, worthy of the Muses and Apollo.*
> *Here, sweet melodies; sweet music, you are here.*
> *And may Orpheus be here likewise, most famous in song,*
> *that he might pluck the lyre with his fingers.*
> *Advance, Amphion, in the competition of learned song.*
> *Gather your faithful followers, Phoebus, and may the goddesses sing.*
> *Indeed, no hour is now empty of the sound of instrumental music.*
> *The day itself is patroness of the fine arts.*

With the concluding prayer to Cecilia herself, van Loo placed his monastery under her protection. But even here, as he finally acknowledged her virginity and sought her intercession, he could not resist one more allusion to classical antiquity:

> Nobis Virgo fave: dignas da solvere grates,
> Fac placeant uni carmina nostra Deo:
> Stetque diu incolumnis sacer Eversammius ordo,
> Longaque Cumeae secula vatis agat.

Favor us, virgin; allow us to give worthy thanks.
 May our songs please the one God;
and may the sacred order of Eversam long remain safe,
 and active for as long as the life of the Cumaean Sibyl.[73]

Van Loo said nothing of food and wine, but another Latin poem published ten years later can hardly be understood except as a product of vast classical learning in combination with hours of heavy drinking on Cecilia's Day. Gerard van Roo, a Flemish musician, poet, and historian, taught the choirboys and sang bass in the court chapel of Archduke Ferdinand II (a son of Emperor Ferdinand I), who resided primarily in Prague and Innsbruck.[74] His *Convivium cantorum* (The Singers' Banquet) was published in 1585 under a subtitle that places Cecilia and the pagan Muses on an equal footing: "Carmine cuiusdam cantoris compositum, castae Caeciliae, Castalioque Camaenarum choro consacratum" (Consisting of a song by a certain singer, dedicated to the chaste Cecilia and to the Castalian chorus of Muses). Not only the title and subtitle, but the preface in prose and the whole poem (333 lines in dactylic hexameter), consist entirely of words beginning with *C*.[75] This bizarre exercise in extreme alliteration describes a musical banquet enjoyed by guests with Greek and Roman names, probably pseudonyms of van Roo's colleagues in the court chapel. It is more remarkable for its ingenuity than for its beauty or sense, as the poet himself admitted in the preface: "Carmen, credo, comperietur crasse concinnatum, centonibusque consutum" (The poem, I believe, will be perceived as crudely composed, and stitched together out of patches). No false modesty, as this introductory passage will show:

Caerea cum Capri clarerent cornua coelo
Concilium cogunt Cantores, Cacciliamque
Caelitibus comitem Clementi, Chrisogonoque
Castis carminibus, caenaque cibuque cyphisque
Concludunt consueta conditione colendam.[76]

When the waxen horns of the goat shine in the heavens,
the singers assemble, and they surround Cecilia,
the companion of Saints Clement and Chrysogonus,
with chaste songs, and with a banquet and food and goblets,
according to the custom by which she is to be venerated.

Another passage exemplifies the poem's humanist mixture of Christian and classical elements:

Cum Curio, Caius, cautusque Cratippus
Cantandum clamant, convivatorque Choraules,
Compositisque cyphis Charites Clariasque Camaenas
Concelebrant, clausoque canunt cecinisse cubili
Caeciliam Christo, coniungi cui cupiebat

Coelibe coniugio: cantataque concio credi
Candida Castalidum cygnorum carmina caepit;
Conticuitque chorus . . .[77]

Cajus and cautious Cratippus, together with Curius,
call for a song, and the master of the feast and a flute player
with matching goblets praise the three Graces and the Muses of Apollo.
And they sing of Cecilia: that, having
barred entry to the nuptial bed, she sang to Christ, to
whom she wished to be joined in a celibate marriage;
. . . and she began beautiful swan songs of the Muses;
and the chorus was silent . . .

Let us assume that van Roo's banquet was not entirely a product of his imagination, but reflected his experience as a choirboy in the Netherlands and a member of a Habsburg court chapel dominated by Flemish musicians. To praise Cecilia during the banquet—to surround her with chaste songs—he and his colleagues needed music. They satisfied that need, above all, with motets in her honor, to be discussed in the following chapters, that French and Flemish composers wrote from the 1530s onward.

CONFRATERNITIES, MUSICAL COMPETITIONS, AND BANQUETS IN ROUEN AND ÉVREUX

During the sixteenth century two confraternities dedicated to Cecilia, and taking a particular interest in music, were active in Normandy. The feast day activities of both included a *puy*: a musical competition in which compositions were solicited and judged, and the winning works awarded prizes. They also included a banquet.

We do not know when a confraternity under Cecilia's patronage was established in the cathedral of Rouen; a copy of its bylaws dated 1601 says only that it had existed "for a long time in the cathedral-church of Notre-Dame, with the permission of Monseigneurs the archbishops, the deans, the canons, and the chapter of the said church."[78] Its first appearance in the documentary record seems to have been on Cecilia's Day 1539. It formed the nucleus of a larger organization that participated in the performance of Vespers and Mass in the cathedral in 1554.[79] Probably in imitation of Rouen's Confraternity of the Immaculate Conception, which had a long and distinguished history and administered an annual poetry contest as part of the observation of its patronal day, the Confraternity of St. Cecilia began in 1565 to offer prizes for the chanson and the motet judged best among those submitted to the choirmaster of the cathedral, where the competition took place.[80]

Each year the confraternity elected a prince, charged with overseeing the *puy* and (by tradition, not statute) paying for the annual banquet. That gave rise, in

1574, to a lawsuit. The legal machinations, recounted amusingly by Dylan Reid, reveal the importance of the Cecilia's Day banquet in Rouen—and elsewhere:

> The Prince, Guerard, *curé* of Tournetot, refused to pay for anything other than the mass, claiming that the rest of the expenses were "chose inutile" and that he could not support such "extreme despence." As the date of the *puy* approached, the past Princes of the confraternity launched a lawsuit to force him to pay the other costs, including the banquet. Their lawyer, De Bretignières, pointed out that Guerard had enrolled in the confraternity voluntarily and had happily eaten at earlier banquets. The representative of the *procureur général du Roi*, Bigot, then made an intervention in which he paraded his considerable erudition. He began by saying that the Greeks had had similar associations for the encouragement of learning, that music had been prized throughout history, and that it was considered valuable to the Church. Since the confraternity's purpose was to encourage musicians to serve the Church, he continued, it should be respected; and therefore, he concluded, Guerard should be made to pay not only for the mass, but also for prizes and other expenses incurred in holding the contest. The banquet, however, could be left to Guerard's discretion. The confraternity's lawyer, De Bretignières, in an attempt to extract the banquet expenses as well, used a musical metaphor: "la musique est composee dharmonie et . . . celuy qui discorde est ennemy." He added that it was necessary that the "estrangers qui apportent motets chansons et compositions" be properly received. This attempt to get the banquet included failed, though the confraternity did win the rest of the case. The Parlement ordered Guerard to pay not only for the mass but also for the prizes and other expenses of the contest.[81]

In 1570 singers employed by the cathedral of Notre Dame in Évreux (about fifty kilometers south of Rouen) joined with members of the cathedral clergy and prominent residents to set up a Cecilian confraternity similar to the one in Rouen; its principal function was to solemnize the feast with a series of services in which music played a major role and with a banquet. Five years later the confraternity added to its Cecilia's Day activities the one for which it became famous: a musical competition, the Puy d'Évreux. Many of the documents associated with the confraternity survive, allowing Elizabeth Teviotdale to recount its founding:

> The twenty-one founding members included local professionals (mostly lawyers), a number of officials of the cathedral (among them presbyters, canons, and the treasurer), and seven musicians (five of whom were in the employ of the cathedral). One outstanding musician numbered among the founders: Guillaume de Costeley, composer and organist at the French royal court and *valet de chambre du Roy*. He had moved to Évreux in the year of the confraternity's establishment, when he went into semi-retirement from the court. The members of the confraternity all contributed to an endowment that financed the Caecilian celebrations.[82]

The founding statutes of 1570 tell us something of the motivations of those who organized the confraternity. The preamble begins with a reference to the central place of music in the Judeo-Christian tradition. It continues, remarkably, by naming Cecilia as one of several saints who praised God with vocal and instrumental music, thus transforming her (as some visual artists had done for about three-quarters of a century) into a practicing musician. In another remarkable claim, the preamble states that other institutions had already been organized in Cecilia's name "in several parts of Christendom" for the purpose of praising her with music. (Rouen was obviously one such place. But the others?) These "beautiful foundations" had been "established by enthusiasts in the service of God and lovers of the art of music"—a phrase that anticipates one used fifteen years later by petitioners in Antwerp to identify themselves ("lieffhebbers van der music- quen") when they requested the city council to reinstate its customary Cecilia's Day gift of wine to the singers of the cathedral. The preamble finally identifies the singers employed by the cathedral of Évreux as the confraternity's initiators:

> God the creator, first author of the sciences, having given to men the invention of the art of music, demonstrated that he wished to be served and honored through it, having been pleased by the praises and canticles sung to his name and played on musical instruments by the children of Israel after they were delivered from the tyranny of Pharaoh. Recognizing this, David, king and prophet, urged each and every one of God's faithful servants to praise him and magnify him by the sound and harmony of the psaltery, harp, and organ. And he himself set an example when, walking before the arc of God, he played the harp, by the sound of which God had previously often caused to cease the torments that Saul suffered from melancholy. In imitation of him and the Fathers, and in accordance with both natural and written law, several saintly persons by the law of grace, both men and women, have praised God and his son Jesus Christ our Savior by means of music's harmonious sounds, both instrumental and vocal, and among others Madame St. Cecilia, virgin and martyr. In honor of God and under her invocation, in several parts of Christendom, several beautiful foundations have been established by enthusiasts in the service of God and lovers of the art of music, who, every year on the day of the feast of the said virgin, sing motets, hymns, and praises to God the creator and to her. Venerable persons having considered these things, the singers in the service of the Cathedral Church of Notre Dame of Évreux, moved by devotion and by their desire that the service of this church be honorably maintained, as it has been up to now, and to invite those who will come after them to take the trouble to learn the said art of music and to make themselves worthy to serve in this church, in honor of God and for the edification of the people, have decided among themselves and several devout and notable residents of this city (and with the approval of the members of the chapter) to found and to establish, every year in perpetuity, a service in honor of God on the day of the feast of the said saint, in the form and manner and by the means that follow.[83]

The statutes contain detailed instructions on how the "service"—actually a series of services, taking place in the cathedral from Cecilia's Eve to the day after her feast, and all involving polyphonic music—were to be organized. I will quote and discuss these instructions in chapter 4 as evidence for the singing of motets on Cecilia's Day.

In 1575 the confraternity in Évreux enhanced its fame with its introduction of a musical competition. The charter promised the awarding of prizes in five categories:

> On the 23rd day of November of each year to come, on the day after the afore-
> mentioned feast and ceremony [i.e., St. Cecilia's day], a Puy or music competi-
> tion shall be celebrated in the house of the choirboys of the aforementioned
> place [Évreux]. At each Puy, Latin motets for five voices and in two parts shall
> be accepted, whose text shall be to the honor of God or in praise of the afore-
> mentioned virgin; and the silver organ shall be awarded to the best motet and
> the silver harp to the second best. Also, chansons for five voices shall be ac-
> cepted, on words of the composer's choosing excepting scandalous texts. The
> best shall have the silver lute; the runner-up shall have the silver lyre. The song
> for four voices found the most pleasing shall be presented the silver cornetto.
> The best witty chanson, also for only four voices, shall take the silver flute. To
> the most excellent French Christian sonnet [i.e., spiritual chanson], composed
> in two parts, shall be given the *triomphe de la Cécile*, decorated in gold, which is
> the highest prize.[84]

The statutes assigned to the prince the responsibility of publicizing the con-
test by having posters, which included a picture of Cecilia, printed in Paris and
widely distributed:

> In order that the Puy shall be known to composers, both of this realm and of the
> surrounding ones, the aforementioned prince and treasurer shall have printed
> two hundred notices by the firm of Adrian Le Roy, printer to the King, residing
> in Paris, at Mont Saint-Hilaire, at the sign of Mont-Parnasse, who has in his
> possession the plate of the figure of St. Cecilia ordered for this purpose. And
> because it is very fitting and necessary to make new invitations to the musicians
> each year for the decoration of the Puy, the prince shall take care in his year to
> make use of a *gentil esprit* to compose new invitations in Latin and French, for
> the motet is in Latin and the chanson is in French. He shall have them deliv-
> ered, corrected and punctually, to the aforementioned Adrian Le Roy, in order
> for them to be printed early and sent to master musicians of cities near and far,
> who shall by this means be advised of the celebration and continuation of the
> aforementioned Puy.[85]

Our only evidence of who answered the call for compositions is a list of win-
ners of first and second prizes between 1575 and 1589, which survives among the

confraternity's papers in Évreux.[86] (Table 4.4 lists the motets that won prizes.) As Teviotdale points out, the winners, mainly minor French composers, suggest that the confraternity did not achieve its goal of attracting substantial numbers of submissions from outside France. The only winner of truly international standing was Orlande de Lassus. But obscure Frenchmen did not necessarily dominate the list of competitors as much as they dominated the list of winners. Musicians from Normandy and Paris were more likely to have personal connections with members of the jury and may consequently have had a better chance of winning prizes than more famous composers from abroad.

A CONFRATERNITY THAT MAY NEVER HAVE EXISTED: THE CONFRAIRIE DE SAINCTE CÉCILE IN PARIS

In 1575, five years after the singers of Évreux cathedral established their annual observance of Cecilia's Day, statutes were drawn up in Paris for a similar organization.[87] Like the confraternity in Évreux, it was to consist mostly of professional musicians, which probably meant—in a city in which a guild of instrumentalists had existed for several centuries—mostly singers of sacred music. The Parisian plans for religious services with a rich musical component seem to have been inspired by those of Évreux:

> Each year on the twenty-first day of November, St. Cecilia's Eve, the said members will assemble to participate in Vespers and Compline, which will be celebrated solemnly in the said church of the Augustinians, with [polyphonic] music and organ, and in such a way as will be dictated by the superintendent, who will be in charge
>
> And on the next day, the feast of St. Cecilia, a large mass will be celebrated solemnly, with [polyphonic] music and the organ, before which a procession around the said monastery of the Augustinians will be made, and a white candle will be given to each member, which will be presented at the offertory, and prayers will be said with the same intention as above. On the said day Vespers and Compline will [again] also be celebrated solemnly.
>
> And after Vespers and Compline, the Vigils for the Dead will be celebrated, especially for deceased members, and on the following day a solemn Requiem for the same purpose.
>
> And to eliminate the disorder and confusion that can arise during these solemn prayers, including in the music and organ playing, no musician, whoever he may be, will be allowed to sing in the said assembly, unless he has been invited to do so by the said superintendent, who will likewise appoint the organist as he sees fit.[88]

The statutes also propose that the confraternity should institute a competition, calling for composers to submit "quelques motets nouveaux ou autres cantiques honnestes" to be judged, with prizes going to the best.

We have no evidence that these statutes led to a functioning organization, but they are useful nevertheless as a record of the values and ambitions of professional musicians in sixteenth-century Paris. In choosing the monastery of the Augustinians, known as the Couvent des Grands-Augustins, as the site of their devotions and music-making, they placed themselves close to the center of Paris. The monastery was a late medieval complex overlooking the Seine from the left (south) bank. A clockwise procession around the monastery on Cecilia's Day would have taken members of the confraternity along the river and the Rue des Augustins, a street that still exists, through the Porte de Buci (a gate in the old city wall), and past the Hôtel de Nesle and the Tour de Nesle (a tower that stood on the riverbank, opposite the castle of the Louvre).

The apparent failure of the Confrairie de Saincte Cécile does not mean that musicians in Paris did not consider Cecilia their patron and mark her feast with performances. The title page of *La Céciliade*, a play by Nicolas Soret with choruses by Abraham Blondet, published in Paris in 1606, openly acknowledges her status as patron of musicians. In their preface the author and composer refer to a "concert Cécilien" that was apparently an annual event in the cathedral of Notre Dame.[89]

Franco-Flemish Cecilian Motets: Composers, Publishers, Performers, Venues

Throughout the Middle Ages and early Renaissance, Europe's monks, nuns, and church musicians chanted the legend of Cecilia during the Divine Office on the eve of her feast and on the day itself. But composers found no reason to praise her in polyphony: to clothe the liturgical texts with music analogous to the elaborations by writers and visual artists quoted and illustrated in chapters 1 and 2 and plates 5–32 and 36–41. I know of no polyphonic music addressed to her before the sixteenth century.[1]

All the more impressive that between 1530 and 1600 many of Europe's greatest composers—including Nicolas Gombert, Cipriano de Rore, Thomas Crecquillon, Jacobus Clemens non Papa, Orlande de Lassus, Giovanni Pierluigi da Palestrina, Philippe de Monte, and Luca Marenzio—as well as many lesser ones wrote music in honor of Cecilia. (For a list of Cecilian music copied or published before 1620, in roughly chronological order, see the appendix.)

As is the case with sixteenth-century motets in general, we rarely know how, when, and where any particular Cecilian piece was performed. But the phenomenon occurred almost certainly in response to developments discussed in chapter 3: the rise of musical institutions dedicated to Cecilia and of celebrations of her feast by musicians. Many of the motets were probably written for and sung on Cecilia's Day by professional musical associations under her protection.

A DELUGE OF PRINTED MUSIC

Most of the surviving sixteenth-century Cecilian motets were published in print. Their sudden appearance in the 1530s needs to be considered within the context

of a huge increase in the amount of music being printed. Ottaviano Petrucci pioneered the printing of polyphonic music with the beautiful editions that he produced from 1501 to 1520; he used triple impression, printing first the staves, then the notes, and finally the words. The printing of music by single impression, introduced in Paris by Pierre Attaingnant in the 1520s, allowed editions to be produced more quickly and efficiently. The rapidly expanding music printing industry of the 1530s gave composers new markets for their music; it also increased the chances that the music would survive to be considered in studies like this one.[2]

Reminding us of the precariousness with which Renaissance manuscripts preserved unprinted music, only a handful of Cecilian motets survive in manuscript alone, and none of them, as far as we know, in more than one copy. One of the earliest Cecilian motets exists in only a fragmentary state. A manuscript that Edward Lowinsky dated to the 1520s on the basis of its repertory and watermarks contains the superius part of a short setting of the antiphon *Cantantibus organis*. The work is anonymous, but given that almost all the known composers represented in the manuscript were French, we might speculate that the composer of this motet was French too.[3]

The year 1539 saw the publication or republication, in Paris, Lyon, and Venice, of no fewer than eight Cecilian motets. Three years later Willem van Vissenaecken issued in Antwerp the first polyphonic music printed by single impression in the Netherlands. This anthology included *Ceciliam intra cubiculum* by Cornelius Canis, three of whose Cecilian motets would eventually see print. The founding of three more Flemish music printing firms, by Tielman Susato (Antwerp, 1543), Hubert Waelrant and Jan de Laet (Antwerp, 1554), and Pierre Phalèse (Leuven, 1553), led to the publication of hundreds of motets, including a significant number of pieces addressed to Cecilia.[4] Another Flemish printer, Jean Bogard, contributed to the dissemination of Cecilian music later in the century. He set up shop in his hometown of Leuven in the 1560s and around 1574 moved to Douai, where he published at least twelve motets in praise of Cecilia.[5]

Yet we should not exaggerate the role of printing in the phenomenon of the Cecilian motet. First, not even print guaranteed that music would survive. A single altus partbook is all that we have of Jacobus de Kerle's first book of motets (Rome, 1557), which included a *Cantantibus organis*. Geert van Turnhout, whom we know to have written at least two works for Cecilia, published in 1568 a book of motets of which not a single copy is known to exist, and whose contents are unknown.[6] More heartbreaking still is the loss of an entire collection of Cecilian motets—an exceedingly rare example of an anthology dedicated to a single saint—published in Rome in 1602, in the aftermath of the discovery of her body under the altar of S. Cecilia.[7] Second, not all publishers promoted the Cecilian motet with equal energy. Petrucci seems to have issued not a single motet in honor of Cecilia. The fourteen volumes of motets published by Attaingnant in the 1530s contain 281 works, of which only one is dedicated to her.[8] The eagerness of a printer to publish sacred music did not necessarily (or by itself) inspire composers to write motets in her honor. Other factors must have been involved.

SACRED MUSIC TURNS TO NEW SUBJECTS

Composers' lack of interest in Cecilia before 1530 was, in part, a manifestation of a much wider preference for the Virgin Mary over other saints (female saints in particular) as the recipient of polyphony. M. Jennifer Bloxam has explained that preference:

> The fervor surrounding the veneration of the Blessed Virgin was everywhere apparent in the late Middle Ages. Thousands of churches, monasteries, chapels and altars were consecrated to her; countless statues, altarpieces and stained glass windows presented her image and told her story to the faithful; and for the literate, devotional writings extolling her virtues in Latin and the vernacular abounded. Her adoration in music, both monophonic and polyphonic, was no less pervasive. Every church observed the five principal feasts in her honor (Purification, Annunciation, Assumption, Nativity and Conception); a weekly votive *Missa de Beata Virgine*, usually celebrated on Saturday, was a standard component of most usages; and in many locales *Salve* services sung in the evening beseeched her intercession daily.[9]

Of course there were exceptions to the Virgin's domination of sacred music, or at least cases in which she dominated less than in others. One manuscript preserves a group of French isorhythmic motets from the early fifteenth century that includes five works dedicated to male saints—Ive, Sebastian, Nicholas of Bari, James the Apostle, and John the Baptist—but only three Marian pieces. Catherine of Alexandria attracted attention from fifteenth-century composers of motets, including Hugo de Lantins, Dunstaple, Fawkyner, and Pullois.[10] But more typical of fifteenth-century taste was the predominance of Marian texts in sacred works sometimes called "English cantilenas."[11]

Some Marian motets were intended for the devotions of the musicians who composed and performed them. In singing Compère's *Omnium bonorum plena* and other works that beg for the Virgin's intercession on behalf of professional musicians, fifteenth-century performers showed that they, like most Europeans of their time, believed that Mary was the most fitting recipient of their appeals.[12]

Josquin des Prez and his contemporaries in the fifty years between 1475 and 1525 continued to use the motet primarily as a medium of Marian devotion; Josquin himself wrote little polyphony for saints other than Mary. But change was in the air at the beginning of the sixteenth century. Jean Mouton, composer at the French court, seems to have been a pioneer in shifting attention to female saints other than Mary: he wrote important motets for Anne, Mary's mother, and for the virgin martyrs Catherine, Barbara, and Margaret.[13] The manuscript known as the Medici Codex, made in 1518, contains, in addition to many Marian works, music for Margaret, John the Baptist, John the Evangelist, and Peter.[14] In Petrucci's two series of motet prints (the first published from 1502 to 1508,

the second from 1514 to 1519), the share of Marian motets fell from one-half to one-quarter.[15]

THE MOTET BETWEEN CATHOLICS AND PROTESTANTS

As the Reformation and Counter-Reformation began to affect sacred music, the subject matter of motets diverged, according to the confessional tendencies of composers and their audiences. Protestants, de-emphasizing or abandoning the cult of saints, preferred biblical texts, especially psalms and passages from the Gospels. Catholics had nothing against biblical texts, of course; but they confirmed the crucial role of saints, including post-biblical ones, in their understanding of Christianity, adding to the music that venerated Cecilia and other saints.[16] For example, in the first book of four-voice motets of Jacquet of Mantua, printed in Venice in 1539, we find, in addition to *Cantantibus organis*, works in praise of Francis, John the Baptist, and Stephen. A manuscript anthology assembled around 1549 (B-Bc 27088) contains music for John the Baptist, the archangel Michael, Peter, John the Evangelist, Philip, Martin of Tours, Lazarus, and Jerome, as well as the anonymous Cecilian *Dum aurora finem daret*.[17]

The trend continued into the second half of the century. Palestrina's first book of four-voice motets, published in 1563, carried a title that advertised its liturgical orientation: *Motecta festorum totius anni*.[18] It contains, in addition to *Dum aurora finem daret*, works dedicated to Stephen, John the Evangelist, John the Baptist, Paul, Mary Magdalene, Laurence, Martin, and Andrew. But perhaps the most extreme example of an anthology devoted to the cult of saints is *Novi atque catholici thesauri musici liber tertius*, published in 1568. The long subtitle describes the contents as "sacred songs . . . sung in the sacred temples of the Catholics on the feast days of the saints" (cantiones sacrae . . . quae in sacris catholicorum templis festis sanctorum diebus cantantur). Almost all the motets that follow, arranged according to the liturgical calendar, are dedicated to individual saints, including Jean de Chaynée's *Cecilia in corde suo* and Pevernage's *O virgo generosa, Cecilia gloriosa*.

Musical organizations dedicated to Cecilia and their observance of her feast offered composers an attractive new market, to which they must have been also drawn by the growing number of saints being honored in motets by some of their contemporaries. Yet composers who hoped that their music would be widely and frequently performed also faced two disadvantages in writing motets in honor of any single saint. Performances would likely be limited to the saint's feast day; and performers would more likely be Catholic than Protestant. The most widely disseminated motets in the sixteenth century had—in addition to musical qualities that endeared them to performers and listeners—other advantages: most of them had texts that appealed to Lutherans as well as Catholics, and few of them had texts that might limit their performance to the feast of a single saint. In what Jennifer Thomas calls the "core motet repertory"—the fifty-four pieces

preserved in twenty or more extant sources—we find only three works in honor of saints other than the Virgin Mary: Paul, Peter, and Mary Magdalene. These biblical saints enjoyed far higher liturgical status than Cecilia.[19]

Publishers were thus pushed in different directions, and they were not always honest in their responses to contradictory pressures. Susato issued a series of anthologies in 1553, describing the texts—in a phrase that appealed to Lutherans—as "from both the Old and New Testaments." But the motets included several in honor of post-biblical saints, including Cecilia.[20]

A firmly Catholic composer active in the late sixteenth-century Netherlands offers insight into the role that Cecilian music played in the rivalry between Catholics and Protestants. In 1578 Pevernage published a big collection of motets under the title *Cantiones sacrae*. He had served as a choral director in Kortrijk, site of a Cecilian confraternity; his collection includes two settings of prayers addressed to her and seven occasional works related to her. A quarter of a century later, a publisher in Frankfurt reissued the collection in an edition that, in David Crook's words, "shows unmistakable signs of repackaging for a Lutheran audience."[21] That repackaging included the omission of all nine Cecilian pieces.

Publishers who wanted to transform motets intended to be sung on a single feast day into works that could be sung any day of the year, and at the same time to increase their appeal to non-Catholics, did another kind of repackaging. In 1559 Phalèse published, in the fifth book of four-voice motets by Clemens non Papa, his popular *Cecilia virgo gloriosa*, but with the original words replaced with the Eucharistic text *Caro mea*.[22] Those who bought printed anthologies but found some of the texts incompatible with their confessional stance—or simply wanted to expand the number of occasions on which the music could be sung—made similar changes. In one copy of an anthology that includes Clemens's Cecilian motet, an owner crossed out the text and replaced it with a prayer addressed to Christ.[23] Gombert's *Ceciliam cantate pii* and Rore's *Cantantibus organis* received the same treatment when copied into a manuscript for use in the cathedral of Treviso; the copyist replaced the Cecilian texts with words more useful in a city where the locally revered Saints Theonistus, Tabra, and Tabratha had displaced Cecilia as the main objects of devotion on 22 November.[24]

CECILIAN MOTETS IN THE CONTEXT OF COMPOSERS' PREFERENCE FOR MALE SAINTS

We can interpret the appearance, in significant numbers, of motets addressed to Cecilia, first in the 1530s and continuing through the rest of the century, as a product of the same Counter-Reformation trend that encouraged Catholic composers to write music in honor of many saints; yet in one respect Cecilian polyphony diverged from the norm. In the collections cited in the previous paragraphs, Cecilia stands out as one of the few female saints. Composers (Mouton being an exception) preferred to write motets about men—a preference that

resulted, in part, from the higher status of men in the hierarchy of feast days (as exemplified in the use of York, cited in chapter 1). With the exception of the Virgin Mary, men dominated the highest-ranking feast days. Yet musicians were apparently willing to make an exception for Cecilia.

The number of motets in honor of two other female saints might help emphasize the extraordinary amount of music written for Cecilia. Catherine of Alexandria and Barbara inspired fervent devotion for many centuries. Their status rose in the fourteenth century when they were included among the Fourteen Holy Helpers, a group of saints believed to possess extraordinary powers of intercession. They were also venerated as members of the *Quatuor Virgines capitales*, a quartet of virgin martyrs that also included Margaret and Dorothy.[25] (Cecilia was absent from both groups.) Many books of hours include prayers to Catherine and Barbara;[26] and, as we saw in chapter 1, their calendars usually rank Catherine's Day higher than Cecilia's. We have already alluded to the motets that Catherine inspired in fifteenth-century England and France. In Bruges processions endowed in the 1470s on the feast days of Barbara, Catherine, and Mary Magdalene included the singing of motets.[27] We might expect motets written for Catherine and Barbara in the sixteenth century to outnumber Cecilian motets. Yet the opposite appears to be true. Although several leading composers, including Mouton, Willaert, and Palestrina, wrote music for both Catherine and Barbara, a preliminary search for motets written for them by other composers suggests that motets in honor of Cecilia were far more numerous.[28]

In 1565 the Parisian printers Le Roy and Ballard issued, in two volumes, a large collection of sacred music by Jean Maillard. Volume 1, dedicated to King Charles IX of France, contains mostly works praising God and a few male saints. Volume 2, dedicated to the Queen Mother, Catherine de' Medici, is just as solidly dominated by motets addressed to the Virgin Mary; but it also contains three motets for Cecilia.[29] The segregation by gender was not enforced with complete consistency. Volume 1 contains the enigmatic *De fructu vitae*, addressed to an unnamed woman, who—as I will suggest in chapter 5—is none other than Cecilia. But the overall division by gender, as defined by the dedications and the subject matter, together with the important role for Cecilian music in the "female" half of the publication, suggests that motets for Cecilia had a special appeal for female musicians and patrons of music.

GEOGRAPHIC ASPECTS OF THE CECILIAN MOTET

Composers resident in northern France and the Netherlands wrote the majority of sixteenth-century Cecilian motets (table 4.1).[30] In contrast, many major composers of motets who spent most or all of their lives outside this area—in England (Tallis and Byrd), Spain (Morales and Victoria), Germany (Senfl), or Italy (Arcadelt, Wert, Phinot, Ruffo, Verdelot, Festa, Willaert, Merulo, and Andrea Gabrieli)—wrote no Cecilian music, as far as we know.

TABLE 4.1. Composers of Cecilian motets before 1600 who spent most or all of their lives in northern France or the Netherlands

Composers (number of Cecilian motets, if more than one)	Location of activity
Josquin Baston	Netherlands
Jacob Bultel	probably Netherlands
Cornelius Canis (3)	Netherlands, also Madrid
Carette (2)	probably France
Jean de Castro (2)	Netherlands, later Düsseldorf and Cologne
Pierre Certon (2)	France
Jean de Chaynée	Netherlands, later Vienna and Graz
Jacobus Clemens non Papa	Netherlands
Séverin Cornet	Netherlands
Thomas Crecquillon (5)	Netherlands
Jean Crespel	probably Netherlands
Petit Jean De Latre	Netherlands
Ludovicus Episcopius	Netherlands, later Munich
Abraham Fourdy	France
François Gallet	Netherlands
Antonius Galli (=Antoine Lecocq?)	Netherlands, later Vienna
Philippe Gheens	probably Netherlands
Nicolas Gombert (1 or 2)	Netherlands
Daniel Guichart	France
François Habert	France
Christian Hollander	Netherlands, later Innsbruck
Hugier	probably France
Jean Maillard (4)	France
Pierre de Manchicourt (2)	France, Netherlands, Spain
Antoine de Mornable	France
Nicolas Pagnier	France
Andreas Pevernage	Netherlands
Loyset Piéton	France
Daniel Raymundi	Netherlands
Cornelis Schuyt	Netherlands
Etienne Testart	France
Daniel Torquet	probably France
Geert van Turnhout (2)	Netherlands, later Spain
Jan van Turnhout	Netherlands
Nicolas Vauquet	France

Note: This table includes composers of whom we know little, but whose names suggest French or Flemish origin.

TABLE 4.2. Cities in northern France and the Netherlands where two or more composers listed in table 4.1 were active, or with which they were associated

City	Composers
Antwerp	Canis, Castro, Cornet, Pevernage, Geert van Turnhout
Bruges	Clemens, Galli, Pevernage
Évreux	Fourdy, Guichart, Habert, Testart, Vauquet
Kortrijk	Canis, Pevernage
Liège	Castro, Chaynée, De Latre, Raymundi
Maastricht	Chaynée, Episcopius
Mechelen	Cornet, Episcopius, Jan van Turnhout
Paris	Certon, Maillard, Mornable, Pagnier, Testart, Vauquet

Even within the relatively constricted area of northern France and the Netherlands, many composers of Cecilian motets spent significant amounts of time in, or were otherwise associated with, a few cities (table 4.2).[31] In most of these—Antwerp, Mechelen, Bruges, Kortrijk, Évreux, Paris—we have already seen (in chapter 3) evidence of the celebration of Cecilia's Day by musicians. In this chapter I will look more closely at the institutions and practices that might have encouraged the composition of Cecilian motets.

COMPOSERS AT THE COURT OF CHARLES V

The cities listed in table 4.2 were not the only places where composers of Cecilian music gathered. They also assembled at the courts of Emperor Charles V and other members of his family.

Charles V inherited, from parents and grandparents belonging to three of Europe's most important dynasties, more territory than any sovereign since Charlemagne. Born in Ghent in 1500, he ruled as king of Spain (whose lands included parts of Italy and quickly expanding territories in the New World), as duke of Burgundy (whose lands included the Netherlands), as archduke of Austria, and as emperor of the Holy Roman Empire, which overlapped with many (but not all) of his inherited lands. He traveled far and often.

Having spent his formative early years in the southern Netherlands, one of Europe's most productive and sophisticated musical regions, Charles patronized musicians throughout his life. Members of his chapel traveled with him, providing finely crafted sacred music throughout the liturgical year and impressing his allies and rivals alike with ceremonial motets on occasions of state. At the top of the chapel's musical hierarchy was the *Grande Chapelle*, inherited by Charles from his Burgundian ancestors.[32] In 1547 it consisted, in addition to the chapelmaster Cornelius Canis and the organist Jean Lestannier, of thirty

singers: twenty men and ten boys, all from the Netherlands (Charles's Spanish subjects called it the *Capilla Flamenca*).[33] Marin Cavalli, the Venetian ambassador at Charles's court, writing in 1551, may have exaggerated the number of singers in the imperial chapel; but in other respects his praise seems justified: "The singers, perhaps forty in number, constitute the most perfect and excellent chapel in the whole of Christendom, chosen from all the Netherlands, nowadays the fountainhead of music."[34]

Gombert, Canis, Crecquillon, and possibly Galli[35] all served in the *Grande Chapelle*; Manchicourt joined under Charles's son and successor as king of Spain, Philip II. Together these five musicians composed some twelve Cecilian motets during Charles's reign (table 4.3). Crecquillon, who is not known to have worked anywhere except the imperial court, wrote more compositions for Cecilia—five—than for any other saint.[36] The only major composer of vocal music in Charles's chapel whose surviving music does *not* include at least one Cecilian piece is Nicolas Payen, to whom in any case only thirteen motets are attributed in surviving sources. All this suggests that a special devotion to Cecilia was part of the culture at the court of Charles V.[37]

No single musical edition claimed more explicitly to represent the tastes and talents of Charles's chapel than the motet anthology published in Augsburg in 1548 under the title *Cantiones selectissimae quatuor vocum ab eximiis et praestantibus caesareae maiestatis capellae musicis M. Cornelio Cane, Thoma Crequilone, Nicolao Payen et Iohanne Lestainnier Organista compositae* (Choicest songs for four voices, composed by the excellent and outstanding musicians of the chapel of His Imperial Majesty: Cornelius Canis, Thomas Crecquillon, Nicolas Payen, and the organist Jean Lestannier). The title and the place and date of publication

TABLE 4.3. Musicians in the service of Emperor Charles V or King Philip II who composed Cecilian motets before 1555

Name	Position at court	Cecilian motets
Canis	singer, *maître des enfants, maître de chapelle*	*Ceciliam intra cubiculum* *O beata Cecilia* *Virgo gloriosa*
Crecquillon	singer, *maître de chapelle*	*Ave virgo gloriosa* *Domine Jesu Christe* *Dum aurora finem daret* *Virgo gloriosa / Cantantibus organis* *Virgo gloriosa / Domine Jesu Christe*
Galli (= Lecocq?)	singer?	*Ceciliae laudes celebremus*
Gombert	singer, *maître des enfants*	*Cantibus organicis* (authorship uncertain; also attributed to Naich) *Ceciliam cantate pii*
Manchicourt	master of the *Capilla flamenca*	*Ave virgo Cecilia* *Cantantibus organis*

have led scholars to believe that it consists of works performed by the imperial chapel during the Diet of Augsburg in 1548, when Charles V tried to restore peace between Catholics and Protestants within the Holy Roman Empire.[38] The selection of pieces does indeed have an ecumenical flavor. Biblical quotations and paraphrases predominate.[39] The collection contains only one piece addressed to a single saint: Crecquillon's Cecilian motet *Virgo gloriosa / Cantantibus organis*.

Manuscripts associated with Charles and his family also preserve Cecilian motets. The emperor's sister Mary, known as Mary of Hungary, served as regent of the Netherlands from 1531 to 1555. She loved music; her court in Brussels "regularly functioned as a central point for the recruiting and engagement of musicians" for Charles's chapel—as well as her own.[40] She almost certainly owned the manuscript B-Bc 27088, the motet anthology that contains the anonymous *Dum aurora finem daret* for eight voices (in Ellen Beebe's estimation "the most ambitious work in the collection"), which survives only in this manuscript.[41] Another piece, *Cantantibus organis* by Petit Jean de Latre, "may also emanate from the chapel of Charles," as Mary Tiffany Ferer has proposed.[42] It survives incomplete in a manuscript, dated 1552, that probably served as a diplomatic gift from the emperor to King Edward VI of England.[43] The manuscript contains many works by Charles's musicians. Although Jean was apparently not one of them, he did serve as chapelmaster to George of Austria, prince-bishop of Liège, a member of Charles's extended family and a close associate of Mary of Hungary.

Other composers of Cecilian motets who worked not at the court of Charles V but close to it were Clemens non Papa and Alexander Utendal. Clemens served Philippe de Croÿ, one of the emperor's most important generals, in the late 1540s, and his music plays an important role in both of the "imperial" manuscripts mentioned in the previous paragraphs.[44] Utendal began his career as a choirboy in the chapel of Mary of Hungary.[45] Later he joined the court of Archduke Ferdinand II (Mary's nephew) in Prague and Innsbruck, where he may have participated in Cecilia's Day banquets like the one described by Gerard van Roo (likewise a member of the Innsbruck court chapel) in his *Convivium cantorum*.

A set of rules for procedures in the imperial chapel during the sixteenth century contains a hint that Cecilia had a special place in its liturgy. The regulations, probably compiled after Charles abdicated but referring specifically to his reign, mention only one saint besides the Virgin Mary. Rule 23 reads: "When Cecilia's Day falls on a Sunday, the first Vespers are sung solemnly."[46] Evidently the feast was observed, at least in some years, with special services that included polyphonic music. That the rule should single out first Vespers is not surprising; we will see that Vespers on Cecilia's Eve played an important part in Cecilian festivities.

A manuscript dated 1559 contains yet another hint of a connection between Cecilia and Charles V.[47] A collection of miscellaneous writings assembled by Adam Bornage, cantor at the abbey of St. Amand, assembles on a single page three Latin poems that were set to music as motets. At the top of the page are

eleven dactylic hexameters in honor of Cecilia: *Cantibus organicis*, composed by Naich or Gombert. Below, in the same hand, are two poems in elegiac couplets addressed to Charles V (under the rubrics "Carolo Imperatori" and "Ad eundem"). *Carole cur defles Isabellam*, on the death of Charles's wife, was set to music by Payen and published in the same collection as Canis's *O beata Cecilia* (1545). *Quis te victorem* was set to music by both Crecquillon (1554, in the same collection as his Cecilian motet *Dum aurora*) and Clemens (1555, in the same collection as *Cantantibus organis* by Gheens). That Cecilia and Charles share a page in this manuscript is hardly conclusive evidence of a connection between them; but it strengthens our suspicion that she enjoyed some kind of special status at the imperial court.

The large number of Cecilian motets by composers associated with Charles V stands in contrast with the small number of pieces by those composers in honor of St. Andrew. As the patron saint of the Order of the Golden Fleece, a confraternity headed by the emperor himself and with members drawn from the highest ranks of the nobility, we would expect Andrew to have been the recipient of many motets for use during the lavish services with which the order recognized his feast. Yet William F. Prizer, in his study of the order's musical activities, searched for this music among "works that stem from imperial circles" (presumably including the composers listed above in table 4.3) and found only three.[48] The scarcity of music for Andrew by Charles's musicians is as strange and tantalizing as the abundance of Cecilian motets.

The steady flow of Cecilian music from the Flemish presses of Susato and Phalèse, much of it by musicians associated with Charles V, stopped almost as suddenly as it started. Two motets by composers of whom we know almost nothing, Jean Crespel and Philippe Gheens, appeared around the same time as Charles's abdication, a momentous event in the history of Europe (1555). During the 1560s only a small handful of Cecilian motets appeared in print. We can attribute that quiescence in part to the terrible *Beeldenstorm* of 1566. But it also suggests that whoever or whatever encouraged composers at or close to the court of Charles V to write Cecilian music no longer had the same effect during the reign of his son. Although Manchicourt, engaged by Philip II as chapelmaster in 1559, wrote two Cecilian works, both of them were published before Charles's abdication. Two of the Flemish musicians who later joined Philip's chapel in Spain, Geert van Turnhout and Philippe Rogier, wrote Cecilian motets, but Geert (like Manchicourt) wrote his two works for Cecilia well before he joined Philip's chapel.

Charles spent his retirement in Spain, at the isolated monastery of San Jeronimo in Yuste. There he found a musical culture to which Cecilia (as a patron of musicians and a recipient of motets) was largely unknown. With the exception of members of the Capilla Flamenca, musicians in Spain showed little interest in Cecilia; I have found no evidence that they acknowledged her feast with elaborate music or with banquets. I know of only three sixteenth-century Cecilian works by Spanish composers, including Francisco Guerrero's *Dum aurora finem daret*. In

1557 or 1558 the young Guerrero visited Charles at Yuste, bringing with him music that he hoped would please the former emperor. Did it include *Dum aurora*?[49]

In 1569 Philip II bought a painting of Cecilia by the Flemish artist Michiel Coxcie, who was very much a Habsburg artist: he had earlier served Mary of Hungary as court painter and had received commissions from Charles as well.[50] The painting shows Cecilia at the keyboard while three angels sing *Cecilia virgo gloriosa* by Clemens (plate 44).[51] The superius partbook held by the boy on the lower left is open to a page (plate 45) that closely resembles the first page of the superius part as it appears in the fourth book of four-voice motets as published by Phalèse in 1559 (plate 46; the tenor partbook on the lower right reveals part of another motet in the same publication, *Per noctes quaesivi in lectulo meo*). Although the instrument has been identified as a clavichord, it is in fact a polygonal virginal (a kind of harpsichord, much louder than a clavichord) similar to a surviving virginal dated 1548 by Joes Karest, a harpsichord builder active in the southern Netherlands.[52]

Coxcie or his workshop made a similar image of Cecilia performing music addressed to her by one of the musicians of Charles V. The Royal Monastery of the Descalzas in Madrid displays one version of this painting; the Château de Chenonceau in France another (plate 47), in which she accompanies four angels, one of whom holds a partbook open to a page on which we can make out the words "Cantantibus organis" and "Cecilia virgo" (plate 48). The combination of those words, the B♭ signature, and the C³ clef allows us to identify this music as a work by one of the most prolific composers of Cecilian motets—and one closely tied to the court of Charles V. This is an excerpt from the tenor voice of Crecquillon's *Virgo gloriosa / Cantantibus organis*, published in *Cantiones selectissimae quatuor vocum* (Augsburg, 1548), an anthology whose title page explicitly linked the music to the imperial court (plate 49).

These paintings of Cecilia at the keyboard, whether by Coxcie, his assistants, or his imitators, with various numbers of angels, performing music of Clemens or Crecquillon, all serve as visual echoes of the music that composers at or near the court of Charles V wrote—and surely sang too—during the 1540s and 1550s.

THE CHURCH AS A VENUE FOR CECILIA'S DAY CELEBRATIONS AND POLYPHONIC ELABORATIONS OF LITURGICAL TEXTS: ÉVREUX, PARIS, AND LEIDEN

How were Cecilian motets used? What function did they serve? Students of the sixteenth-century motet have been trying to answer similar questions for several decades.[53] They generally agree that motets with liturgical texts did not necessarily replace those texts within the liturgy. On the contrary: the word "motet" itself seems to have carried with it, for sixteenth-century musicians, an implication that works so labeled were not predominantly liturgical in function. In this respect they differed fundamentally from Mass propers, Vespers hymns, and

Magnificats—polyphonic settings of which musicians rarely called "motets." But that does not mean that motets were not sometimes sung during services in church.

Of the musical organizations in northern France and the Netherlands that honored Cecilia as their patron saint, some (the instrumentalists' guilds in Leuven and Mons, the confraternities in Rouen, Évreux, and Paris) adopted her formally, naming her in their statutes; others (church choirs in Antwerp, Mechelen, Bruges, and other cities in the Netherlands) seem to have recognized her more informally, limiting their "devotions" to the celebration of Cecilia's Day. That many of the festivities took place in cities where composers of Cecilian motets worked (compare tables 3.3 and 4.2) does not prove that the musical groups encouraged the composition and performance of that music. But it seems likely that they did, and that motets provided some of the repertory for performances both in and out of church. Composers who belonged to such groups might have provided music for their colleagues. Moreover, they had reason to hope their music would be in demand by others who observed her feast, and that publishers would be eager to meet that demand.

The bylaws of some guilds and confraternities required members to attend services on Cecilia's Day. The size and splendor of these services depended on the wealth and generosity of those who sponsored them. The observation of Cecilia's Day at the church of St. Germain in Mons, where the town's guild of instrumentalists marked her feast, was, if one can judge from the guild's statutes, probably quite modest. Members were not required to participate in the liturgy's musical component; they only had to attend. This guild probably lacked the resources to pay for the composition or performance of polyphonic music of high quality. In contrast, the confraternity that initiated Cecilia's Day festivities in the cathedral of Évreux in 1570 had something much grander in mind, even before they added a musical competition in 1575.

The cathedral singers who introduced the "service" in Évreux laid down very detailed guidelines on how it was to unfold over the three-day schedule typical of saint's-day celebrations in the fifteenth and sixteenth centuries. What role might motets have played in these events? To answer that question, let us consider the bylaws one or two sentences at a time.

> La veille de la feste madame saincte Cécille, vingt et ungiesme jour de novembre, après les vespres et complye du choeur, sera chanté, à l'honneur de Dieu et commémoration de lad. vierge, par deux choraulx, ung respons en plain chant, le vers et *Gloria Patri* aprèz une anthienne en fleurtis. Suyuamment sera chanté *Magnificat* en faulzbourdon avecques les orgues, puys sera recommencée lad. anthienne, et, en la fin d'icelle, sera dicte l'oraison de madame saincte Cécille.[54]

> *On the eve of the feast of madame St. Cecilia, the twenty-first day of November, after Vespers and Compline in the choir, two choirboys will sing, in honor of God and in commemoration of the said virgin, a responsory in plainchant, its verse, and the*

Gloria Patri, *after an anthem in florid counterpoint. Next, the* Magnificat *will be sung in fauxbourdon, with organ, and then the said anthem will be performed again, at the end of which the prayer for madame St. Cecilia will be declaimed.*

"Vespers and Compline in the choir" were presumably regular services in the cathedral's choir that involved little or no music other than plainchant. (As at Notre Dame in Paris, the liturgy of Évreux evidently treated Vespers and Compline as a unit.[55]) The new ceremony that followed was, from a liturgical point of view, a repetition of the Vespers and Compline that had already taken place, but with the focus of attention on music. Although the first sentence seems to mean that two choirboys alone sang, we need to keep in mind that the event was organized by the cathedral's adult male singers, who probably thought it unnecessary to mention that they would participate throughout; the two boys presumably sang the cantus voice in the polyphony that followed.

The "responsory in plainchant" was probably *O beata Cecilia quae duos fratres convertisti* (Cantus ID 007253), which served in much of Europe as the Vespers responsory on Cecilia's Eve.

The French "antienne," like the English "anthem," evolved from the Latin "antiphona"; it sometimes took on the meaning of a polyphonic composition that replaced a plainchant antiphon. That meaning is implied here by the phrase "anthem in florid counterpoint." This gave the singers in Évreux their first opportunity to perform a motet. We have no way of knowing which one, but the chant *Virgo gloriosa semper evangelium Christi* (Cantus ID 005451) was widely sung as the Magnificat antiphon for Vespers on Cecilia's Eve, making its text particularly fitting for use at this stage in the service. Whoever chose the music for the Cecilian Vespers at Évreux had many polyphonic settings of *Virgo gloriosa* (often with Cecilia's name added before or after the first two words and with other minor variations in the text) to choose from. At least nine composers had set it to music before 1570.[56]

et aprez lad. oraison sera chanté *Benedicamus Domino*, par deux choraulx, et au lieu de *Deo gratias* ung motetz de lad. vierge. Conséquemment celuy qui fera l'office commencera *Conveerte nos*, et puys seront chantez en fauxbourdon troiz psalmes de complye, à savoir, *Cum invocarem*, *In te Domine*, et *Ecce nunc benidicte*, à quoy respondront les orgues.[57]

. . . and after the said prayer the two choirboys will sing the Benedicamus Domino, *and in place of the* Deo gratias *a motet for the said virgin. Next, whoever is presiding at the Office will begin* Converte nos, *and then the three psalms of Compline will be sung in fauxbourdon, namely* Cum invocarem, In te Domine, *and* Ecce nunc benedicite, *to which the organ will respond.*

The *Benedicamus Domino* signaled the approaching end of Vespers, which concluded with another piece of polyphony, this one explicitly called a motet.

In singing a motet at the end of Vespers, the choir in Évreux was following a precedent more than a century old. Robert Nosow has pointed to evidence of motets sung at the end of Vespers in the fifteenth century in Bruges, Tournai, and Cambrai. And the practice continued: the performance of motets was an important part of Vespers in many Italian churches in the late sixteenth and early seventeenth centuries.[58]

Since polyphony "for the said virgin" (Cecilia) required a text different from and much longer than *Deo gratias*, the singers in Évreux must have departed from the liturgy here. Music took precedence over tradition, as probably happened often during her feast. Many Cecilian motets use texts from Matins (such as the responsory *Cantantibus organis*) and Lauds (such as the antiphon *Dum aurora finem daret*): offices that played a smaller role than Vespers in festive observances of Cecilia's Day. When musicians sang polyphony in place of *Deo gratias* or some other chant whose text was unrelated to Cecilia, they may have felt free to choose it on the basis of its musical interest and its relevance to the saint rather than the liturgical aptness of its text. On these occasions they may have turned often to settings of *Dum aurora* or *Cantantibus organis*.

> Lendemain, jour et feste de lad. Vierge, aprèz la messe du choeur, sera chanté en musique et orgues une haulte messe par led. sieur chanoyne, ou l'un des dessusd., avec diacre et trois choraulx.[59]

> *The next day, the feast day of the said virgin, after the Mass in the choir, a high Mass will be sung with music and organ by the said canon, or one of the abovementioned, with deacon, subdeacon, and three choirboys.*

The Proper of the Mass for Cecilia's Day, as discussed in chapter 1, contains few references to her and her legend, leaving composers without much material for the composition of motets. The statutes do not tell us if the Mass on 22 November was to include music directly related to her. If it was, the singers in Évreux could have sung Cecilian pieces. The solemnization of the Mass in the sixteenth century often involved the singing of motets, especially in place of the Offertory, during the Elevation and Communion, and at the end of Mass. These did not have to be settings of Mass texts, as long as the subject matter suited the day.[60]

Another way in which the singers at Évreux could have integrated the Mass into the musical festivities was to perform a polyphonic setting of the Ordinary based on a Cecilian motet. Two parody Masses by Pierre Cléreau, on Certon's *Cecilia virgo gloriosa* and *Cantantibus organis*, were probably the only ones printed in the sixteenth century. Published in Paris in 1554, Cléreau's Cecilian Masses would have been the most easily obtainable from Évreux.

> Le mesme jour, aprez vespres et complye de lad. église, sera réitéré comme, au jour précédent, ung pareil et semblable service, adioutant aux trois psalmes de complye, cy-devant mentionnez, le psalme, *Qui abitatat in adiutorio.*

On the same day, after Vespers and Compline in the said church, a service similar to the one celebrated the previous evening will take place, adding to the three psalms of Compline, mentioned above, the psalm Qui habitat in adiutorio.[61]

This second evening service on 22 November gave the singers a chance to perform at least two more Cecilian motets.

We learn in the next sentence that the ringing of bells was an essential part of the festive soundscape:

Et, pour inviter le peuple à la solennité, sera faict sonner trois carrillons, deux pour les premier et second services, et l'aultre pour la messe.

And, to invite the people to the celebration, three carillons will be rung: two for the first and second [evening] services, and the other for the Mass.[62]

The music resumed on 23 November:

Le jour d'aprèz, en recommandation des ames de tous fidèles trespassez, spéciallement des fundateurs, sera célébrée une haulte messe de *Requiem* en musique, aprèz les matines du choeurs, avecques le *Libera, De profundis*, et oraison acoustumez avec diacre, soubzdiacre et deux choraulx; laquelle messe sera sonnée à deux cloches.

The following day, on behalf of all the souls of the faithful departed, and especially the founders, a high Requiem Mass will be celebrated in music, after the Matins in the choir, with the Libera, De profundis, *and the customary prayers, with the deacon, the subdeacon, and two choirboys; which Mass will be announced with two bells.*[63]

The founders mentioned here were those, mostly residents of Évreux and surrounding towns, whose contributions made the event possible. In this Requiem Mass we find one of the main *raisons d'être* for the three-day event in Évreux. Those who supported it financially did so partly to enjoy the music while they were alive; even more important, after their deaths the priests and singers of Évreux would pray for their souls.

Unlike the statutes for the confraternity at Évreux, those drafted for the projected Confrairie de Sainte Cécile in Paris do not mention the singing of motets. But in declaring that Vespers and Compline on Cecilia's Eve and on the day itself were to be solemnized "avec la musique et orgues," the Parisian statutes created a perfect opportunity for the performance of motets for Cecilia.

The composition and performance of polyphony for a particular saint did not need to be initiated by a group of musicians like those in Évreux and Paris. An endowment from a non-musical organization such as a guild, a confraternity, or even a single person, if large enough, could generate income to fund the composition of music in honor of a saint and its annual performance on his or her feast day.

An endowment of this kind might help explain the large amount of Cecilian music by composers resident in Paris (Pagnier, Certon, Mornable, and Maillard together wrote eight motets) many years before the drafting of bylaws for a confraternity under her protection in 1575. Josse van Clichtove, the humanist scholar whose retelling of the Cecilia legend in an essay published in 1516 we sampled in chapter 1, may have developed a devotion for Cecilia during his childhood in Nieuwpoort, a town on the North Sea forty kilometers west of Bruges, and his studies in Leuven. Having moved to Paris, he endowed celebrations of her feast both during his lifetime and after his death. In a series of documents dated 1529, 1530, and 1532, he established, with donations amounting to 1,100 *livres*, celebrations of Vespers on Cecilia's Eve and of Mass on the day itself. When he died in 1543, he left to the cathedral of Chartres, where he was a member of the Chapter, an endowment for the celebration of Mass in the cathedral twice a month and on Cecilia's Day.[64]

One of the documents recording Clichtove's foundations stipulates only that Vespers and Mass be said ("dicuntur"), leaving in doubt whether he wished for the performance of polyphonic music. If his endowments were large enough, they might have paid for the composition and performance of some of the early Cecilian motets by Parisian musicians.

The printed anthologies in which many Cecilian motets are preserved rarely contain any hint of how, or even if, this music was sung within celebrations of the feast. Manuscripts, in contrast, are sometimes closely associated with particular churches and even with particular parts of the liturgy. That is the case with the manuscripts known as the Leiden Choirbooks, copied in the mid-sixteenth century for St. Peter's Church in Leiden. A series of endowments allowed this non-collegiate church to organize a *Zeven-Gerijdencollege* ("college of the seven canonical hours"): a group of clerics and singers who sang the Office, often with polyphony, throughout the day. Eric Jas has shown that the choirbooks were assembled for this group. Many of the works preserved in them are motets, which must have formed an important part of the polyphonic repertory of the *Zeven-Gerijdencollege*.[65]

The choirbooks contain few works addressed to saints other than the Virgin Mary. Whoever chose the musical repertory for the College must have felt that the feasts of most saints could pass without the performance of music written specifically in their honor. But Cecilia, exceptionally, merited polyphony: the collection includes Crecquillon's *Domine Jesu Christe*. Her special place in the Leiden Choirbooks reminds us of an earlier chapter in the artistic history of Leiden, when Cornelis Engebrechtsz and his workshop were active there. As we saw in chapter 2, Engebrechtsz played an important role in establishing the organ as Cecilia's visual emblem, producing numerous altarpieces in which she is shown with an organ at her feet.

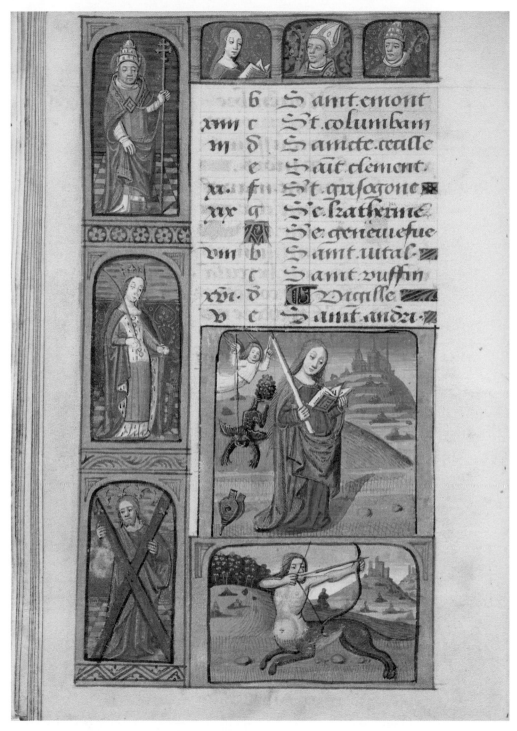

PLATE 1. Book of Hours, France, mid- to late fifteenth century: calendar for the last eleven days of November. Philadelphia Museum of Art, 1945-65-13, p. 22. The miniatures (clockwise, starting with the largest image) depict St. Geneviève holding a candle (blown out by a devil with bellows and relit by an angel), Sagittarius (zodiac sign), St. Andrew, St. Catherine, St. Clement, St. Cecilia, and two prelates. Photo: Philadelphia Museum of Art / OPENN

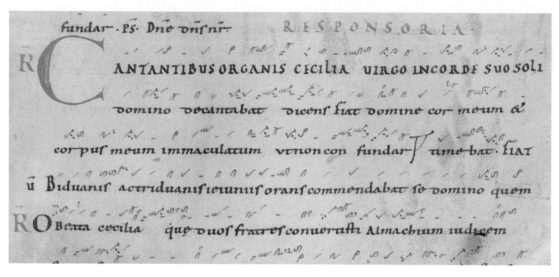

PLATE 2. *Cantantibus organis*, first responsory in Matins for Cecilia's Day (Cantus ID 006267) in the Hartker Antiphonary, copied around 990–1000. Stiftsbibliothek, St. Gallen, Cod. Sang. 391, p. 155. Photo: Stiftsbibliothek, St. Gallen

PLATE 3. Responsory *Cantantibus organis* in an antiphonary copied in the twelfth century. Stiftsbibliothek, Klosterneuburg, Cod. 1012, fol. 93r. Photo: Stiftsbibliothek, Klosterneuburg

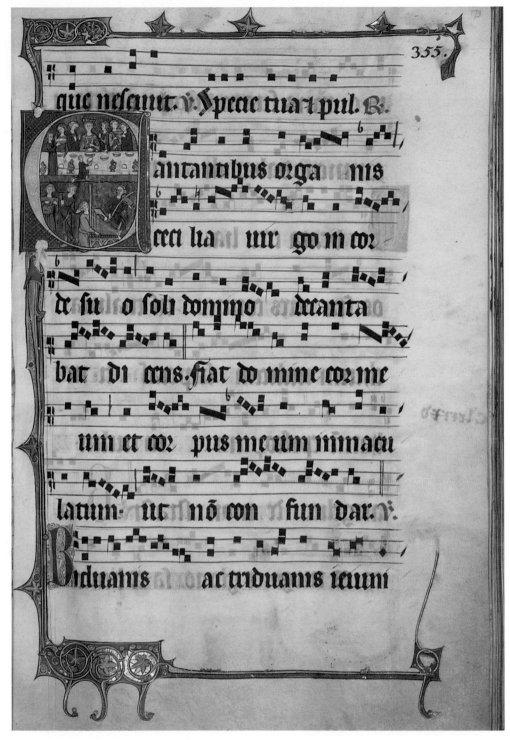

PLATE 4. Responsory *Cantantibus organis* with the beginning of the verse *Biduanis ac triduanis* in the Beaupré Antiphonary, vol. 2. Walters Art Museum, Baltimore, Ms W. 760, p. 355. The historiated initial *C* depicts Cecilia's wedding feast; see the detail in plate 5. Photo: Walters Art Museum

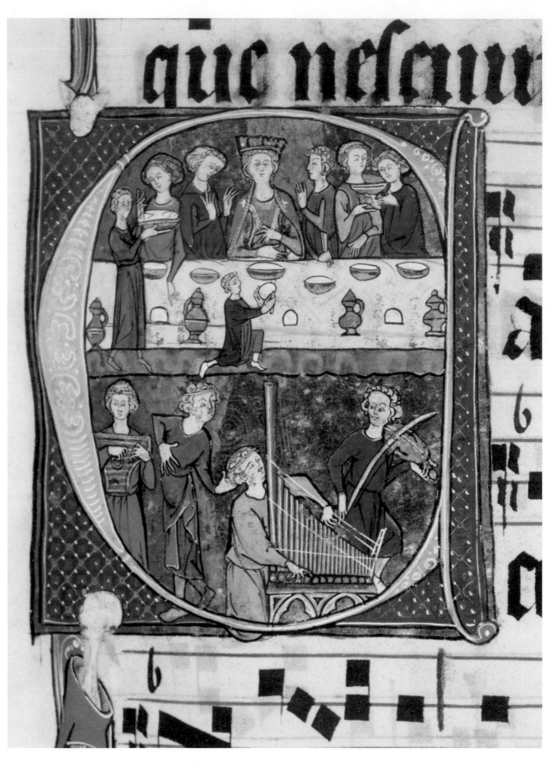

PLATE 5. Cecilia's wedding feast. Historiated initial *C* for the responsory *Cantantibus organis* in the Beaupré Antiphonary. Detail of plate 4. Photo: Walters Art Museum

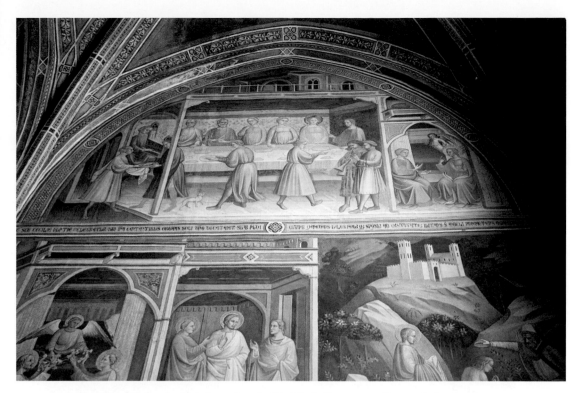

PLATE 6. Lippo d'Andrea (attrib.), *Scenes from the Life of St. Cecilia*, ca. 1400. Frescoes in the church of Santa Maria del Carmine, Florence, as seen from below. During the wedding banquet, an organist (on the left) and two shawm players (on the right of the central image) entertain the guests. In the following scene (far right), Cecilia explains to Valerian that her guardian angel will kill anyone who threatens her virginity. Photo: Sailko / Wikimedia Commons

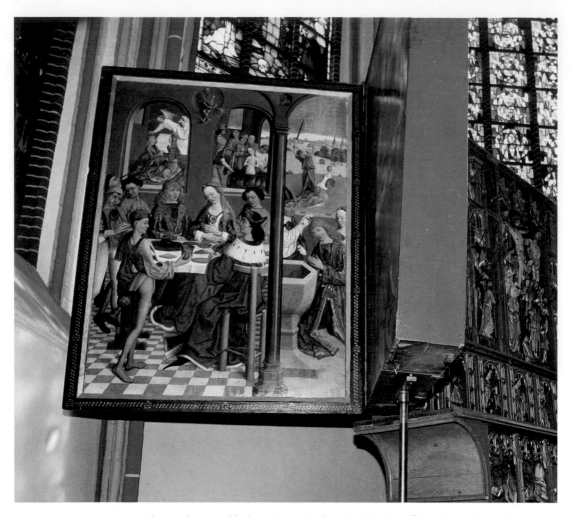

PLATE 7. The Lüneburg Retable (ca. 1482–1485) above the high altar of the Johanniskirche, Lüneburg, open to reveal Hinrik Funhof's *Scenes from the Life of St. Cecilia*. In his depiction of the wedding banquet, which takes up by far the most space, Funhof included three musicians (on the left) playing brass instruments or a combination of brass and woodwind. Photo: Stefan_68 / Flickr

PLATE 8. Wedding guests and musicians accompany Cecilia and Valerian to their marital bed. Illumination in a French translation by Jehan du Vignay of Vincent de Beauvais, *Speculum historiale* (*Le Mirouer Historial*). Bibliothèque Nationale de France, MS Fr. 51, fol. 8. Photo: Bibliothèque Nationale de France

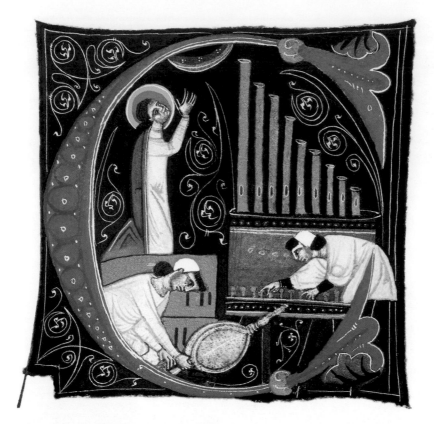

PLATE 9. Cecilia prays at her wedding, begging God to preserve her virginity, while a male organist plays and another man pumps the bellows. Historiated initial *C* for the responsory *Cantantibus organis*. Ravenna, Archivio Storico Arcivescovile, Antifonario II, fol. 122v. Photo: digital restoration by Giancarlo Dessì, in Paola Dessì, *Cantantibus organis* (Bologna, 2002)

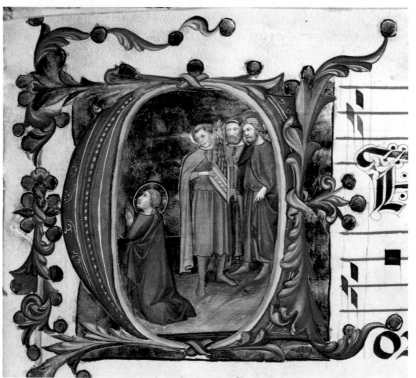

PLATE 10. Cecilia prays, ignoring the wedding music. Historiated initial *C* for the responsory *Cantantibus organis* in an antiphonary made in the second half of the fourteenth century. Studium Biblicum Franciscanum, Jerusalem, Antifonario 7 (H), fol. 233r. Photo: Erich Lessing / Art Resource

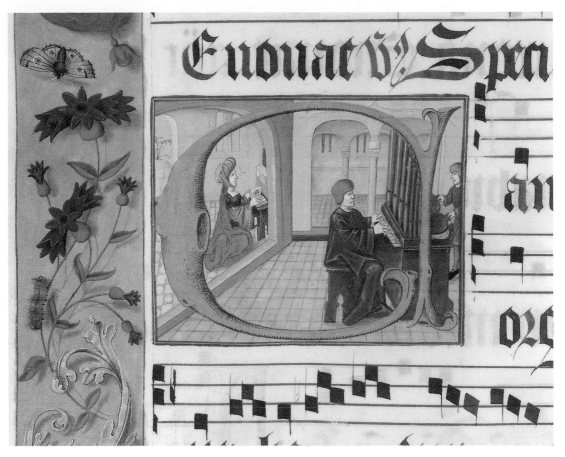

PLATE 11. While an organist plays, Cecilia prays in the next room. Historiated initial *C* for the responsory *Cantantibus organis*. Abdij van Onze-Lieve-Vrouw van het Heilig Hart, Westmalle, Groot antifonarium van Vorst, pars prima, p. 427. Photo: © KIK-IRPA, Brussels

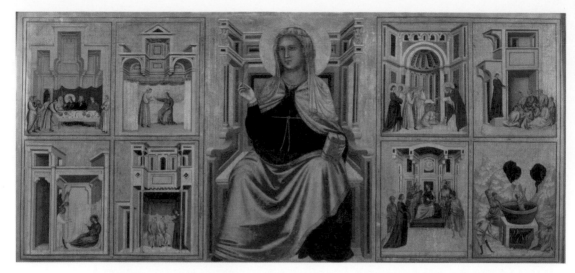

PLATE 12. Master of St. Cecilia, *St. Cecilia Altarpiece*, ca. 1304. Uffizi, Florence. Photo: Scala / Art Resource

PLATE 13. Scenes from the life of St. Cecilia, ca. 1505. Frescoes by several artists simulating a set of choir tapestries in the Oratory of Saints Cecilia and Valerian (next to the church of S. Giacomo Maggiore) in Bologna. Photo: Wikimedia Commons

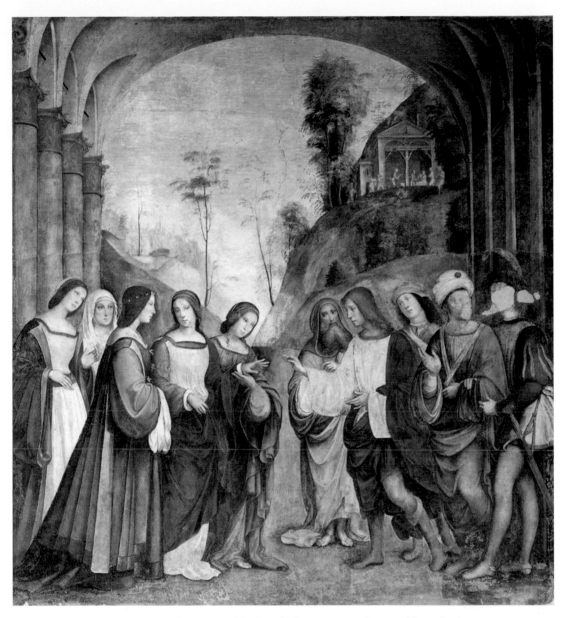

PLATE 14. Francesco Francia, *The Marriage of Cecilia and Valerian*, ca. 1505. Oratory of Saints Cecilia and Valerian. Photo: Alamy

PLATE 15. Cecilia without identifying attributes. Historiated initial *C* for the Lauds antiphon *Cantantibus organis*, from an antiphonary believed to have been made at the Benedictine monastery at Melk. Free Library of Philadelphia, Lewis E M 65.47. Photo: Free Library of Philadelphia / OPENN

PLATE 16. Cecilia holds a palm in a historiated initial *C* from *Cecilia virgo clarissima*, the first lesson of Matins. Benediktinerinnen–Kloster St. Martin, Hermetschwil, Cod. membr. 6, fol. 256r. Photo: Benediktinerinnen–Kloster St. Martin

PLATE 17. Five virgin martyrs (Agatha, Agnes, Cecilia, Lucy, and Catherine) in an illuminated Litany made in northeastern France around 1300. Getty Museum, Los Angeles, MS. Ludwig IX 3, fol. 105v. Photo: Getty Museum

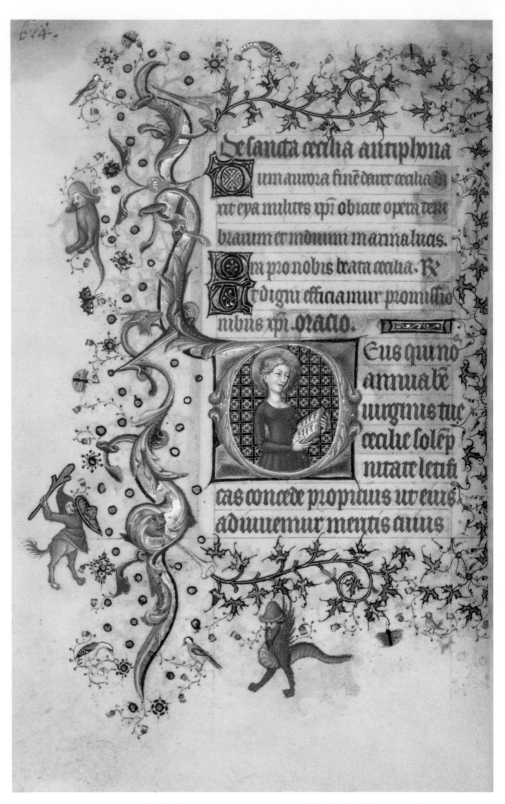

PLATE 18. Cecilia holds a book in a historiated initial *D* for the Cecilia's Day oration (prayer) *Deus qui nos annua beate virginis tue cecilie solempnitate letificas* (God, who gladdens us with the annual celebration of your blessed virgin Cecilia). Hours of Charles the Noble, King of Navarre, ca. 1404. Cleveland Museum of Art, 1964.4011.b, fol. 301v. Photo: Cleveland Museum of Art

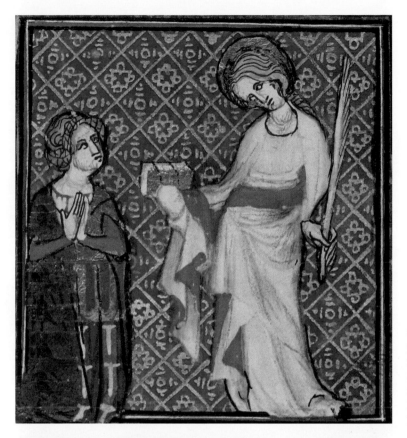

PLATE 19. Marie de Saint Pol praying to Cecilia. Illumination in the Breviary of Marie de Saint Pol. Cambridge University Library, MS Dd.5.5, fol. 388r. Photo: Cambridge University Library

PLATE 20. Cecilia crowned with red roses and white lilies. Illuminated initial *C* for the responsory *Cantantibus organis* in an antiphonary from the convent of San Domenico, Perugia, made in the early fourteenth century. Biblioteca Comunale Augusta, Perugia, MS 2796, fol. 121v. Photo: Biblioteca Comunale Augusta

PLATE 21. Stefan Lochner, *A Female Martyr Flanked by Ambrose and Augustine*, ca. 1445–1450. Wallraf-Richartz-Museum, Cologne. Photo: Rheinisches Bildarchiv

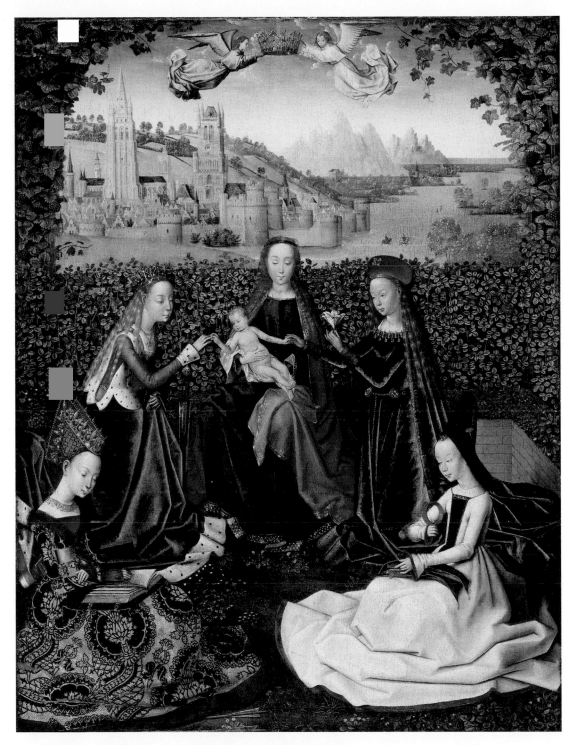

PLATE 22. Master of the St. Lucy Legend, *Virgin of the Rose Garden*, 1475–1480. Detroit Institute of Arts. The four virgin martyrs (clockwise from left): Ursula (identified by two arrows below the hem of her gown), Catherine (sword), Barbara (necklace of golden towers), and Cecilia (her name in golden letters). Photo: Detroit Institute of Arts

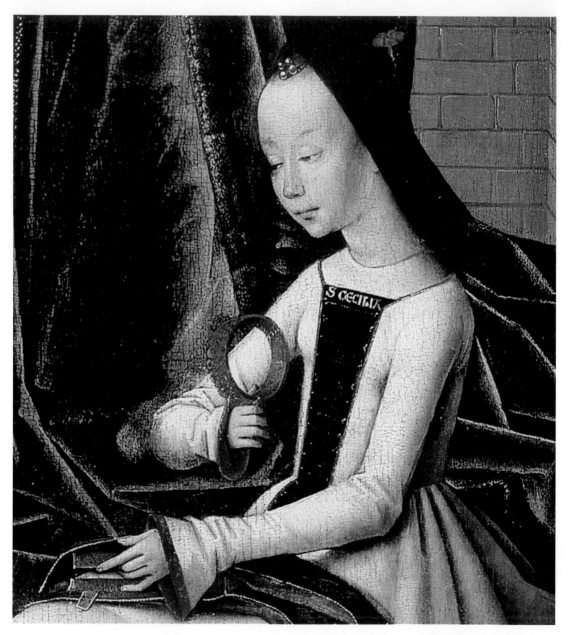

PLATE 23. *Virgin of the Rose Garden*. Detail showing Cecilia with book and crown (?). Photo: Detroit Institute of Arts

PLATE 24. Cecilia feeds her falcon. Illustration for suffrages to Cecilia in the Hours of Catherine of Cleves (Utrecht, ca. 1440), Morgan Library, New York, MS M917, p. 308. Photo: Morgan Library

PLATE 25. Cecilia with a falcon in one hand, a sword in the other, and an organ at her feet. Woodcut from *Passionael Winter Stuck*, Delft, 1489 (a Dutch translation of Voragine's *Legenda aurea*). University of Sydney Library, Rare Books and Special Collections, Inc. 89.3. This woodcut also appeared in an earlier edition of the *Passionael*, published in Delft in 1487, and in a later one, published in 1499. Photo: University of Sydney Library

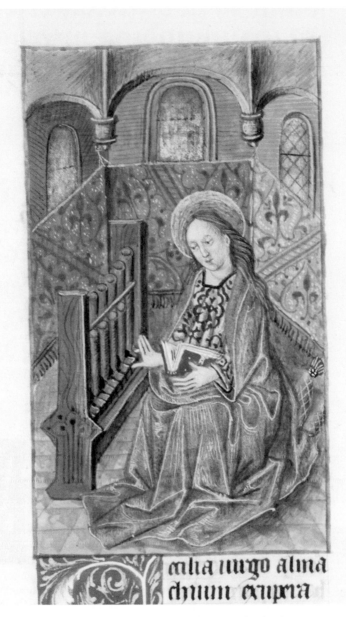

PLATE 26. Cecilia at the organ, holding a book with one hand and gesturing toward the keys with the other. Below, the beginning of *Cecilia virgo Almachium*, the first antiphon for the first nocturn in Matins. Breviary of Marguerite de Houchin-Longastre (ca. 1480–1489), present location unknown. Photo: Rheinisches Bildarchiv

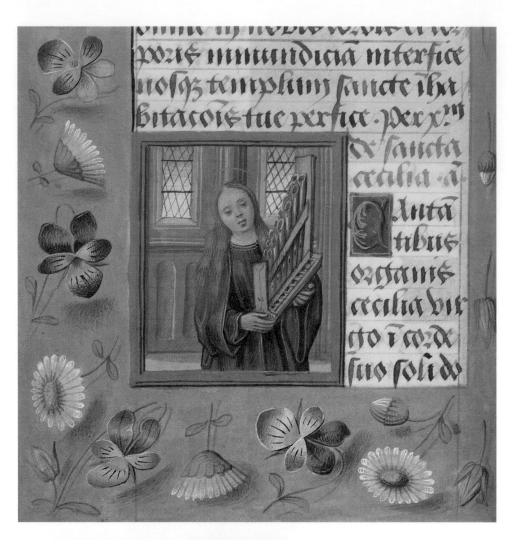

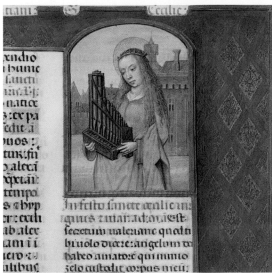

PLATE 27. Cecilia holding but not playing an organ, which has supplanted all her other attributes, in a book of hours probably made in Bruges between 1510 and 1520. University of Syracuse Library, Special Collections, MS 7, fol. 231v. To the right, the beginning of the Matins Responsory *Cantantibus organis*. Photo: University of Syracuse Library

PLATE 28. Cecilia holds a silent organ above the rubric "In festo sancte cecilie" in the Breviary of Mayer van den Bergh, ca. 1500. Miniature attributed to the Maximilian Master (active about 1475–1515). Museum Mayer van den Bergh, Antwerp, fol. 575r. Photo: © KIK-IRPA, Brussels

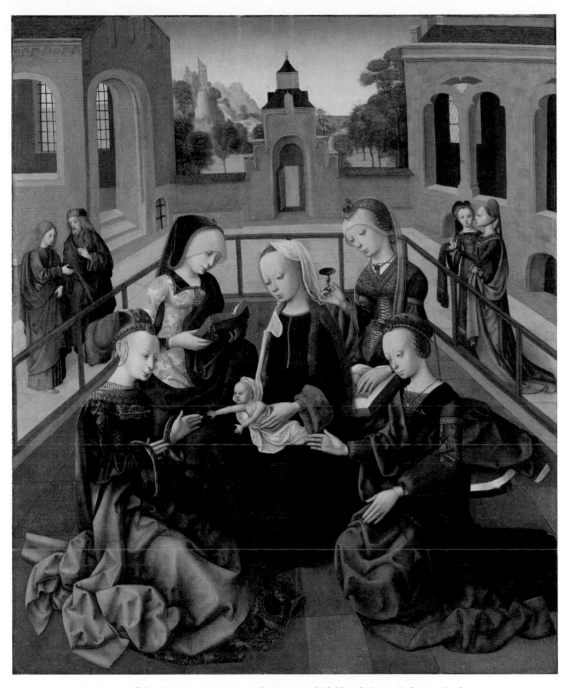

PLATE 29. Master of the Virgo inter Virgines, *The Virgin and Child with Saints Catherine, Cecilia, Barbara, and Ursula*, ca. 1495–1500. Rijksmuseum, Amsterdam. Photo: Rijksmuseum

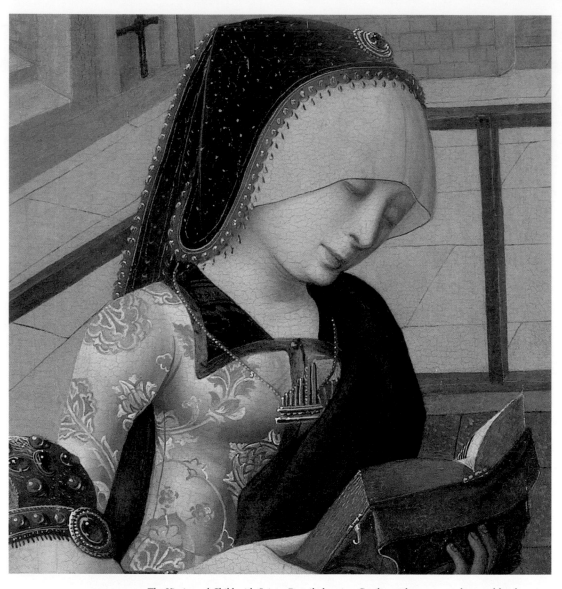

PLATE 30. *The Virgin and Child with Saints*. Detail showing Cecilia with organ pendant and book. Photo: Rijksmuseum

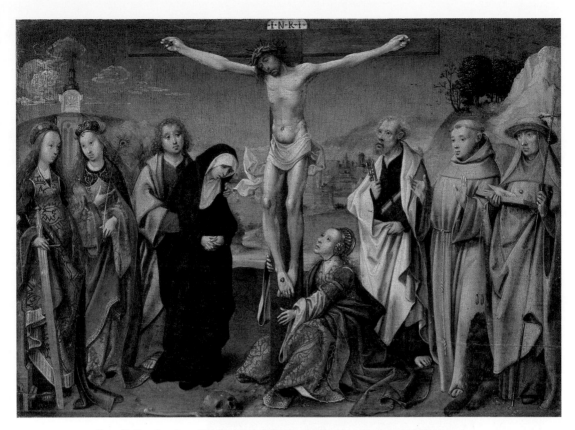

PLATE 31. Cornelis Engebrechtsz, *The Crucifixion Witnessed by Saints*, ca. 1505–1510. Rijksmuseum, Amsterdam. From left to right: Cecilia, Barbara, John the Evangelist, the Virgin Mary, Mary Magdalene, Peter, Francis, and Jerome. Photo: Rijksmuseum

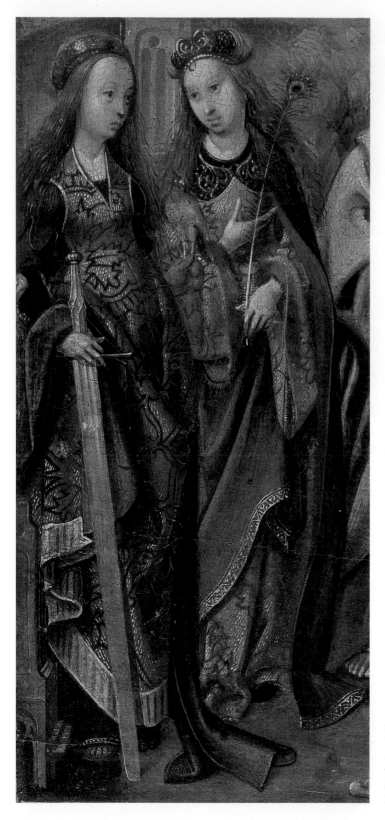

PLATE 32. *The Crucifixion Witnessed by Saints*. Detail showing Barbara and Cecilia, with floral crown, falcon, sword, and organ. Photo: Rijksmuseum

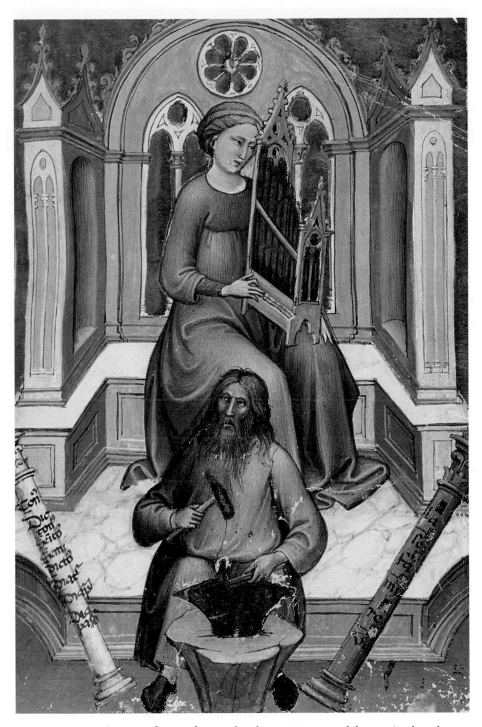

PLATE 33. Musica, the personification of music, plays the portative organ, while a man in whom the artist has conflated two biblical figures—Jubal, the inventor of music, and his half-brother Tubal-Cain, the first blacksmith (Genesis 4:19–22)—hammers an anvil. Illumination in a manuscript (Bibliothèque Nationale de France, MS Italien 568), probably made in the early fifteenth century, containing the most important collection of Italian secular music of the fourteenth century. Photo: Bibliothèque Nationale de France

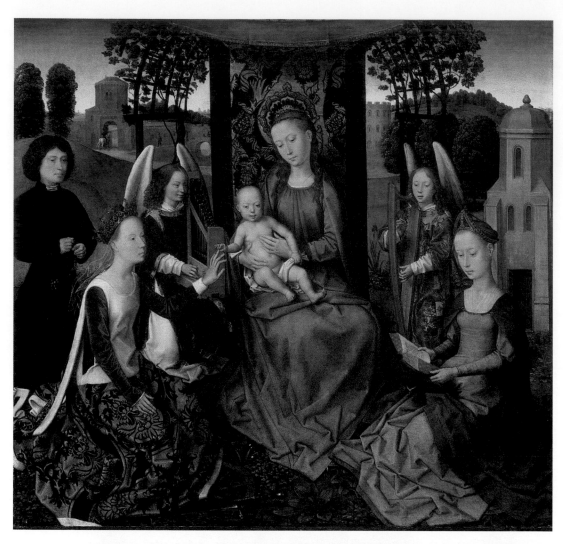

PLATE 34. Hans Memling, *Mystic Marriage of St. Catherine*, ca. 1480. Metropolitan Museum, New York. On the right, St. Barbara; on the left, the patron; and two angels making music. The painting is apparently modeled on the central panel of the Triptych of John the Baptist and John the Evangelist (plate 35). Photo: Art Resource, NY

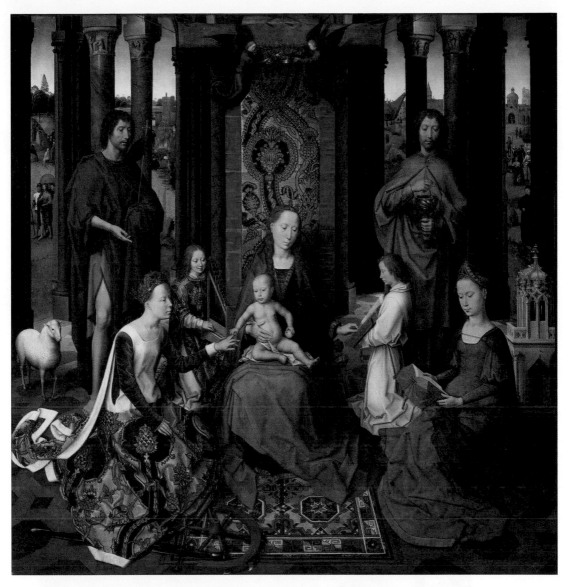

PLATE 35. Memling, *Triptych of John the Baptist and John the Evangelist*, ca. 1479. Memling Museum, Bruges. Central panel, showing the mystic marriage of St. Catherine, with the two Johns, Barbara, and two youths or wingless angels. Photo: Hugo Maertens / Musea Brugge

PLATE 36. Memling, *Diptych of Jean de Cellier*. Louvre, Paris. Left panel, showing the mystic marriage of St. Catherine, with five other virgin martyrs (clockwise from left: Agnes, Cecilia, Lucy, Margaret, and Barbara). Assuming the attribution is correct, it cannot have been painted later than 1494, the year of Memling's death. Photo: Jean-Louis Mazières

PLATE 37. Master of the Holy Kinship the Younger, *Intercession Image*. Wallraf-Richartz-Museum, Cologne. From left to right: John the Evangelist, John the Baptist, the patron, Columba of Sens, and Cecilia. Photo: Rheinisches Bildarchiv

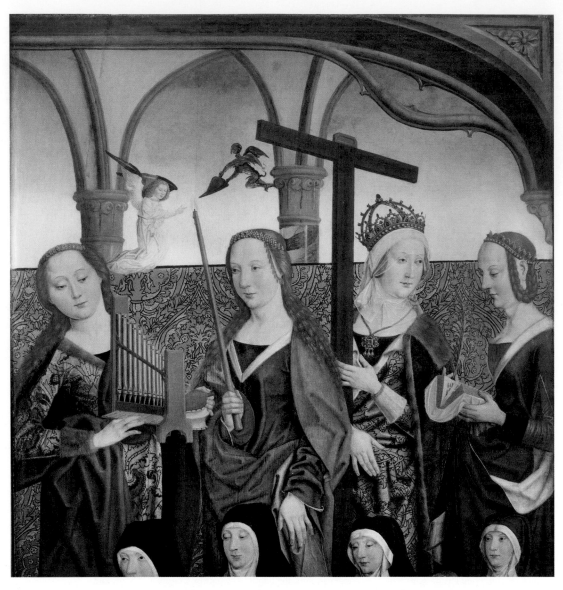

PLATE 38. Master of the Holy Kinship the Younger, *Altar of the Holy Kinship*, ca. 1502. Wallraf-Richartz-Museum, Cologne. Detail of a side panel depicting Cecilia, Geneviève, Helen, and an unidentified martyr. Photo: Rheinisches Bildarchiv

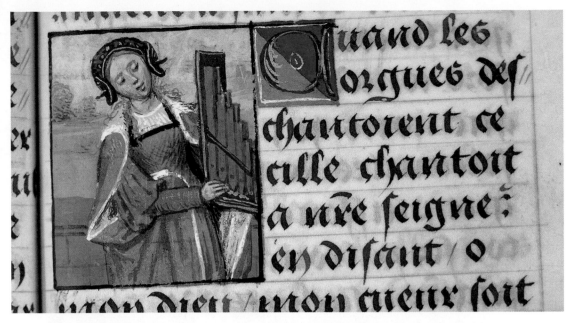

PLATE 39. French prayerbook from the early sixteenth century. Bibliothèque municipale, Valenciennes, MS 1206, fol. 112r. A picture of Cecilia playing the organ illustrates a translation of the antiphon *Cantantibus organis*: "Quand les orgues deschantoient cecille chantoit a n[ôt]re seigne[ur] en disant o mon dieu mon cueur soit fait immacule affin que ne soye confondue." Photo: Bibliothèque municipale / BVMM

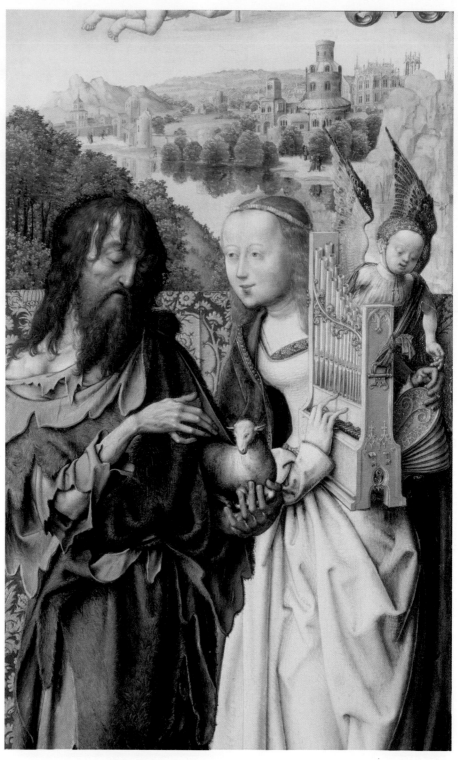

PLATE 40. Master of the Bartholomew Altarpiece, *Crucifixion Altarpiece*, ca. 1490–1495. Wallraf-Richartz-Museum, Cologne. Detail of the left wing, showing John the Baptist and Cecilia playing the portative organ. Photo: Rheinisches Bildarchiv

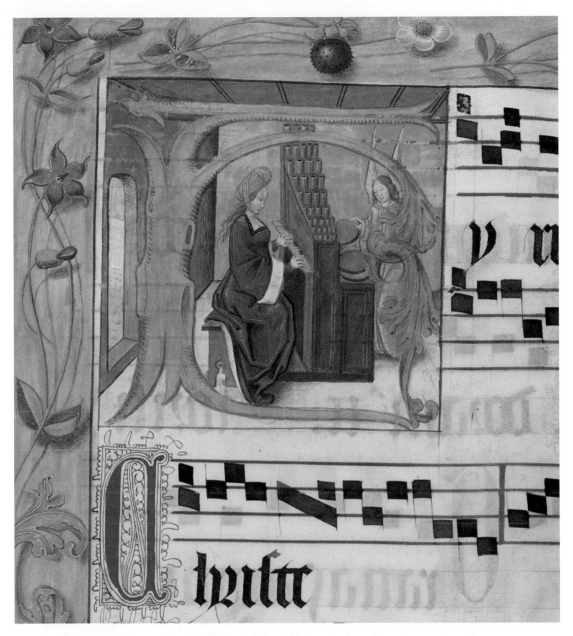

PLATE 41. Jean Massy, *Cecilia Plays the Organ while an Angel Pumps the Bellows*. Historiated initial *K* (in Kyrie) in a gradual from the Abbey of Gembloux (1514). Bibliothèque Royale, Brussels, MS 5648, fol. 262r. Photo: Bibliothèque Royale

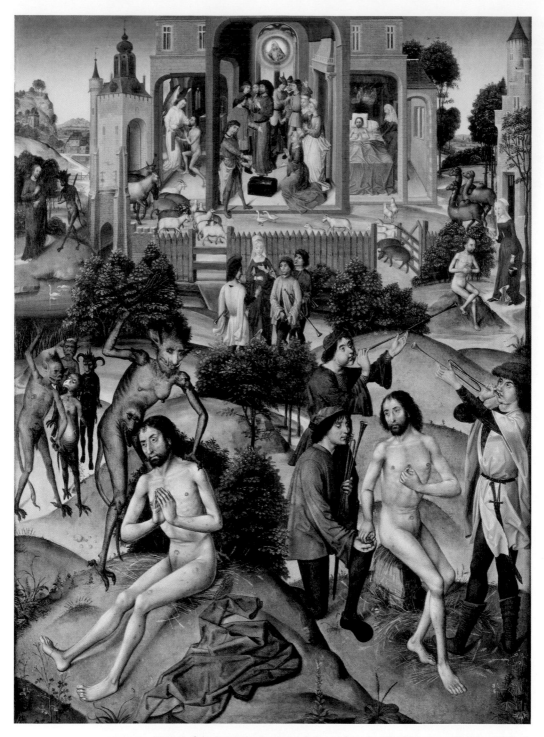

PLATE 42. Master of the St. Catherine Legend, *Scenes from the Life of Job*, ca. 1466–1500. Wallraf-Richartz-Museum, Cologne. On the lower right, trumpeters serenade Job, who pays them with scabs that miraculously turn into gold. Photo: Rheinisches Bildarchiv

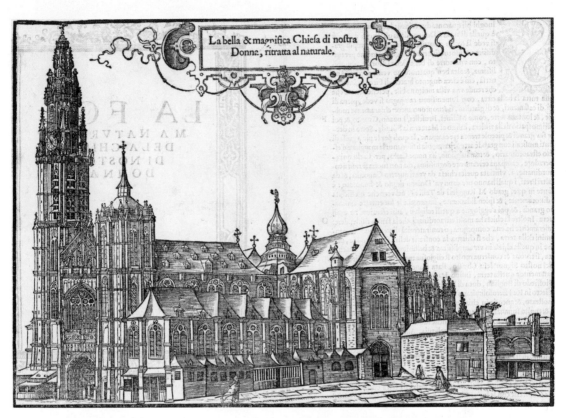

La bella & magnifica Chiesa di nostra Donnæ, ritratta al naturale.

PLATE 43. Cathedral of Our Lady in Antwerp, where Cecilia's Day gratuities for the singers, in the form of money, food, or wine, are documented from 1515. Woodcut in Ludovico Guicciardini, *Descrittione di tutti i Paesi Bassi* (Antwerp, 1567), between pp. 68 and 69.

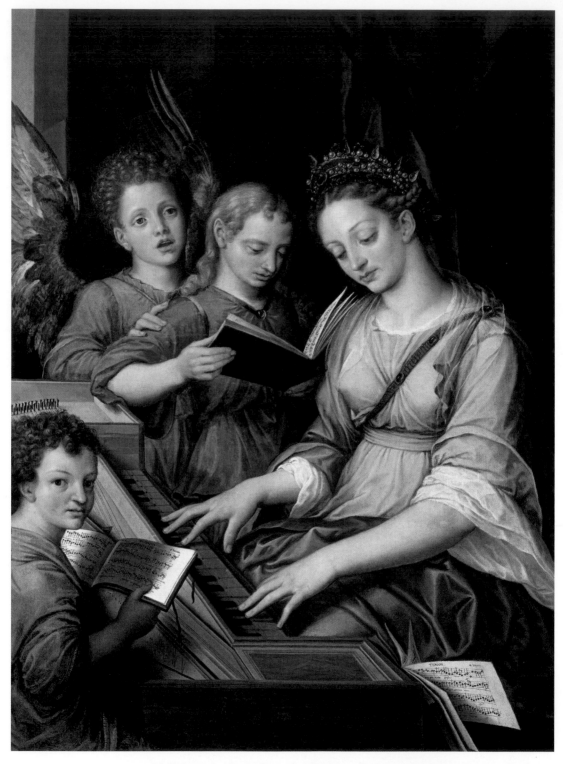

PLATE 44. Michiel Coxcie, *St. Cecilia at the Virginal, Accompanying Angels in a Performance of Clemens non Papa's* Cecilia virgo gloriosa, 1569. Prado, Madrid. Photo: Art Resource

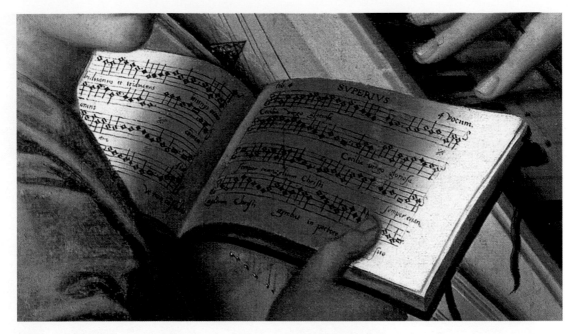

PLATE 45. Coxcie, *St. Cecilia at the Virginal*. Detail showing the first page of Clemens's *Cecilia virgo gloriosa* in a superius partbook. At the top of the page: "lib. 4. SVPERIVS 4 vocum." Photo: Art Resource

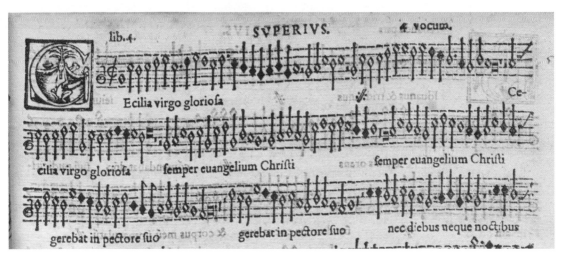

PLATE 46. Beginning of Clemens's *Cecilia virgo gloriosa* in the superius partbook published by Phalèse under the title *Liber quartus cantionum sacrarum . . . quatuor vocum* (Leuven, 1559; RISM C 2698). At the top of the page: "lib. 4. SVPERIVS 4 vocum." The notation in the painting corresponds to that of the first two and a half staves of the print. Photo: Bayerische Staatsbibliothek, Munich

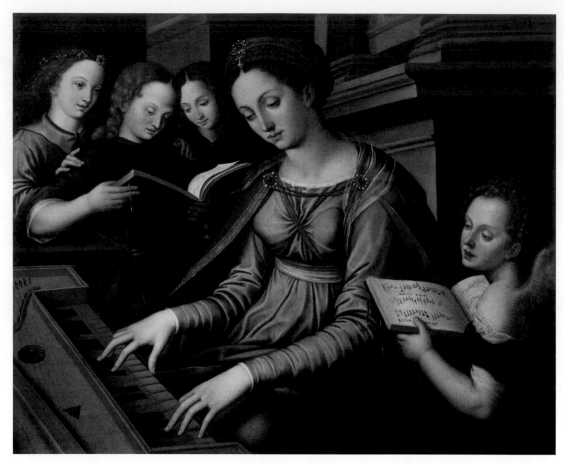

PLATE 47. Michiel Coxcie or workshop, *St. Cecilia at the Virginal with Angels Performing Crecquillon's Virgo gloriosa / Cantantibus organis*. Château de Chenonceau. Photo: Manuel Cohen

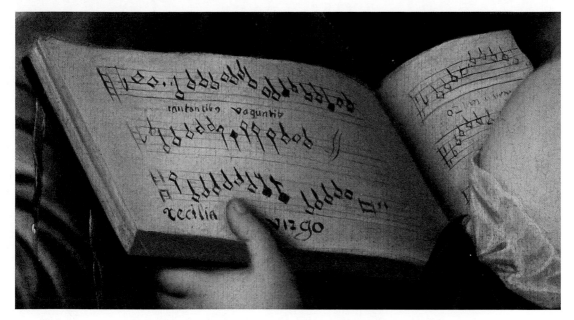

PLATE 48. Coxcie or workshop, *St. Cecilia at the Virginal*. Detail showing the open tenor partbook. The music on the left, with the text "Cantantibus organis Cecilia virgo," is an approximate depiction of Crecquillon's motet, part 2, tenor voice, breves 8–23. Photo: Manuel Cohen

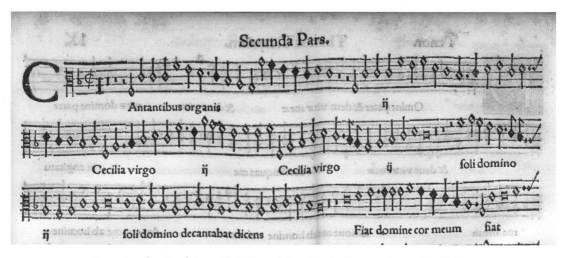

PLATE 49. Beginning of part 2 of Crecquillon's *Virgo gloriosa / Cantantibus organis*, as printed in the tenor partbook of *Cantiones selectissimae quatuor vocum* (Augsburg, 1548). The music in the painting starts with the two semibreves just past the halfway point of the first staff and continues to the breve and rests near the end of the second staff. Photo: Bayerische Staatsbibliothek, Munich

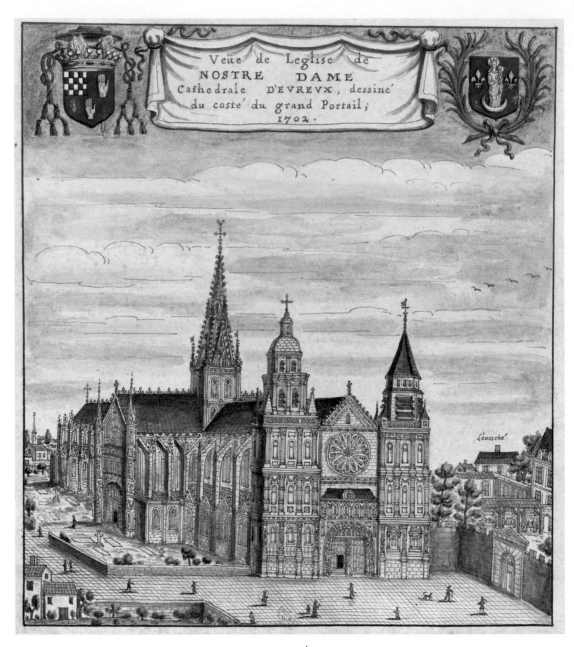

Veüe de Leglise de
NOSTRE DAME
Cathedrale D'EVREVX, dessiné
du costé du grand Portail;
1702.

Leuasché

PLATE 50. The cathedral of Notre Dame in Évreux, with the grand portal as it looked in 1702. Bibliothèque Nationale de France. Before this portal, motets awarded prizes at the Puy d'Évreux were performed *à haulte voix* on the day after Cecilia's Day. Photo: Bibliothèque Nationale de France

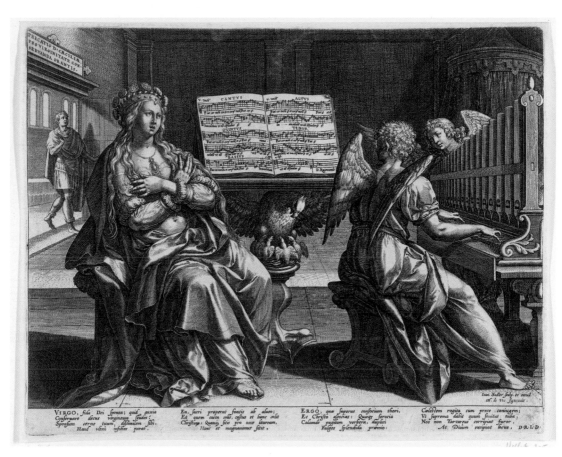

PLATE 51. Jan Sadeler I, *Fiat cor meum et corpus meum immaculatum*, ca. 1585. Engraving after a drawing by Martin de Vos. Rijksmuseum, Amsterdam. The choirbook is open to a motet by Daniel Raymundi. Photo: Rijksmuseum

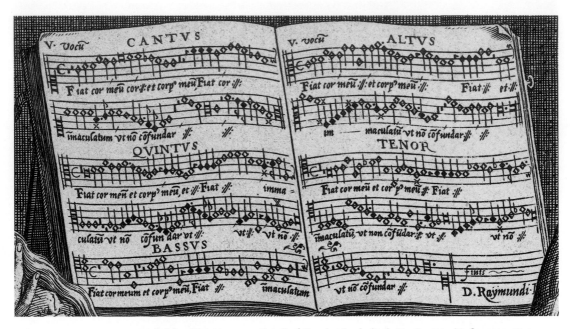

PLATE 52. Sadeler, *Fiat cor meum*. Detail of the choirbook displaying Raymundi's five-voice *Fiat cor meum*. Photo: Rijksmuseum

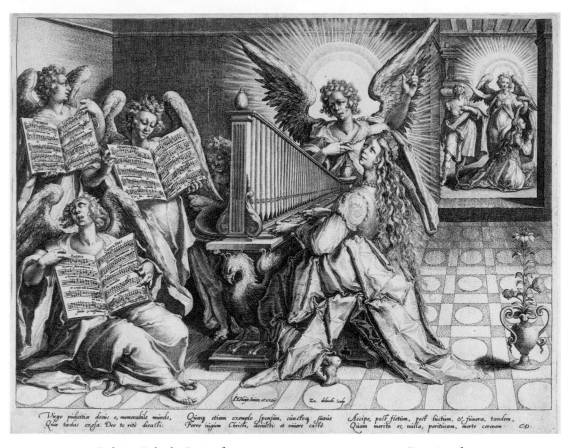

PLATE 53. Zacharias Dolendo, *Domine fiant anima mea et corpus meum*, ca. 1593. Engraving after a drawing by Jacques de Gheyn II. Rijksmuseum, Amsterdam. Three angels hold partbooks open to a Cecilian motet by Cornelis Schuyt. Photo: Rijksmuseum

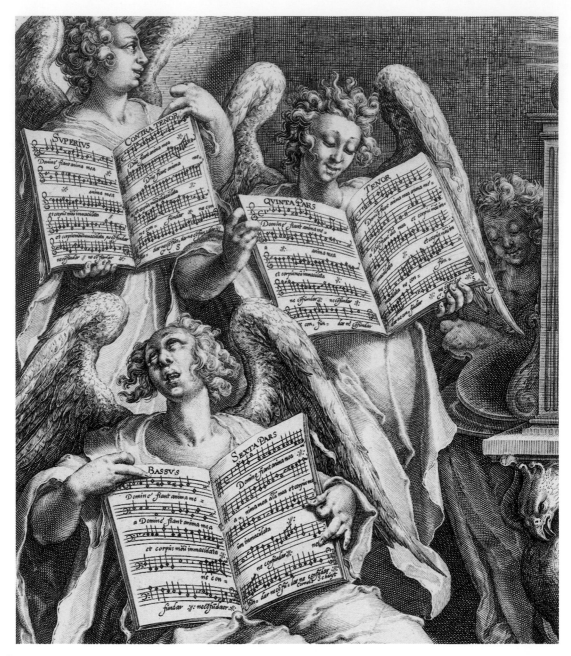

PLATE 54. Dolendo, *Domine fiant anima mea*. Detail showing the three partbooks, each with two voice-parts for Schuyt's six-voice motet. Photo: Rijksmuseum

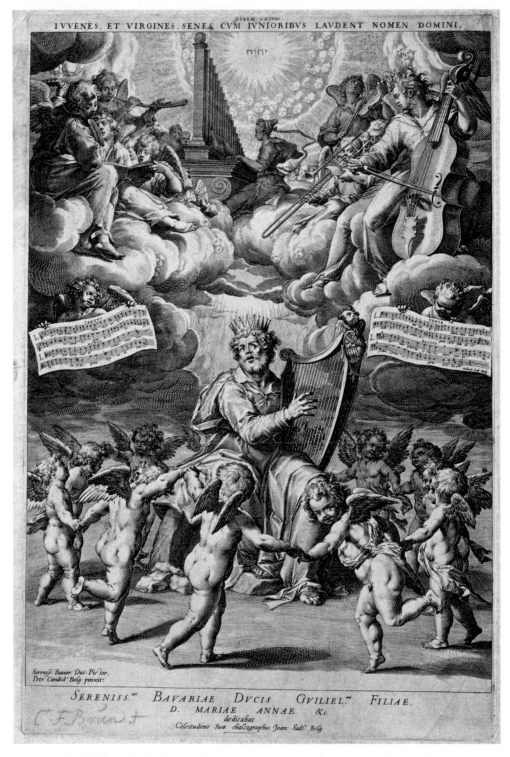

PLATE 55. Jan Sadeler I, *Laudent Deum cithara*, ca. 1593. Engraving after a painting by Peter Candid. Plantin-Moretus Museum, Antwerp. The image, with a miniature motet by Orlande de Lassus, illustrates a line from Psalm 148. Photo: Plantin-Moretus Museum

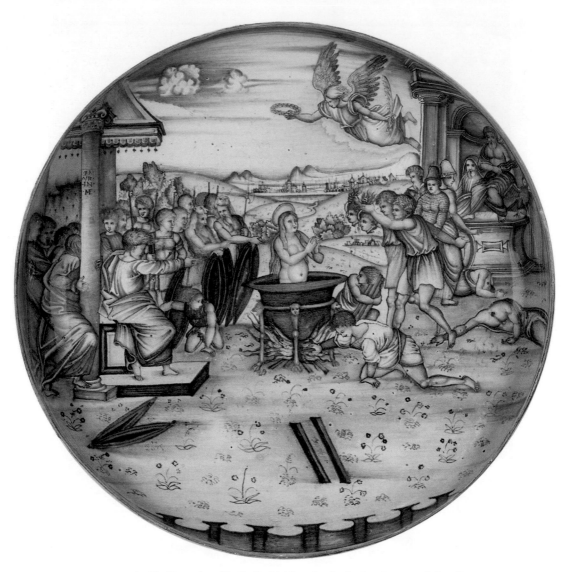

PLATE 56. *The Martyrdom of St. Cecilia.* Maiolica plate by the Casa Pirota workshop, Faenza, ca. 1525, based on an engraving by Marcantonio Raimondi, itself based on a fresco (ca. 1518, no longer extant) by Raphael and his workshop. Musée des Arts Decoratifs, Paris. Photo: Jean Tholance / © MAD, Paris

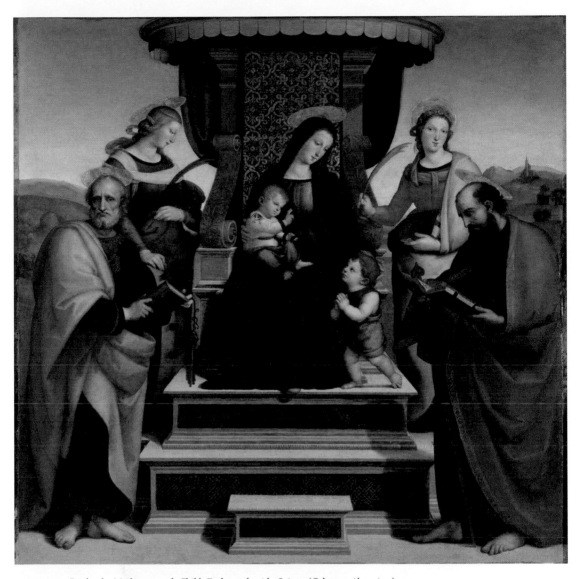

PLATE 57. Raphael, *Madonna and Child Enthroned with Saints (Colonna Altarpiece)*, ca. 1504. Metropolitan Museum, New York. Central panel, showing (from left) Saints Peter, Catherine, Cecilia (?), and Paul. Photo: Art Resource, NY

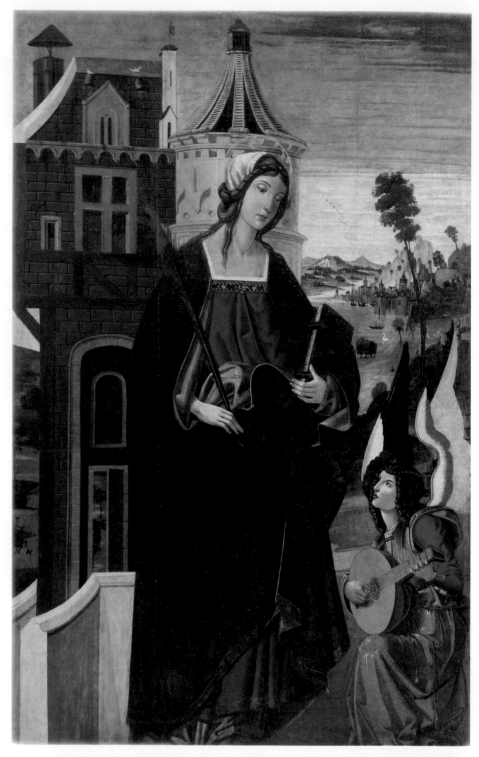

PLATE 58. Cristoforo Faffeo (attrib.), *St. Barbara with Palm and Book, Serenaded by an Angel*, ca. 1475–1500. Museo Diocesano, Palermo. This image documents the state of the painting after restoration by Mauro Sebastianelli (2014–15). Photo: Museo Diocesano

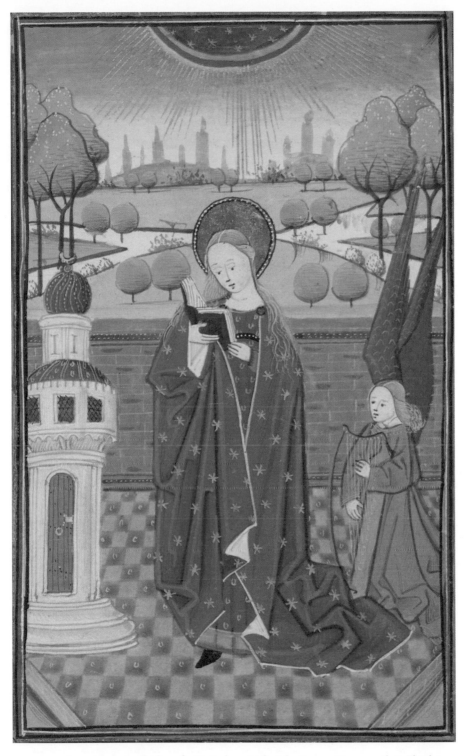

PLATE 59. An angel playing the harp for St. Barbara, in the John Browne Hours, made in Flanders between 1450 and 1475. Free Library of Philadelphia, Widener 3, fol. 33v. Photo: Free Library of Philadelphia / OPENN

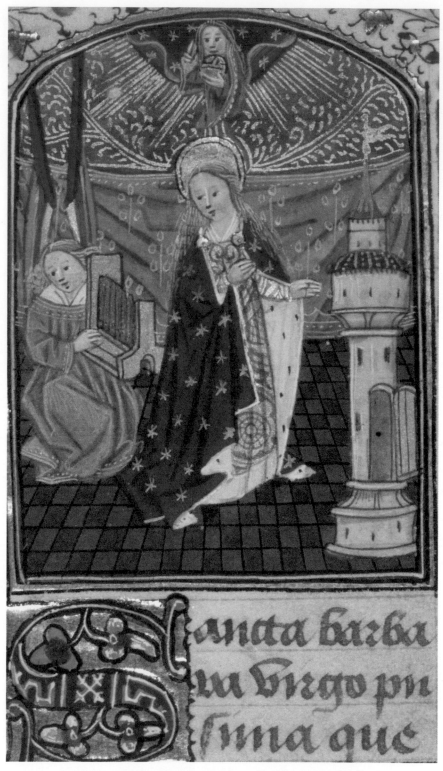

PLATE 60. An angel playing the portative organ for Barbara, in a book of hours made in Bruges around 1450. Walters Art Museum, Baltimore, Ms. W. 186, fol. 288r. Photo: Walters Art Museum

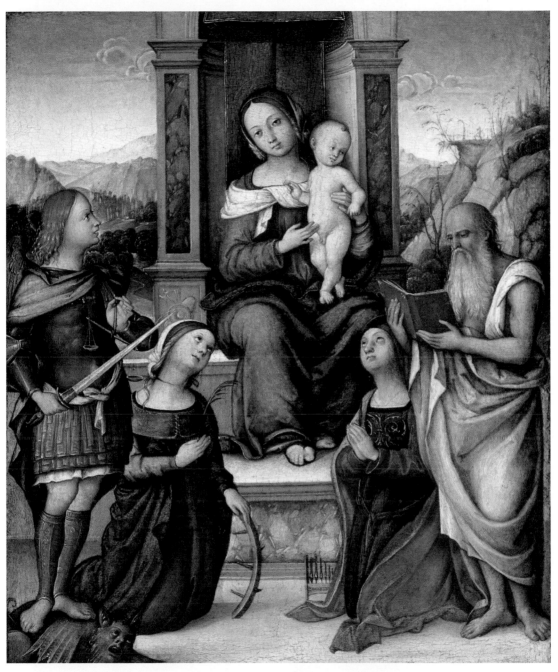

PLATE 61. Girolamo Marchesi (attrib.), *Virgin and Child with Saints Michael, Catherine, Cecilia, and Jerome*, ca. 1512. Museum of Fine Arts, Houston. Photo: Museum of Fine Arts, Houston

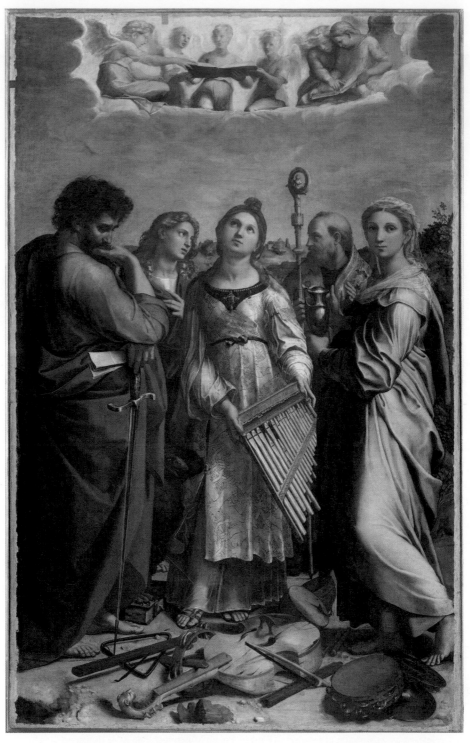

PLATE 62. Raphael, *The Ecstasy of St. Cecilia*, ca. 1515. Pinacoteca Nazionale, Bologna. Photo: Pinacoteca Nazionale

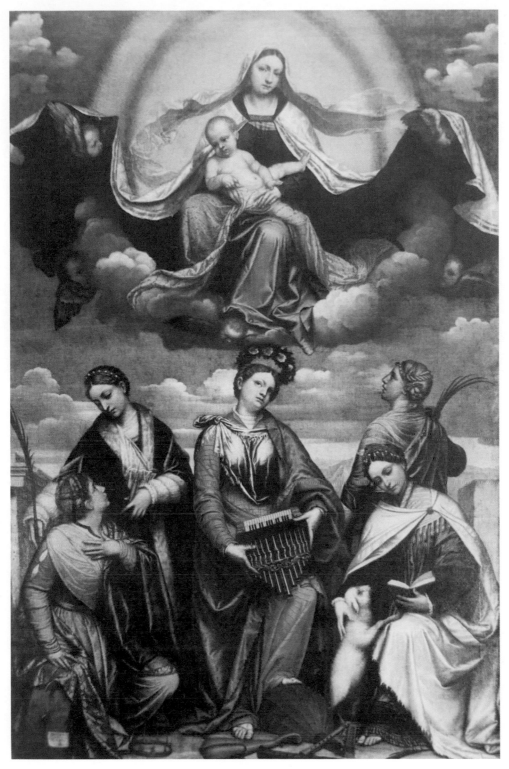

PLATE 63. Moretto da Brescia, *Virgin and Child with Five Virgin Martyrs*, 1540. Church of S. Giorgio in Braida, Verona. Photo: RobyBS89 / Wikimedia Commons

PLATE 64. Denis Calvaert (attrib.), *St. Cecilia*. Parma, Galleria Nazionale. Photo: Scala / Art Resource, NY

PLATE 65. Domenico Panetti (attrib.), *Virgin and Child with Cecilia*, probably made in northern Italy in the early sixteenth century. Palais des Beaux-Arts, Lille. Photo: Sailko / Wikimedia Commons

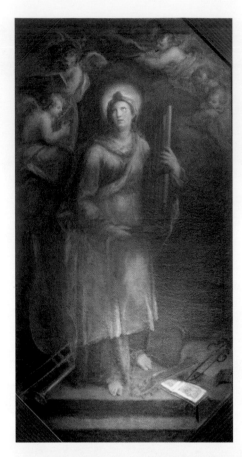

PLATE 66. Sebastiano Filippi (Bastianino),
St. Cecilia, ca. 1598. Pinacoteca Nazionale
di Ferrara. Photo: Sailko / Wikimedia
Commons

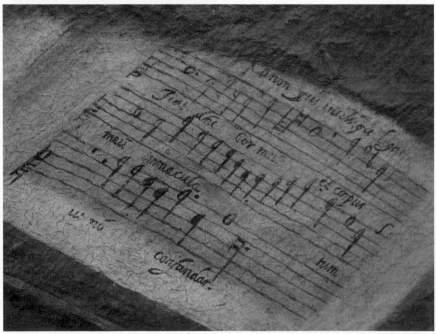

PLATE 67. Filippi, *St. Cecilia*. Detail showing musical notation. Photo: Pinacoteca Nazionale di
Ferrara

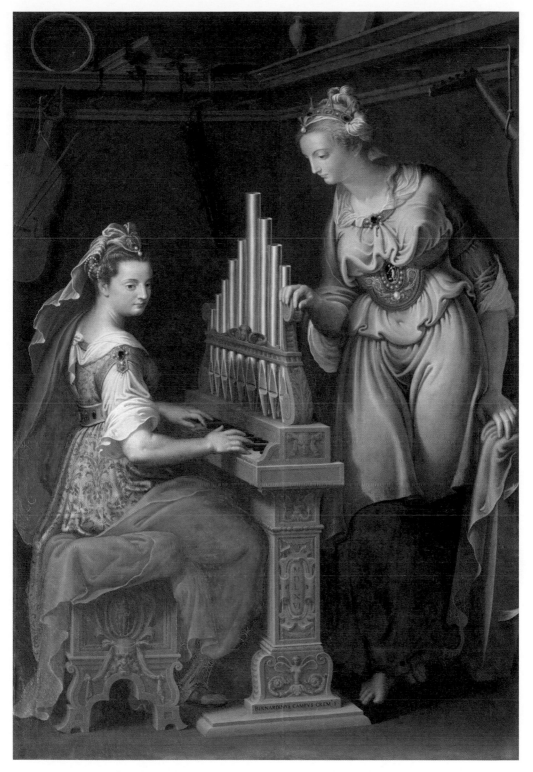

PLATE 68. Bernardino Campi, *Saints Cecilia and Catherine*, 1566. Church of S. Sigismondo, Cremona. Photo: Mario Bonotto / Scala /Art Resource, NY

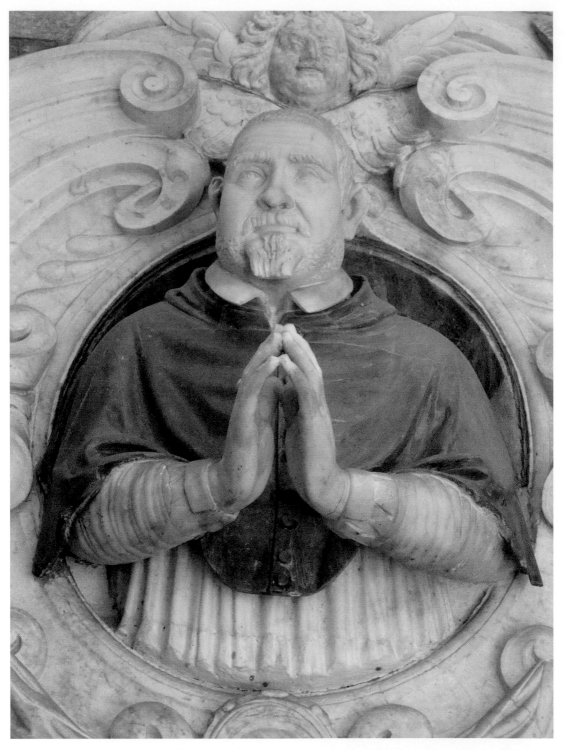

PLATE 69. Bust of Cardinal Paolo Camillo Sfondrato on his tomb at the entrance of the church of S. Cecilia. Photo: Mariza de Andrade

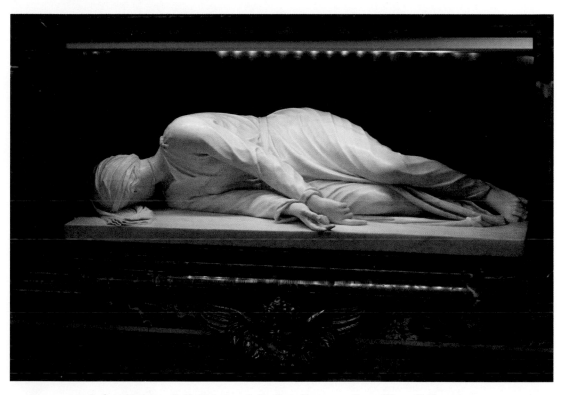

PLATE 70. Stefano Maderno, *St. Cecilia*, 1600. S. Cecilia in Trastevere, Rome. Photo: Heidemarie Niemann

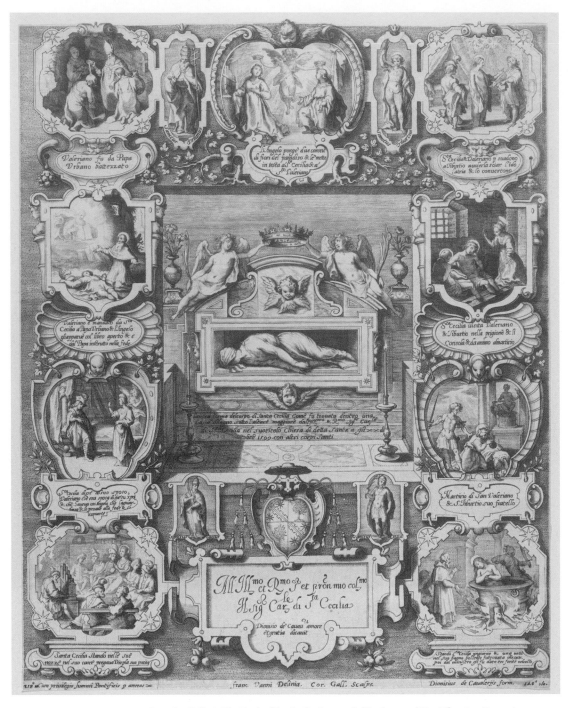

PLATE 71. Cornelis Galle I, *The Tomb of St. Cecilia Surrounded by Scenes of Her Life*, 1601. Engraving after a drawing by Francesco Vanni. Rijksmuseum, Amsterdam. Photo: Rijksmuseum

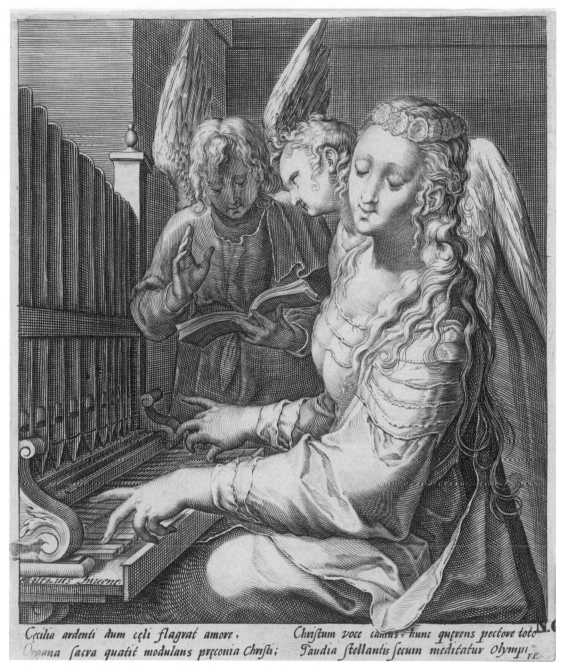

Cecilia ardenti dum cæli flagrat amore, Christum voce canens, hunc quærens pectore toto
Organa sacra quatit modulans præconia Christi; Gaudia stellantis secum meditatur Olympi.

PLATE 72. Jacob Matham, *Cecilia at the Organ, Accompanying Two Singing Angels*, ca. 1590. Engraving after a drawing by Hendrick Goltzius. Rijksmuseum, Amsterdam. Photo: Rijksmuseum

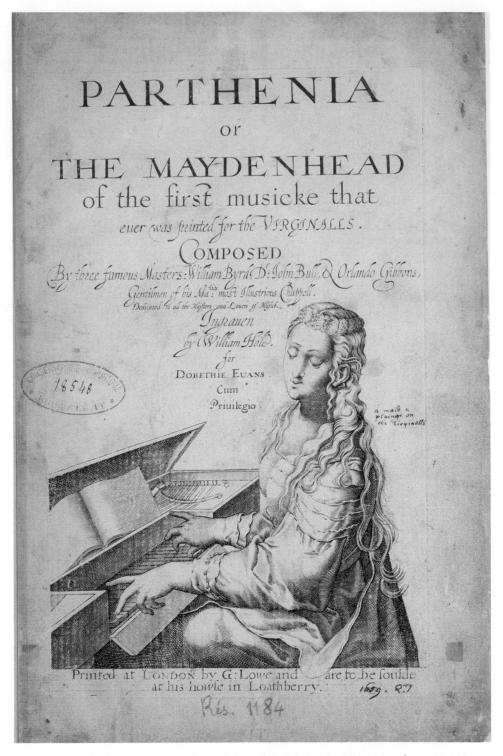

PLATE 73. *Parthenia*, title page. This anthology of English keyboard music was first published ca. 1612; this is the second edition, published ca. 1613. Photo: Bibliothèque Nationale de France

"CECILIAM CANTATE PII": MUSIC FOR BANQUETS AND OTHER EVENTS OUTSIDE OF CHURCH

The archival records of payments to musicians for wine and food on Cecilia's Day in Antwerp and other cities in the Netherlands suggest that a banquet with wine on 22 November (resembling, at least in some respects, the one described by van Roo in his *Convivium cantorum*) was a widespread custom among professional musicians during the sixteenth century. Festive meals also had a role in some events whose principal functions were religious or musical, such as the observation of Cecilia's Day at Rouen and Évreux. One of the prince's main responsibilities was to provide food and drink for members and performers; the refusal of one prince in Rouen to pay for a Cecilia's Day banquet led to a lawsuit. A document recording the activities of Jehan La Biche, who served as prince in Évreux in 1581, states approvingly that he "gave the dinner and supper [on Cecilia's Day] and the next day lunch after the Requiem Mass, gratis. And on the same day, the supper of the Puy, in the aid of his fellow members, and all these took place in his residence in this city of Évreux."[66]

Music was a regular component of banquets during the Renaissance, and that music often included motets. During the famous Feast of the Pheasant, given by Philip the Good, Duke of Burgundy, at Lille in 1454, musicians performed motets in addition to trumpet fanfares, chansons, and organ music; and more than a century later, the guests at a wedding banquet in Munich in 1568 heard a mixture of motets, madrigals, chansons, and instrumental pieces.[67] Motets were also performed during dinners given by the pope.[68] No wonder the title pages of many of the motet collections published by Phalèse bear, as a motto, a biblical quotation that links music and wine: "Sicut in fabricatione auri signum est smaragdi, sic numerus musicorum in iucundo et moderato vino" ("As a signet of an emerald in a work of gold: so is the melody of music with pleasant and moderate wine"—*Sirach* 32:5).

If motets played a role in Cecilia's Day banquets, what works would more likely have been sung than those that praise her, including those published by Phalèse under this motto? It is probably no coincidence that Antwerp, where more payments to musicians for wine on Cecilia's Day are documented than anywhere else, was also the city where at least six composers of Cecilian music lived and where much of it was printed.

Of the musician whose surname was Carette, we know nothing except that he wrote two early Cecilian motets, published in Lyon in 1539. One, *Cantantibus organis*, is a setting of two texts from the Cecilia's Day liturgy; we can imagine it being sung during the Office celebrated by the Cecilian organizations in Évreux or Paris. The other, *Laudemus Dominum cum Cecilia*, uses nonliturgical texts, though they paraphrase the Bible. Part 1 emphasizes singing

and playing musical instruments as a primary means for glorifying God. It was thus apt for performance by professional musicians outside of church. With the words "cum Cecilia," the singers of Carette's work transformed her into an active musician, performing along with them as they praised God:

Laudemus Dominum cum Cecilia in tympanis et organis, in jubilationibus cantemus Domino, in cymbalis modulemus illi, et invocemus nomen eius, quoniam Domini est terra et plenitudo eius.

Let us praise the Lord with Cecilia, with drums and organs; let us sing to the Lord with jubilation, let us make music with cymbals; and let us invoke his name, for the earth is the Lord's and the fullness thereof.

Another non-liturgical piece, *Cantibus organicis*, attributed to both Gombert and Naich, encompasses two sides of Cecilian festivities in the sixteenth century: sacred and secular. In dactylic hexameters,[69] the text of the *prima pars* alludes to the Cecilian Office; but the *secunda pars*, urging singers to praise Cecilia on her feast day, seems to refer to singing outside of church. In addition to the musical sources, the poem is recorded without musical notation in a sixteenth-century manuscript, mentioned earlier, of which the following is a transcription.

[C]antibus organicis Christi Cecilia sponsa
Dedita fundebat dulcem paeana tonantem.
Noctes atque dies, ut apes intenta labori,
Cogebat petulans sacra per ieiunia corpus
At[que] animum servire deo: cane peius et angui
Omne voluptatis genus execrata, pudicis
Carmina cantabat pernox resonantia verbis.

Fundite cantores dulci modulamina voce
Cantibus exultat vestris Cecilia virgo,
Cuius festa dies totum veneranda per orbem
Devotis animis rediit. Gaudete fideles.[70]

Cecilia, the bride of Christ, devoted to instrumental song,
poured forth a sweetly thundering paean.
Day and night, as intent in her work as bees,
and despite her desire, through holy fasting she forced her body
and soul to serve God. Cursing every kind of pleasure
as worse than a dog or a snake, she sang songs
through the night that resounded with chaste words.

Pour forth, singers, melodies with a sweet voice.
Your songs delight Cecilia the virgin,
whose feast day, venerated through the whole world,
returns for devoted hearts. Rejoice all ye faithful!

The first two lines can be traced back to Arnobius by way of the liturgical texts based on the *Passio*. We can see clearly in this poetic adaptation how the phrase "Cantantibus organis" (unusable for metrical reasons, as explained in chapter 1) has been taken out of its original context and given a new meaning. The poet, probably inspired by images of Cecilia playing an organ, has made her a performing musician, her "sweetly thundering paean" audible to everyone. The next two lines borrow from a number of liturgical sources. "Noctes atque dies" recalls "non diebus neque noctibus" in the antiphon and responsory *Virgo gloriosa*. The simile "ut apes intenta labori" recalls the phrase "Cecilia famula tua Domine quasi apis tibi argumentosa deservit," sung widely as an antiphon in Lauds.[71] The word "ieiunia" is from the verse of the responsory *Cantantibus organis*. By recasting this material as poetry, the author of the text has given it a new, non-liturgical function.

The clear reference in the last four lines to the musical observation of Cecilia's Day means that this music was actually written for singers to perform on that day, probably for their own pleasure, and almost certainly outside of church. It is likely that the other settings of non-liturgical texts were made for the same purpose.

Gombert set to music another non-liturgical text, this one in elegiac couplets, for Cecilia's Day, with hardly a trace of Cecilia as depicted by Arnobius and the liturgy. She has become, perhaps for the first time, almost completely secularized. First published in 1541, *Ceciliam cantate pii, cantate pudici* is again addressed to musicians; it urges them to honor Cecilia with music, instrumental as well as vocal. The text says nothing about Cecilia's virginity; it focuses instead on her love of music. Most of part 2 consists of a long list of ancient instruments. The text survives in two different versions, both of which appear to be corrupt. The following edition is based on the text as published in Augsburg in 1546 (RISM 1546[5]), but with several words and phrases emended following Scotto's edition of 1541 (RISM 1541[3]).

Ceciliam cantate pii, cantate pudici,
 carmine nam modulis carminibusque favet.
Organa Ceciliam resonent stridulaeque Camoenae;
 suavia delectant organa Ceciliam:
argutaque juvant dulcis modulamina vocis.

 Concordes igitur voce ciete modos;
perstrepat hic lituus,[72] citharae, calamus, decachordon,
 cumque foraminibus, tibia, plectra, lyra,

tympana cum chordis, oris quoque[73] cornua flexi,
 cymbala, testudo, barbita rauca,[74] chelys,
Ars hominum quidquid vel reperit illa sonorum:[75]
 laudare volumus plangere Ceciliam.[76]
Musas Ceciliam sapiens quis nescit amare
 cum cecinit sponsa,[77] carmina sponso suo?

Sing of Cecilia, pious and chaste ones,
 with a song, for she favors melodies and songs.
Let the organ and the high-pitched Muses echo Cecilia;
 the sweet organ delights Cecilia,
and the lively melodies of a gentle voice are pleasing.

 Therefore raise harmonious songs with your voice;
let the trumpet sound loudly, the citharas, the panpipe, the ten-string psaltery,
 the flute with holes, and the lyre and plectra,
the tambourine with strings, the horns with twisted mouth,
 the cymbals, the tortoiseshell lyre, the hoarse barbitons, the chelys,
or whatever sounds the art of man discovers.
 We wish to praise Cecilia and to mourn her.
Who, knowing the Muses, does not love Cecilia
 when, as a bride, she sang songs to her husband?

This largely secular text seems less appropriate for the church than for the banquet—especially a banquet involving instrumentalists as well as singers. But when Gheerkin de Hondt used Gombert's motet as the basis for a parody Mass, he transformed music unsuitable for the church into music ideal for Mass on Cecilia's feast.

Yet another Cecilian work with a non-liturgical text is *Ceciliae laudes celebremus* by Antonius Galli. Choirmaster at St. Donatian in Bruges from 1545 to 1550, Galli was dismissed because under his lax supervision the choirboys frequented the city's taverns.[78] The Chapter of St. Donatian, as we saw in chapter 3, gave the choristers money for a Cecilia's Day banquet in 1560. Galli might have written *Ceciliae laudes* (published in 1554) for a similar banquet during his tenure.

The text, six elegiac couplets, tells the story of Cecilia's life; but it also alludes to musical events on Cecilia's Day, and to Cecilia as a real musician: "she herself always sang thanks and hymns to God." As in *Cantibus organicis*, her singing was perfectly audible. The last couplet identifies the performers as her "disciples" (*alumnis*) and pleads for her aid. In the first couplet it urges these performers to sing "joyful songs" in her praise:

Ceciliae laudes celebremus, virginis atque
 martyris egregiae; cantica laeta sonent.

Ipsa Deo semper grates hymnosque canebat,
 et domuit rigido membra tenella sago.
Ipsa suum docuit sponsum mysteria Christi,
 contempsit patrios religiosa deos.

Praeses atrox illi ferrum flammasque minatur,
 et struit accensis balnea dira focis.
Omnia sed semper superavit pectore virgo;
 jam fruitur caeli nectare Cecilia.
Virgo fave nobis succurre tuis alumnis,
 et placeant petimus carmina nostra tibi.[79]

Let us celebrate praises of Cecilia, excellent virgin
 and martyr, let joyful songs resound.
She herself always sang thanks and hymns to God,
 and she subdued her delicate limbs with a rough cloak.
She taught her husband the mysteries of Christ,
 and she piously rejected her family's gods.

A cruel official threatened her with sword and fire,
 and he devised a deadly bath with burning flames.
But the virgin always overcame everything with her heart,
 and now Cecilia enjoys the nectar of heaven.
Virgin, protect us and help your disciples;
 and we ask that our songs please you.

Galli's setting of this text is yet another example of the "music about musicians" of which Jane Hatter has written,[80] but with Cecilia instead of the Virgin Mary as the object of musicians' devotion.

GEERT VAN TURNHOUT'S MOTETS: REFLECTING THE TWO SIDES OF CECILIA'S DAY AT THE CATHEDRAL OF ANTWERP?

The singers of Antwerp Cathedral enjoyed a tradition of observing Cecilia's Day with wine and food. But the annual banquet was only one part of their celebration of the feast. The singers presumably participated in a full schedule of liturgical events in honor of Cecilia, starting with Vespers the evening before. For these singers (as for many professional singers in the Netherlands and northern France) the day offered a mixture of sacred and secular, solemn prayer and boisterous merry-making: the spiritual sustenance of the Eucharistic feast, with its faint whiffs of the communion wine, followed by the earthly pleasures of the banquet, washed down with hearty gulps of Rhine wine donated by the city of Antwerp.

What motets can we associate with the observance of Cecilia's Day at the Cathedral of Our Lady? Of the four musicians who served as choirmasters in the church between 1528 and 1591, three wrote music for Cecilia: Geert van Turnhout, Séverin Cornet, and Pevernage. (The fourth, Antoine Barbe, choirmaster for thirty-four years, from 1528 to 1562, handled some of the Cecilia's Day gratuities that the Confraternity of Our Lady gave the singers during the 1550s.[81] But either he composed very little or he kept most of his music from being published and his manuscripts are lost—perhaps destroyed in the *Beeldenstorm* of 1566.) In addition, an anthology that, according to Kristine Forney, "easily could have been employed as repertory for confraternity services" in the cathedral, includes *Ceciliam intra cubiculum* by Cornelius Canis.[82]

The two Cecilian motets by Turnhout embody most clearly the contrast between sacred and secular so characteristic of the celebration of Cecilia's Day in Antwerp. Turnhout served in the cathedral from 1562 to 1572, when he became chapelmaster at the court of Philip II in Spain. His Cecilian pieces survive incomplete, and by a single thread: a bass partbook in a manuscript anthology of which all the other partbooks are lost. In a hand that Forney has identified as that of a copyist who worked for the cathedral, the manuscript is dated 1566, when Turnhout was serving as choirmaster.[83] (A third Cecilian motet in this manuscript, Crecquillon's *Virgo gloriosa / Domine Jesu Christe*, is likewise linked to Antwerp; its final prayer "Sancta Cecilia, ora pro nobis," quotes from a version of the Litany used in the cathedral.[84])

Turnhout could not have chosen two more different texts for his Cecilian motets. In *Virgo gloriosa / Domine Jesu Christe*, he set the same texts as Crecquillon: two of the most familiar liturgical texts for the feast, both of which were sung repeatedly during the Office and were set to music often by other composers. Like Crecquillon's work, Turnhout's ends with "Sancta Cecilia, ora pro nobis," for which Turnhout, following Crecquillon, used Antwerp Cathedral's version of the Litany.

Turnhout's other Cecilian piece, *Venit autem nox*, consists of three non-liturgical texts that, as far as I know, had never been set to polyphonic music before (with the exception of the first sentence of the *secunda pars*, which Certon had composed as the end of part 1 of *Cantantibus organis*):

Venit autem nox in qua Sancta Cecilia suscepit una cum sponso suo cubiculi secreta silentia, et ita eum alloquitur: "O dulcissime et amantissime juvenis, est mysterium quod tibi volo dicere.

Angelum Dei habeo amatorem qui nimio zelo custodit corpus meum. Si in Deum verum crederis et baptizatus, ipsum videre valebis."

Valerianus igitur a Sancto Urbano baptizatus, Ceciliam cum angelo loquentem in cubiculo invenit, et sic ambo cum palma virginitatis et martyrii ad Dominum pervenerunt.

Then came the night in which St. Cecilia, together with her husband, entered the secret silence of the bedroom, and she said to him: O sweetest and most loving youth, what I wish to tell you is a mystery.

I have an angel of God as my lover, who guards my body with excessive zeal. If you truly believe in God and [allow yourself to be] baptized, you will be able to see him.

So Valerian, baptized by St. Urban, found Cecilia speaking with the angel in the bedroom, and thus both came to the Lord with the palm of virginity and martyrdom.

Turnhout apparently took most of these passages from the *Golden Legend*. His setting of them had no obvious usefulness in the liturgy, but that in itself might have made them especially attractive to singers at a Cecilia's Day banquet. Probably tired of the liturgical texts that they had been singing in the cathedral, they might have welcomed the chance to sing relatively unfamiliar words in praise of their patron saint.

MOTETS FOR COMPETITIONS

The musical competitions that took place on Cecilia's Day as part of the *puys* in Normandy and were proposed as part of celebrations in Paris by the Confrairie de Saincte Cécile offer us some further links between the feast day and the motet as a genre, since documents associated with all three of these competitions mention the motet. During the lawsuit in Rouen over a prince's financial obligations to the Confraternity of St. Cecilia, one witness spoke of the necessity that "visitors who bring motets, chansons and [other] compositions" be hospitably received. At Évreux the organizers of the Puy invited submissions in five categories, including motets. And in Paris the bylaws recommended that "quelques motets nouveaux ou autres cantiques honnestes" be solicited for the competition.

The surviving documentation on feast day events in Paris and Rouen do not deal with the texts on which competing motets were to be written. In Évreux the guidelines were more specific. The stipulation that prizes were to go to the best motets for five voices in two *partes*, "in honor of God or the said virgin [Cecilia],"[85] led several competitors to submit settings of Cecilian texts.

According to instructions issued to the prince at Évreux, the winning motets (first prize, a golden organ; second prize, a silver harp) were to be sung in public, transforming the competition into a musical performance:

Le jugement résolu, le Prince, accompagné des fondateurs et confrères, marchera avec les chantres; lesquelz, pour rendre grâces à Dieu de l'heureux succeès de leur concertation, s'iront présenter devant le grand portail de l'église Nostre-Dame; et là, chanteront à haulte voix, les motets prémiez au Puy, après

chacun desquelz chanté, ils feront entendre aux assistans, par led. doyen, les
noms des autheurs, suivant ce qui faict en a esté l'an passé.[86]

*The judgment having been made, the prince, accompanied by the founders and the
members, will walk with the singers, who, to give thanks to God for the successful out-
come of the competition, will present themselves before the great portal of the church
of Notre Dame. There they will sing in full voice the motets awarded prizes at the Puy
and, after each of them has been heard, the said senior member [the prince?] will an-
nounce the names of the authors to those present, as was done last year.*

The list of winners at Évreux shows that several Cecilian works won prizes.
We can thus be fairly confident that Cecilian motets were among the pieces sung
"à haulte voix" in front of the cathedral of Notre Dame in Évreux (plate 50).
Although the competition attracted entries from all over northern France, and
a few from foreign countries, only one composer of international importance
was among the winners. Lassus twice won the silver organ, the second time for
Cantantibus organis (table 4.4).

PEVERNAGE AND HIS MUSIC FOR THE CONFRATERNITY
OF ST. CECILIA IN KORTRIJK

In Kortrijk (Courtrai) in the southern Netherlands, we find a rare confluence of
evidence about the interaction of Cecilia's cult and the composition of motets.
Gerald R. Hoekstra has assembled this evidence in his edition of the motets of
Pevernage.[87]

Born at Harelbeke, a village near Kortrijk, in 1542 or 1543, Pevernage briefly
served as a singing master at St. Salvator in Bruges in 1563. Later that year he
took up the position of chapelmaster at the collegiate church of Notre Dame
(Onze Lieve Vrouwkerk) in Kortrijk, where he supervised the performances of
six choirboys, six adult singers, and an organist. From 1585 he served as music
director in the cathedral in Antwerp. There, following the restoration of Spanish
rule, he helped revive the singers' custom of observing Cecilia's Day with wine
supplied by the city council. But we are concerned here with his two decades in
Kortrijk and the remarkable publication that documents his work as a composer
at Notre Dame and as a contributor to the town's Confraternity of St. Cecilia.

In 1578 Bogard in Douai issued a large collection of motets by Pevernage un-
der the title *Cantiones aliquot sacrae, sex, septem, et octo vocum, quibus addita sunt
elogia nonnulla versibus latinis expressa, tam viva voce, quam omnis generis instru-
mentis cantatu commodissimae* (Many sacred songs in six, seven, and eight voices,
to which are added several *elogia* in Latin verse, most suitable to be sung both by
voices and by all sorts of instruments). It consists of sixty-three motets in three
groups: for the Temporale (the cycle of feasts commemorating Christ's birth,
life, death, and resurrection), for the Sanctorale and general use, and *elogia*—

TABLE 4.4. Winners of the first and second prizes for five-voice motets at the Puy d'Évreux, 1575–1589

Year	Composer	Motet
First prize		
1575	Orlande de Lassus	*Domine Jesu Christe qui cognoscis*
1576	Eustache du Caurroy	*Tribularer si nescirem*
1577	Michel Fabry	*Aspice Domine*
1578	Estienne Testart	***Ceciliam intra cubiculum***
1579	?	?
1580	?	?
1581	Jacques Maudit	*Afferte Domine*
1582	?	?
1583	Lassus	***Cantantibus organis***
1584	Toussainctz Savary	*Ne recorderis*
1585	Adrian Allou	*Gustate et videte*
1586	Robert Goussu	*Respice in me*
1587	De la Cassaigne	*Lauda Jerusalem*
1588	Nicolas Vauquet	***Dum aurora finem daret***
1589	Jean Boette	*In hymnis et confessionibus*
Second prize		
1575	De la Cassaigne	*Quis miserebitur*
1576	De la Hele	*Nonne Deo subiecta erit*
1577	?	?
1578	Jean Planson	*Aspice Domine*
1579	?	?
1580	Robert Goussu	*Aspice Domine*
1581	Michel Nicole	*In voluntate tua*
1582	Michel Malherbe	*Heu mihi Domine*
1583	Abraham Blondet	*In Domine benignus es*
1784	Pascal Delestogart	*Ecce quam bonum*
1585	François Habert	***Dum aurora finem daret***
1586	Regolo Vicoli	*De profundis*
1587	Abraham Fourdy	***Dum aurora finem daret***
1588	Daniel Guichart	***Dum aurora finem daret***
1589	Jacques Péris	*O Regina, reum miseratrix*

Note: Cecilian motets in boldface.

Sources: Bonnin and Chassant, *Puy de musique*; Teviotdale, "The Invitation to the Puy d'Évreux," 20–22.

settings of Latin poems in praise of the composer's friends, colleagues, and supe-riors.[88] To emphasize the importance of the poems, Pevernage had them printed separately at the end of the publication, most of them with a brief explanatory preface. As a subgenre of the motet, the *elogium* is close to Albert Dunning's *Staatsmottete*, but with the objects of praise being people of importance in Kor-trijk and the surrounding region, not popes, kings, or emperors.[89]

The last seven *elogia*, settings of elegiac couplets, are eight-voice pieces ad-dressed, in whole or in part, to Cecilia. They recognize the installation of the first seven princes of Kortrijk's Confraternity of St. Cecilia, who served from 1570 to 1576. The preface to the first of these works, *Alma patrona veni*, refers explicitly to the organization for which Pevernage wrote it: "In principatum D. Ludovici van Tsestich, Principis Confraternitatis D. Caeciliae apud Cortracenses primi" (In celebration of the principate of Lodewijk van Tsestich, first prince of the Confraternity of St. Cecilia in Kortrijk). The poems refer repeatedly to the or-ganization as a "chorus"—suggesting that its members were primarily singers. Like the Cecilian organizations in Rouen and Évreux, this was a confraternity consisting largely of musicians.[90]

As in Rouen and Évreux, the princes were annually elected leaders, though the poems say little about their responsibilities. The poem in praise of van Tses-tich calls him "the first glory of our chorus" ("nostri gloria prima chori"). That could mean that he was a professional singer, but "nostri . . . chori" (given the way the word "chorus" is used in the poems) could simply mean "of our confra-ternity." In any case, most of the princes seem to have been valued more for their social status and wealth—their ability and willingness to pay for the inevitable banquet—than for their musical expertise.

The Cecilian *elogia* reveal her feast as an occasion to make music: both celebrating the installation of the new prince and praising Cecilia. The first begins:

> Alma patrona veni, coeptis assiste precamur,
> > Cecilia, et placitus sit novus ordo tibi.
> Scilicet instituit chorus hic laudabile votum,
> > annua decernens thura sacrare Deo.
> Et renovare tuas laudes, ac fortia gesta,
> > dulcibus et modulis hunc celebare diem.

> *Come, kindly patroness, be with us in our undertakings,*
> > *we pray, and let our new order please you, Cecilia.*
> *This chorus has surely taken a praiseworthy vow,*
> > *promising to offer annual sacrifices of incense to God,*
> *and to recall your praises and brave deeds,*
> > *and to celebrate the day with sweet measures.*[91]

Music was the principal subject when the confraternity elected a local noble-man, Josquin le Martin, Lord of Mesplau:

Ducite festivos Musae, cytharaque triumphos;
 hoc resonent laudes organa, plectra die.
Annua Ceciliae redeunt solemnia divae.
 Huic exquisitum prome Thalia melos.

Muses and lyres, lead the festive triumphs;
 let the organs, let the plectra resound with praises of this day.
The annual rites of St. Cecilia return.
 For her, Thalia, pour forth an exquisite song.[92]

Cecilia and Thalia, Muse of comedy and idyllic poetry, interact again in the work praising Adrian van Landeghem:

Solemnis redit ecce dies: Age plectra lyramque
 psaltria tam festo prome Thalia die.
Solemnis redit ecce dies tibi diva, sonoris
 cui fidibus Christum psallere dulce fuit.

Behold! The solemn day returns. Come, bring forth your plectra and lyre,
 string-playing Thalia, on so festive a day.
Behold! The solemn day returns, Saint,
 in whose honor it has been sweet to hymn Christ with melodious strings.[93]

Hockstra is surely correct in speculating about the function of the Cecilian *elogia*: "From the nature of the texts, it seems more likely that the motet would have been sung at an occasion accompanying the mass, such as an installation ceremony or a banquet following the mass, than during the mass itself or another devotional service such as vespers."[94]

In addition to the seven Cecilian *elogia*, the *Cantiones aliquot sacrae* also include two works by Pevernage in honor of Cecilia alone. While *Dum aurora*, as a setting of a responsory for Cecilia's Day, could have been sung in a liturgical context, *O virgo generosa* is a non-liturgical, devotional prayer (in crude verse) for musicians alone, referring to Cecilia as their "patronam." Pevernage almost certainly wrote it for the Cecilian confraternity in Kortrijk:

O virgo generosa,	*O noble virgin,*
Cecilia gloriosa,	*glorious Cecilia,*
audi preces nostras	*hear our prayers*
et impetratam caelitus	*and bring down an indulgence*
Tu defer indulgentiam	*obtained from on high,*
quo letemur triumphantes,	*in which we may rejoice, triumphant,*
te patronam venerentes.	*venerating you, our patroness.*
O virgo felix	*O happy virgin,*
quae jam in caelis	*you who now in the heavens*

regnas cum angelis,	*reign with the angels,*
illic tu nostri	*be so mindful*
sic memor esto,	*of us there,*
ut tuo possimus	*that we may be able*
sociari collegio.	*to join your choir.*
Sancta Cecilia,	*St. Cecilia,*
ora pro nobis.	*pray for us.*[95]

I mentioned in chapter 3 the wine that the city council of Kortrijk gave to the singers in 1570 and 1590 to help mark Cecilia's Day. Together with the nine Cecilian motets by Pevernage, these presents suggest that the confraternity in Kortrijk celebrated its patronal day with a mixture of wine and music typical of these festivities elsewhere in the Netherlands and northern France.

DUELING PICTURE-MOTETS: CATHOLIC VS. PROTESTANT, SOUTHERN VS. NORTHERN NETHERLANDS

The efflorescence of Franco-Flemish Cecilian music that began in the 1530s can be credited, in part, to the adoption by musicians of Cecilia as a patron saint and to the religious services and banquets with which they observed her feast. Going back a step further, musicians considered her a fitting patron, despite her sex, largely because of the many pictures of her by late fifteenth- and early sixteenth-century artists that used a portative organ as her identifying attribute. Musicians later returned the favor, composing Cecilian motets to be displayed in works of art.

Several printmakers in the Netherlands published engravings that show musicians, who read from a choirbook or hold up a set of partbooks clearly legible to the viewer.[96] Two of these prints depict angels making music for or with Cecilia. Composers apparently wrote these short motets especially for the prints. Produced during a period of war in which the Netherlands were breaking into two parts—Catholic in the south, and ruled by Philip II of Spain; Protestant in the north, and independent—the prints make an intriguing pair.

The engraving by Jan Sadeler was probably made around 1585, when the Spanish Army recaptured Antwerp after a period of Calvinist rule (plate 51).[97] It is based on a drawing by Martin de Vos. In the middle, on an elaborately decorated eagle lectern,[98] a choirbook displays a little five-voice piece by Daniel Raymundi: *Fiat cor meum et corpus meum* (plate 52).

De Vos and Sadeler were active in Antwerp. De Vos, having briefly flirted with Protestantism, returned to Catholicism after the fall of Antwerp. Raymundi was a church musician in the dependably Catholic city of Liège.[99]

Cecilia crosses her arms in front of her, signaling her desire to remain a virgin (as in the fourteenth- and fifteenth-century images discussed in chapter 1). Her mouth appears to be closed: she sings, as Arnobius put it, in her heart to the

Lord alone. On the left, above the doorway, an inscription explains: "Precatio d[ivae] Caeciliae pro virginitate conservanda orantis" (Prayer of St. Cecilia, begging for the preservation of her virginity). Below is a sixteen-line poem beginning "Virgo, fida Dei sponsa" (Virgin, faithful spouse of God), signed D. R. L. D. On the right, an angel plays a positive organ. Like the much smaller portative that Cecilia holds upside down in Raphael's painting in Bologna (see plate 62), this is a mirror image of a real organ, with the longest pipe (producing the lowest note) on the right, where the shortest pipe should be. Did De Vos depict a realistic organ in his original drawing, with the ultimate intention of depicting an unplayable instrument in the print, to remind viewers that Cecilia's "song" was a silent prayer? The problem is complicated by the existence, in the Plantin-Moretus Museum in Antwerp, of another version of this print: a mirror image of the Sadeler engraving (except that the texts and music are legible) that the museum has attributed to Philips Galle and dated 1586.[100] Although this might be a copy in reverse of Sadeler's engraving, I see no reason to assume that Sadeler's print came first. So we are left in doubt as to the orientation of De Vos's drawing.

A print made a few years later in Leiden—a city that, in the few decades since the production of the Leiden Choirbooks, had slipped irrevocably into the Protestant realm—competed with the print from Antwerp (plate 53). *Domine fiant anima mea et corpus meum* was a product of collaboration between three residents of Leiden. Jacques de Gheyn II made the design, Cornelis Schuyt provided the music, and Zacharias Dolendo did the engraving, published in 1593.[101] Gheyn grew up in Antwerp but left for religious reasons after the fall of the city in 1585; the other two were natives of Leiden. Three angels hold partbooks, each with two voices. Together, they contain the music of Schuyt's *Domine fiant anima mea*—a setting of a non-liturgical paraphrase of Cecilia's prayer (plate 54). In writing his motet for six voices, Schuyt raised the ante vis-à-vis Raymondi's five-voice piece.

The Protestant rejection of the cult of saints may have encouraged Gheyn and his collaborators in Leiden to treat Cecilia's music-making more freely and dramatically than their Catholic rivals in Antwerp. Although the poem below the image praises Cecilia as "pudicitiae decus" (ornament of chastity), the picture emphasizes the pleasure of music. Unlike the organ in Sadeler's version of "Fiat cor meum," this one is playable, with the longest pipes on the left side of the instrument. The eagle, no longer needed to hold up the music, now helps hold up the organ. This Cecilia is very much a practicing musician. Fully absorbed in her organ playing, she looks up to heaven with an expression of abandon—an ecstasy more musical than devotional.

One of the first works of art—musical as well as visual—involving Cecilia to be produced by Protestants in a Protestant city, *Domine fiant anima mea* anticipates what happened to her in the seventeenth century, when Protestant musicians, especially in England, adopted her as a patron valued more for her musicality than her virginity. Yet Schuyt's motet may have been sung in a liturgical context, more than a century after its publication. A manuscript score is

preserved, under the title *Domine fiant anima mea / Antifona / Per S: Cecilia / di / Cornelio Schüyt*, in the collection of music assembled by the Ricasoli family of Florence during the eighteenth and nineteenth centuries.[102]

A PICTURE-MOTET FROM MUNICH: EXPORTING
THE MUSICAL CECILIA TO CENTRAL EUROPE

Another picture-motet, this one by Lassus, does not mention Cecilia; but the image that serves as an elaborate frame for the music depicts her now fully transformed into a symbol of music and a patron of musicians (plate 55). Artists and a musician who were born in the Netherlands but found employment in Munich made this image. It was thus a product of the transfer of Flemish culture to central Europe that accompanied a diaspora of Flemish artists and musicians, whose destinations included not only Munich but the Habsburg courts in Prague, Innsbruck, and Vienna.[103] Among the Flemish musicians who migrated to the courts of central Europe were composers of Cecilian music (table 4.5). The most elaborate description of a Cecilia's Day banquet, the *Convivium cantorum*, was written by a Flemish singer at the court of Innsbruck and published in Munich.

The picture-motet composed by Lassus illustrates the line from Psalm 148 quoted at the top of the print: "Iuvenes et virgines, senes cum iunioribus laudent nomen Domini" (May youths and virgins, old men and younger ones praise the name of the Lord). In the lower half of the print, surrounded by a ring of dancing cherubs, King David plays his harp. Above, in heaven, a young woman plays the organ in the midst of angels who sing and play the cornetto, lute, violin, trombone, and bass viol: a celestial reunion of *haute musique, basse musique*, and choir. (The artists could have made the organist an angel too; but in making her the only heavenly musician without wings, they encouraged us to identify her as Cecilia.) Higher still, the Hebrew Tetragrammaton, symbolizing God, appears in a sunburst.

Between these images of terrestrial and celestial music, two angels hold up the fully legible notation of a four-voice motet: cantus and altus on the left, tenor and bassus on the right. The composer is identified at the bottom of the right-hand sheet: "Orland. Lass. Belg." ("Belg." stands for *belgicus*, and refers to Lassus's Flemish origins; he was born in Mons, in the southern Netherlands, in 1530 or 1532.) The text, adapted from Psalm 150, consists mostly of a list of musical instruments, *hauts* and *bas*:

Laudent Deum cithara, chori vox, tuba, fides, cornu, organa. Alleluia.

May the cithara, the voice of the chorus, the trumpet, the violin, the horn, the organ praise God. Alleluia.

TABLE 4.5. Flemish composers of Cecilian motets who left their homeland for central European courts

Composer	Residence	Motet(s)
Jean de Chaynée	Vienna, Graz	*Cecilia in corde suo*
Ludovicus Episcopius	Munich	*O beata Cecilia*
Antonius Galli	Vienna	*Ceciliae laudes celebremus*
Christian Hollander	Innsbruck	*Dum aurora finem daret*
Jacobus de Kerle	Prague	*Cantantibus organis*
Orlande de Lassus	Munich	*Cantantibus organis*
		Domine Jesu Christe
Jan Lefebure*	Constance, Mainz	*Cantantibus organis*
Philippe de Monte	Vienna, Prague	*Cecilia virgo Almachium*
		Cilicio Cecilia membra domabat
Jacob Regnart	Prague, Vienna, Innsbruck	*Dum aurora finem daret*
Franz Sales	Innsbruck, Prague	*Cantantibus organis*
Alexander Utendal	Prague, Innsbruck	*Cantantibus organis*

*Although Lefebure's place of birth is unknown, his name was and still is common in the southern Netherlands, according to Ignace Bvossuyt (email, 24 January 2020); see Renate Weytens, "Johannes Le Febure and the *Fasciculus Sacrarum Cantionum*" (essay accompanying the CD *Johannes Le Febure: Motetten*, Eufoda 1273, 1999).

The extreme brevity of the music (only thirteen breves) suggests strongly that Lassus, Kapellmeister at the Bavarian court, wrote it specifically for the print.[104] (This was only one of several contributions by Lasso and his family to the Franco-Flemish Cecilian tradition. We have seen already that he competed at the Puy d'Évreux, twice winning the silver organ. He wrote two full-length Cecilian motets; his sons Ferdinand and Rudolph wrote four more.)

The engraver identified himself as "Joan. Sad. Belg.": the same Jan Sadeler who worked with Martin de Vos and Daniel Raymundi on *Fiat cor meum et corpus meum*. He dedicated the print to Maria Anna, daughter of Duke William V of Bavaria. Though undated, the dedication allows us to date the print to Sadeler's period of employment at the Bavarian court. He was Lassus's colleague in Munich from 1588 until the composer's death in 1594. He engraved a portrait of the composer, showing him as he looked in 1593. Perhaps Lassus wrote *Laudent Deum cithara* in exchange for, or in gratitude for, the portrait.

The print is based on a painting by Peter Candid (also known as Peter de Witte and Pietro Candido). Candid was born in Bruges around 1548 and moved with his family to Florence at the age of ten. In 1586 Duke William engaged him

as court painter in Munich, where he remained for the rest of his life. Although Candid received most of his artistic training in Italy, the print identifies him by his country of birth: "Petr. Candid' Belg. pinxit."[105]

The print thus refers to all three of the artists who produced it—the painter, the composer, and the engraver—as natives of the southern Netherlands who had left their homeland. The repeated abbreviation "Belg." reminds us that Cecilia, as a patron of musicians and as a musician, was herself mostly "belgica." During the roughly six decades that preceded the making of Sadeler's print, composers in the Netherlands and northern France strengthened her status as a patron of musicians with their motets, especially those that referred to her love of music. The migration of Flemish artists and musicians to other parts of Europe, in turn, encouraged the spread of the cult of the musical Cecilia, of which Sadeler's print is but one of many manifestations.

Franco-Flemish Cecilian Motets: Words and Music

After discussing, in chapter 4, the context of the motets that French and Flemish musicians wrote in honor of Cecilia in the sixteenth century (why they wrote them, and for whom), in this chapter I look more closely at the motets themselves, as listed in table 5.1. Here I follow in the footsteps of many students of medieval and Renaissance music who have focused their attention on motets written in honor of a single saint.[1] I will take into account not only works by musicians (listed in table 4.1) who spent most or all of their lives in France or the Netherlands, but also two anonymous motets preserved in sources that suggest French or Flemish origin and works by Franco-Flemish composers who spent most of their careers outside their homelands, such as Lassus, Rore, and Monte.

TEXTS

In selecting the text of music for Cecilia, composers had many options, which we might classify as liturgical, para-liturgical, and non-liturgical. Liturgical texts are those taken directly from the Cecilian liturgy. The Office, in particular Vespers, Matins, and Lauds, provided most of the liturgical texts used for motets. (In assigning a motet text to a particular place in the liturgy, we have to keep in mind that in the sixteenth century, as earlier, the liturgy varied from place to place, and from one institution to another; also that—as mentioned in chapter 4—motets with liturgical texts were not necessarily sung as part of the liturgy.) Para-liturgical texts are those based on or derived from the liturgy, but with changes that go beyond the minor alterations that liturgical texts often

TABLE 5.1. Sixteenth-century Franco-Flemish Cecilian motets in roughly chronological order

Year of first publication (with RISM number*) or date of manuscript (with library siglum and call number)	Composer	Motet
1520–1530 (I-Bc, Q.27/2)	Anonymous	*Cantantibus organis*
ca. 1530 (I-Bc, R142)	Jacquet of Mantua	*Inclita sanctae virginis*
1532[11]	Loyset Piéton	*Sponsa Christi Cecilia*
1532[11]	Nicolas Pagnier	*Gloriosa virgo Cecilia*
1539[10]	Carette	*Cantantibus organis*
1539[10]	Carette	*Laudemus Dominum*
1539[10]	Hugier	*Cecilia virgo me misit*
1539[11]	Hubert Naich or Nicolas Gombert	*Cantibus organicis*
1539 (J 9)	Jacquet of Mantua	*Cantantibus organis*
1539 (M 269)	Pierre de Manchicourt	*Cantantibus organis*
1541 (G 2984)	Gombert	*Ceciliam cantate pii*
1542[7]	Cornelius Canis	*Ceciliam intra cubiculum*
1542 (C 1707)	Pierre Certon	*Cantantibus organis*
1542 (C 1707)	Certon	*Cecilia virgo gloriosa*
1544 (B 4185)	Simon Boyleau	*Ceciliam intra cubiculum*
1545[2]	Canis	*O beata Cecilia*
1545 (R 2474)	Cipirano de Rore	*Cantantibus organis*
1546 (B-LVu MS 163)	Christian Hollander	*Dum aurora finem daret* (not extant)
1546 (M 3716)	Antoine de Mornable	*Domine Jesu Christe*
1547[6]	Jacobus Clemens non Papa	*Cecilia virgo gloriosa*
1548[2]	Thomas Crecquillon	*Virgo gloriosa / Cantantibus organis*
1549 (NL-L MS 1438)	Crecquillon	*Domine Jesu Christe*
ca. 1549 (B-Bc MS 27088)	Anonymous	*Dum aurora finem daret*
1550–75 (A-Wn, Mus. Hs. 19189)	Ludovicus Episcopius	*O beata Cecilia*
1551[1]	Jean Maillard	*Domine Jesu Christe*
1552 (GB WA, B. VI. 23)	Petit Jean De Latre	*Cantantibus organis*
1553[10]	Manchicourt	*Ave virgo Cecilia beata*
1553[16]	Jean Crespel	*Cecilia ex praeclaro genere*
1554[1]	Crecquillon	*Dum aurora finem daret*
1554[2]	Jacob Bultel	*Dum aurora finem daret*
1554[5]	Crecquillon	*Ave virgo gloriosa*

Year of first publication (with RISM number*) or date of manuscript (with library siglum and call number)	Composer	Motet
1554[8]	Crecquillon	*Virgo gloriosa / Domine Jesu Christe*
1554[15]	Canis	*Virgo gloriosa*
1554[15]	Antonius Galli	*Ceciliae laudes celebremus*
1555[8]	Philippe Gheens	*Cantantibus organis*
1555 (M 179)	Maillard	*Cantantibus organis*
1555 (M 179)	Maillard	*De fructu vitae*
1556[6]	Josquin Baston	*Virgo gloriosa Cecilia*
1557 (K 440)	Jacobus de Kerle	*Cantantibus organis*
1564[1]	Daniel Torquet	*Cantantibus organis*
1565 (M 184)	Maillard	*Dum aurora finem daret*
1566 (B-LVu MS 1050)	Geert van Turnhout	*Virgo gloriosa*
1566 (B-LVu MS 1050)	Turnhout	*Venit autem nox*
1568[4]	Andreas Pevernage	*O virgo generosa*
1568[4]	Jean de Chaynée	*Cecilia in corde suo*
1571 (C 1470)	Jean de Castro	*Cantantibus organis*
1574 (M 3314)	Philippe de Monte	*Cecilia virgo Almachium*
1577 (U 125)	Alexander Utendal	*Cantantibus organis*
1578	Etienne Testart	*Ceciliam intra cubiculum* (not extant)
1578 (P 1669)	Pevernage	*Dum aurora finem daret*
1578 (P 1669)	Pevernage	*Alma patrona veni*
1578 (P 1669)	Pevernage	*Ceciliae gaudete*
1578 (P 1669)	Pevernage	*Ducite festivos Musae*
1578 (P 1669)	Pevernage	*Ecce triumphali revolutis*
1578 (P 1669)	Pevernage	*Nectite Ceciliae*
1578 (P 1669)	Pevernage	*Plaudite: Cecilia*
1578 (P 1669)	Pevernage	*Solemnis redit ecce dies*
1580 (C 3945)	Séverin Cornet	*Cantantibus organis*
1582 (L 939)	Orlande de Lassus	*Cantantibus organis*
1585	François Habert	*Dum aurora finem daret* (not extant)
1585 (L 958)	O. de Lassus	*Domine Jesu Christe*
ca. 1585	Daniel Raymundi	*Fiat cor meum* (picture motet)
1586 (G 164)	François Gallet	*Benedicta es, virgo Cecilia*

(continued)

TABLE 5.1. (*continued*)

Year of first publication (with RISM number*) or date of manuscript (with library siglum and call number)	Composer	Motet
1587	Abraham Fourdy	*Dum aurora finem daret* (not extant)
1588	Daniel Guichart	*Dum aurora finem daret* (not extant)
1588	Nicolas Vauquet	*Dum aurora finem daret* (not extant)
1588 (C 1478)	Jean de Castro	*Cantantibus organis*
1588 (L 753)	Ferdinand de Lassus	*Dum aurora finem daret*
1589 (M 2196)	Rinaldo del Mel	*Cantantibus organis*
ca. 1593	Cornelis Schuyt	*Domine fiant anima mea*
1593 (S 394)	Franz Sales	*Cantantibus organis*
1594 (T 1436)	Jan van Turnhout	*O virgo generosa*
1595 (R 1936)	Philippe Rogier	*Cantantibus organis*
1596 (M 3325)	Philippe de Monte	*Cilicio Cecilia membra domabat*
1597[3]	F. de Lassus	*Cantantibus organis*
1597[3]	F. de Lassus	*Cecilia virgo gloriosa*

*RISM numbers for anthologies consist of the year of publication and a superscript number; RISM numbers for publications of works by one composer are preceded by the first letter of the composer's surname.

underwent when being set to music. Non-liturgical texts, some of which we have already seen and discussed in chapter 4, are often in verse. Some refer to Cecilia's love of music, some address her as patron and plead for her intercession, while some celebrate the election of princes of a Cecilian confraternity.

As we saw in chapter 1, the words "cantantibus organis" originally appeared in the fifth century AD in Arnobius's *Passio sanctae Caeciliae*. In the liturgy, the passage in which they occur was declaimed several times, most often as a responsory in Matins and (in an abbreviated form) as an antiphon in Lauds and Second Vespers. These chants, as recorded in the Beaupré Antiphonary, are transcribed in chapter 1; they continued to be sung during the Renaissance. Here are the texts alone, based on a source published slightly earlier than the earliest surviving motets, an edition of the *Breviarium Romanum* printed in Paris in 1531:

RESPONSORY (CANTUS ID 006267, 006267A)

[Respond:] Cantantibus organis cecilia virgo in corde suo soli domino decantabat dicens. Fiat domine cor meum et corpus meum immaculatum ut non confundar. [Verse:] Biduanis ac triduanis ieiuniis orans: commendabat domino quod timebat. [*Repetendum*:] Fiat.[2]

While the instruments sang, Cecilia the virgin sang in her heart to the Lord alone, saying: "Lord, let my heart and my body be made pure, that I may not be confounded." Fasting every two and every three days, she prayed, commending herself to the Lord, because she was afraid. "Lord, let my heart and my body be made pure, that I may not be confounded."

ANTIPHON (CANTUS ID 001761)

Cantantibus organis cecilia domino decantabat dicens fiat cor meum domine immaculatum ut non confundar.

While the instruments sang, Cecilia sang to the Lord, saying: "Let my heart be made pure, Lord, that I may not be confounded."

The antiphon differs from the respond in lacking the words "virgo in corde suo soli" and "corpus meum." But a variant of the respond that seems to have been widespread in the second half of the sixteenth century blurs the difference between the texts because it too lacks "in corde suo":

Cantantibus organis: cecilia virgo soli domino decantabat dicens: Fiat domine cor meum et corpus meum immaculatum ut non confundar.[3]

While the instruments sang, Cecilia the virgin sang to the Lord alone, saying: "Lord, let my heart and my body be made pure, that I may not be confounded."

Since the words "cantantibus organis" played such an important role in the early stages of the process by which Cecilia became associated with music, it is fitting that texts that include them should be particularly attractive to musicians, who wrote no fewer than twenty-three works in which they appear (table 5.2). The popularity of this text among composers probably owed something to Cecilia's paraphrase, in her prayer, of a verse from Psalm 118, to which many composers turned during the sixteenth century as a source of motet texts.[4]

Some of these motets are settings of the whole responsory (including the version with the abbreviated respond), some of the respond only, and some of the antiphon. The table shows that composers much preferred the two versions of the responsory to the antiphon. Eight motets, by Jacquet, Rore, Maillard, Gheens, Kerle, Castro (two settings), and Sales, use the whole responsory text, with its distinctive AB/CB form. Other composers set the respond only, in the form of a single movement—either a complete motet (De Latre, Mel, Rogier, Torquet, Utendal) or part of a two-movement work (Carette, Crecquillon, Manchicourt). A few others, in setting the respond to music, divided it into two parts: in the motets of Cornet, Lassus, and his son Ferdinand, the *secunda pars* consists of Cecilia's prayer.

Missing from table 5.2 is Chaynée's *Cecilia in corde suo*: a setting of the respond

TABLE 5.2. Motets that include the phrase "Cantantibus organis" in roughly chronological order

Composer	Text incipit(s) (part 1 / part 2)	Source of text with "Cantantibus organis"
Anonymous	*Cantantibus organis / Fiat cor meum*	Antiphon
Carette	*Cantantibus organis / Cecilia virgo*	Responsory (respond only, shorter version)
Jacquet	*Cantantibus organis / Biduanis ac triduanis*	Responsory (shorter version)
Manchicourt	*Cantantibus organis / Cecilia virgo*	Responsory (respond only, shorter version)
Certon	*Cantantibus organis / Benedico te*	Antiphon
Rore	*Cantantibus organis / Biduanis ac triduanis*	Responsory
Crecquillon	*Virgo gloriosa / Cantantibus organis*	Responsory (respond only, shorter version)
Episcopius	*O beata Cecilia / Cilicio induta*	Non-liturgical text quoting "cantantibus organis"; see table 5.16
De Latre	*Cantantibus organis*	Responsory (respond only)
Manchicourt	*Ave virgo Cecilia beata / Ave virgo prudens*	Responsory (free adaptation, shorter version)
Gheens	*Cantantibus organis / Biduanis ac triduanis*	Responsory
Maillard	*Cantantibus organis / Biduanis ac triduanis*	Responsory
Kerle	*Cantantibus organis / Biduanis ac triduanis*	Responsory (shorter version)
Torquet	*Cantantibus organis*	Responsory (respond only, shorter version)
Castro (1571)	*Cantantibus organis / Biduanis ac triduanis*	Responsory
Utendal	*Cantantibus organis*	Responsory (respond only)
Cornet	*Cantantibus organis / Fiat cor meum*	Responsory (respond only)
O. de Lassus	*Cantantibus organis / Fiat Domine cor meum*	Responsory (respond only, shorter version)
Castro (1588)	*Cantantibus organis / Biduanis ac triduanis*	Responsory
Mel	*Cantantibus organis*	Responsory (shorter version)
Sales	*Cantantibus organis / Biduanis ac triduanis*	Responsory
Rogier	*Cantantibus organis*	Responsory (respond only)
F. de Lassus	*Cantantibus organis / Fiat Domine cor meum*	Responsory (respond only, shorter version)

Cantantibus organis, but strangely without its opening words! It presents the respond in a single movement, and adds an appeal to Cecilia at the end:

> Cecilia in corde suo soli Domino decantabat dicens: "Fiat tibi [*sic!*] Domine cor meum immaculatum, ut non confundar." Sancta Cecilia, ora pro nobis.

> *In her heart Cecilia sang to the Lord alone, saying: "Let my heart be made pure for you, Lord, that I may not be confounded." St. Cecilia, pray for us.*

Chaynée's motet takes us into the realm of the para-liturgical, represented on a larger scale in Piéton's *Sponsa Christi Cecilia*. This text (including its AB/CB form) is clearly based on that of the responsory *Cantantibus organis*, yet many of the words have been changed. Moreover, in the *secunda pars*, whoever compiled

the text mistakenly attributed to Cecilia words spoken, according to Arnobius, by Pope Urban ("Domine Jesu Christe . . . seminasti"):

[Part 1] Sponsa Christi Cecilia psallentibus organis ferventer orabat, suamque pudicitiam Domino toto corde commendabat, et dicebat: "Fiat cor meum et corpus meum immaculatum, ut non confundar." [Part 2] Biduanis ac triduanis jejuniis, devotissimis precibus orabat dicens: "Domine Jesu Christe, pastor bone, seminator casti consilii, suscipe seminum fructus quos in Cecilia seminasti, et fiat cor meum et corpus meum immaculatum, ut non confundar."

Cecilia the bride of Christ, while the instruments sang, prayed fervently, commended her chastity to the Lord with all her heart, and said: "Let my heart and my body be made pure, that I may not be confounded." Fasting every two and every three days, with the most devout prayers she prayed, saying: "Lord Jesus Christ, good shepherd, planter of good advice, take the fruit of the seeds you planted in Cecilia, and let my heart and my body be made pure, that I may not be confounded."

Another para-liturgical text based on the responsory was set to music by Manchicourt as part 2 of *Ave virgo Cecilia beata*:

Ave virgo prudens, quae cantantibus organis soli Domino decantabat: "Fiat cor meum et corpus meum immaculatum, ut non confundar."

Hail wise virgin, who, while the instruments were singing, sang to the Lord alone: "Let my heart and my body be made pure, that I may not be confounded."

Settings of the antiphon *Cantantibus organis* are much rarer than settings of the respond. For Certon the antiphon was the first of two that serve as the text of part 1 of his unusually long *Cantantibus organis*. The anonymous composer of the *Cantantibus organis* that survives as a fragment in the manuscript I-Bc Q.27 divided the antiphon into two parts, setting the first as the *prima pars* and the second as the *secunda pars* (*Fiat cor meum*).

I referred in chapter 4 to settings of texts beginning *Virgo gloriosa semper evangelium Christi*: a respond and an antiphon that, as preserved in the *Breviarium Romanum* of 1531, differ only slightly:

RESPOND (CANTUS ID 007902)

Virgo gloriosa semper evangelium Christi gerebat in pectore suo: et non diebus neque noctibus vacabat a colloquiis divinis et oratione. [Verse: *Est secretum Valeriane* (Cantus ID 007902a)]

The glorious virgin always bore the gospel of Christ near her heart, and neither day nor night did she cease sacred conversation and prayer.

TABLE 5.3. Motets with text derived (in whole or in part) from *Virgo gloriosa* (respond or antiphon)

Composer	Text incipit(s) (part 1 / part 2)
Pagnier	*Gloriosa virgo Cecilia / Dum aurora finem daret*
Manchicourt	*Cantantibus organis / Cecilia virgo gloriosa*
Carette	*Cantantibus organis / Cecilia virgo gloriosa*
Certon	*Cecilia virgo gloriosa / Dum aurora finem daret*
Clemens	*Cecilia virgo gloriosa / Biduanis ac triduanis*
Crecquillon	*Virgo gloriosa / Cantantibus organis*
Crecquillon	*Virgo gloriosa / Domine Jesu Christe*
Canis	*Virgo gloriosa / Cilicio Cecilia*
Baston	*Virgo gloriosa Cecilia / Biduanis ac triduanis*
G. van Turnhout	*Virgo gloriosa / Domine Jesu Christe*
F. de Lassus	*Cecilia virgo gloriosa*

ANTIPHON (CANTUS ID 005451)

Virgo gloriosa semper evangelium Christi gerebat in pectore suo: et non diebus neque noctibus a colloquiis divinis et oratione cessabat.

[The translation of the respond applies here as well.]

The responsory *Virgo gloriosa* is highly variable. In some sources it continues with verses other than *Est secretum Valeriane*, including *Cantantibus organis* (Cantus ID 007902zb; see ex. 1.2) and *Cilicio Cecilia* (Cantus ID 007902b). This variability helps account for the wide variety of motet texts that include the words "*Virgo gloriosa.*"

At least eleven motets contain settings of some version of the respond or antiphon *Virgo gloriosa* (table 5.3), often adding Cecilia's name before or after the first two words. When writing motets in honor of a saint, composers generally preferred texts in which the saint is named in the first phrase. In setting *Virgo gloriosa*, they were often willing to depart from the liturgical texts (which do not include Cecilia's name) so that performers and listeners would know right away that these motets honored not just any glorious virgin, but Cecilia in particular.

Yet another Cecilian text that inspired many composers is *Dum aurora finem daret*, which served widely as the antiphon for the Benedictus in Lauds on Cecilia's Day and as a respond in Matins. Like the passage beginning "Cantantibus organis," this one quotes Cecilia directly—and again she paraphrases a Bible verse (Romans 13:12). Here is the respond (Cantus ID 006531), as recorded in the *Breviarium Romanum* of 1531; the antiphon (Cantus ID 002437) in the same source differs only in having "exclamavit dicens" instead of "dixit."

TABLE 5.4. Motets that include the phrase "Dum aurora finem daret"

Composer	Text incipit(s) (part 1 / part 2)
Pagnier	*Gloriosa virgo Cecilia / Dum aurora finem daret*
Certon	*Cecilia virgo gloriosa / Dum aurora finem daret*
Mornable	*Domine Jesu Christe / Dum aurora finem daret*
Hollander	*Dum aurora finem daret*
Crecquillon	*Domine Jesu Christe / Dum aurora finem daret*
Anonymous	*Dum aurora finem daret*
Crecquillon	*Dum aurora finem daret*
Bultel	*Dum aurora finem daret*
Maillard	*Dum aurora finem daret / O beata Cecilia*
Pevernage	*Dum aurora finem daret / Cecilia virgo, valedicens*
Habert	*Dum aurora finem daret* (winner at Évreux)
Fourdy	*Dum aurora finem daret* (winner at Évreux)
F. de Lassus	*Dum aurora finem daret*
Vauquet	*Dum aurora finem daret* (winner at Évreux)
Guichart	*Dum aurora finem daret* (winner at Évreux)

Dum aurora finem daret cecilia dixit. Eia milites Christi abiicite opera tenebrarum: et induimini arma lucis. [Verse: *Cecilia valedicens fratribus*]

While dawn was bringing an end [to the night], Cecilia said: "Arise, soldiers of Christ, cast off the works of darkness and put on the armor of light."

Composers evidently considered this wonderfully evocative text self sufficient in a way that other Cecilian responds and antiphons of similar length were not (table 5.4). It caused them to break out of their habit of composing motets in two parts and to write works in a single movement, but on a grand scale: the anonymous setting in the manuscript B-Bc 27088 and the settings by Bultel and Crecquillon.[5] This text was a particular favorite of those competing at the Puy d'Évreux; four settings (alas, no longer extant) won prizes.

The length of texts, as roughly quantified by the number of words, varies greatly, from fifteen (the anonymous *Cantantibus organis* in I-Bc Q.27) to eighty-one (*Plaudite: Cecilia*, as set to music by Pevernage). The length is closely related to the classification of texts proposed earlier. Limiting ourselves, for the sake of comparison, to motets in two parts, liturgical texts tend to be the shortest. The three texts set by Canis, all liturgical, range from thirty-two to thirty-eight words. Gallet's *Benedicta es, virgo Cecilia* (a setting of excerpts from a sequence for Cecilia's Day) has thirty-six words. At the other extreme are non-liturgical

texts in verse, most of which have over sixty words. Prolix neo-Latin poems in elegiac couplets or dactylic hexameters forced Gombert, Galli, and Pevernage to choose between two compositional strategies: writing very long works (Gombert's choice in *Ceciliam cantate pii*, the text of which is transcribed in chapter 4) or moving through the words at an unusually fast pace (as Pevernage did in the *elogia* for Kortrijk's Confraternity of St. Cecilia).

But one of the strangest non-liturgical texts is quite short. Maillard included in his first book of motets (Paris, 1555) a piece that makes no explicit reference to Cecilia. Four voices declaim the main text, addressed to an unnamed woman—

> De fructu vitae non gustabit cor tuum, nec sub umbra alarum mearum protegeris in aeternum. Nam virgineum decus futuro sponso immaculatum custodiam in seculum seculi

> *Your heart will not taste the fruit of life, nor will you be protected eternally under the shadow of my wings. For I will keep your virginal purity immaculate for your future husband forever and ever*

—while the quinta pars sings a cantus firmus on different words:

> Fiat cor meum et corpus meum immaculatum, ut non confundar.

The notation of the cantus firmus (fig. 5.1) is enigmatic. A riddle, "Everything comes at the right time to those who know how to wait," contains clues as to how to interpret the notes. As Katelijne Schiltz has explained, the word *poinct* is a pun that tells the quinta pars to add a dot to each note, increasing its length by half; the singer who "knows how to wait" has to work out the length of the rests to be added before and between the segments of the cantus firmus.[6] The text of the cantus firmus is less puzzling. This is Cecilia's wedding prayer.[7] It suggests that the main text is God's response to the prayer, in which he foretells her death by martyrdom and her marriage to Christ. The melody of the cantus firmus resembles that of *Conditor alme siderum*, the hymn for the First Sunday in Advent. That Sunday sometimes falls on 29 November, the octave of Cecilia's Day. Perhaps Maillard wrote this motet for performance on such an occasion, when allusions to both Cecilia and Advent would be suitable.

EXISTING MELODIES IN CECILIAN MOTETS

Composers rarely quoted directly or even paraphrased from the Cecilian chants to which many of the texts had been sung for centuries and continued to be sung

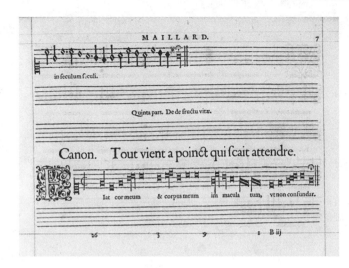

FIGURE 5.1. The quinta pars of Maillard's *De fructu vitae*. Cantus firmus with a version of Cecilia's wedding prayer in enigmatic notation, in *Ioannis Maillardi musici excellentissimi moteta quatuor, quinque, & sex liber primus*, Paris, 1555. Bibliothèque Nationale de France. Photo: Bibliothèque Nationale de France

in the sixteenth century. They preferred to invent new melodies, but in a style that embodied some of the qualities of plainchant and at the same time facilitated the pervasive imitation that they favored.

We do, on occasion, find melodic parallels between chants and polyphonic settings of the same text. For instance, the *secunda pars* of Mornable's *Domine Jesu Christe*, a setting of the antiphon *Dum aurora finem daret*, begins with a melody (ex. 5.1) loosely based on the chant (shown here in a version that begins with a different word; ex. 5.2). Although *Cantantibus organis* by Ferdinand de Lassus is a setting of the (abbreviated) respond, its opening paraphrases the beginning of the plainchant antiphon that begins with the same words.[8] But the significance of such parallels is sometimes open to question. In the anonymous *Dum aurora finem daret* in eight voices, preserved in a manuscript copied around 1549, one of the voices enters with a melody that leaps up a fourth, then continues up by step (ex. 5.3). The composer could have taken the beginning of the tune from a version of the responsory *Dum aurora finem daret* (also preserved with the text *Dum aurora nocti finem daret*; ex. 5.4). But he could just as easily have borrowed it from the opening of a Cecilian motet, *Cecilia virgo gloriosa* by Clemens, first published in 1547 (ex. 5.5). The melody by Clemens is as close to the chant as the melody in the anonymous *Dum aurora*; yet Clemens, setting a different text, had no reason to paraphrase this chant. The ascending leap of a fourth from C to F helps establish the anonymous motet's *Ut* tonality with an F final. (Here and henceforth I adopt the terminology for denoting sixteenth-century tonality proposed by Cristle Collins Judd.[9]) Tonality-defining leaps of a fourth or a fifth are common at the beginning of sixteenth-century motets, regardless of their texts. The composer of *Dum aurora* could have invented the opening melody without knowledge of either the chant or the motet by Clemens.

EXAMPLE 5.1. Antoine de Mornable, *Domine Jesu Christe*, part 2, breves 1–5, superius. Source: *Antonij Mornable doctissimi musici motetorum musicalium, liber primus* (Paris, 1546); RISM M 3716

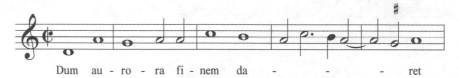

Dum au - ro - ra fi - nem da - - - ret

EXAMPLE 5.2. Beginning of *Cum aurora finem daret*, antiphon for Lauds on Cecilia's Day (Cantus ID 002437). Source: NL-Uu, Ms. 406 (shelfmark 3 J 7), as transcribed in the Cantus database

Cum au - ro - ra fi - nem___ da - ret

EXAMPLE 5.3. Anonymous, *Dum aurora finem daret*, tenor [1], breves 1–5. Source: B-Bc MS 27088

Dum au - ro - ra fi - nem da - ret

EXAMPLE 5.4. Beginning of the responsory *Dum aurora nocti finem daret* (Cantus ID 006531). Source: CH-E, MS 611

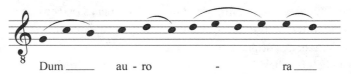

Dum___ au - ro - ra___

EXAMPLE 5.5. Jacobus Clemens non Papa, *Cecilia virgo gloriosa*, part 1, superius, breves 1–3. Source: *CMM* 4.9

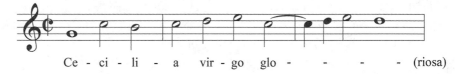

Ce - ci - li - a vir - go glo - - - (riosa)

One of the few unambiguous quotations of plainsong is in a setting of a text associated with a very well-known chant. In chapter 1 we encountered *Benedicta es, virgo Cecilia*, a sequence for the Cecilia's Day Mass sung to the tune of the Annunciation sequence *Benedicta es, caelorum regina*. The latter served as the basis for motets by Prioris, Josquin, Mouton, Willaert, and Gombert, all of whom incorporated its melody into their music. Josquin's setting, first published in 1520 in an edition that contributed greatly to his popularity among German singers and music publishers,[10] fascinated his successors, who elaborated it in various ways. They added extra parts to his already perfectly balanced counterpoint, composed

EXAMPLE 5.6. Josquin des Prez, *Benedicta es, caelorum regina*, part 1, breves 1–11. Source: *Liber selectarum cantionum . . . sex quinque et quatuor vocum* (Augsburg, 1520); RISM 1520[4]

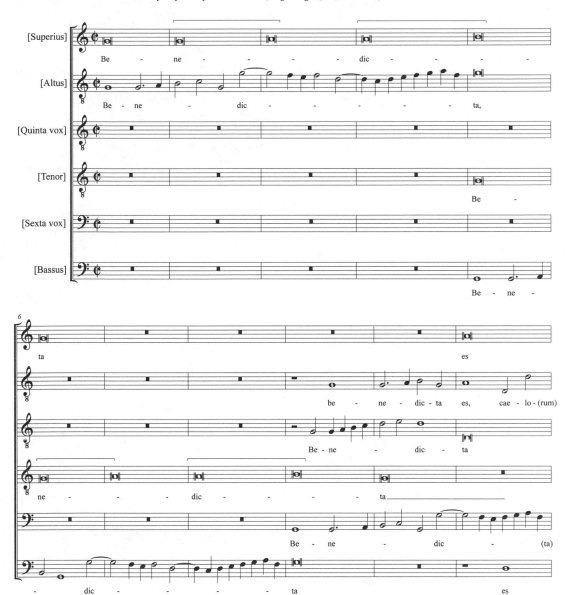

parody Masses, and arranged the music for lute and keyboard. Josquin's opening duets, with the first notes of the sequence in breves and florid counterpoint below, must have been familiar to musicians all over Europe (ex. 5.6).

The only polyphonic setting of the Cecilian version of the sequence is a six-voice motet by Gallet.[11] Born in Mons (the hometown of Lassus) around 1555, Gallet studied at a Jesuit college near Douai and served as a chaplain in Douai during the early 1580s. He was thus a product of the same region, along the border of the Netherlands and France, into which Josquin was born about a cen-

EXAMPLE 5.7. François Gallet, *Benedicta es, virgo Cecilia*, part 1, breves 1–9. Source: *Sacrae cantiones quinque, sex, et plurium vocum* (Douai, 1586); RISM G 164

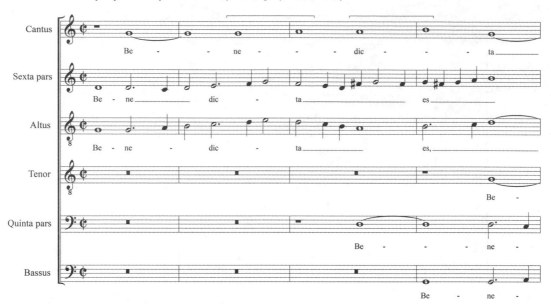

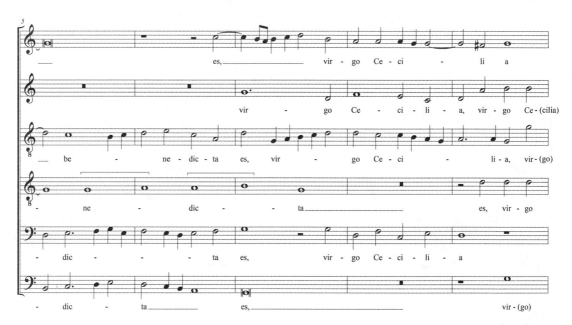

tury earlier. In *Benedicta es, virgo Cecilia*, published in 1586, he demonstrated an intense awareness of his musical heritage. This is a late contribution to the series of musical homages to Josquin's motet. Its *Ut* tonality with G final and statements in the cantus and tenor of the first notes of the sequence allude less to the plainchant than to Josquin's masterpiece (ex. 5.7). Gallet's appropriation and reworking, in transforming Marian music into Cecilian music, is marred by some signs of inexperience (such as the parallel octaves between cantus and

altus at the first cadence); but it attractively exemplifies the role that Cecilia played in the Netherlands and northern France in joining (and to some extent replacing) the Virgin Mary as patron of professional musicians.

Another kind of existing melody that found its way into Cecilian polyphony came from the Litany of the Saints: a prayer for intercession addressed to a series of saints, the name of each followed by the supplication "ora pro nobis," sung to a chant consisting of a repeated melodic formula. Appeals to Cecilia caused composers to incorporate no fewer than three different Litany formulas into their motets.

Crecquillon's *Virgo gloriosa / Domine Jesu Christe, pastor bone*, published in 1554, is a setting of two antiphons, to the second of which are appended the words "Sancta Cecilia, ora pro nobis." Crecquillon set them using a Litany formula close to one sung in the Cathedral of Our Lady in Antwerp (ex. 5.8), where the singers enjoyed a long tradition of observing Cecilia's Day with food and wine. Martin Ham called attention to the Litany chant at the end of *Virgo gloriosa*: "The chant quotation is accompanied by particularly active part writing which would have been entirely appropriate for a piece addressed to the patroness of musicians."[12] The plainsong is strongly anchored in mode 1, to which the motet's *Re* tonality constitutes a close analogy. We might assume that the chant would play a crucial role in the final authentic cadence on D. But Crecquillon presented the chant (in the superius) on A, not D, probably with the expectation that the motet, with its high clefs, would be sung a fifth lower than written (ex. 5.9).

Crecquillon's use of the Antwerp Litany formula is not the only aspect of *Virgo gloriosa / Domine Jesu Christe* that connects it with the Cathedral of Our Lady. In addition to the printed sources in which it is preserved, part of Crecquillon's motet also survives in a manuscript (a single bass partbook) that was probably copied for the cathedral.[13] That manuscript, dated 1566, also contains fragments of two Cecilian motets by Geert van Turnhout. One of those works, *Virgo gloriosa*, is a setting of the same text as in Crecquillon's motet, and it uses the same Litany formula, also at the end. Turnhout served as chapelmaster in the cathedral in Antwerp, so we might expect him to have made use of that church's Litany formula. The bass partbook presents the melody on D (fig. 5.2).

The end of Pevernage's *O virgo generosa*, the only motet scored for seven voices (on a devotional poem also set to music by Crecquillon, but addressed to St. Christine,[14] and later by Jan van Turnhout), quotes a different Litany formula. This one is recorded in several sixteenth- and seventeenth-century French sources, usually beginning and ending on G (ex. 5.10).[15]

EXAMPLE 5.8. Formula for the Litany of the Saints in *Processionale insignis cathedralis ecclesiae Antverpiensis* (Antwerp, 1574), 99–100, as quoted in CMM 63.6, xxxiii.

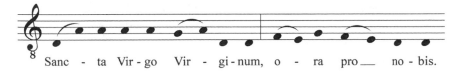

Sanc - ta Vir - go Vir - gi-num, o - ra pro ___ no - bis.

EXAMPLE 5.9. Thomas Crecquillon, *Virgo gloriosa / Domine Jesu Christe*, part 2, breves 63–76: end of motet. Melody from the Litany of the Saints (transposed up a fifth) in the superius. Source: *CMM* 63.13

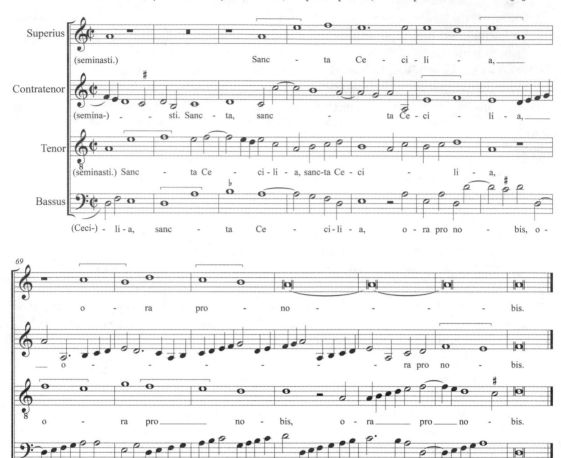

Pevernage understood the Litany's repeated G as a reciting tone a fifth above an implied C final. Since the motet is firmly in *Ut* tonality with an F final, he transposed the formula up a fourth, making it more compatible with the rest of the music. He used capital letters in the text underlay to signal quotations of the Litany formula in whole or in part (ex. 5.11, in which I have tried to use capital letters for this purpose with more consistency than Pevernage and his printer achieved). The Litany formula appears in full only once, at the very end of the contratenor 2 part.

The same chant pervades the end of Jan van Turnhout's eight-voice setting of the same text, published in 1594 in a book of motets dedicated to King Philip II of Spain.[16] The passage, like Pevernage's, is preceded by a rest in all the parts; it begins with a homorhythmic phrase for the full choir and the first phrase of the Litany declaimed in the highest voice.

Utendal used this Litany formula, but in a completely different way, in his

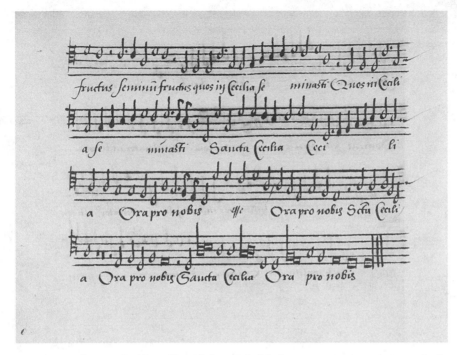

FIGURE 5.2. Geert van Turnhout, *Virgo gloriosa*. End of the bassus voice in a manuscript partbook. KU Leuven Libraries, Special Collections, MS 1050, fol. 31r, showing Turnhout's use of a Litany formula similar to that of Antwerp Cathedral. Photo: KU Leuven Libraries

EXAMPLE 5.10. Litany formula from *Processionale ad usum prioratus Sancti Martini de Campis Parisiensis* (F-Pn, MS Latin 1124, fol. 18v)

brief six-voice *Cantantibus organis*. Probably inspired by the five-voice *Andreas Christi famulus* by Cristóbal de Morales, in which the Litany serves as an ostinato, Utendal's sexta vox repeats the formula throughout the motet, mostly floating above the other voices in the highest voice part, but occasionally sinking below the discantus (fig. 5.3).[17] Like Morales, Utendal presented the Litany with the reciting tone on D and G in alternation; but unlike Morales, he presented it haphazardly, stating phrases once or twice, using a variety of rhythmic values and rests, and shifting unpredictably between the two reciting tones.

 Chaynée used a third Litany formula at the end of *Cecilia in corde suo*, once again in response to the words "Sancta Cecilia, ora pro nobis." As in Pevernage's motet, the chant sounds in full in a single voice: the altus declaims it in semibreves throughout, while the other three voices embroider a polyphonic fabric above and below.[18]

EXAMPLE 5.11. Andreas Pevernage, *O virgo generosa*, part 2, breves 60–77 (end of motet). Capital letters mark music from the Litany formula transcribed in ex. 5.10. Source: *RRMR* 154, with minor emendations in the use of capital letters

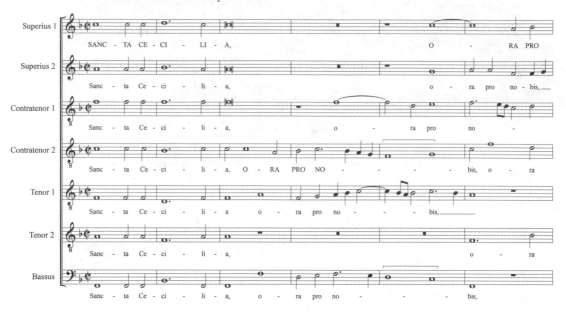

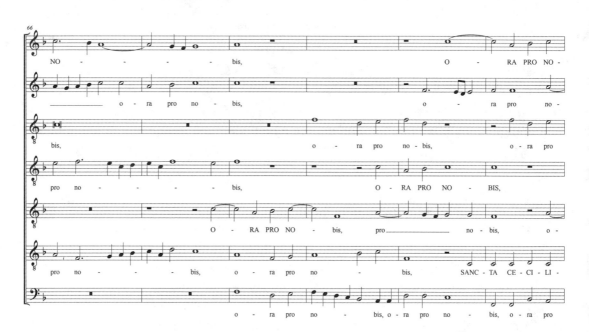

POINTS OF IMITATION

Like most sixteenth-century motets, those in honor of Cecilia typically consist of segments, each of which constitutes a verbal as well as a musical unit. In each segment a different verbal phrase is set to music distinctive in its melodic material and contrapuntal techniques. Most of these segments begin with the voices

EXAMPLE 5.11 *(continued)*

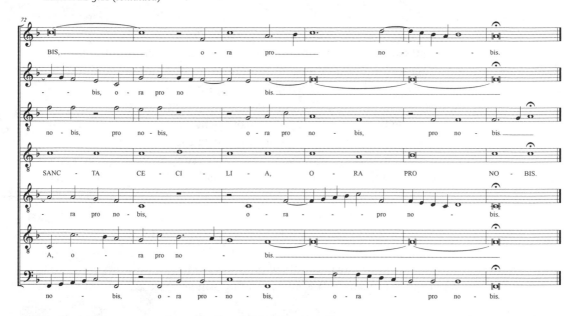

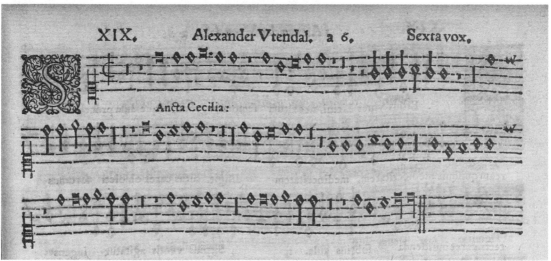

FIGURE 5.3. Alexander Utendal, *Cantantibus organis*, published in *Liber tertius sacrarum cantionum* (Nuremberg, 1577). Bayerische Staatsbibliothek, Munich. Sexta vox with cantus firmus based on Litany formula close to the one in example 5.10. Photo: Bayerische Staatsbibliothek, Munich

entering one after another and end with a cadence. Many musicians call these segments "points of imitation" ("points" for short), despite the lack of imitative textures in some of them.

Composers clearly wanted listeners to perceive the differences, both verbal and musical, between points. At the same time they valued continuity, and to achieve it they usually arranged points so that one begins before the previous one has ended. Even so, the beginning of a point is almost always easy to identify, announced by the simultaneous appearance of a new word and a new melodic

idea—what Italian theorists called a *soggetto*. The end of a point is often more ambiguous, because the finality signaled by the cadence is often undercut by a continuation of the point in one or more of the voices.

The number of points in a movement varies greatly, from two (in part 2 of Cornet's very short *Cantantibus organis*) to fifteen (in part 2 of Gombert's very long *Ceciliam cantate pii* and part 2 of Pevernage's *Plaudite: Cecilia*). Yet if we ignore these outliers, we find that a majority of movements consist of five, six, or seven points, with the largest number of movements consisting of six points.[19]

Cecilian motets differ a great deal in the mean length of their points. In works with an unusually large number of points (such as the *elogia* by Pevernage), those points tend to be shorter than usual. The length of points affects what we might call the music's pace: the rate at which its musical-verbal argument unfolds. For example, the anonymous *Dum aurora finem daret* and the setting of the same text by Bultel (both in a single *pars*) have unusually long points, contributing to the sense of grandeur and spaciousness that both motets convey. In contrast, the exceptional brevity of points in the first movements of Castro's two settings of *Cantantibus organis* results in brilliant cascades of contrasting effects.

The number of words that composers set to music as a single point varied little: the large majority of points have three or four words. Composers seem to have regarded the approximate number of words per point as a given, and adjusted other aspects of the work—the number of movements, the number and length of points—to accommodate the distribution of words. The number of words per point tends to be predictable even in otherwise extraordinary works. For example, part 1 of Pevernage's *Alma patrona veni* has an exceptionally large number of words (37) and an unusually large number of points (11), each of which is extremely short (averaging five breves); but the mean number of words per point (3.4) is close to that of the majority of Cecilian motets. Composers generally chose texts, and divided them into *partes*, with the intention of further dividing each movement into five, six, or seven points, each consisting of between two and five words.

A text that musicians, if they judged it by these standards, might have considered ideal is *Dum aurora finem daret*. The anonymous setting of this text exemplifies an approach adopted by most composers who set it to music: it consists of a single movement, divided into five points that range from two to four words (table 5.5). Other settings of this text are in a single movement (sometimes the first or second part of a two-part work); they consist of four, five, or six points and distribute the text among those points in a manner similar or identical to that of the anonymous *Dum aurora* (table 5.6).

Settings of *Cantantibus organis*, both the respond and the shorter antiphon, are similarly informed by composers' preference for points consisting of two to five words (table 5.7). Partly because the text is subject, within the liturgy, to more variation than *Dum aurora*, the overall number of points varies more, from five to nine. Yet certain verbal phrases ("Cantantibus organis," "Cecilia virgo," "in corde suo," "Fiat Domine cor meum," the exceptionally long phrase

TABLE 5.5. Anonymous, *Dum aurora finem daret* (B-Bc 27088): distribution of points

Point	Text (number of words)	Location (and length) in breves
1	Dum aurora finem daret, (4)	1–22 (22)
2	Cecilia dixit: (2)	21–33 (13)
3	"Eia milites Christi, (3)	32–42 (11)
4	abjicite opera tenebrarum (3)	42–58 (17)
5	et induimini arma lucis." (4)	57–88 (31)

TABLE 5.6. Settings of *Dum aurora*: distribution of text in points

Composer	Point 1	Point 2	Point 3	Point 4	Point 5	Point 6
Anonymous	Dum aurora finem daret	Cecilia dixit:	"Eia milites Christi,	abjicite opera tenebrarum	et induimini arma lucis."	
Bultel	Dum aurora finem daret, Cecilia dixit:	"Eia milites Christi,	abjicite	opera tenebrarum	et induimini arma lucis."	
Certon*	Dum aurora finem daret,	Cecilia dixit:	"Eia milites Christi,	abjicite opera tenebrarum	et induimini arma lucis."	Alleluia
Crecquillon**	Dum aurora finem daret,	Cecilia sancta dixit:	"Eia milites Christi,	abjicite opera tenebrarum	et induimini arma lucis."	Sancta Cecilia, ora pro nobis.
Crecquillon***	Dum aurora finem daret,	Cecilia dixit:	"Eia milites Christi,	abjicite opera tenebrarum	et induimini arma lucis."	
F. Lassus	Dum aurora finem daret,	Cecilia dixit Valeriano ac Tiburtio fratribus	"Eia milites Christi,	abjicite opera tenebrarum	et induimini arma lucis."	
Maillard	Dum aurora finem daret,	Cecilia dixit:	"Eia milites Christi,	abjicite opera tenebrarum	et induimini arma lucis."	
Mornable**	Dum aurora finem daret, beata Cecilia dixit:	"Eia milites Christi,	abjicite opera tenebrarum	et induimini arma lucis."		
Pagnier****	Dum aurora finem daret,	Cecilia dixit:	"Eia milites Christi,	abjicite opera tenebrarum	et induimini	arma lucis."
Pevernage	Dum aurora finem daret,	Cecilia dixit:	"Eia milites Christi,	abjicite opera tenebrarum	et induimini arma lucis."	

Note: This table is limited to motets that survive complete.

*Part 2 of *Cecilia virgo gloriosa*.

**Part 2 of *Domine Jesu Christe*.

***Motet in a single movement.

****Part 2 of *Gloriosa virgo Cecilia*.

TABLE 5.7. Motets (and motet movements) that begin "Cantantibus organis": distribution of texts in points

Composer	Point 1	Point 2	Point 3	Point 4	Point 5	Point 6	Point 7	Point 8	Point 9
Carette	Cantantibus organis	decantabat Cecilia virgo	soli Domino Deo dicens:	"Fiat Domine cor meum	et corpus meum immaculatum,	ut non confundar."			
Castro (1571)	Cantantibus organis	Cecilia virgo	in corde suo	soli Deo,	soli Domino	decantabat dicens:	"Fiat Domine cor meum et corpus meum immaculatum,	ut non confundar."	
Castro (1588)	Cantantibus	organis	Cecilia virgo	in corde suo	soli Deo	decantabat dicens:	"Fiat Domine cor meum	immaculatum,	ut non confundar."
Certon*	Cantantibus organis	Cecilia virgo	decantabat dicens:	"Fiat cor meum immaculatum,	ut non confundar."				
Cornet**	Cantantibus organis	Cecilia virgo	in corde suo soli Domino	decantabat dicens:	"Fiat cor meum et corpus meum immaculatum,	ut non confundar."			
Crecquillon***	Cantantibus organis	Cecilia virgo	soli Domino decantabat dicens:	"Fiat Domine cor meum	et corpus meum immaculatum,	ut non confundar."			
Gheens	Cantantibus organis	Cecilia virgo in corde suo	soli Domino	decantabat dicens:	"Fiat Domine cor meum	et corpus meum immaculatum,	ut non confundar."		
Jacquet of Mantua	Cantantibus organis	Cecilia virgo	in corde suo soli Domino	decantabat dicens:	"Fiat Domine cor meum	et corpus meum immaculatum,	ut non confundar."		
Lassus, F.**	Cantantibus organis	Cecilia virgo,	cantantibus organis Cecilia virgo	soli Domino	decantabat dicens:	"Fiat Domine cor meum	et corpus meum	immaculatum,	ut non confundar."

	Cantantibus organis	Cecilia virgo,	cantantibus organis	Cecilia virgo	soli Domino	decantabat dicens:	"Fiat Domine cor meum	et corpus meum immaculatum,	ut non confundar."
Lassus, O.,**	Cantantibus organis	Cecilia virgo,	cantantibus organis	Cecilia virgo	soli Domino	decantabat dicens:	"Fiat Domine cor meum	et corpus meum immaculatum,	ut non confundar."
Maillard	Cantantibus organis Cecilia virgo	in corde suo	soli Deo decantabat dicens:	soli Domino	et corpus meum	immaculatum,	"Fiat Domine cor meum	ut non confundar."	
Manchicourt	Cantantibus organis	decantabat Cecilia virgo	soli Domino Deo dicens:	"Fiat Domine cor meum et corpus meum immaculatum,	ut non confundar."				
Mel	Cantantibus organis	Cecilia virgo	in corde suo soli Domino decantabat,		"Fiat Domine cor meum et corpus meum immaculatum,	ut non confundar."			
Rogier	Cantantibus organis	Cecilia virgo	in corde suo	soli Domino decantabat dicens:	"Fiat Domine cor meum	et corpus meum immaculatum,	ut non confundar."		
Rore	Cantantibus organis	Cecilia virgo	in corde suo	soli Domino decantabat dicens:	"Fiat cor meum et corpus meum	immaculatum,	ut non confundar."		
Sales	Cantantibus organis	Cecilia virgo gloriosa	soli Domino in corde suo	decantabat dicens:	"Fiat Domine cor meum	et corpus meum immaculatum	ut non confundar."		
Torquet	Cantantibus organis	Cecilia virgo	Domino decantabat dicens:	"Fiat cor meum et corpus meum immaculatum,	ut non confundar."				
Utendal	Cantantibus organis	Cecilia virgo	in corde suo	soli Domino	decantabat dicens:	"Fiat Domine cor meum	immaculatum,	ut non confundar."	

Note: This table is limited to motets that survive complete.

*Part 1 of Certon's *Cantantibus organis* continues with another text, beginning "Est secretum Valeriane" (points 6–10).

**The motets by Cornet, O. Lassus, and F. Lassus are in two parts; part 2 consists of Cecilia's prayer.

***Part 2 of *Virgo gloriosa*.

"Fiat Domine cor meum et corpus meum immaculatum," and above all "ut non confundar") come up repeatedly as the texts of individual points.

SONIC ARCHITECTURE: THE TRIPARTITE RHETORICAL MODEL

Gallus Dressler, born in 1533, served most of his career as a music director in Magdeburg. In 1564 he wrote a treatise, *Praecepta musicae poeticae*, that sums up his understanding of the compositional practices of the post-Josquin generation; as examples it often cites passages by Gombert, Clemens, and Crecquillon.[20] Among his most useful insights (later developed and disseminated by Joachim Burmeister in his more famous *Musica poetica* of 1606) is a three-fold division of motets and motet movements, based on the traditions of rhetoric, into *exordium* (introduction), *medium* (middle) or *media pars* (middle part), and *finis* (end).

Dressler's *exordium*—"the beginning of any song as far as the first cadence"[21]—corresponds to the first point of imitation. The *finis*, less clearly defined, presumably corresponds to the final point, leaving all the intervening points together as the *medium*:

> When the exordium has been constituted, some voices come together into a cadence so that there, as if wearied, they rest in perfect consonances . . . Afterwards, having regained their strength, they return to another fugue. [*Fuga* here apparently means a point of imitation.] With its order having been expressed by the individual voices, a cadence is again constituted. Not infrequently at the very cadence itself, some voice lays the foundation of a new fugue [*fundamentum* probably means theme or *soggetto*], which afterwards the remaining voices follow as far as the cadence.[22]

Daniele Filippi has applied terminology close to Dressler's to the "sonic architecture" of Palestrina's first book of motets for four voices (published around the same time as Dressler wrote his treatise), all of them in a single movement. Filippi (using the term "segment" instead of point of imitation) calls attention to "the tripartite rhetorical model (*exordium*-central part-*conclusio*)" as an influential force in shaping the motets:

> The first segment is imitative: its rhythmic structure, the often widely-spaced imitative entries, the modal transparency of its *soggetto* and its final cadence, its weight in the balance of form reveal its rhetorical function of *exordium* . . .
>
> The generally shorter internal segments present a kaleidoscopic variety of imitative (or more rarely homorhythmic) textures, and overlap, even though they mostly conclude with a cadence. Clear-cut interruptions in the polyphonic continuum are generally avoided . . .

The final segment is characterized by specific strategies (repetitions, metric or textural contrast, etc.) and by a stereotyped form of coda, with the so-called *extensio* in the top voice and a concluding plagal cadence.[23]

We can perceive the tripartite rhetorical model in most Franco-Flemish Cecilian motets, many of them composed by musicians whom Dressler admired and cited, and from whom Palestrina learned much. As the number of motets grew over the decades, the phrases "Cantantibus organis" and "Dum aurora finem daret" emerged as musico-verbal units that composers, performers, and listeners must have eventually recognized as classic *exordia*. The contrapuntal tours de force with which composers often dramatized the words "ut non confundar" made it an ideal *finis*.

At the same time, a feature of two texts most often set to music posed a challenge because it invited composers to divide the texts into two rhetorical units, rather than three. The texts *Cantantibus organis* and *Dum aurora* both shift from a narrative to the direct quotation of Cecilia's words. In their responsorial form they shift to direct quotation twice: first in the respond, then between the verse and the *repetendum*. The opening narratives consist of more words—at least six—than composers usually set to music as an *exordium*. And Cecilia's statements are too long for the *finis*. That forced composers, with few exceptions, to place the shift to direct quotation somewhere in the *medium*. This bipartite division offers listeners a structural counterpoint to the three-part rhetorical framework.[24]

One of the most extreme dramatizations of the shift from narrative to direct quotation is in Certon's *Cecilia virgo gloriosa*, of which the *secunda pars* is a setting of the respond *Dum aurora* (ex. 5.12). Point 2, "Cecilia dixit," has the normal imitative texture, its opening melodic lines (starting in the bassus at breve 14) fully intertwined with those at the end of point 1. But point 2 ends emphatically, with a strong cadence to D (a fifth above the work's final, G), followed by a semibreve rest in all the parts. Certon set Cecilia's words "Eia milites Christi" with music in a completely different style: a short homorhythmic passage beginning with breves in all the parts, with no repetition of text. The cadence, the rest, and the change in texture together make this the most important point of articulation in the movement, easily outweighing any trace of a tripartite structure.

MOTETS IN ONE MOVEMENT

Bultel's splendid *Dum aurora*, in a single movement, perfectly exemplifies the tripartite rhetorical model, while offering an unusual solution to the problem of how to integrate the shift to direct quotation (table 5.8). Bultel, a musician of whom we know nothing,[25] laid out the composition in a roughly symmetrical structure, with the longest points at the beginning and end and the shortest point in the middle.

EXAMPLE 5.12. Pierre Certon, *Cecilia virgo gloriosa*, part 2, breves 14–36: points 1 (end), 2, 3, and 4 (beginning). Source: *Recens modulorum editio . . . liber tertius* (Paris, 1542); RISM C 1708

Point 1 is a powerful *exordium* (ex. 5.13). The initial leap of a fifth, D up to A, in the superius and the cadence to D in breves 6–7 (undercut by the G in the bass) might lead listeners at first to guess that the work's tonality is *Re* with a D final. But the G-D upward leap of a fifth in the quinta pars, the contratenor, and most importantly in the bassus, together with the cadence on G in breve 9,

EXAMPLE 5.12 (*continued*)

TABLE 5.8. Jacob Bultel, *Dum aurora*: distribution of points

Rhetorical function	Point	Text	Location (and length) in breves
Exordium	1	Dum aurora finem daret, Cecilia dixit:	1–32 (32)
Medium	2	"Eia milites Christi,	30–48 (19)
	3	abjicite	48–56 (9)
	4	opera tenebrarum	53–65 (13)
Finis	5	et induimini arma lucis."	64–87 (24)

quickly identifies G as the final. Bultel could have ended the *exordium* in breve 9, setting "Cecilia dixit" as the beginning of the *medium* (as many other composers did); but he evidently felt it was important for the beginning of Cecilia's speech "Eia milites Christi" to coincide with the beginning of the *medium*. He incorporated "Cecilia dixit" into the *exordium*, which continues to unfold until the cadences on G in breves 29–30 and 33. Yet even here, as we start to hear Cecilia's words, a love of musical continuity expresses itself in the overlap of the *exordium* and the *medium*. Bultel simultaneously emphasized and disguised the shift from narrative to direct quotation.

The shortest point of imitation (point 3: "abjicite") also has the smallest time interval between imitative entries (two minims). The contrast between points 1 and 3 reminds us of a remark that Peter Schubert made in discussing Palestrina's music, but it is just as relevant here: "A widespread feature is that the time interval of imitation tends to be longer at the opening of the motet, shorter as the piece goes on. Thus the motet gets off to a slow start, with maximum *gravitas* and with plenty of room for growth in speed (in time interval of imitation) and texture."[26]

EXAMPLE 5.13. Jacob Bultel, *Dum aurora finem daret*, breves 1–36: *exordium* and beginning of *medium*. Source: *Liber secundus cantionum sacrarum quinque et sex vocum* (Leuven, 1554); RISM 1554²

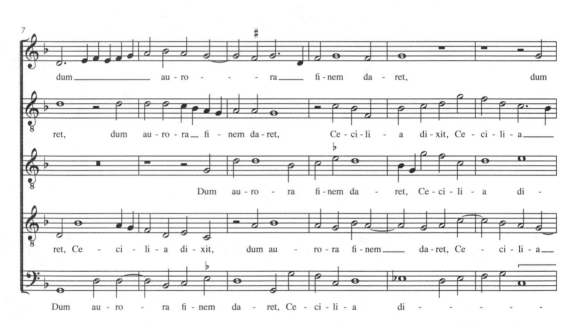

The *finis* ("et induimini arma lucis") is shorter than the *exordium*, but it still conveys finality, not least through the majestic passage at the very end (ex. 5.14). The superius and tenor, having cadenced to the final G, sustain that note while the three other voices continue to interact contrapuntally until they reach a plagal cadence. What Burmeister called the *supplementum* is characteristic of the final point.[27] But rarely does it attain the weight and grandeur of this one.

Another work in a single movement that embodies the tripartite rhetori-

EXAMPLE 5.13 (*continued*)

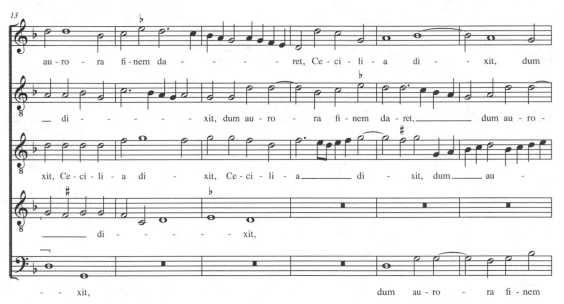

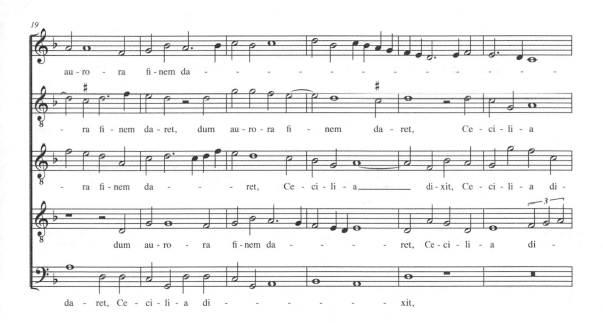

cal model is Maillard's *De fructu vitae*, whose two texts we considered above. Maillard made the first and last points the longest (table 5.9), encouraging us to hear them as the introduction and conclusion of a three-part structure. But the cantus firmus, in long notes and in segments separated by rests, undercuts the tripartite model. The cantus firmus enters near the end of the *exordium*, and its first phrase ("Fiat cor meum") continues into point 2. Similarly, the second phrase of the cantus firmus ("et corpus meum") blurs the transition from

EXAMPLE 5.13 *(continued)*

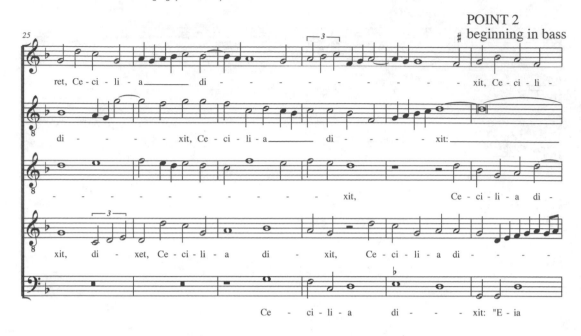

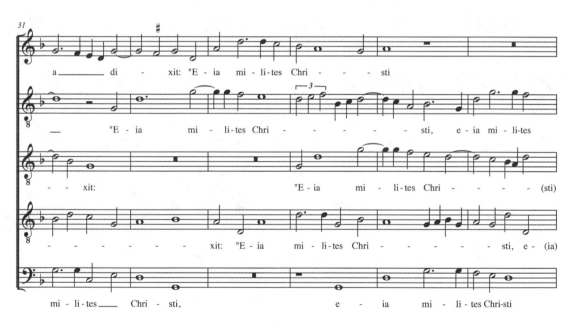

point 2 to point 3. In contrast, the end of the second phrase of the cantus firmus coincides exactly with the end of point 3 (just beyond the motet's halfway point).

This produces a clear break near the middle (in other words, it divides the *medium* in two); but this articulation works because the main text falls into two grammatically self-sufficient phrases, the first of which ends here. Maillard could have set this text to music in two parts, with part 2 beginning at "Nam

EXAMPLE 5.14. Bultel, *Dum aurora finem daret*, breves 81–87: cadence to G and six-breve *supplementum*.

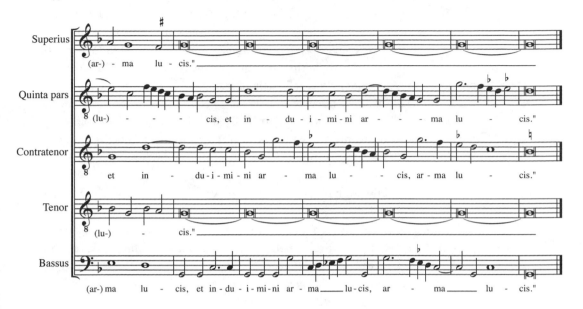

TABLE 5.9. Jean Maillard, *De fructu vitae*: distribution of points

Rhetorical function	Point	Main text	Location (and length) in breves	Text in cantus firmus
Exordium	1	De fructu vitae non gustabit cor tuum,	1–18 (18)	Fiat
Medium	2	nec sub umbra alarum mearum	18–32 (15)	cor meum
	3	protegeris in aeternum.	32–39 (8)	et corpus meum
	4	Nam virgineum decus	39–43 (5)	
	5	futuro sponso	43–48 (6)	immaculatum,
	6	immaculatum custodiam	48–60 (13)	
Finis	7	in seculum seculi.	60–75 (16)	ut non confundar.

virginaeum decus," but a two-part work of 75 breves would have been extremely short. More important, the text of the cantus firmus consists of a single sentence.

SONIC ARCHITECTURE IN TWO-PART MOTETS

In motets in two movements, the tripartite rhetorical model operates on two levels: that of the work as a whole and that of the individual movements. These motets have two *exordia* and two *fines*. But often the *exordium* of part 1, serving as the introduction for the entire piece, is longer and grander than that of part 2,

and the *finis* of part 2, serving as the conclusion for the whole piece, provides a more substantial and powerful ending than that of part 1.

Jan van Turnhout's *O virgo generosa / O virgo felix* shows vividly how a composer could designate the beginning of the first movement as the *exordium* of the whole work. The movements begin with similar verbal phrases, seemingly inviting the composer to treat them similarly. But Turnhout could hardly have differentiated them more dramatically. The motet begins with an imposing fourteen-breve setting of the first three words in which all eight voices declaim the words at least twice. The *secunda pars*, in contrast, begins with a three-breve point—by far the shortest in the piece—with no verbal repetition at all. That directs our attention to the elaborate setting of "Sancta Cecilia, ora pro nobis," mentioned earlier, which serves as the *finis* of the motet as a whole.

One way of adding weight to the second *finis* was to furnish it (but not the end of the *prima pars*) with a *supplementum*. A corpus study of just under 4,000 Renaissance motets has revealed that, in the works that contain at least one *supplementum*, 57 percent of final movements end with a *supplementum*, while only 28 percent of first movements do.[28] Several Cecilian motets show the same preference, including settings of *Cantantibus organis* by Certon, Maillard, Cornet, and Orlande de Lassus.

Another way of keeping the *finis* of the first movement from upstaging that of the composition as a whole was to end the first movement with a cadence on a pitch other than the final—most commonly a fifth above it. To cite two motets by Pevernage as examples, *Alma patrona veni* is in *Re* tonality with a G final, but the *prima pars* ends on D; *Ecce triumphali* is in *Ut* tonality with an F final, but the *prima pars* ends on C.

One of many Cecilian motets in which composers distributed the three rhetorical functions among two movements is *Cecilia virgo gloriosa* by Clemens (table 5.10). First published in 1547, it was widely disseminated in manuscript and print and depicted by Michiel Coxcie and his workshop in paintings of Cecilia at the keyboard (see plates 44, 45, and 46). Clemens set to music two liturgical texts—the Magnificat antiphon *Virgo gloriosa* and the verse *Biduanis ac triduanis* from the responsory *Cantantibus organis*—that together apparently have no liturgical function.

The first point in part 1 and the last point in part 2 are the longest, but they stand out in other respects as well, fulfilling their roles as the introduction and conclusion to the work as a whole. The *exordium* of part 2 and the short *finis* of part 1, in contrast, serve more local functions.

In the opening point a rising *soggetto*, already quoted (ex. 5.5) and briefly discussed, generates what Jessie Ann Owens calls "modules": units of counterpoint that can be repeated and varied—by transposition, by inversion, or by the addition or subtraction of voices (ex. 5.15).[29] With the G-to-C leap of a fourth in the superius and tenor, the *soggetto* quickly establishes the motet's *Ut* tonality with a C final (melodically and tonally the opening recalls that of Josquin's famous *Ave Maria . . . Virgo serena*). This tonal realm is confirmed by more G-to-C leaps,

TABLE 5.10. Jacobus Clemens non Papa, *Cecilia virgo gloriosa*: distribution of points

Part	Rhetorical function	Point	Text (number of words)	Location (and length) in breves
1	*Exordium*	1	Cecilia virgo gloriosa (3)	1–18 (18)
	Medium	2	semper evangelium Christi (3)	19–33 (15)
		3	gerebat in pectore suo, (4)	32–47 (16)
		4	non diebus neque noctibus (4)	47–57 (11)
		5	a colloquiis divinis (3)	57–73 (17)
		6	et oratione (2)	74–76 (3)
	Finis	7	cessabat (1)	76–84 (9)
2	*Exordium*	1	Biduanis ac triduanis (3)	1–16 (16)
	Medium	2	jejuniis orans (2)	17–27 (11)
		3	commendabat Domino (2)	17–27 (11)
		4	suam pudicitiam, dicens: (3)	32–41 (10)
		5	"Fiat Domine cor meum (4)	42–47 (6)
		6	et corpus meum immaculatum, (4)	47–61 (15)
	Finis	7	ut non confundar." (3)	61–80 (20)

increasing in frequency as the *exordium* nears its conclusion, and by the cadence to C with which it ends (breves 14–18).

The last point of part 2, "ut non confundar," likewise fulfills its function as the conclusion of a long, two-*pars* work—but not with an impressive *supplementum* like the one in Bultel's piece. Clemens built a musical climax by combining a descending sequence involving the three-fold statement of a four-voice module, each time a third lower, with triple-meter patterns in the individual voices that conflict with the other voices and with the duple framework of the composition as a whole. Together, these devices communicate confusion and at the same time offer the performers an amusing challenge and an opportunity to display their skills. Clemens gave additional weight to the *finis* by a simpler means, doubling its length by repeating the musical depiction of confusion in full (ex. 5.16).

That exuberant and expansive *finis* probably inspired Crespel to do something similar in *Cecilia ex praeclaro genere* (published six years after Clemens's motet). On a non-liturgical text derived from the *Legenda aurea*, Crespel's work ends with Cecilia's wedding prayer. The *finis* is another setting of "ut non confundar"—and another musical evocation of complexity and confusion. Like Clemens, Crespel enhanced the grandeur of the final point by presenting it twice, the second time with a short *supplementum*. But he went further than Clemens in the sheer size of the *finis*. At twenty-nine breves it is by far the longest point in the work,

EXAMPLE 5.15. Clemens non Papa, *Cecilia virgo gloriosa*, part 1, breves 1–18 (*exordium*). Source: *CMM* 4.9

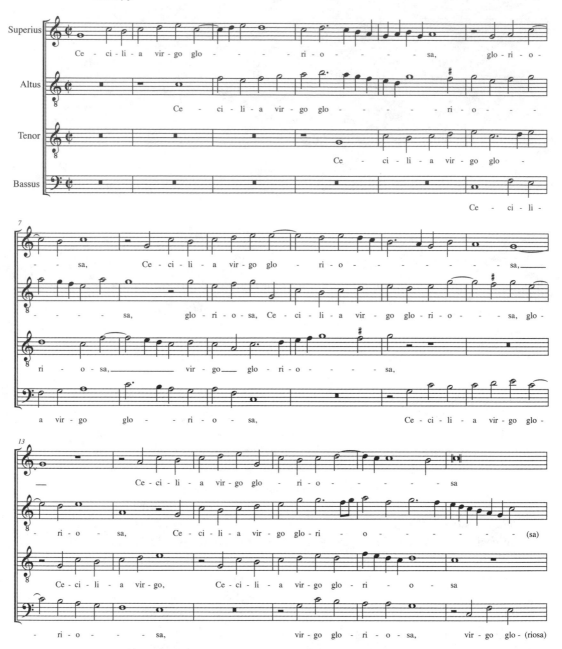

accounting for almost half of the *secunda pars*, and one of the longest final points in any Cecilian motet.

 Cecilia virgo gloriosa by Clemens satisfies our expectations for an *exordium*, a *medium*, and a *finis*; at the same time it brings to musical life the shift from narrative to direct quotation that constitutes an important rhetorical event in

EXAMPLE 5.16. Clemens, *Cecilia virgo gloriosa*, part 2, breves 68–80: repetition of the musical depiction of confusion at the end of the motet. Brackets mark conflicting three-semibreve metrical units in the tenor and bassus.

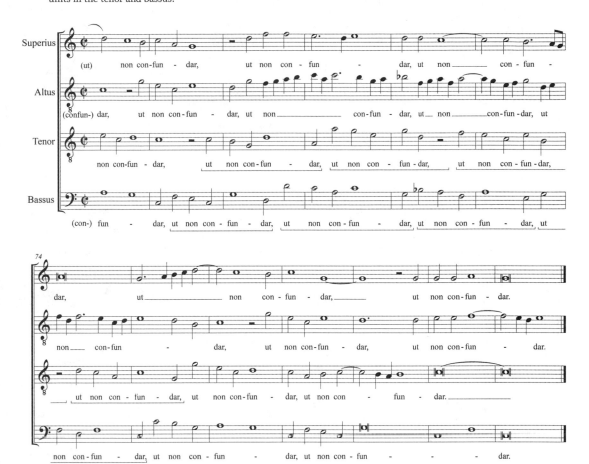

the texts of many Cecilian works. Here the shift occurs in the middle of the *secunda pars*, and it persuaded Clemens to abandon, for once, the love of continuity that he shared with other Franco-Flemish composers (ex. 5.17). Point 4, "suam pudicitiam, dicens," ends with an emphatic full cadence on C (the motet's final); Cecilia's prayer begins without any overlap with the previous point and with music completely different in rhythm (breves in all parts) and texture (homorhythmic except for the out-of-sync tenor). In this dramatization of the shift from narrative to direct quotation, Clemens used many of the same musical devices as Certon in the analogous place in *Cecilia virgo gloriosa* (see ex. 5.12).

Cornet (the chapelmaster at the cathedral of Antwerp whose plea to the city council for Cecilia's Day wine for his choir we noted in chapter 3) found another way to differentiate Cecilia's prayer from the narrative that precedes it. He set to music only the first part of the responsory *Cantantibus organis*, dividing into two

EXAMPLE 5.17. Clemens, *Cecilia virgo gloriosa*, part 2, breves 36–47: end of point 4, point 5 (complete), and beginning of point 6.

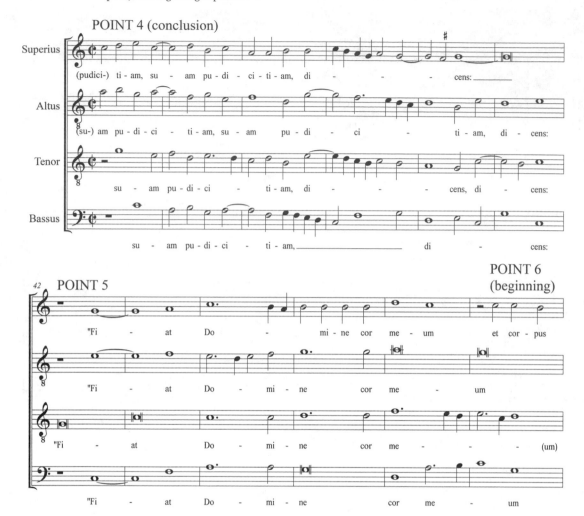

TABLE 5.11. Séverin Cornet, *Cantantibus organis*: distribution of points

Part	Rhetorical function	Point	Text (number of words)	Location (and length) in breves
1	*Exordium*	1	Cantantibus organis (2)	1–16 (16)
	Medium	2	Cecilia virgo (2)	17–25 (9)
		3	in corde suo soli Domino (5)	25–29 (5)
	Finis	4	decantabat dicens: (2)	29–39 (11)
2	*Exordium*	1	"Fiat cor meum et corpus meum immaculatum, (7)	1–24 (24)
	Finis	2	ut non confundar." (3)	25–35 (11)

movements a text that most composers treated as one (table 5.11). The *secunda pars* consists entirely of a setting of Cecilia's prayer; it contains only ten words, set to music in only two points of imitation. From a rhetorical point of view, it has a beginning and an end, but no middle.

TONAL VARIETY IN GALLI'S *CECILIAE LAUDES CELEBREMUS*

Galli's *Ceciliae laudes celebremus*, based on a non-liturgical poem in praise of Cecilia and published in Venice in 1554, exemplifies the use of cadences to pitches other than the motet's final as a way of introducing tonal variety.

The anonymous text, consisting of six elegiac couplets, is presented in its poetic form, with translation, in chapter 4. Galli divided it exactly in half, setting the first three couplets as part 1 and the last three as part 2 (table 5.12). Although he did set three whole lines as points, he preferred to follow the caesuras in the verse in dividing it into shorter segments. For instance, in the last couplet of the *prima pars*, the main caesuras fall as follows:

> Ipsa suum docuit sponsum || mysteria Christi;
> contempsit patrios || religiosa deos.

> *She taught her husband the mysteries of Christ; she piously rejected her family's gods.*

Galli's division of these lines into four points nicely captures the poem's prosody, while ignoring the grammatical and semantic unity of both lines.[30]

The first *exordium* closely resembles Bultel's (see ex. 5.13). Galli, like Bultel, established *Re* as the tonality and G as the final with the G-to-D leaps in the altus and bassus (after an initial bassus entry in breve 5 that Schubert might call a "red herring"; ex. 5.18).[31] On the effectiveness with which the *exordium* fulfills its tonal function depends the success of the rest of the music, because much of its interest consists in moves *away* from *Re* to *Ut* tonality with B♭ as a temporary final. Galli may have intended this alternate tonality, after establishing *Re* so strongly at the beginning, as a response to a text that celebrates the joy of music while remembering the pain of Cecilia's martyrdom.

The first sustained appearance of *Ut* tonality is in points 5 and 6, Galli's setting of another single line of poetry divided by caesura: "et domuit rigido || membra tenella sago" (ex. 5.19). Galli set the first three words as a pair of modular duets that shift the tonality from *Re* to *Ut* (point 6). The short point that follows ("membra tenella sago") is entirely in *Ut* tonality with a B♭ final. *Ut* tonality returns in part 2, most memorably just before the *finis* (ex. 5.20). The penultimate point ends with a cadence to B♭, whose arrival is accompanied by a shift from duple to triple meter. The *finis* is a homorhythmic dance, reminiscent of a galliard, that communicates something of the physical pleasure with which Franco-Flemish musicians celebrated their patron's feast.[32] The *finis* is unlike anything

TABLE 5.12. Antonius Galli, *Ceciliae laudes celebremus*: distribution of points

Part	Rhetorical function	Point	Text (number of words)	Location (and length) in breves
1	*Exordium*	1	Ceciliae laudes celebremus, (3)	1–18 (18)
	Medium	2	virginis atque martyris egregiae; (4)	19–34 (16)
		3	cantica laeta sonent. (3)	32–42 (11)
		4	Ipsa Deo semper (3)	43–48 (6)
		5	grates hymnosque canebat, (3)	47–56 (10)
		6	Et domuit rigido (3)	56–61 (6)
		7	membra tenella sago. (3)	61–65 (5)
		8	Ipsa suum docuit sponsum (4)	65–73 (9)
		9	mysteria Christi, (2)	73–78 (6)
		10	Contempsit patrios (2)	77–86 (10)
	Finis	11	religiosa deos. (2)	86–98 (13)
2	*Exordium*	1	Praeses atrox illi ferrum flammasque minatur, (6)	1–25 (25)
	Medium	2	Et struit accensis (3)	24–29 (6)
		3	balnea dira focis. (3)	30–38 (9)
		4	Omnia sed semper superavit pectore virgo; (6)	37–49 (13)
		5	jam fruitur caeli (3)	49–55 (7)
		6	nectare Cecilia. (2)	55–59 (5)
		7	Virgo fave nobis (3)	59–65 (7)
		8	succurre tuis alumnis, (3)	66–69 (4)
	Finis	9	et placeant petimus carmina nostra tibi. (6)	69–88 (20)

else in the piece, except for its tonal content. Starting in *Ut* tonality with a B♭ final, it works its way back to *Re* with a G final; it then repeats the process, recapitulating the motet's tonal dialogue.

PERMUTATIONS OF RESPONSORY FORM

Several motets in two movements adapt the tripartite rhetorical model to the characteristic AB/CB form of the responsory. In most of these works, composers presented the same *finis*—words and music—twice, thus forfeiting the opportunity of having part 2 end more emphatically than part 1. For instance, of the com-

EXAMPLE 5.18. Antonius Galli, *Ceciliae laudes celebremus*, part 1, breves 1–18 (*exordium*). Source: *Motetti del laberinto a quatro voci libro terzo* (Venice, 1554); RISM 1554[15]

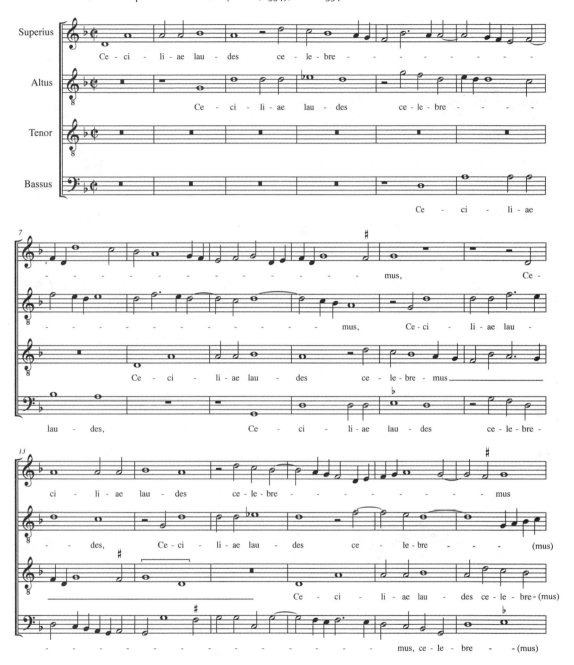

posers who set the whole responsory *Cantantibus organis*, all but one responded to the textual repetition with musical repetition; in other words, the music as well as the text is in the form AB/CB (table 5.13). The repeated text is Cecilia's prayer ("Fiat Domine cor meum"), making the repetition of the musical setting of those words especially apt.

EXAMPLE 5.19. Galli, *Ceciliae laudes celebremus*, part 1, breves 55–66: end of point 5 with cadence to G, point 6 with cadence to B♭, point 7 with cadence to B♭ (*Ut* tonality), beginning of point 8.

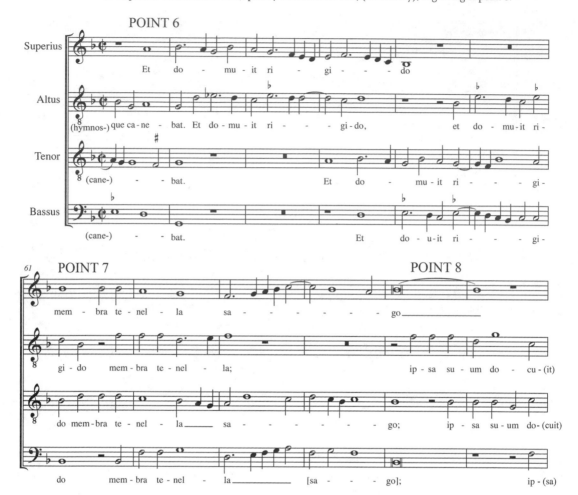

Canis set the responsory *Virgo gloriosa* the same way (in *Virgo gloriosa / Cilicio Cecilia*); Boyleau, setting another responsory (in *Ceciliam intra cubiculum*), likewise wrote music in AB/CB form. And Pevernage also used AB/CB form in *Dum aurora finem daret / Cecilia virgo valedicens fratribus*, an unusual setting of this entire Matins responsory, including the verse.

Gheens's *Cantantibus organis* exemplifies a straightforward application of responsory form (table 5.14). Although the three-part rhetorical structure is apparent in the length of the opening point (the longest in the motet), Gheens emphasized a framework consisting of two parallel structures by dividing the texts of both parts into the same number of points, making the movements roughly symmetrical (with the shortest points in the middle) and finally ending both parts with the same music.

In the midst of settings of *Dum aurora* as works in a single movement (see table 5.4), the two-part setting by Pevernage of the responsory *Dum aurora / Cecilia virgo valedicens fratribus* (published in 1578) calls for attention (table 5.15).

EXAMPLE 5.20. Galli, *Ceciliae laudes celebremus*, part 2, breves 68–88: end of point 7 with a cadence to B♭ (*Ut* tonality) and the entire *finis* in triple meter with two cadences to G (*Re* tonality).

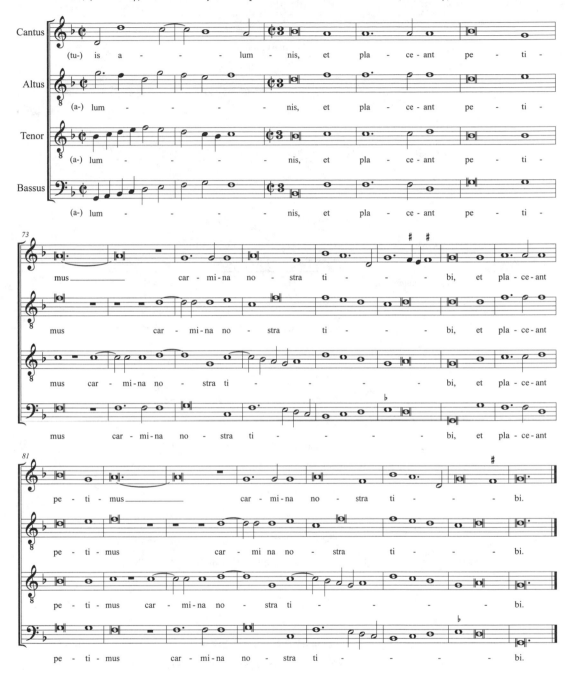

Faced with the challenge of twice differentiating Cecilia's words from those of the narrator, Pevernage adopted a solution close to those of Certon (ex. 5.12) and Clemens (ex. 5.17). The music that precedes "Eia milites Christi" in both *partes* ends with a cadence on F, the motet's final; Cecilia's speech begins with long notes (ex. 5.21). While Certon and Clemens marked the shift from narra-

TABLE 5.13. Settings of the responsory *Cantantibus organis* in roughly chronological order

Composer	Remarks on music
Jacquet	Responsory form with 2-breve *supplementum* at end of part 2
Rore	Responsory form
Gheens	Responsory form
Maillard	Through-composed
Kerle	Responsory form
Castro (1571)	Responsory form
Castro (1588)	Responsory form
Sales	Responsory form

TABLE 5.14. Philippe Gheens, *Cantantibus organis*: distribution of points

Part	Rhetorical function	Point	Text (number of words)	Location (and length) in breves
1	*Exordium*	1	Cantantibus organis (2)	1–18 (18)
	Medium	2	Cecilia virgo in corde suo (5)	15–27 (13)
		3	soli Domino (2)	25–31 (7)
		4	decantabat dicens: (2)	32–36 (5)
		5	"Fiat Domine cor meum (4)	37–42 (6)
		6	et corpus meum immaculatum, (4)	42–50 (9)
	Finis	7	ut non confundar." (3)	51–61 (11)
2	*Exordium*	1	Biduanis ac triduanis (3)	1–17 (17)
	Medium	2	jejuniis orans, (2)	16–28 (13)
		3	suam Domino pudicitiam (3)	27–35 (9)
		4	commendabat dicens: (2)	33–38 (6)
		5	"Fiat Domine cor meum (4)	39–44 (6)
		6	et corpus meum immaculatum, (4)	45–52 (8)
	Finis	7	ut non confundar." (3)	53–63 (11)

tive to quotation by an absence of elision between points, Pevernage elided "Eia milites Christi" with the preceding points; but the overlaps are short enough to allow us to perceive immediately the new character of the music with which he set Cecilia's words. Composing for six voices, Pevernage had ways of producing contrast not available to Certon and Clemens, whose motets have only four voices. At "Eia milites Christi," Pevernage reduced the number of voices from six to three. The lowest voices declaim Cecilia's words in homophony decorated

TABLE 5.15. Andreas Pevernage, *Dum aurora finem daret*: distribution of points

Part	Rhetorical function	Point	Text (number of words)	Location (and length) in breves
1	*Exordium*	1	Dum aurora finem daret (4)	1–17 (17)
	Medium	2	Cecilia dixit: (2)	17–29 (13)
		3	"Eia milites Christi, (3)	30–49 (20)
		4	abjicite opera tenebrarum, (3)	48–61 (14)
	Finis	5	et induimini arma lucis." (4)	60–73 (14)
2	*Exordium*	1	Cecilia virgo, (2)	1–13 (13)
	Medium	2	valedicens fratribus (2)	11–20 (10)
		3	et exhortans eos, ait: (4)	19–30 (12)
		4	"Eia milites Christi, (3)	30–50 (21)
		5	abjicite opera tenebrarum, (3)	49–61 (13)
	Finis	6	et induimini arma lucis." (4)	61–74 (14)

with canon. Tenor 1 and bassus rise scalewise in parallel thirds, while bassus imitates tenor 2 in a canon at the fifth below. (This schema, now known as the ascending 5–6 sequence, had already been popularized by Josquin in his *Ave Maria . . . virgo serena*; composers would continue to use it for centuries.) A moment later the three highest voices repeat the module up an octave, producing a polychoral effect.

Occasionally composers manipulated responsory form so as to combine the repeated text with some difference between the musical settings of that text in the two movements. Maillard wrote new music for the repetition of text in his settings of Cecilian responsories: not only *Cantantibus organis* but also *Domine Jesu Christe, pastor bone*. Hugier took a different approach in setting the responsory *Cecilia me misit ad vos*. His motet has the normal AB/CB form, except that the second statement of B is followed by a final Alleluia: a seven-breve *finis* that brings the whole work to a satisfying conclusion.

The responsory form left its mark on settings of para-liturgical and non-liturgical texts as well. Two motets with texts freely derived from the liturgy, *O beata Cecilia* by Episcopius and *Sponsa Christi Cecilia* by Piéton, consist of two movements that end—music as well as text—the same way. I quoted the text of Piéton's work above; the layout of Episcopius's composition is summarized in table 5.16.

Episcopius, born in Mechelen around 1520, spent most of his career as a music director in Maastricht before serving in the Bavarian court chapel in Munich. He set to music a text that alternates between short quotations from the liturgy and devotional prayers. As in some other para-liturgical and non-liturgical texts, "we" are the performers, addressing Cecilia as their patron:

EXAMPLE 5.21. Andreas Pevernage, *Dum aurora finem daret*, part 1, breves 28–38: end of point 2 and beginning of point 3 (beginning of Cecilia's speech). Source: *RRMR* 154

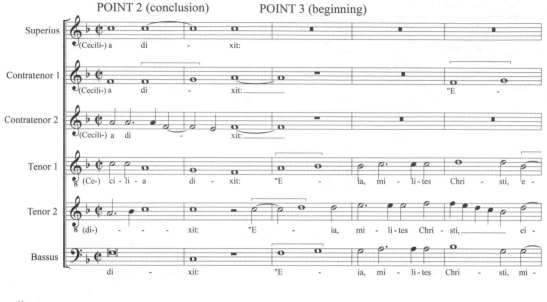

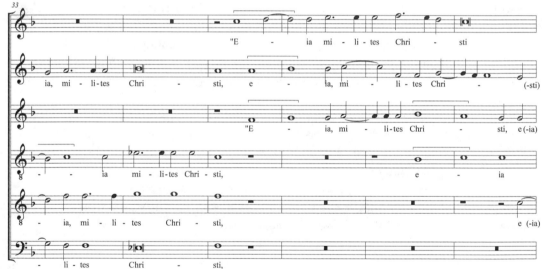

O blessed Cecilia, who converted Valerian and his brother to the faith of Christ, intercede for us with the son of God, that we might reign with you forever. St. Cecilia, pray for us.

Dressed in haircloth while you lived, Cecilia, while the instruments sang you praised God, and now you reign with him; therefore be our patron, that we might reign with you forever. St. Cecilia, pray for us.

Both movements end with an excerpt of the Litany of the Saints, using the same formula that Utendal used as a cantus firmus in his *Cantantibus organis*

TABLE 5.16. Ludovicus Episcopius, *O beata Cecilia*: distribution of points

Part	Rhetorical function	Point	Text (number of words)	Location (and length) in breves	Text of cantus firmus (ostinato)
1	*Exordium*	1	O beata Cecilia, (3)	1–13 (13)	Sancta Cecilia, ora pro nobis.
	Medium	2	quae Valerianum (2)	13–17 (5)	Sancta Cecilia, ora pro nobis. × 4
		3	et fratrem eius (3)	17–20 (4)	
		4	ad Christi fidem convertisti, (4)	20–29 (10)	
		5	deprecari pro nobis filium Dei, (5)	29–37 (9)	
		6	ut tecum regnemus in perpetuum. (5)	38–49 (12)	
	Finis	7	Sancta Cecilia, ora pro nobis.	50–54 (5)	Sancta Cecilia, ora pro nobis.
2	*Exordium*	1	Cilicio induta dum viveres, Cecilia, (5)	1–9 (9)	Sancta Cecilia, ora pro nobis.
	Medium	2	cantantibus organis Deum laudabas, (4)	10–20 (11)	Sancta Cecilia, ora pro nobis. × 3
		3	Deum laudabas et nunc cum eo regnas, (7)	20–23 (4)	
		4	fac igitur patrona nostra, (4)	24–28 (5)	
		5	ut tecum regnemus in perpetuum. (5)	27–40 (14)	
	Finis	6	Sancta Cecilia, ora pro nobis. (5)	41–45 (5)	Sancta Cecilia, ora pro nobis.

(see fig. 5.3) and that Pevernage and Jan van Turnhout quoted in the *finis* of their settings of *O virgo generosa* (see ex. 5.11). Like Pevernage, Episcopius transposed the formula (normally notated with its reciting tone on G) up a fourth, to make it more compatible with polyphony in *Ut* tonality with an F final. But *O beata Cecilia* differs from the motets of Pevernage and Turnhout and resembles Utendal's in allowing the Litany to dominate the work as a whole. A cantus firmus or ostinato in the highest voice consists of the formula repeated six times in part 1 and five times in part 2, with four breves of rest between each statement. In the last statement of the litany in each movement, all the voices join in a homorhythmic plea for Cecilia's intercession.

Despite the regularity and ubiquity of the ostinato, we can still perceive various parts of the music as having different rhetorical functions. Both movements open with recognizable *exordia*, the first (ex. 5.22) noticeably longer than the

EXAMPLE 5.22. Ludovicus Episcopius, *O beata Cecilia*, part 1, breves 1–14: *exordium* and beginning of point 2, with first statement and beginning of second statement of ostinato. Source: A-Wn 19189

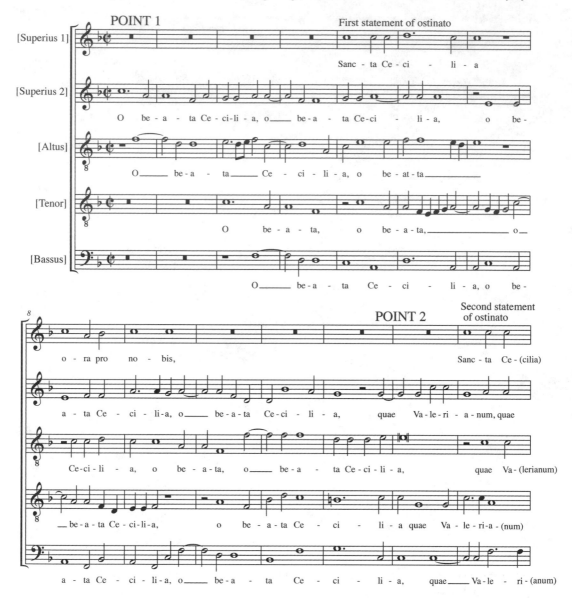

second; and the sudden coming together of all the singers in unanimous supplication makes for a compelling, albeit very brief, *finis* (ex. 5.23).

SETTINGS OF *CANTANTIBUS* AS CELEBRATIONS OF SINGING

As the sixteenth century progressed, composers of motets increasingly used music to communicate or to emphasize the meaning of particular words and

EXAMPLE 5.23. Episcopius, *O beata Cecilia*, part 1, breves 50–54: *finis*, with the sixth statement of the Litany ostinato in the highest voice. Part 2, in keeping with the music's responsory form, ends with the same passage.

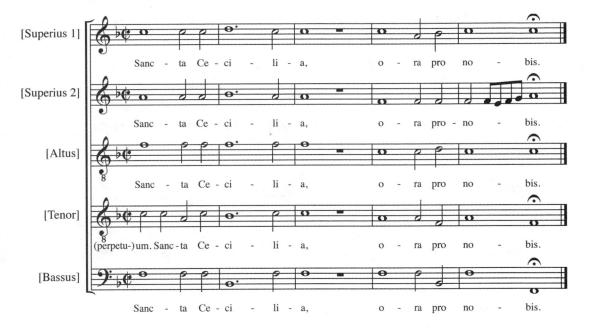

phrases, transferring to the sacred realm the "madrigalisms" of secular music. In the 1580s and 1590s, composers of Cecilian music gravitated to the word *Cantantibus* as an opportunity to depict the act of singing itself, and to communicate something of the sensual pleasure that it could arouse. Their awareness that Cecilia was no singer and that her wedding prayer was silent did not keep them from transforming the opening of Cecilian motets into spectacular glorifications of the vocal art.

The Franco-Flemish diaspora carried Mel, Castro, Sales, and Rogier to disparate courts (Mel to Italy, Castro to Düsseldorf and Cologne, Sales to Innsbruck and Prague, and Rogier to Madrid); but these masters responded to *Cantantibus* in similar ways. All their *exordia* are dominated by long melismas of semiminims on the second syllable of the opening word. In Mel's motet the melismas pervade the whole six-voice fabric (ex. 5.24); the motets of Castro, Sales, and Rogier begin with the three highest voices alone, the two treble voices in the same register (exx. 5.25, 5.26, 5.27). Even if these motets are transposed down in performance (as was customary with music notated with high clefs), these brilliant passages have nothing to do with a young woman silently begging God to preserve her virginity. They suggest, instead, that by the late sixteenth century Franco-Flemish musicians, wherever they were, had fully transformed 22 November into an occasion for celebrating their art and displaying their skill.[33]

EXAMPLE 5.24. Rinaldo del Mel, *Cantantibus organis*, breves 1–12: *exordium*. Source: *Sacrae cantiones . . . V. VI. VII. ac XII. vocum* (Antwerp, 1589); RISM M 2196

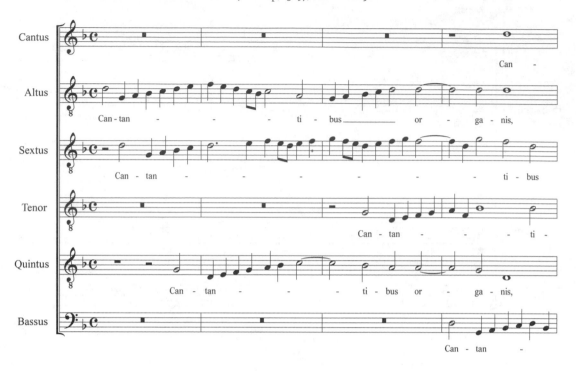

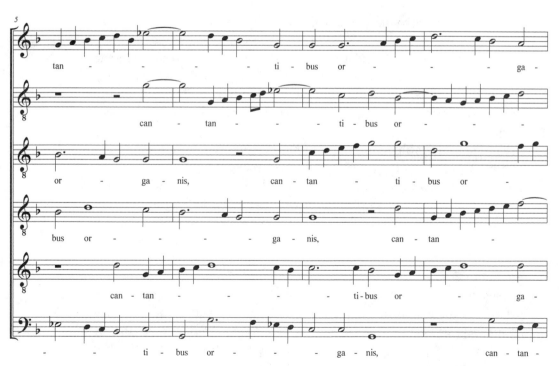

EXAMPLE 5.24 (*continued*)

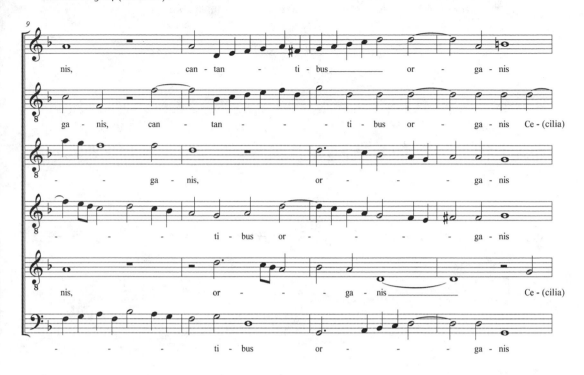

EXAMPLE 5.25. Jean de Castro, *Cantantibus organis* (1588), part 1, breves 1–4. The lower two voices enter later. Source: *DRM* 18

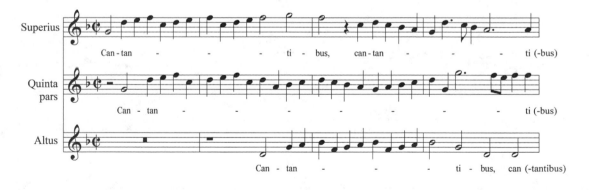

EXAMPLE 5.26. Franz Sales, *Cantantibus organis*, breves 1–8. The lower two voices enter later. Source: *Sacrarum cantionum . . . liber primus* (Prague, 1593); RISM S 394

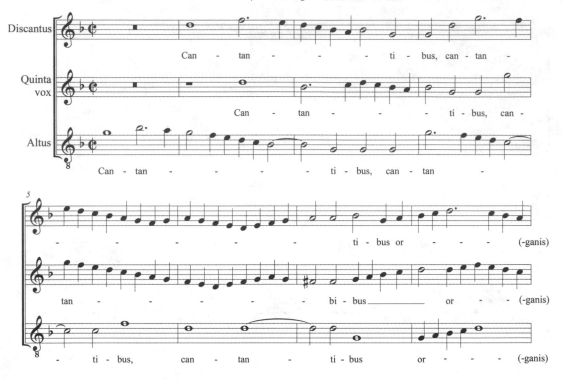

EXAMPLE 5.27. Philippe Rogier, *Cantantibus organis*, breves 1–7. The lower three voices enter later. Source: *RRMR 2*

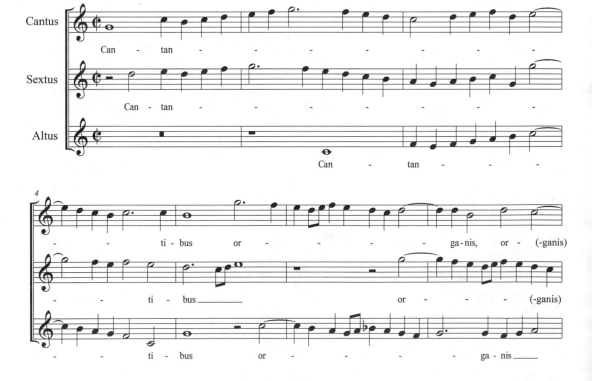

Italian Artists Depict Cecilia from the Late Fifteenth Century to the Late Sixteenth Century

Chapter 1 ends with one of the frescoes on the Cecilia legend in the Oratory of Saints Cecilia and Valerian in Bologna: a depiction of her wedding made by Francesco Francia between 1504 and 1506 in which music plays no role (see plate 14). Music is absent from the other frescoes as well. Some of the most famous portrayals of Cecilia by Italian artists of the cinquecento show her holding an organ, but in a way that suggests that making music is the last thing on her mind. Such images are in keeping with the lack of interest that Italian musicians showed in her during most of the century. In contrast to their brothers in the Netherlands and northern France, Italian composers seem to have published no motets in her honor before 1563 and founded no musical organizations under her protection before 1585.[1]

The frescoes in Bologna do not need identifying attributes; we recognize Cecilia immediately, as we do in the fresco that Raphael and his workshop made at the Villa Magliana, near Rome, around 1518. The painting does not survive, except as recorded in an engraving by Marcantonio Raimondi. The painting on a maiolica plate made in Faenza around 1525 is probably based on Raimondi's print rather than the original fresco (plate 56). The naked woman standing in a tub of boiling water, being shown the heads of two male martyrs, is Cecilia with her dead husband and his brother. Almachius, having failed to persuade her to worship Jupiter (whose statue is on the right), has sentenced her to death. An angel descends to bestow signs of her heavenly reward.

One of the female martyrs in Raphael's *Madonna and Child Enthroned with Saints* (known as the Colonna Altarpiece), probably painted around 1504, is harder to identify (plate 57). On the left is Catherine of Alexandria. Giorgio

Vasari identified the woman on the right, crowned with flowers and holding a palm and a book, as Cecilia.[2] He may have been right: we have seen several instances of Cecilia witnessing Catherine's mystic marriage (plates 22, 29, 36). Yet the Metropolitan Museum's catalog entry describes her as "an unidentified female saint"; and Linda Wolk-Simon, in her monograph on the painting, points to the tower in the distance as suggesting that she might be Barbara.[3]

The Metropolitan more confidently identifies as Cecilia another woman without musical attribute, again standing opposite St. Catherine, in a painting on vellum inscribed with the name of the Veronese artist Francesco Morone (1471–1529), an older contemporary of Raphael.[4] Yet the identity of this saint, holding a palm and crowned with roses, has likewise been subject to uncertainty and disagreement. Those arguing for Cecilia base their case on her being "virtually identical" to a woman in an anonymous triptych in Verona (ca. 1480).[5] The presence of two men, both with palms, in the Verona painting allows us to name the three martyrs with some certainty Valerian, Tiburtius, and Cecilia, who holds a book as well as a palm.[6] The woman in the Metropolitan's miniature, in contrast, has no book, and its absence leaves her identity less certain.

ITALIAN PAINTERS FOLLOWING FLEMISH ICONOGRAPHIC PRECEDENT

One of the earliest Italian paintings that scholars have described as a depiction of Cecilia listening to music with interest and pleasure shows a young woman holding a book and a palm while an angel serenades her with a lute (plate 58). Art historians have dated the painting, on stylistic grounds, to the end of the quattrocento and have attributed it to the Sicilian Riccardo Quartararo (1443–1506).[7] If the woman is indeed Cecilia, and the dating of the painting reasonably accurate, it would be an exceptionally early instance of an image that associates Cecilia with a musical instrument other than the organ.

But not all of those who have written about the painting have been fully convinced that it depicts Cecilia. An alternative was proposed more than a century ago: this is Barbara, standing in front of the tower with which she was often identified.[8] Fifteenth-century illuminations show one angel playing a harp for Barbara (plate 59) and another angel playing an organ (plate 60). The painting in Palermo, embodying on a large scale the iconographic tradition represented by these miniatures, encourages viewers to identify its subject as Barbara, not Cecilia.

Just as indebted to Flemish precedent is the woodcut of Cecilia with an organ and a palm in Giacomo Filippo Foresti's *De plurimis claris selectisque mulieribus* (Concerning the many famous and select women; Ferrara, 1497), a collection of biographical sketches (fig. 6.1). But the significance of this image as an early— and potentially influential—appearance in Italy of the organ as Cecilia's emblem

De fancta Cecilia martyre. cap. lxxxiij.

Ecilia Romana *go z ma
tyr/femia cozpozeo ocoze/
magnanimitatem/ozib⁹/ca
ftitate/ z fctitate fplédida
atcz pcelfa / áno a natali xpiano/nono
z vigeffio fupza oucéteffimum/ feuero
pncipe romáis ipáte/ clariffiuz ,p xpo
ptulit martyriú: Dec qppe/tametfi/ei⁹
gen⁹/religionécz/ac parétú noia nobis
ignota babeáf/pcláiffimi tñ patritijcz
generis/z potétiffimoz pfuluz eá filiá
fuiffe reoz/cz qdez ex facinozib⁹ fuis p
clariffis a fe geftis pzobaffe vifa é/ ,p

qb⁹ céte/ñ imeritá fibi aqfiuit claritaté z laudé/ac vitá poftréo pãfiuitefná:
ñ cú ab puéitia ñi oib⁹ oidiciffz eé amabil/ei⁹ vniuéfa ,ppigtaf/tácz ofdiuina

FIGURE 6.1. Cecilia holding an organ and a palm. Woodcut in Giacomo Filippo Foresti, *De plurimis claris selectisque mulieribus* (Ferrara, 1497). National Library of Romania. Photo: National Library of Romania

is undercut by its use to illustrate not only her biography but that of another virgin martyr, Eulalia.

In another early Italian adoption of the organ as Cecilia's identifying attribute, a tiny (25 cm × 20 cm) *sacra conversazione* attributed to Girolamo Marchesi and believed to have been painted around 1512, Cecilia and Catherine kneel before the Virgin and Child (plate 61). The artist gave Cecilia a toy-like instrument whose small size and lack of bellows make it unplayable.

In Luca Signorelli's *Pala di Santa Cecilia*, the organ serves an identifying (as well as decorative) role.[9] Working around 1516 (a little later than the estimated date of Marchesi's painting), Signorelli showed the Christ child, sitting on the Virgin's lap and surrounded by saints, crowning Cecilia. He placed the organ in Cecilia's hands, and about the right size for a functioning portative organ; but he painted it without a keyboard or bellows.

Agostino Carracci's much later *sacra conversazione* depicting Cecilia opposite St. Margaret identifies Cecilia by means of her old attributes, the palm and the book, and another miniature organ on the floor, again without bellows. Commissioned by Margherita Farnese, a princess who had become a nun after the annulment of her marriage with Vincenzo Gonzaga, this painting may have played a role in a scandal involving the close relations between the music-loving nun and a young musician, Giulio Cima. By choosing Margaret as one of the

saints adoring the Christ child, Margherita made sure that viewers would iden-
tify the painting with its commissioner. And with the inclusion of Cecilia, the
princess probably hoped to suggest that in her music-making with Cima she was
as chaste as the Roman martyr.[10]

CECILIA WITH AN ORGAN, DEPICTED BY RAPHAEL
AND HIS FOLLOWERS

Arnobius, Voragine, and the liturgy for Cecilia's Day focused attention on a few
key moments of her life, including the moment most important for her treatment
by artists and musicians: when, during her wedding, as instruments played, she
sang in her heart to God alone. That passage led artists to use the organ as Ceci-
lia's emblem, but it also led them occasionally to depict her in ways that conform
more closely to the spirit of the text (see plates 9, 10, and 11). Kneeling in prayer,
she actively avoids the conventional music of the wedding. In these images she
becomes what I call an "anti-musician."

By the early sixteenth century the organ had become so closely associated
with Cecilia that depictions of her as anti-musician, despite their liturgical ap-
propriateness, might have confused viewers of religious art, especially when
they saw it outside a liturgical context. How was an artist to remain true to the
spirit of Cecilia's rejection of the wedding music while at the same time depict-
ing her in a way that allowed early sixteenth-century viewers, increasingly used
to seeing her with an organ, to recognize her?

This was the dilemma that Raphael's patrons confronted around 1515, when
they commissioned him to paint an altarpiece for a St. Cecilia chapel in the
church of S. Giovanni in Monte in Bologna.[11] Earlier Raphael had depicted a
female martyr who might be Cecilia on the periphery of a *sacra conversazione*;
but the Colonna Altarpiece (plate 57) carries the same impact whether we iden-
tify the woman as Cecilia or not. Now he had to place Cecilia in the center of a
painting, and to leave viewers without any doubt about her identity. He followed
late fifteenth-century Flemish masters in having her hold a portative organ. But
in almost every other respect he departed radically from Flemish precedent.

In the painting that has come to be called *The Ecstasy of St. Cecilia* (plate 62),
Cecilia stands prominently at the center; the other saints—Paul, John the
Evangelist, Augustine, and Mary Magdalene (all normally higher than Ceci-
lia in liturgical rank)—surround her. She holds the organ upside down, allow-
ing the pipes to slide downward out of the instrument. The sliding pipes lead
the viewer to look farther down, to instruments on the ground, some of them
in disrepair, and all of secular character: percussion instruments (a triangle,
two tambourines—one with a drumhead, one without—and pairs of small
kettledrums and cymbals) and three recorders surround a viola da gamba with
broken strings.

Even if it were not falling apart, Cecilia's organ would not be playable. Raphael

painted the organ with its longest pipes on the right (that is, under Cecilia's right hand).[12] What looks superficially like an instrument capable of producing beautiful sounds is only a mirror image—a reflection of reality.

Raphael put Cecilia's musical emblem to a new use: to show her emotional and spiritual state at her wedding feast, when she turned from worldly pleasures to God. While the pipes of the illusory organ fall down, she looks up, to a higher reality. The parting clouds reveal a celestial choir from which musical instruments are absent. The singing angels accompany Cecilia's song: her silent prayer to God alone.

Raphael's brilliantly original interpretation of Cecilia's iconographic tradition won several imitators. They knew it primarily through an engraving by Raimondi, which differs significantly from Raphael's altarpiece (most significantly, perhaps, in having the angels play musical instruments) and may document some of the painter's early ideas that he subsequently rejected.[13]

Moretto da Brescia made a handsome variation on Raphael's theme in 1540 by placing Cecilia at the center of a group of five virgin martyrs (plate 63). A crown of roses floats over her head, as if functioning also as a halo. The pipes of her organ are arranged symmetrically, with the longest pipes in the middle; it looks intact despite being held upside down.[14] Instruments lie on the ground; and again a stringed instrument occupies center stage. Cecilia rests one foot on the back of a lute, firmly rejecting its "lascivious pleasing." Like Raphael, Moretto juxtaposed the fragility and impermanence of earthly pleasures to the never-ending glories of heaven, represented here by the Virgin Mother and Child.[15]

Even closer to Raphael (and Raimondi) is Federico Barocci's *Cecilia surrounded by Mary Magdalene, John the Evangelist, Paul, and Catherine*, painted around 1555.[16] Barocci gave Cecilia a conventional portative, with the longest pipe above the key that plays the lowest note. Again she holds the organ upside down, but uses her right hand to keep some of the pipes from sliding out. Following Raimondi, Barocci filled the heavens with angelic instrumentalists. As if their instruments replaced some of the terrestrial instruments in Raphael's painting, Barocci placed only two small instruments, a recorder and a viol, on the ground; that left room for a book with musical notation—an element of many seventeenth-century depictions of Cecilia.

Aside from the use by Raphael of the organ to identify Cecilia, and aside from the echoes of Raphael's painting in the work of Moretto, Barocci, and that of a few other sixteenth-century Italian painters, *The Ecstasy of St. Cecilia* is an isolated masterpiece. It falls outside the main iconographic and musical traditions associated with Cecilia, carried forward during the sixteenth century primarily by Flemish artists and musicians in northern France and the Netherlands who had no interest in depicting her as an "anti-musician."

A painting in which Raphael's influence is clearly apparent differs from the altarpieces of Raphael, Moretto, and Barocci in showing Cecilia alone (plate 64). More importantly, it abandons the characterization of her as "anti-musician" by surrounding her with musical instruments that are apparently in good order: an

organ on the right, a violin, a recorder, a tambourine, and another unidentifiable wind instrument on the left. Her hand rests lightly on the organ keyboard, as if about to play. The heavenly concert, instead of taking place far above her, seems to emerge from her head, or as an extension of her halo. This Cecilia is apparently a musician and a lover of music. Yet her right hand points upward, as do her eyes, to the celestial music above, leaving her relation to earthly music in doubt.[17]

Art historians have attributed this painting to Denis Calvaert and have assigned it to the last third of the sixteenth century.[18] Calvaert was born in Antwerp around 1540 but spent most of his adult life in Italy. Having come of age in a city where musicians celebrated Cecilia's feast with enthusiasm, and where many composers of Cecilian music were active, he was in a perfect position to introduce Italians to Cecilia as a woman who enjoyed making music and listening to it.

CECILIA WITH MUSICAL NOTATION

Amid so many *sacre conversazioni*, both Italian and Flemish, in which Cecilia is one of several saints, a painting that depicts the Virgin and Child with Cecilia alone, in front of four organ pipes, stands out conspicuously (plate 65). Art historians have attributed this painting to various Italian contemporaries of Raphael: Lorenzo Costa, Tommaso Aleni, and (the current favorite) Domenico Panetti (ca. 1460–before 1513).[19]

Just as extraordinary as the "solo" role that Cecilia plays is the small placard on which she displays legible musical notation. It records a single melodic line in the treble register: a setting of her wedding prayer (ex. 6.1). Volker Scherliess interpreted the music as a canon; if he were right, the notation in the painting would constitute a complete work.[20] Edward E. Lowinsky disagreed, arguing that the *signa congruentiae* with which composers normally indicated the location of successive entries in a canon serve here instead as fermatas at the end of

EXAMPLE 6.1. Transcription by Jason Stoessel of the notation in Domenico Panetti (attrib.), *Virgin and Child with Cecilia* (plate 65).

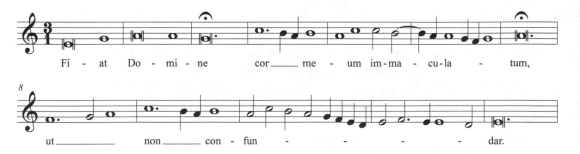

musical phrases.[21] Jason Stoessel has come down on Lowinsky's side, concluding that the notation preserves "the upper part of a polyphonic setting though it could be a pure confection"—in other words, a fragment of a motet, real or imagined.[22] The music corresponds to none of the Cecilian works that I have seen, although it does faintly resemble the cantus firmus—likewise a setting of Cecilia's wedding prayer and likewise in the Phrygian mode—in Maillard's *De fructu vitae* (see fig. 5.1). If Panetti really painted this picture, and if the musical notation was not added at some later time, it records a remarkably early stage in the history of the Cecilian motet, well before it began to be documented in printed editions in the 1530s.

Another painting, made as much as a century after the one attributed to Panetti, likewise features musical notation (plate 66). Sebastiano Filippi (*alias* Bastianino, ca. 1536–1602) painted this altarpiece for the chapel of St. Cecilia in the church of Santa Maria in Vado, in Ferrara. From 1598 that chapel was under the patronage of Antonio Goretti, a passionate music lover—a composer and performer as well as a generous supporter of professional musicians—who probably commissioned the painting.[23]

Bastianino portrayed the virgin martyr standing alone except for angels flying about her head, playing instruments and singing. His Cecilia, instruments and a music book scattered at her feet, might be communicating the same rejection of worldly music as Raphael's: and in support of that interpretation we might point out that the organ, like Raphael's, is backward, with the longest pipes on the right. But the instruments on the floor (lute, trombone, tambourine, viola da gamba) appear to be in good condition; and although Cecilia does not play the organ, she holds it upright and cradles it lovingly. The angels' music (as in the painting attributed to Calvaert) seems to give her pleasure, not just spiritual satisfaction.

The musical notation at Cecilia's feet preserves yet another setting of her wedding prayer; and this time it is definitely a canon. It carries the legend "Canon qui intelligit legat" ("Canon: Let him who understands read it"; plate 67). Anna Valentini had good reason to speculate that Goretti himself composed this music for display (and performance) in his chapel.[24] Lowinsky proposed a resolution that resembles a miniature three-voice motet, complete with concluding *supplementum*.[25] Stefano Melloni (working with Valentini) suggested a different resolution that allows for the repeat of the canon ad infinitum (ex. 6.2). The effect evokes the eternity of celestial music.

AN ITALIAN CECILIA PLAYING THE ORGAN

One of the first Italian composers to acknowledge in writing Cecilia's role as patron of musicians was Adriano Banchieri, who in 1609 dedicated his *Conclusioni nel suono dell'organo* to Cecilia, "devota degli musici e organisti" (object of devotion of musicians and organists). In a prefatory essay entitled "Origin

EXAMPLE 6.2. *Fiat Domine cor meum*, canon in Sebastiano Filippi's painting of St. Cecilia, as resolved by Stefano Melloni (in Valentini, "Iconografia musicale a Ferrara," 165–66), with a subsequent correction that Melloni kindly shared with me (email, 17 October 2020). Note the suggested repeat of the canon starting at breve 15.

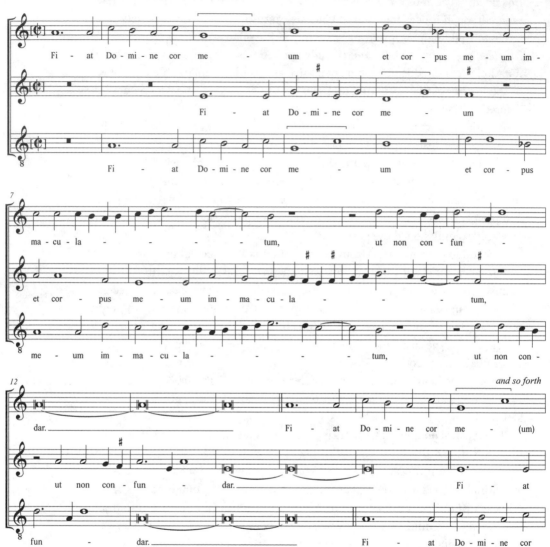

of the devotion that musicians and organists maintain to the glorious St. Cecilia, virgin and martyr," Banchieri attributed musicians' adoption of Cecilia as their patron saint in part to Raphael's *Ecstasy of St. Cecilia* and the many copies and adaptations by which it was disseminated. But he also pointed to another influential image: a painting in Siena by Giovanni Antonio Bazzi, known as Il Sodoma (1477–1549), "with the organ being played by her almost enthusiastically, and with a joyful expression, in the company of a little angel resembling a pelican; they seem to be performing with all their hearts those never-ending melodies of heaven."[26]

Il Sodoma's depiction of Cecilia playing the organ with obvious pleasure does not seem to have survived (leaving us at a loss to explain how the angel could have resembled a pelican). But a painting that Rodolfo Baroncini has pointed to as similar to the one described by Banchieri, Bernardino Campi's altarpiece for the chapel of Cecilia in the church of S. Sigismondo in Cremona (signed and dated 1566; plate 68), is a rare example of a sixteenth-century Italian depiction of Cecilia actually playing an instrument.[27] After Cecilia and Catherine appeared so often with other saints, and with Catherine's mystic marriage so often the main event, here, finally, they appear by themselves, with the enjoyment of music their only concern—and Cecilia taking the active role and drawing the viewer's attention.

The organ that Campi placed so prominently in the middle of his painting has some features that one might find on a real sixteenth-century instrument, and others that are the product of the artist's imagination. He accurately depicted the width-to-length ratio of the pipes, the progression of the scaling from bass to treble, and the form of the mouths (the openings near the bottom of the pipes). On the other hand, many pipes seem to be missing. To judge from our partial view of the keyboard, the instrument probably has a range of at least three octaves, requiring thirty-two pipes. Furthermore, if this were a real instrument, Catherine would be busy pumping the bellows—an essential feature of any organ—that this one apparently lacks.[28]

Despite these inaccuracies, Campi's painting is a vivid evocation of music-making and of the pleasure it can arouse in performers and listeners alike. The other instruments in the painting are not strewn carelessly on the floor. A tambourine sits on a shelf while a *lira da braccio*, an unidentified wind instrument (or perhaps a set of wind instruments), and a lute hang safely from pegs. The fresco of celestial musicians on the wall above the altarpiece—an angelic band of *bas instruments* (lute, harp, and viol) accompanying cherubs who sing from a choirbook—complements Cecilia's music-making and amplifies its effect.[29]

Banchieri's description of Il Sodoma's lost painting of Cecilia and Campi's surviving portrayal of her suggest that the Franco-Flemish conception of Cecilia as a performer, a music lover, and a patron of musicians was spreading to Italy, albeit slowly, in the sixteenth century. That process, shifting to Rome, accelerated in the last quarter of the century, as we will see in the following chapter.

Cecilia Returns to Rome

In dedicating his *Conclusioni nel suono dell'organo* to Cecilia in 1609, and in describing her as "object of devotion of musicians and organists," Adriano Banchieri could look back on several decades in which her status as a musical icon had gradually strengthened in Italy. He and other Italian musicians had ample opportunity to learn of her adoption as a patron by musicians in northern France and the Netherlands and of the musical traditions quickly growing around it. Northern composers of Cecilian motets included several who spent substantial time in Italy (table 7.1). The Venetian printers Gardano and Scotto published Cecilian music by Franco-Flemish composers, even those who may never have visited Italy. Scotto's *Motetti del labirinto libro terzo* (1554) included three Cecilian motets by Canis and Galli. The text of Galli's *Ceciliae laudes celebremus* (quoted and discussed in chapter 4), which refers to the non-liturgical, musical observance of Cecilia's Day, might have increased Italian awareness of how northern musicians were marking her feast in the mid-sixteenth century.

Some of the earliest Franco-Flemish Cecilian music found its way into the most prestigious of Italian chapels, the Cappella Sistina. Its music library had copies of editions that include motets addressed to Cecilia: in addition to anthologies published by Gardano and Scotto, the pope's chapel owned the book of Certon's motets, published by Attaingnant in 1542, that includes two Cecilian works. Although we do not know precisely when these books entered the library, they eventually gave the papal singers access to seven Cecilian motets published in 1554 or earlier, by Canis, Certon, Galli, Pagnier, and Piéton.[1]

Probably under the influence of these and other prints, Italian musicians reclaimed Cecilia as one of their own, initiating in the 1560s an Italianization

TABLE 7.1. French and Flemish composers of Cecilian motets who spent substantial time in Italy

Composer	Motet(s)
Boyleau	*Ceciliam intra cubiculum*
Jacquet	*Inclita sanctae virginis Ceciliae* (also circulated in version addressed to St. Catherine)
	Cantantibus organis
Kerle	*Cantantibus organis*
Lassus	*Cantantibus organis*
	Domine Jesu Christe
Mel	*Cantantibus organis*
Monte	*Cecilia virgo Almachium*
	Cilicio Cecilia membra domabat
Naich	*Cantibus organicis* (also attributed to Gombert)
Rore	*Cantantibus organis*

of the Franco-Flemish Cecilian motet tradition. This was largely a Roman phenomenon, despite the role that Venetian publishers played in it. The two earliest Cecilian motets by an Italian composer, as far as I know, are Roman: Palestrina's *Dum aurora finem daret* and *Cantantibus organis*.[2] Romans founded what seems to have been the first Italian musical society under Cecilia's protection. Several of its members collaborated on an extremely unusual project: a jointly composed *Missa Cantantibus organis*, based on Palestrina's work.

In 1608 and 1609 two composers, Banchieri and Francesco Pappo (an organist in Milan), dedicated books of motets to Cardinal Paolo Sfondrato. Both books begin with music for Cecilia: fitting tributes to a man who called himself "Il Cardinale Santa Cecilia" and had done more than anyone else to enhance her prestige in Italy.[3] On his elevation to the cardinalate in 1590, Sfondrato received S. Cecilia in Trastevere as his titular church. Fascinated by the history of this ancient building and by the stories of the virgin martyr to whom it was dedicated, he undertook excavations that culminated in the discovery of a body that he believed to be that of Cecilia herself. Pope Clement VIII officiated at her reinterment, on Cecilia's Day 1599—a ceremony that attracted the cream of the Roman clergy and nobility. The musicians, instrumental as well as vocal, who took part must have done so with pride in their patron saint's newly won celebrity.

CECILIAN MOTETS BY PALESTRINA AND MARENZIO

Palestrina published his setting of the antiphon *Dum aurora finem daret* in the *Motecta festorum totius anni* (Rome, 1563[4]), a book reprinted at least seven times during his lifetime, and one of the first sets of motets by Italian composers arranged according to the liturgical calendar.[5] The thirty-six pieces include ten

TABLE 7.2. Palestrina, *Dum aurora finem daret*: distribution of points

Rhetorical function	Point	Text (number of words)	Location (and length) in breves
Exordium	1	Dum aurora finem daret, (4)	1–23 (23)
Medium	2	Cecilia exclamavit, dicens: (3)	21–43 (23)
	3	"Eia milites Christi, (3)	43–55 (13)
	4	abjicite opera tenebrarum, (3)	56–71 (16)
Finis	5	et induimini arma lucis." (4)	71–88 (18)

dedicated to individual saints other than Mary; of these, only two are female: Mary Magdalene and Cecilia. By including *Dum aurora finem daret* in a collection so often reprinted, and by labeling it specifically "In festo sanctae Ceciliae," Palestrina enhanced her status in relation to that of the female saints (such as Barbara and Catherine) not represented in the book and the importance of her feast for Italian—and especially Roman—musicians.

The *Motecta festorum* are all in one movement. Palestrina, in choosing the text *Dum aurora*, acknowledged the Franco-Flemish tradition of single-part motets on this text (see table 5.4). In the number of points of imitation, the number of words per point, the length of the points, the length of the work, and its division into the basic rhetorical units proposed by Gallus Dressler around the same time as *Dum aurora* was published, Palestrina showed himself to be heavily indebted to the French and Flemish composers whose Cecilian music we surveyed in chapter 5. Although there is no reason to think that he was familiar with the anonymous *Dum aurora* or the setting by Jacob Bultel, whose contents are summarized in table 5.8, it is surely no accident that the layout of Palestrina's composition closely resembles those of earlier settings of the same text (table 7.2).

Palestrina gave Cecilia's Roman cult another boost in 1575, with the publication of his third book of motets in five, six, and eight voices, which included the five-voice *Cantantibus organis*. This assortment is unusual in the number of pieces honoring female saints and other women: not only Cecilia but also Catherine, Lucy, and the biblical heroines Susanna and Esther.[6]

Cantantibus organis is a setting of the Cecilian responsory with which we are now familiar, but without the phrase "in corde suo," whose presence normally helps distinguish the responsory from the antiphon that begins with the same words. Palestrina might have found this version of the responsory in the *Cantantibus organis* of Jacobus de Kerle, which likewise lacks the words "in corde suo." That Kerle's motet was published by Valerio Dorico, who also published some of Palestrina's early music, increases the likelihood that Palestrina knew it.[7]

Palestrina's two *partes* reflect the musical form of the responsory chant, in which the repetition of text is accompanied by repetition of music: part 1 AB, part 2 CB.[8] By the time he published *Cantantibus organis*, Franco-Flemish musicians had composed at least fifteen settings of texts that include the words "Can-

tantibus organis" (see table 5.2), six of which (including Kerle's) were settings of the whole responsory (see table 5.13). But the use by both Palestrina and Kerle of the same abbreviated variant of the responsory suggests that the earlier motet, as the work of a Flemish composer published in Rome, served as a link between a musical culture in which Cecilia already played a crucial role and one in which her status among musicians was soon to reach new heights.

In the number of words in each point (ranging from two to five) and their length in breves (ranging from eight to twenty-three), Palestrina achieved a pleasing variety while staying within the norms, discussed in chapter 5, established by his French and Flemish predecessors (table 7.3). Reinforcing the balance that the responsory form gives to the two movements, Palestrina divided the text so that the points are roughly equal in number (six in part 1, five in part 2), and set them to music so that the length of each part is almost identical. At the same time, he differentiated the movements with their opening *soggetti*. Part 1 begins with the disjunct declamation of the final and *confinalis* (G and D) characteristic of the sixteenth-century *exordium* (ex. 7.1). Part 2, in contrast, begins with a conjunct melodic contour—of the kind that composers considered more fitting for the resumption than for the beginning of a motet (ex. 7.2). Not only did Palestrina conform to the general approach to motet composition documented in chapter 5, he also closely resembled such composers as Gheens (see table 5.14) in his setting of this particular responsory text.

Many of Palestrina's points feature the modular counterpoint that Peter Schubert has elucidated in his essay on Palestrina's first book of four-voice

TABLE 7.3. Palestrina, *Cantantibus organis*: distribution of points

Part	Rhetorical function	Point	Text (number of words)	Location (and length) in breves
1	Exordium	1	Cantantibus organis (2)	1–15 (15)
	Medium	2	Cecilia virgo (2)	15–22 (8)
		3	soli Domino decantabat dicens: (4)	23–37 (15)
		4	"Fiat Domine cor meum (4)	36–43 (8)
		5	et corpus meum immaculatum, (4)	43–54 (12)
	Finis	6	ut non confundar." (3)	54–69 (16)
2	Exordium	7	Biduanis ac triduanis jejuniis orans, (5)	1–23 (23)
	Medium	8	commendabat Domino quod timebat: (4)	23–39 (17)
		9 (=4)	"Fiat Domine cor meum (4)	37–44 (8)
		10 (=5)	et corpus meum immaculatum, (3)	44–55 (12)
	Finis	11 (=6)	ut non confundar." (3)	55–70 (16)

Note: I have assigned a single series of numbers to the points in parts 1 and 2 to facilitate identification of the passages used in the *Missa Cantantibus organis* (see table 7.6).

EXAMPLE 7.1. Palestrina, *Cantantibus organis*, part 1, breves 1–14: Primary *exordium*, with two-voice module presented three times: altus-cantus, bassus-tenor, and bassus-quintus. Source: Palestrina, *Le opere complete*, ed. R. Casimiri et al., vol. 8, Rome, 1940

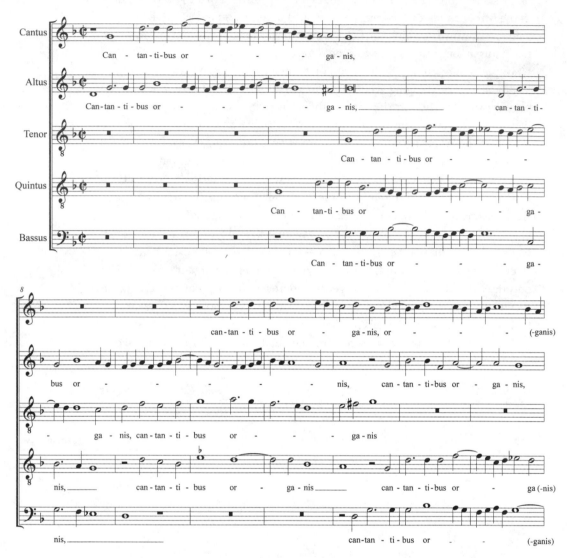

motets.[9] In point 1, for example, the altus-cantus duet at the beginning returns twice: as a bassus-tenor duet, with the quintus (whose entry a breve earlier is a "red herring") adding a third part, and as a bassus-quintus duet (with the cantus and altus adding a third and a fourth part). The basic contrapuntal framework of the duet keeps returning while the texture becomes progressively richer. Later, in point 5 ("et corpus meum immaculatum," which returns in the *secunda pars* as point 10), Palestrina uses a three-voice module with a fragment of fauxbourdon. Heard first in the lower three voices, then in the upper three, the recurring module creates an antiphonal effect (ex. 7.3).

We saw in chapter 5 that Galli's *Ceciliae laudes celebremus*, in *Re* tonality with

EXAMPLE 7.2. Palestrina, *Cantantibus organis*, part 2, breves 1–9 (beginning of secondary *exordium*).

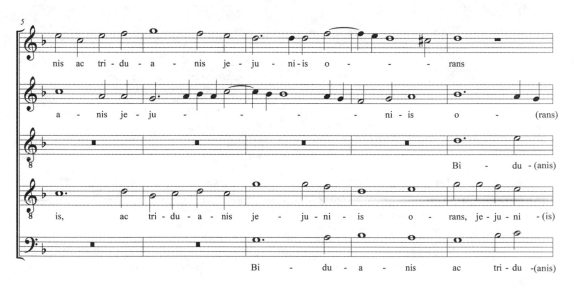

a G final, makes repeated and striking excursions to *Ut* tonality with a temporary
B♭ final (see exx. 5.19 and 5.20). Palestrina's motet uses the same tonal contrast.
The last point of both movements, "ut non confundar," begins with an ascending
5–6 sequence with a canon between quintus and bassus. The bassus declaims
the first four notes of the hexachord, beginning on F. (Palestrina made a pun,
setting the word "ut" on F.) Later in the *finis*, just a few breves from the final ca-
dence on G, the ascending sequence returns, but now beginning on B♭. With this
juxtaposition of tonalities, Palestrina paints a musical picture of the confusion to
which Cecilia alludes in her prayer (ex. 7.4).[10] Yet the effect pales in comparison
to the much more dramatic syncopations, descending sequence, and unstable
harmony in the setting of the same words by Clemens (see ex. 5.16).

EXAMPLE 7.3. Palestrina, *Cantantibus organis*, part 1, breves 42–53 (repeated in part 2, breves 43–54): point 5.

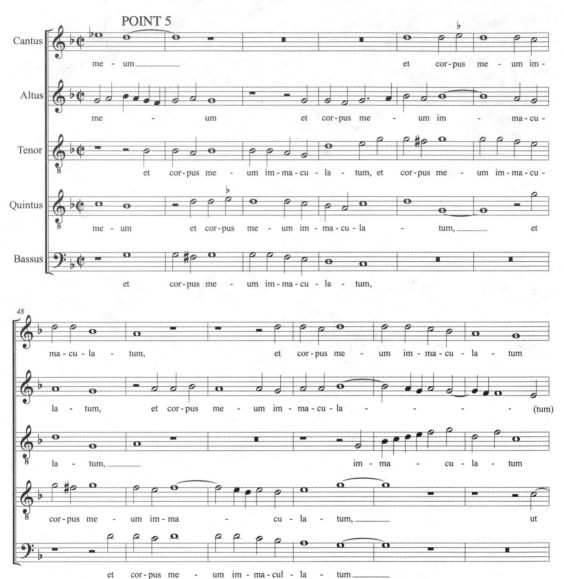

Luca Marenzio, born in 1553 or 1554 probably in a small town near Brescia, spent much of his early life in Rome, in the employ of Cardinals Cristoforo Madruzzo and Luigi d'Este.[11] Although most famous for his madrigals, he also wrote much sacred music. He published some of his early motets in *Motectorum pro festis totius anni . . . liber primus*, a book of four-voice pieces that appeared in Rome in 1585, organized according to the liturgical year. Obviously inspired by Palestrina's *Motecta festorum totius anni* of 1563, the thirty-two-year-old Marenzio brought a young man's energy to his project, offering forty-two works in place of Palestrina's thirty-six.[12]

EXAMPLE 7.4. Palestrina, *Cantantibus organis*, part 1, breves 53–69 (repeated in part 2, breves 54–70): end of point 5, point 6.

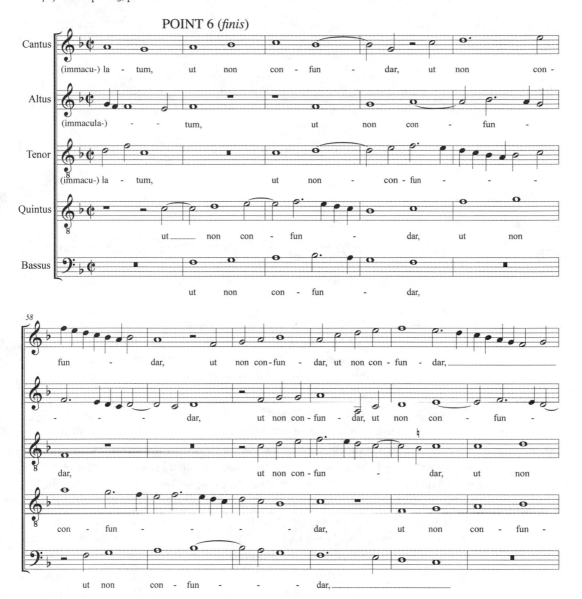

One way a young Renaissance composer paid tribute to a respected master was to set a text that had already been set by the older composer, with music that displayed both the younger composer's indebtedness and his originality and creativity.[13] Marenzio honored the sixty-year-old Palestrina with his *Cantantibus organis* for four voices, published ten years after Palestrina's five-voice motet. Marenzio's work, like Palestrina's, begins with a cantus-altus duet in which the word "organis" is set to a melisma of semiminims (ex. 7.5). Overlapping with this duet, the tenor and bassus enter with a duet of their own. Marenzio's use of

EXAMPLE 7.4 (*continued*)

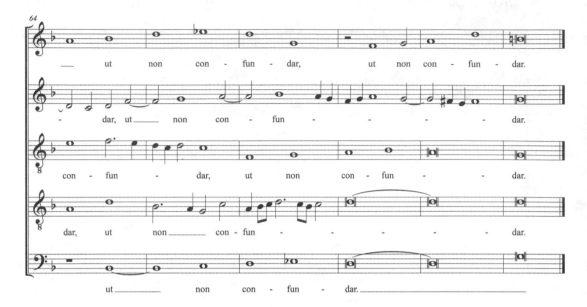

the same contrapuntal content in both duets identifies them as manifestations of a module, deployed here (and reused later in the point) in a context very similar to the modular duets at the beginning of Palestrina's setting. But Marenzio's melisma is longer and more extravagant than Palestrina's, and the fourth statement of the module extends the melisma to three lower voices simultaneously—a particularly sensuous effect characteristic of the master madrigalist.

The motets differ in other respects too. Marenzio's is in one movement only. Although the text is that of the first part of the responsory (the respond), he did not set the verse *Biduanis ac triduanis* to music. Marenzio showed more interest than Palestrina in textural contrast. After three imitative points, he began the fourth, "soli Domino decantabat dicens," with homophony that emphasizes the single-mindedness of Cecilia's devotion to God. He called attention to the following quotation of Cecilia's prayer more emphatically than Palestrina, treating "Fiat Domine cor meum et corpus meum immaculatum" as a single point, without any repetition, and setting these eight words as a musical segment typically occupied by two to four words. Using only white notes (an allusion to Cecilia's purity) and the same 5–6 ascending sequence that Palestrina used to set Cecilia's words "ut non confundar," Marenzio reduced the number of voices to three and shifted to a homorhythmic texture. The altus and tenor seem to accompany the cantus, which presumably represents Cecilia herself (ex. 7.6).

Marenzio wrote at least two more Cecilian pieces: *Ceciliam cantate pii* and *Dum aurora finem daret*. Though not published until 1616, after his death, both the subject matter and the musical style suggest that he wrote these pieces during his early years in Rome.[14] His reuse, in *Ceciliam cantate pii*, of part of a nonliturgical text (transcribed in chapter 4) that had been set to music by Gombert and that refers explicitly to the musical celebration of Cecilia's Day neatly docu-

EXAMPLE 7.5. Luca Marenzio, *Cantantibus organis*, breves 1–18 (*exordium*, complete), with module based on canon at the fifth below. Source: *CMM 72.2*

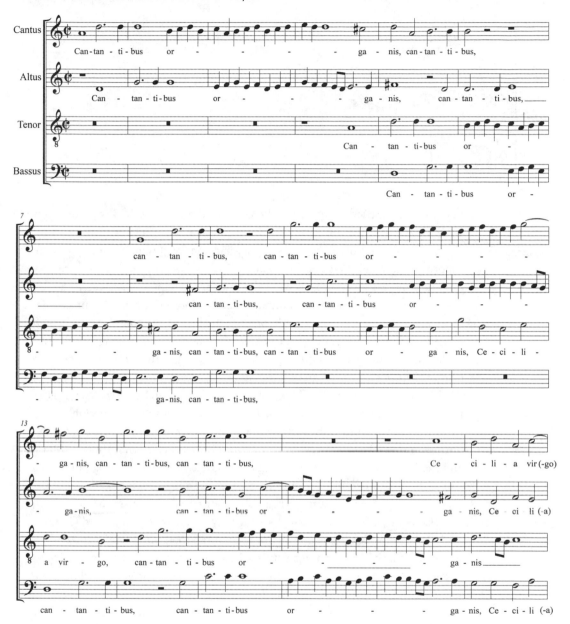

ments the transfer of Cecilian culture from the Netherlands to Italy that took place during the sixteenth century.

THE COMPAGNIA DEI MUSICI DI ROMA

On 1 May 1585 the newly elected Pope Sixtus V (ruled 1585–1590) issued a decree, *Confirmatio erectionis Confraternitatis Musicorum de Urbe cum indulgentiis*

EXAMPLE 7.6. Marenzio, *Cantantibus organis*, breves 43–51: point 5, with canon at the fifth below between cantus and tenor.

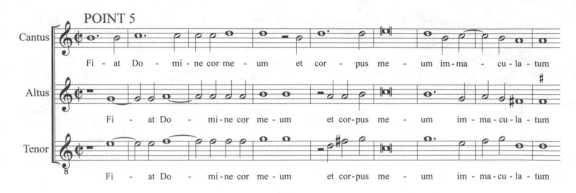

in forma Rationi congruit, in which he confirmed a decision by his predecessor Gregory XIII (ruled 1572–1585) shortly before his death.[15] In response to a request from a group of musicians, Gregory had approved the formation of a confraternity of musicians resident in Rome. (*Confraternitas* can mean confraternity or guild—using those words as we defined them in chapter 3. Although the Roman musicians may have had in mind something more like a guild—an association of professionals—than a confraternity, the loss of the founding statutes, if indeed they ever existed, leaves the character of the organization in some doubt.)

The musicians, in asking Pope Gregory to sanction their organization, told him of their wish to place themselves under the protection of the Visitation of the Blessed Virgin Mary, St. Gregory, and St. Cecilia, and to establish an altar in S. Maria Rotonda—the Pantheon. The musicians chose the Visitation, 2 July, as a patronal feast probably because of its association with two of the most important texts in the Christian liturgy, both often set to music: the Ave Maria and the Magnificat. They chose Gregory the Great (pope from 590 to 604) as a patron because a centuries-old legend attributed to him the introduction of the repertory of plainchant sung during Christian rituals since the Middle Ages, and also because the pope whose blessing they sought was also named Gregory. And they chose Cecilia, about eighty years after the guild of instrumentalists in Leuven adopted her as their patron, because by the 1580s Italian musicians were finally beginning to think of her as a patron whose feast they should observe and enjoy.

As for the purpose of their group, the Roman musicians were apparently quite vague, to judge by the opening paragraph of Sixtus's decree; they sought to contribute to the glory of God, to holy works, and to the salvation of souls. The pope left the formulation of statutes to the group itself. But in the hope of shaping those statutes, he confirmed decisions made by his predecessor, who had offered an indulgence to all members—NB: women as well as men!—on their entry into the confraternity. The indulgence was to go "to all and each of the faithful, male or female, who were truly penitent and had confessed, who enter and are received into the confraternity, on the day when they first enter and are received, if they should have received the Most Holy Eucharist."[16] Moreover, any

other believer could earn an indulgence by taking part in Mass and the Divine Office at the confraternity's altar on its feast days. Members could earn a further indulgence by acts of charity and piety: giving dowries to poor women and arranging for them to be married, giving aid to the destitute and the imprisoned, accompanying the bodies of dead members to their place of burial, participating in processions organized by the confraternity, accompanying the Holy Eucharist when it was carried in procession, singing the Our Father and the Hail Mary five times for the souls of deceased members of the confraternity, and teaching young men grammar, music, reading, and writing.

We know little of the membership of the newly recognized society. But in 1589 the publication of an anthology of madrigals brought the membership into sharper focus, and gave the confraternity something resembling an official name. Felice Anerio, in the dedicatory letter in *Le gioie* (The Jewels), identified the composers as members of the "vertuosa Compagnia de i Musici di Roma" and called himself the group's maestro di cappella. From the composers of *Le gioie*, William J. Summers has extrapolated a partial list of members (table 7.4).[17]

TABLE 7.4. Members of the Compagnia dei musici di Roma, 1589

Names (in alphabetical order)	Position(s) or place(s) of activity in or about 1589 (unless otherwise specified, all institutions and patrons in Rome)
Felice Anerio	Maestro di cappella, Collegio degli Inglesi
Paolo Bellasio	Organist, Orvieto Cathedral
Arcangelo Crivelli	Singer, Cappella Sistina
Giovanni Andrea Dragoni	Maestro di cappella, S. Giovanni in Laterano
Ruggiero Giovannelli	S. Luigi de' Francesi
Orazio Griffi	Tenor, Cappella Sistina
Bartolomeo Le Roy	Viceroyal maestro di cappella, Naples
Giovanni Battista Lucatelli	Organist, S. Pietro
Giovanni de Macque	In the service of Carlo Gesualdo, Naples
Cristofano Malvezzi	Maestro di cappella in the Duomo, Florence
Luca Marenzio	In the service of Virginio Orsini
Giovanni Bernardino Nanino	Maestro di cappella, S. Maria dei Monti
Giovanni Maria Nanino	Tenor, Cappella Sistina
Giovanni da Palestrina	Maestro di cappella, Cappella Giulia
Paolo Quagliati	Organist, S. Maria Maggiore (from 1591)
Francesco Soriano	Maestro di cappella, S. Maria Maggiore
Annibale Stabile	Maestro di cappella, Collegio Germanico
Giovanni Troiano	Maestro di cappella, Spoleto
Annibale Zoilo	Maestro di cappella, Santa Casa, Loreto

Source: *Le gioie* (Venice, 1589).

This roster shows, among other things, that the confraternity was by no means limited to Roman musicians. For our purposes, the list is especially valuable as evidence that by the end of the 1580s the confraternity included some of Italy's best musicians—musicians willing, through their membership, to associate their names with that of St. Cecilia.

The names of the contributors to *Le gioie* allow us to trace the origins of the Compagnia de' musici di Roma back to the early 1580s. In 1582 a collection of madrigals appeared under the title *Dolci affetti: Madrigali a cinque voci de' diversi eccellenti musici di Roma*, which contains music by sixteen composers, ten of whom were later represented in *Le gioie*. Evidently the organization sanctioned by Sixtus V in 1585 already existed, albeit informally, at least three years earlier.[18]

Other anthologies published in Rome itself during the 1580s and 1590s feature some of the same names, as well as the names of a few other musicians who presumably operated in the same circles, and who might have also been members of the Compagnia de' musici. Beginning in 1586 Simone Verovio, a Flemish engraver, publisher, and musician living in Rome, issued a series of anthologies in which he pioneered the process of music engraving on a copper plate.[19] The composers he published, under title pages that usually describe them as "diversi eccellenti musici," were largely limited to those we know (from their later presence in *Le gioie*) to have been members of the Compagnia.[20]

From *Le gioie*, *Dolci affetti*, and Verovio's anthologies we might reasonably conclude that members of the Compagnia de' musici di Roma, while mostly employed in churches, devoted much of their time to secular music in Italian.[21] This would help explain why one of the most distinguished musicians active in Rome in the 1570s and 1580s does not seem to have been a member. Tomás Luis de Victoria had a single-minded interest in sacred music that probably encouraged him to keep his distance from the Compagnia.

We should not be surprised that Victoria's forty-four motets include none addressed to Cecilia—who, as we have seen in chapter 4, received little attention from Spanish composers in the sixteenth century. But during the last four decades of the century, several Italian musicians joined Palestrina in composing music for Cecilia's Day (table 7.5).

The cluster of Italian motets published in 1585 demands attention: three works in honor of Cecilia appeared in the same year as Pope Sixtus V gave his official blessing to the Compagnia dei musici di Roma. Two were by members of the Compagnia. Did Marenzio and Stabile (who included his *Cantantibus organis* in a book dedicated to the newly elected pontiff) write Cecilian music in response to the pope's requirement that the new confraternity celebrate Vespers and Mass on Cecilia's Day?

Although Costanzo Porta, born in Cremona in 1528 or 1529, never (as far as we know) worked in Rome, it was not for lack of trying. He wrote two Cecilian works, the second of which appeared in a compilation of six-voice motets dedicated, like Stabile's 1585 motet book, to Pope Sixtus V. Porta's edition, a blatant

TABLE 7.5. Cecilian motets by Italian musicians published before 1600

Year of publication (RISM number)	Motet	Composer
1563 (RISM *deest*)	*Dum aurora finem daret*	Giovanni da Palestrina
1575 (P 711)	*Cantantibus organis*	Palestrina
1580 (P 5181)	*Cantantibus organis*	Costanzo Porta
1585 (M 494)	*Cantantibus organis*	Luca Marenzio
1585 (P 5182)	*Gloriosa virgo Cecilia*	Porta
1585 (S 4201)	*Cantantibus organis*	Annibale Stabile
1586 (C 986)	*Cantantibus organis*	Giacomo Antonio Cardillo
1590 (M 1274)	*Beata Cecilia dixit Tiburtio*	Tiburzio Massaino
1792 (M 1276)	*Cilicio Cecilia*	Massaino
1792 (S 1182)	*Cantantibus organis*	Damiano Scarabelli
1796 (B 2599)	*Psallite cantantes Domino*	Francesco Bianciardi
1598 (M 3642)	*Cantantibus organis*	Bernardino Morelli

gambit for papal patronage, ends with *Gloriosa virgo Cecilia*. In placing music in honor of Cecilia at the end of his book, Porta showed that he recognized that Cecilia's place in Italian musical life was changing. She was no longer just a virgin martyr among many virgin martyrs: she was a patron of musicians, and thus a fitting subject for an *envoi*.

Porta was not the only composer outside Rome who acknowledged Cecilia's new status by placing a motet in her honor at the end of a collection of his music. In 1586, a year after the publication of Porta's *Musica sex canenda vocibus . . . liber tertius*, Giacomo Antonio Cardillo, maestro di cappella at the Este court, published in Venice his second book of motets. It too ends with a Cecilian motet: *Cantantibus organis*.

CARDINAL SFONDRATO AND THE RISING PROFILE
OF THE CHURCH OF SANTA CECILIA

In 1590, the newly elected Pope Gregory XIV made his nephew Paolo Camillo Sfondrato a cardinal, with S. Cecilia in Trastevere his titular church (plate 69). Cardinal-nephews often amassed great wealth and became important patrons of the arts; Sfondrato would probably have done so if Pope Gregory had not died within a year of his election, leaving his nephew with less income than he might have expected. Yet Sfondrato managed to find time and money for artistic—including musical—patronage, one of the aims of which was to enhance the visibility and prestige of his titular church.[22]

From the very beginning of his cardinalate, Sfondrato used music to call

attention to the church of S. Cecilia and to himself. Evidently he learned quickly of Cecilia's new role in Rome, confirmed only a few years earlier by Sixtus V, as patron of musicians. In the ceremony that marked his taking possession of the church, on 25 January 1591, he arranged for a "large number of the finest musicians of Rome" to participate.[23] "The church was furnished with superb decorations, with many objects of silver, and the sweetest songs were performed"— songs that included motets.[24]

It was probably in response to the assignment of Santa Cecilia to Sfondrato as his titular church, and as a speculative bid for the new cardinal's patronage, that Bernardino Passeri issued, also in 1591, a set of prints illustrating scenes from Cecilia's life.[25] The depiction of Cecilia's wedding gives instrumentalists as prominent a role as they had in the Beaupré Antiphonary about three centuries earlier. An organist plays in the background, next to the banquet table, while directly behind the bride and groom a quartet plays a mixture of winds (cornetto and recorder?) and strings (viol and harp or lyre; fig. 7.1).

The growing importance of Cecilian motets, of Cecilia's Day, and of the church of S. Cecilia in Rome's liturgical and musical life during the 1590s is illustrated in the diaries of the Sistine Chapel: records of the choir's day-to-day activities kept by its members. In the diaries covering the years 1535–1560, neither the feast nor the church played an important role; year after year Cecilia's Day passed without events that might suggest that it was of special importance to the papal musicians, to the pope, or to the cardinal whose titular church was S. Cecilia.[26] By the mid-1590s, the situation had changed drastically. Efforts by Sfondrato to bring papal singers to his titular church on Cecilia's Day in 1594 were so insistent that they caused controversy:

> Monday, 21 [November] . . . after the Mass Cardinal Sfondrato sent a chaplain to invite our entire choir to go to sing tomorrow the Mass and Vespers at his titular church of S. Cecilia. The maestro di cappella responded to him that we would go to Mass to serve His Eminence, but at Vespers it is not customary that the pope's chapel sing as a group anywhere, and the said chaplain was informed that Cardinal Mont'alto and Cardinal Matthei have given to the chapel—that is, for the singers—fifteen *scudi* for the Mass alone; but with the bosses there are no contracts.[27]

The aphoristic concluding phrase ("con li padroni non si fa patti," probably playing on the proverb "Con i matti non ci sono patti") suggests that the papal singers were annoyed by Sfondrato's importunity; the reference to the generosity of other cardinals alludes to his inability to compete financially with Rome's richest patrons. Yet the disagreement was quickly settled, as we learn from the next entry. The resolution involved a combination familiar to those who knew about Cecilian festivities in the Netherlands and northern France: food and money.

FIGURE 7.1. Bernardino Passeri, *Wedding of Cecilia and Valerian*, 1591. Metropolitan Museum, New York. Photo: Metropolitan Museum

Tuesday the 22nd. St. Cecilia's Day. This morning, at the request of His Most Illustrious and most Reverend Cardinal Sfondrato we went to sing the Mass at his titular church of Santa Cecilia . . . The said most illustrious cardinal gave us lunch at his residence and then begged the chorus to sing Vespers at the same church, and for our convenience he arranged for us all to go by coach; and we sang Vespers . . . The said most illustrious cardinal sent, this same day, fifteen *scudi* in cash.[28]

These performances probably included motets, of which the Sistine Chapel's music library may have had, by 1594, not only the seven Franco-Flemish works mentioned at the beginning of this chapter, but also Palestrina's *Dum aurora* and *Cantantibus organis* and Massaino's *Cilicio Cecilia*.[29]

THE DISCOVERY OF CECILIA'S BODY ON THE EVE OF THE JUBILEE

Cardinal Sfondrato's efforts on behalf of his church and his patron saint increased in urgency as the Holy Year 1600 approached.[30] At the height of the Counter-Reformation, the Jubilee offered Roman Catholicism a chance to display its capital city at its most magnificent to the thousands of pilgrims who would visit from all over Europe. With the Jubilee in mind, many cardinals remodeled their titular churches, embellishing them with altarpieces and frescoes.[31] In 1597 Sfondrato began a series of renovations in S. Cecilia, which soon took on the character of an archaeological exploration.[32] He saw this exploration as a means of confirming the legitimacy of Catholicism as the one true faith and as an opportunity for self-promotion—and probably cheaper than commissioning spectacular works of art.

Sfondrato established relations with some of Rome's leading scholars, including two who were to play important roles in verifying that one of the bodies found under the church was indeed Cecilia's and in documenting her reburial. Antonio Bosio was a specialist in the archaeology of early Christian Rome. Cardinal Cesare Baronio, editor of the *Martyrologium romanum* and author of a multivolume history of the Church, occupied a place at the very center of debates in Counter-Reformation Rome about Catholic liturgy and the cult of saints.[33] By associating himself with these famous scholars, Sfondrato probably hoped to benefit from their prestige and influence.

The approaching Holy Year focused Sfondrato's archaeological interests on a single goal: to find evidence of Cecilia's existence and to confirm reports that Pope Paschal I (817–824), having found her body in the Catacomb of Callixtus, had reburied her beneath the church of S. Cecilia. Paschal's claim aroused the cardinal's curiosity and ambition. But the accounts of what happened next differ in their explanations of why he began digging under the main altar.

According to a chronicle compiled by one of the nuns of the Benedictine con-

vent that adjoins the church of S. Cecilia, "His Eminence had a very great desire to know if the body of St. Cecilia was in our church, and to this effect he often came to the parlatory and insistently asked the reverend mothers if any of them could give him information about it."[34] The chronicler implied that Sfondrato, encouraged by the nuns, excavated to satisfy his curiosity and out of a desire to find the body. Bosio, in contrast, left the impression that the cardinal found the body by accident, having dug below the altar with the intention of burying a reliquary there.[35]

Whatever his motivation, it was probably not until October 1599 that Sfondrato began excavating beneath the high altar. Beginning in that month, a sequence of events unfolded with such perfect timing that we are tempted to suspect that he planned them in advance. On 20 October the cardinal and his workmen found two sarcophagi, in one of which was the body of a woman he identified as Cecilia. After a month on public display, attracting large and emotional crowds, the corpse was reburied in great magnificence on Cecilia's Day. A little more than a month later, the Holy Year began. Sfondrato commissioned the young sculptor Stefano Maderno to make a replica of the body in white marble. Installed during the Jubilee, the sculpture, and the events it commemorated, transformed the church of S. Cecilia into one of Rome's most revered shrines.

Late in the Holy Year (so possibly the last in this well-timed sequence of events), Bosio published a book that included an edition of *Passio sanctae Ceciliae* and accounts of the discovery of Cecilia's body and of its reburial. Dedicated to Sfrondrato, and probably commissioned by him as well, the book placed the stunning events of late 1599 in a scholarly context—thus serving as a kind of intellectual counterpart to Maderno's sculpture.[36] Although not present at the discovery of the body, Bosio described the event with an archaeologist's attention to detail:

[On 20 October 1599], in his [Sfondrato's] presence and in front of everyone he ordered that the pavement be broken open; when it was demolished, the earth below removed, and the upper wall [of the crypt] having been broken through, two sarcophagi of marble became visible. They measured about three feet each, and almost touched each other; they were arranged along the length of the altar, in such a way that the altar, above them, was closely adjacent. All these actions were undertaken in the presence of the same illustrious cardinal, who, before proceeding further with work requiring other decisions, ordered that trustworthy witnesses be summoned. These were the Most Reverend Paolo di Isernia, bishop-vicegerent of the Supreme Pontiff's vicar; Iacopo Buzzi, canon of the Lateran and secretary of the congregation of the same illustrious vicar; and the reverend fathers Pietro Alagona and Pietro Morra of the Company of Jesus. After they had arrived, and with them as well as several members of the cardinal's household watching carefully, the investigation continued.

When the marble lid was removed from the first sarcophagus of marble— that is, the one facing the entrance of the church—it was perceived that inside

was enclosed a cypress box, six palms in length, one and a half palms wide and two palms high. It was not locked with a key, nor held shut with nails, but closed with a cover of flexible wood, fastened at one end, which could be moved or twisted easily by a movement of the hand. When, after a brief inspection, the means of opening it had been discovered, with the help of God the cover was pulled back and removed, with all due respect and with the greatest devotion, by the cardinal himself with his own hands.[37]

In describing the box's contents, Bosio referred repeatedly to a letter by Paschal I, the ninth-century pope who, he and Sfondrato believed, had reburied Cecilia in the church named for her.[38] Risking charges of circular reasoning, he assumed Paschal's letter and the account of his papacy by the historian Anastasius Bibliothecarius of Paschal's translation of Cecilia's body to be true, citing them with the implicit purpose of establishing the authenticity of the newly discovered body; but at the same time he implied that the discovery verified the claims of Paschal and Bibliothecarius:

The open box appeared to be decorated on all sides of the interior with cloth similar to silk, in color a mixture of green and red, whose brightness however had faded over time. This is the cloth of which Bibliothecarius wrote, in reference to Paschal, when he related what the pontiff took to this church: *In the little coffin for the body of the said virgin he made a lining of four layers with a fringe.* In this box the body of the blessed Cecilia lay on the silk, covered with a dark veil, and under the veil, golden fabric, sprinkled with spots of virginal blood, shined through with a faint glow. With these golden garments (which she used when she was alive), the same holy body was found by the blessed Paschal, as both his letters and Bibliothecarius, whom we mentioned above, state. But—and in accordance with what the cardinal himself has testified—under the golden robe a rigid layer of haircloth was concealed, near the sacred bones, commemorated in the Acts of her passion: *But underneath, near her flesh, Cecilia wore haircloth, while outside she wore golden robes.* At the feet of the holy body lay a ball of linen, undoubtedly that which Paschal recorded as follows in his letter describing his discovery: *where we found linen, with which the most holy blood was absorbed from the wounds that the executioner had cruelly inflicted with three blows, one after another, full of blood.* Of this linen the history of her passion reports: *The people whom she had converted wiped off all her blood with absorbent linen.*

The virginal body appeared to be almost five and a half palms long, the bones no doubt having dried and shrunk over time; for who could doubt that the living virgin was of greater stature? The body lay resting on its right side, her legs bent a little, her arms extended, her neck extremely bent, her face toward the ground as if she were sleeping, so that one might believe that she retains the pose in which, after three blows, which she survived, she fell, giving her soul back to God, and was placed in a grave by the pontiff Urban; for thus Paschal placed her under the main altar, with her head toward the southern part of the

church, her feet toward the northern part. The illustrious Cardinal Sfondrato has arranged for the body in this state to be represented in a marble replica, to be discussed below.[39]

Bosio expressed no skepticism; at the same time he made clear that in describing the body he was simply reporting the testimony of others. He knew that the better preserved the corpse, the more likely it would be accepted as that of a virgin saint. Whatever his personal feelings as an archaeologist, he used the dark veil that covered the body as an excuse to remain, for the most part, tactfully silent about its condition. Yet he acknowledged openly that it had greatly shrunk. Moreover, he referred to haircloth "near the sacred bones" before quoting from the *Passio* that the living Cecilia wore haircloth "near her flesh."

In addition to Bosio's description of the corpse, which we might call the "official" description, sanctioned by Sfondrato, accounts of the discovery of the body can be found in anonymous *avvisi*: manuscript newsletters preserved in the Vatican Library. These tend to emphasize the body's miraculous state of preservation, repeatedly describing it as *intiero*, with Cecilia's wound visible on her neck, and blood still fresh; in short, "everything like new" (ogni cosa come nuovo).[40]

A sketch of the body in an anonymous account of its discovery shows it quite differently from Bosio's description (fig. 7.2), raising the suspicion that, in depending on Sfondrato's statements, Bosio (and the sculptor Maderno as well) might have perpetuated an inaccurate image of the body's appearance. The drawing calls attention to the absence, in the abovementioned *avvisi*, of any mention of the body's lying on its side.

Sfondrato, shortly after finding the body, departed for the papal villa at Frascati, to tell Pope Clement VIII of his discovery. The pope, although overjoyed at the news, was too sick with gout to return to Rome. In his place he sent Cardinal Baronio, who published a report in his *Annales ecclesiastici*. Though presented as

FIGURE 7.2. The body believed to be Cecilia's, discovered under the altar of S. Cecilia in Trastevere in 1599, from an anonymous manuscript describing the event. Biblioteca Apostolica Vaticana, Fondo Chigi, N. III.60, fol. 428r. The ink has caused serious corrosion of the paper and consequent loss of parts of the drawing. For a photo published in 2010, documenting an earlier state of the drawing, see Lirosi, "Il corpo di santa Cecilia," fig. 3. Photo: Biblioteca Apostolica Vaticana

eyewitness testimony, it echoes that of Bosio, published a year earlier. Baronio came to S. Cecilia already convinced that he was to see a "sacred body." But he was no more willing than Sfrondrato to lift the veils that covered the corpse:

> Having fully examined and admired the shrine, we wished to see the sacred body which it enclosed. Then were verified the words of David: *As we have heard, so have we seen, in the city of the Lord of hosts in the city of our God* [Psalm 47:9].
>
> We found the venerable body of Cecilia in the same state as we have read she was found and reburied by Pope Paschal. At her feet were still veils imbued with blood; the robe of which the pope spoke was still recognizable as a material of silk and gold, though damaged by time.
>
> We remarked other light silken textures upon the body, their depression aided us in perfectly distinguishing the beautiful cumbent figure so modestly and gracefully distended. We were struck with admiration to see that the body was not stretched out in the coffin, as the bodies of the dead generally are. The chaste virgin was lying upon her right side, as if gently sleeping on a couch, her knees modestly joined, her whole appearance inspiring such respect, that notwithstanding our curiosity, no one dared to uncover her virginal body. Everyone was deeply moved with veneration, as if her heavenly spouse, watching over his sleeping bride, had uttered this warning: *I adjure you that you wake not my beloved till she please* [Song of Songs, 3:5].[41]

Baronio, in short, having seen what he presumably expected and wished to see, happily confirmed that the body was indeed Cecilia's: "Vidimus, cognovimus, et adoravimus" (We saw, we recognized, and we adored).

News of the discovery spread quickly, and Sfondrato put the body on temporary display. Soon, Bosio reported, crowds were converging on S. Cecilia:

> The streets and bridges that led to the neighborhood of Trastevere resounded with the noise of great crowds coming and going, and the closer one got to the temple of the holy martyr, the larger the crowds became. Often the pedestrians were obstructed by carriages rushing here and there. And when one arrived at the door and the atrium of the church, the space could in no way contain the multitude, which was pushed out in waves, or rather, when one part of the crowd had been admitted with difficulty, it was often necessary to close the door of the church.[42]

The spectacle at S. Cecilia was especially attractive to women, according to Bosio:

> It was above all the matrons and the young girls of the highest Roman nobility, swept up by love for their virgin fellow citizen, who hurried there, lingered and prostrated themselves as supplicant worshippers. They did not get up again until dusk called them home at the end of the day when they went with the

impatient desire of returning. These vigils were devotedly conducted by the female sex on all the days when the body of the Saint was shown to the public.[43]

Such disorder could not be allowed to continue for long. The pope (probably acting on a suggestion from Sfondrato) decided to rebury Cecilia on her feast day, less than a month away:

> The honorable display remained in public view for a whole month, that is, until the twenty-second day of November, which is the feast of Blessed Cecilia and her birthday. During all that time the people received from God, through the intercession of the same holy martyr, many blessings. Miracles occurred, as when many people were cured of the most serious illnesses and afflictions, for which they publicly gave thanks to her and to which monuments, erected in the fulfillment of vows, bear witness. Thus, when the twenty-second of November approached, the pious pontiff Clement decided to make this same day, already famous for the glorious triumph of her virginal martyrdom, even more famous by means of a solemn ritual.[44]

REBURIAL ON CECILIA'S DAY, MADERNO'S SCULPTURE, AND GALLE'S PRINT

Sfondrato made sure that Cecilia's reinterment took place with the greatest magnificence, rivaling other Counter-Reformation ceremonies that involved the reburial of saints and the movement of their relics. Among the events in which he might have found inspiration was the translation of five saints' bodies in Todi in 1596, solemnized with a procession that lasted four hours. Giovambattista Possevino, in the preface to a book that includes a detailed description of the procession, boasted:

> One can learn important things here [in this book]: which is to say that one can see with what study one must seek to resuscitate devotion to saints of one's church who have fallen into oblivion; how one is to recover their relics, translate them with the most solemn pomp, place them in precious tombs, and ensure that they are revered with particular devotion and that their feast days are solemnly observed by all the diocesan clergy.[45]

Bosio's account of the reburial suggests that Sfondrato had learned such lessons well:

> An edict announcing the event was promulgated throughout the city, and a generous indulgence promised to those present. In order to avoid disturbances and dangers, and to insure that peaceful access be open to the pope and the large number of people and that fewer two-horse carriages should circulate in

the inhabited part of Trastevere, it was hardly the fourteenth hour when the pontiff Clement VIII, accompanied by the Holy Senate and Palace Curia and a great crowd of people, arrived at the doors of Santa Cecilia.[46]

The nuns' chronicle states clearly what Bosio was too discreet to mention: that Sfondrato himself had organized the event:

> When St. Cecilia's Day arrived, by order of His Eminence the cardinal all the cardinals, bishops, prelates, ambassadors, and gentlemen—in short, all the clergy and nobility of Rome were invited to attend the service that was to take place in the church, and likewise invited were the most excellent musicians to be found in Rome.[47]

As for the pope's arrival at S. Cecilia at "the fourteenth hour," Romans counted the hours of a day beginning with sunset of the previous day. Taking into account the long Roman night of 21–22 November, the reburial ceremony probably began shortly before sunrise.[48]

> Vows having been fulfilled at the main altar, and the heavenly Host having been adored, the pope immediately entered the sacristy, where the silver coffin, made at his expense, was prepared to receive more honorably—in weight, size, appearance, and value—the holy martyr's body, as described below.[49] He blessed her with the accustomed prayer found in the ritual books. After this, adorned with the papal train and the precious tiara known as the *regnum*, preceded by seven candelabra, the cross, and bishops and cardinals dressed in vestments customary for such a solemnity, under the umbrella sparkling with gold and silver, held by the representatives of the Venetian senate, the Duke of Savoy, and the Roman nobility, with the ambassador of the Most Christian King [Henry IV of France] holding the fringe of the train, he processed from the sacristy to the tribune, which had been constructed under the apse.[50]

Bosio listed the names of all forty-two cardinals who attended the service, before continuing with his narrative:

> As the pontiff sat down, with the cardinals around him, and the others returned to their assigned places, room for which had been added by the expansion of space in the old presbytery with the construction of risers, and when the customary ceremonies of adoration had been performed by the cardinals, the psalms of Terce were sung by the choir. When these were finished the pope, dressed in priestly vestments, descended from the tribune to the altar, made visible to the congregation by means of a magnificently decorated wooden platform. On the altar was placed the cypress box with the sacred body of the virgin covered with a golden cloth. The holy sacrifice of the Mass began in the presence of the cardinal deacons Sforza and Montisalti; [the pope] gave

the first oration about St. Cecilia, and the other about Sts. Valerian, Tiburtius, and Maximus; the most illustrious Cinzio Aldobrandini, titular cardinal of San Giorgio, chanted the Gospel, and the pope completed the rest of the Mass with the greatest devotion, up to the end of Communion. This was the moment, according to the old rite of the Church in similar situations, for the reburial of the body of the holy virgin and martyr in the original location of the crypt.[51]

As the ceremony approached its culmination, Sfondrato took the lead:

> Paolo Sfrondrato, in his role as titular cardinal, descended first to the place to which the silver coffin, after being blessed by the pontiff, was carried, so those things necessary for the reburial could be prepared. At the altar the pontiff incensed the sacred body three times; then the four cardinal deacons [Odoardo] Farnese, [Giovanni Antonio Facchinetti, titular cardinal of] Santi Quattro Coronati, [Pietro] Aldobrandini, and [Bartolomeo] Cesi, one on each side of the coffin, carried it with the greatest reverence, the cross preceding them, and with silver torches they bore the coffin into the crypt, while the supreme pontiff followed, offering assistance piously with gestures of his hands; the other cardinals stood nearby on all sides.

Cardinals Odoardo Farnese and Pietro Aldobrandini (the cardinal-nephew) were among Rome's richest men—and patrons of the arts on a scale far beyond Sfondrato's means.[52] The cardinal of S. Cecilia must have found it gratifying indeed to see these *pezzi grossi* bearing the body of "his" saint.

> In the meantime the choir sang the antiphon *O beata Caecilia, quae Almachium superasti, Tiburtium et Valerianum ad martyrii coronam vocasti* [Cantus ID 003991]. The four cardinals had reached the crypt, when the pontiff, drawing near, with the assistance of the deacons placed the cypress box containing the body into the silver one that he himself had commissioned. And having received from Cardinal Sfondrato the silver tablet on which is engraved the inscription reproduced below,[53] he placed it at the side of the virgin's body and, having expressed veneration with a triple thurification, fell to his knees and for some time prayed, his face moist with pious tears. The lid having finally been lowered, the coffin closed, he rose and, returning to the sacred altar, brought the sacrifice of the Mass to its conclusion. The congregation, which had assembled in such a large number that neither the temple nor the exterior atrium could contain it, received the pontifical blessing. The joyful solemnity of the sacred reburial was successfully completed; and the pope, having admirably discharged the pious office, returned to the Vatican.[54]

The installation of Maderno's statue of Cecilia in front of the main altar of S. Cecilia constituted a kind of epilogue to the story of Cecilia's rediscovery and reburial—and a means of perpetuating the excitement and devotional ardor they

aroused. Sfondrato commissioned it, according to Bosio, as a "marble replica" (*marmoreo simulachro*) of the body as he found it. Bosio's *Historia*, published during the Holy Year 1600, refers to the statue as already complete and in place, with an inscription by the cardinal himself, addressing the viewer:

> Behold, for you, this image of the most holy virgin Cecilia, whom I myself saw lying intact in her sepulcher; for you I have expressed her in this marble, with exactly the same pose of the body.[55]

Maderno represented the "pose of the body" (*corporis situ*), according to Sfondrato, who did not claim that the statue reproduced exactly the body's state of preservation. The inscription says only that the body was *integram* (intact), a conveniently vague word that could be applied to any corpse that had not suffered dismemberment. While Bosio and Baronio had used the veils that covered the body as an excuse to remain largely silent on the state of the body itself, Maderno's veils reveal more than they hide. Displaying his virtuosity as a sculptor, and taking full advantage of his artistic license, he made Cecilia's body clearly perceptible under the veils: it is that of a young woman who had just died of the wound on her neck (plate 70). Maderno thus gave rise to what Thomas Connolly has called "the legend . . . that the saint's body was found incorrupt when the sarcophagus was opened."[56]

Another artwork that commemorated the events of 1599, a large-scale print dedicated to (and probably sponsored by) Sfondrato, was published in 1601. Francesco Vanni, an artist who received extensive patronage from the cardinal, made a drawing in which nine elaborately framed scenes from Cecilia's life surround a depiction of Maderno's sculpture. Cornelis Galle I, a Flemish engraver who was living in Rome at the turn of the century, used Vanni's drawing as the basis for an engraving (plate 71).[57] Captions below the images explain their contents, with information that includes the date of the discovery of Cecilia's body. But far more prominent is the dedication to Sfondrato, for whom this impressive print served as yet another element in his campaign to win prestige for his church, his saint, and himself.

MUSIC AT CECILIA'S REBURIAL AND AT SUBSEQUENT SERVICES AT S. CECILIA

Accounts of the discovery of Cecilia's body and of her reinterment say nothing about her association with music, which has no place in Maderno's sculpture. In Galle's engraving, music plays a peripheral role. The scene of Cecilia's wedding banquet (lower left) shows an organist entertaining the guests, with Cecilia as silent as in the medieval depictions of the wedding reproduced in chapter 1. At the top of the print, in the image of the newlyweds crowned by an angel, Cecilia

kneels next to an inconspicuous organ: the only acknowledgment of her status as a musician. The events of 1599 and their commemoration in words, marble, and printed images can thus be interpreted as a step backward in the emergence of Cecilia as a musical icon. Yet music played a crucial role in the reburial service and in subsequent ceremonies at S. Cecilia.

Sfondrato himself, the nuns' chronicle records, summoned "the most excellent musicians who were to be found in Rome" to take part in the reburial ceremony. Possibly they participated in the "schola cantorum" that sang "the psalms of Terce" (presumably in plainchant) during an early phase of the ritual and the antiphon *O beata Caecilia* (also probably in plainchant) during the reburial itself. But surely Rome's finest musicians would have also sung polyphony. Although Bosio did not refer explicitly to music sung during Mass (except to say that the Gospel was chanted), the nun who wrote an account of the event for the monastery's chronicle took appreciative notice of it, mentioning specifically that instrumentalists as well as singers performed:

> His Holiness arrived with little delay, accompanied by all the clergy, and in an instant the whole church was amazingly full. The pontiff, having given the benediction to the people, went to the tribune and declaimed a good part of the Office. At this moment the body of the saint was brought to the tribune and laid in the silver casket, while His Holiness stood. Then preparations were made to say Mass; the musicians began to play and to sing with such sweetness and excellence that truly our church resembled Paradise.[58]

The music had actually begun earlier, at Vespers on Cecilia's Eve. The papal choir provided music for this service; at least that was the plan announced a few days earlier in a manuscript *avviso*: "On Sunday, which will be the eve of Cecilia's Day, solemn Vespers will take place with the music of the Pope in honor of this saint."[59] In 1594 the singers of the Sistine Chapel had resisted Sfondrato's invitation to sing Vespers at S. Cecilia. But the discovery of the body five years later had changed everything.

The return of Cecilia's feast a year later gave Sfondrato and his Roman audience a chance to relive parts of the reburial ceremony; and reports of this occasion give us more information about the service's musical component. The nuns' chronicle recorded the event, which included trumpet music (probably fanfares) in addition to motets:

> The most illustrious cardinal celebrated [the feast day] with magnificence; there were three choirs of musicians from among Rome's most excellent . . . The pontiff Pope Clement VIII came, and he celebrated Mass with the greatest devotion . . . That morning Mass was not sung [by the nuns?] because of the one that the pontiff had celebrated at the main altar; but several motets were sung, and Vespers were said most solemnly, with an astonishingly large crowd

of people. The Roman senate came, bringing a chalice that they placed on the altar of Santa Cecilia with the greatest devotion and reverence; at that moment the trumpeters played their trumpets most brilliantly.[60]

This is not the only evidence of polychoral music at S. Cecilia. Music for three choirs was also sung there in 1604. The pope and his retinue said Mass at S. Cecilia, one of Rome's stational churches, every year during Lent. On stational day at S. Cecilia in 1604, Sfondrato greeted the pope with "a solemn celebration . . . with music for three choirs and three organs, with a display of all the relics on the high altar."[61]

What was the music with which Rome's best musicians, "with such sweetness and excellence," solemnized the reinterment of their patron saint in 1599? The music performed a year later by "three choirs of musicians from among Rome's most excellent" in the same church? And the "music for three choirs and three organs" performed at S. Cecilia for the pope in 1604? We have no way of knowing for sure. Polychoral music was common in late sixteenth- and early seventeenth-century Rome,[62] so its presence at S. Cecilia is not particularly remarkable in itself. But we should consider the possibility that on one or more of these occasions the musicians sang the *Missa Cantantibus organis*: a Mass for three choirs based on a Cecilian motet by Rome's most eminent composer.

THE *MISSA CANTANTIBUS ORGANIS*

Sometime between Palestrina's composition of *Cantantibus organis* (published in 1575) and his death in 1594, he and other Roman composers began to collaborate on a Mass for twelve voices (three four-voice choirs) based on his five-voice motet.[63] (I say "began to collaborate" because, as we will see, parts of the Mass may have been written after Palestrina's death.) The Mass is preserved in three manuscripts, one of which, a set of three choirbooks in the archive of S. Giovanni in Laterano in Rome, carefully names the composer of each movement.[64] The origins of the Mass are unknown, although some internal evidence suggests that one of the composers, Giovanni Andrea Dragoni, may have organized the project (table 7.6).

The first two major sections of the Mass, the Kyrie and the Gloria, have much in common, and they both differ in many ways from the last several sections—two settings of the Sanctus, both incomplete, and the incomplete Agnus Dei. The Credo, in the middle, constitutes a transition between the characteristics of the Kyrie and Gloria on the one hand and the Sanctus and Agnus Dei on the other.

One feature shared by the Kyrie and Gloria that distinguishes them from the Mass's last sections is the status of the composers involved. Palestrina, Annibale Stabile, Francesco Soriano, and Dragoni, all born before 1550, were leading members of the Roman musical establishment in the 1580s. The Credo signals

TABLE 7.6. *Missa Cantantibus organis*

Text incipit	Composer	Source in Palestrina's motet (points as numbered in table 7.3)	No. of voices (No. of chorus)	Length in breves
Kyrie I	Stabile	1	4 (Chorus 1)	27
Christe	Soriano	2	8 (Chorus 1, 2)	20
Kyrie II	Dragoni	3, 4	12	45
Gloria	Palestrina	1, 2, 3, 4	12	48
Domine Deus	Anonymous	7	4 (Chorus 1)	37
Qui tollis	Dragoni	5, 6, 8	12	60
Credo	Stabile	1, 4	12	82
Crucifixus	Stabile	7	4 (Chorus 2)	47
Et ascendit	Soriano	1, 2, 3, 4, 5	4 (Chorus 3)	43
Et in spiritum	Giovannelli	1, 5, 6	12	83
Sanctus [Hosanna and Benedictus missing]	Santini	1, 4	12	63
Sanctus [Hosanna and Benedictus missing]	Mancini	1, 2	12	33
Agnus Dei [Agnus Dei II and Dona nobis pacem missing]	Mancini	1, 5	12	38

a change in the project's participants: Palestrina and Dragoni have withdrawn, and Stabile and Soriano are joined, at the end of the Credo, by a new contributor, Ruggiero Giovannelli. The musicians who wrote the last parts of the Mass—Giovannelli, Prospero Santini, and Curzio Mancini—were younger: all of them born (to the extent we can date their births) after 1550. Eventually they occupied some of the prestigious positions left vacant by the death or retirement of the older musicians (three of whom died in the 1590s).

The composers of the Kyrie and Gloria were all early members of the Compagnia dei Musici di Roma, as shown by the inclusion of their works in *Le gioie*. Neither Santini nor Mancini contributed a madrigal to that anthology. They may have been members of the Compagnia, but perhaps they joined after 1589.

The composers of the Kyrie and Gloria also differed from those of the Sanctus and Agnus Dei in their closeness to Palestrina. Both Stabile and Dragoni claimed, in prefaces to editions of their own music, that they had studied with Palestrina, who himself referred to Soriano as his student. There seems to be no evidence that either Santini or Mancini studied with Palestrina.

Given the survival of a manuscript of the *Missa Cantantibus organis* in the archive of San Giovanni in Laterano, it may be of significance that all four of the older composers served in the prestigious position of the basilica's maestro di cappella, while only one of the younger composers (Mancini) did so.

The Kyrie and Gloria are organized with much care. Either a single supervisory composer coordinated the contributions of Stabile, Soriano, Palestrina, and Dragoni, or these composers worked together, aware of what the others were doing and making sure their own contributions complemented the others. The last parts of the Mass, in contrast, show signs of disorganization: most obviously in their incompleteness and in the redundancy of the second Sanctus.

The Kyrie and Gloria make effective use of Palestrina's motet by distributing its material with the same meticulousness that Palestrina himself showed in the distribution of existing material in his parody Masses.[65] With the exception of the opening movement of the Gloria, each movement develops a different part of the motet. The Kyrie is based largely on material found only in part 1 of the motet; the Gloria includes a movement (*Domine Deus*) based on material found only in the motet's *secunda pars*. In his Kyrie I, Stabile used Palestrina's *exordium*, including the two-voice module that serves as its foundation. Stabile reduced Palestrina's five voices to four and reversed the order of the opening duets (ex. 7.7). Soriano, in setting the Christe, developed point 2 of Palestrina's *prima pars*. Dragoni then based his elaborate setting of Kyrie II on points 3 and 4 of the *prima pars*. This wide-ranging exploration of Palestrina's musical material contrasts noticeably with the predominance of the motet's first point of imitation that characterizes the last part of the Mass.

Both the Kyrie and Gloria are designed so that each builds to a climax: music for three choirs by Dragoni. A sense of increasing complexity and excitement is conveyed most dramatically in the Kyrie. The number of voices builds gradually, from one four-voice choir in Kyrie I to two choirs in the Christe, to three choirs in Kyrie II, requiring a minimum of twelve singers. This process reproduces, on a large scale, the staggered entry of voices in the *exordium* of Palestrina's motet, encouraging us to hear the whole three-part Kyrie as the *exordium* of the Mass. The length of the movements also increases, but not steadily: the last movements of both the Kyrie and the Gloria are by far the longest.

The important role of Dragoni's music in both the Kyrie and Gloria, together with the extremely tight and effective organization of both of these movements, suggests that he was responsible for organizing the composition of the Mass. Dragoni was maestro di cappella at the Lateran from 1596 to 1598; his music survives largely in the archive of that church, where it formed a central part of the repertory. That archive's possession of a manuscript of the Mass adds support to the idea that Dragoni coordinated its composition.

The composers of the Mass exploited the wide variety of textures offered by three choirs, but again more fully and coherently near the beginning of the work. All three choirs get a chance to sing four-voice movements by themselves. Chorus 1 sings Kyrie I and the anonymous Domine Deus; chorus 2 sings Stabile's

EXAMPLE 7.7. *Missa Cantantibus organis*, Kyrie. Kyrie I by Annibale Stabile for Chorus 1 only, breves 1–9. Source: *Missa Cantantibus organis*, ed. R. Casimiri (Rome, 1930)

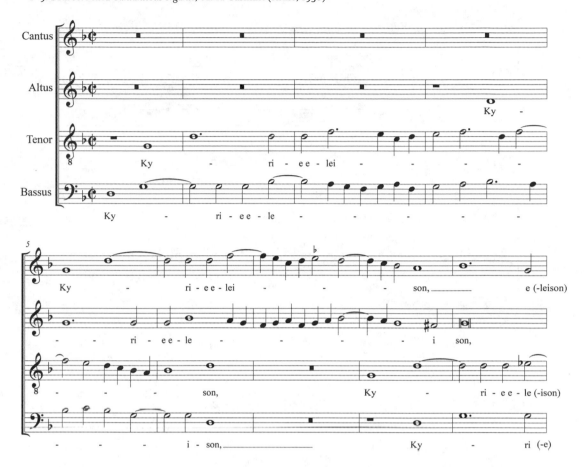

Crucifixus; and chorus 3 sings Soriano's Et ascendit. These movements for single choir are typically the most conservative in texture, with imitative polyphony predominant (as in ex. 7.7 above). The Mass has only one movement for two choirs (Soriano's Christe eleison). More common are movements for all three choirs. Here one choir normally alternates with another, with each singing homorhythmic passages of varying length. The passages frequently overlap, and the antiphonal effects are occasionally replaced with passages for two or three choirs singing simultaneously. These simultaneous passages serve two functions. Some emphasize the importance of certain names, words, and phrases. For example, in Qui tollis, the final movement in the Gloria, Dragoni saved the first entry of all twelve voices for "Jesu Christe"—the culmination of a passage that, in cadencing on F (at breve 29) and B♭ (at breve 32), alludes to the appearance of *Ut* tonality in Palestrina's motet (ex. 7.8). In the first movement of the Credo, Stabile used a twelve-voice *tutti* to dramatize the words "Et in unum Dominum Jesum Christum." Passages in twelve voices also serve as climactic events at the end of all the movements that use three choirs.

EXAMPLE 7.8. *Missa Cantantibus organis*, Gloria. Qui tollis by Giovanni Dragoni, breves 26–36.

One of the most remarkable antiphonal effects occurs at the beginning of Santini's Sanctus. All twelve voices enter one after another, with a melody derived from the beginning of Palestrina's motet: first the voices of chorus 1, from highest to lowest, then those of chorus 2, from highest to lowest, and so forth (ex. 7.9). Although chorus 1 drops out when the voices of chorus 3 begin to enter, the effect of this opening is of a gradual expansion in sound as the number of voices rises from one to eight. The initial entry of chorus 1 is based on a traditional two-voice module; but as more voices enter, that module is abandoned in favor of a contrapuntal technique more fitting for polychoral music: an eight-

EXAMPLE 7.8 (*continued*)

voice module, three and a half breves in length, is presented three times, each time by a different combination of choruses. If the choirs occupied different spaces within the church, Santini's music offered a kaleidoscopic shifting of its source as well as its strength, pitch, and richness of texture.

This raises the question of how and where the *Missa Cantantibus organis* might have been performed. The only clue offered by the Lateran manuscript is an inscription on the first page of the choirbook for chorus 1: "el [=e il or al?] p.° organeto"—presumably meaning that chorus 1 should stand next to the first (of three) small organs. This inscription calls to mind the report, quoted earlier, of Mass at S. Cecilia in Trastevere during Lent 1604: "con musica a tre cori, e tre

EXAMPLE 7.9. *Missa Cantantibus organis*, Sanctus by Prospero Santini, breves 1–13

organi." But, given the popularity of antiphonal choral music in late sixteenth- and early seventeenth-century Rome, S. Cecilia was not the only venue that offered three organs to accompany "musica a tre cori."

The differences between the Kyrie and the Gloria on the one hand and the rest of the Mass on the other also suggest the possibility that the Kyrie and Gloria were composed first, and the rest later—and in haste. Perhaps the collaboration was interrupted by the deaths of Palestrina in 1594 and Stabile in 1595, and the work resumed at some later time. Two of Dragoni's successors at the Lateran

EXAMPLE 7.9 (*continued*)

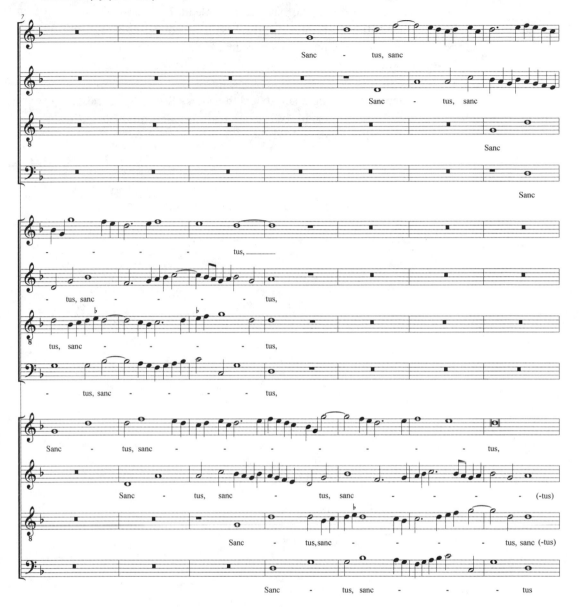

were Soriano and Mancini. The latter served as maestro di cappella from 1601 to 1603, between the years (1600 and 1604) for which we have documentation of performances of music for three choirs at S. Cecilia. If the deaths of Palestrina and Stabile left the Mass incomplete, what better reason to finish it (or at least to bring it to a state in which it could be performed in a liturgical context) than for a performance at one of the solemn services at S. Cecilia involving three choirs?

One of the most imposing products of the sixteenth century's veneration of Cecilia, the *Missa Cantantibus organis* represents a culmination of the Romaniza-

tion of the Franco-Flemish Cecilian tradition. Just as Palestrina played a crucial role in that process, so also did he play a crucial role in the creation of the Mass: as the composer of the music on which it is based, the composer of the first part of the Gloria, a member of the Compagnia dei Musici di Roma, and the teacher of the leading Roman musicians who contributed to the Mass. Maderno's sculpture of Cecilia in the church that bears her name is the most renowned monument to the revival of her cult in late sixteenth-century Rome. In the *Missa Cantantibus organis*, Palestrina and his colleagues made a sonic monument to Cecilia no less impressive than Maderno's marble one.

From Saint to Muse

The title comes from an article by Barbara Russano Hanning that traces the evolution of Cecilia's cult in Florence in the seventeenth century.[1] Hanning ends by quoting Dryden's "From Harmony, from heav'nly Harmony" (1687), in which Cecilia is no longer portrayed as a virgin, a martyr, or a bride of Christ, but as a personification of music and a source of inspiration for musicians. Beginning in 1683—or possibly earlier—English musicians and music lovers used Cecilia's Day as an opportunity not to pray for intercession but to enjoy music—making it and hearing it—and a banquet that accompanied the concert.

The transformation from saint to muse began much earlier. In some of the Cecilia's Day festivities in northern France and the Netherlands in the second half of the sixteenth century (such as those in Antwerp, Évreux, and the monastery of Eversam), we have already seen signs that—beyond any spiritual benefits—the pleasure of making and hearing music played an important role. In this epilogue I will briefly follow a few aspects of the transformation as it continued in the seventeenth century. In doing so, I hope to enrich our understanding of the origins of the English celebration of Cecilia's Day and her adoption by Protestants as a symbol of music's power.

MUSICAL REVERBERATIONS OF THE ROMAN JUBILEE

The elaborate musical performances at S. Cecilia in Trastevere that accompanied the ceremonies before, during, and after the Holy Year 1600 implicitly acknowledged her status—especially in Rome—as a patron of professional musicians.

Those performances, in turn, probably inspired the composition and publication of motets in honor of Cecilia in early seventeenth-century Italy. They also helped lay the conceptual foundation on which artists of the first half of the seicento—many of them active in Rome—based their paintings of her making music, as a player not only of the organ but of the violin, viol, and lute.[2]

Over the centuries, publishers of sacred music have rarely issued anthologies in honor of individual saints. It was thus an extraordinary event when, in 1602, an anthology appeared in Rome under the title *Mottetti de' diversi autori in lode di Santa Cecilia*. Sadly no copy exists, and we know the names of only three of the composers who contributed to it.[3] But the many surviving motets by Italian musicians published between 1600 and 1620 testify to a renewed interest in Cecilia, and not only in Rome.

Using the appendix to compare works published in the twenty years before 1600 to those published in the twenty years after (and leaving aside the explicitly liturgical works—polyphonic Vespers antiphons—by Girolamo Lambardi and Giovanni Francesco Anerio[4]), we see a dramatic shift from Franco-Flemish composers to Italians.[5] In an echo of the *annus mirabilis* 1539, when eight Cecilian motets by French and Flemish composers appeared in print, 1613 saw the publication or republication of at least five Italian motets in honor of Cecilia. The appendix also documents the divergence in the early seventeenth century of two distinct kinds of motets. What musicologists call "few-voice" or "small-scale concertato" motets or "small-scale *concerti ecclesiastici*" (the Italian term popularized by Lodovico Viadana's influential *Cento concerti ecclesiastici*) became increasingly distinct from the motets that predominated in the sixteenth century, with four or more voices of similar melodic character and an emphasis on imitative polyphony. Few-voice works, typically with one to four voices over a basso continuo, sometimes feature elaborate ornamentation in the vocal parts, as if conceived for performance by one singer on a part. The appendix gives the number of voices for motets of the older type and (in the column headed "Remarks") the performing forces for the motets of the newer type, as specified in the music.

Composers active in Rome—Antonio Cifra, Francesco Martini, Domenico Massenzio, Giovanni Bernardino Nanino, and Vincenzo Ugolini—wrote Cecilian motets of both types. Several motets, starting with Bernardino Morelli's *Cantantibus organis* (1598), were published by Ricciardo Amadino, a prolific Venetian music printer who adorned his title pages with a woodcut of an organ and the motto "Magis corde quam organo"—"more with the heart than with the organ." His large output of Cecilian music suggests that he intended his motto as an allusion to Cecilia's wedding prayer.[6]

MUSICAL CELEBRATIONS IN SIENA, MILAN, FERRARA, AND FLORENCE

In 1609 Banchieri, in the book dedicated to Cecilia from which I quoted at the end of chapter 6, named three Italian cities as sites of Cecilia's Day celebrations.

Every year on 22 November, "the musicians and organists of Siena . . . organize a solemn Mass in the cathedral . . . arranged for an immense ensemble of virtuosi."[7] The musicians of Milan and Ferrara observed the feast with similar combinations of music and liturgy: the Milanese at S. Maria della Scala, the Ferrarese at S. Maria del Vado. Unfortunately Banchieri said nothing about when these events began or about what organizations (if any) sponsored them.

Banchieri claimed to have attended the Cecilia's Day Mass in Siena twelve years before he wrote his book, meaning 1597 or thereabouts.[8] But manuscripts and prints preserved in Siena refer to musical observances of the feast that took place almost a decade earlier. The nineteenth-century scholar Curzio Mazzi, citing a "copy of an oration addressed to the musicians on St. Cecilia's Eve . . . 1588,"[9] summarized the manuscript as follows: "It tells us in a beautiful preface how 'in earlier times' it was customary to celebrate that day not only with musical concerts but also with the reciting of an oration in praise of the holy patroness."[10] According to another manuscript cited by Mazzi, "the musicians [of Siena], to honor their saint in the Duomo with two vespers and a solemn Mass, 'create a king of the feast, who makes plans about both the music and the banquet, which they enjoy, like a medieval feast, on this night only, with some elaborate entertainment.'"[11] The "king of the feast" presumably corresponded to the annually elected prince who, as we saw in chapter 3, oversaw the celebrations of Cecilia's Day in Rouen and Évreux, and whose election in Kortrijk Pevernage solemnized with motets for eight voices.

Banchieri named Francesco Bianciardi, maestro di cappella in the Duomo of Siena, as a leading participant in the musical observance of Cecilia's Day. Bianciardi's three Cecilian motets, published in 1596 and 1601, were probably among his contributions to the festivities. They include a setting of this poem in dactylic hexameters in praise of Cecilia as musician and music lover.

Psallite cantantes Domino nova cantica gentes,
omnis Ceciliae nomen benedicite tellus,
impia pro Christo quae passa est regna tyranni.
Tu virgo exultans dulcisona dum organa cantant,
Psallere non cessas Domino nova cantica semper.[12]

Sing to the Lord, singers, new songs;
may the whole world bless the name of Cecilia,
who suffered for Christ in a tyrant's wicked kingdom.
May you, virgin, rejoicing while the sweet-sounding organ sings,
never stop singing new songs to the Lord.

Musical celebrations of Cecilia's Day in Milan also began in the late sixteenth century. An oration in praise of Cecilia, published in 1599, describes her feast day on the title page as "celebrated with the greatest solemnity by the musicians in the royal-ducal church of Milan" (that is, S. Maria della Scala). The preface, by the publisher Agostino Tradate, attributes to the musicians of Milan the

choice of Cecilia as their *prottetrice* and says the event involved "musica di molti stromenti e di ben cento voci." The oration itself refers to Cecilia as "questa eccellentissima cantatrice."[13] Two decades later a Milanese almanac placed the Cecilia's Day music in other churches, S. Lorenzo Maggiore and S. Sepolcro.[14] Many composers active in Milan wrote music for Cecilia, including Orfeo Vecchi, Giovanni Battista Stefanini, Francesco Pappo, Vincenzo Pellegrini, Giovanni Paolo Cima, Giovanni Battista Ala, and Giovanni Antonio Cangiasi. In chapter 1 we took note of the chant *Cantantibus organis*, sung in the Ambrosian Mass as the "antiphona post Evangelium" on 22 November. Perhaps that conspicuous use of the most recognizable of Cecilian texts encouraged Milanese composers to set it to music. Robert L. Kendrick, discussing some of this music as part of the city's soundscape in the early seventeenth century, pointed also to an eight-voice setting of *Cantantibus organis* published in 1592 in a motet book by Damiano Scarabelli, vice-maestro di cappella in the Duomo, as evidence that already in the late sixteenth century Milanese musicians regarded Cecilia's Day as a feast of special importance.[15]

Cecilia's Day in Ferrara, in contrast, was something of a one-man show. We met Antonio Goretti, an enthusiastic patron of music and an amateur composer, in chapter 6, as the probable commissioner of Bastianino's painting for the chapel of St. Cecilia in the church of S. Maria del Vado. That is precisely the church in which, according to Banchieri, Ferrara's musicians celebrated the feast; and the fact that Goretti took over the patronage of the chapel in 1598 gives us a plausible *terminus post quem* for both the painting and the musical festivities. Goretti composed and conducted the music, some of it for as many as seven choirs. Marin Mersenne, visiting Goretti around 1645, saw "22 large fascicles of music for St. Cecilia, which he himself composed for voices and instruments, and which he arranged to be sung every year in Ferrara to universal admiration."[16] On Goretti's death in 1649, his son sold his music library to an archduke of Austria, an inventory of whose collection made in 1665 documents the presence of "Musica di Antonio Goretti fata a 7 chori, messa e salmi et concerto et cantione per Sta. Caecilia."[17] The manuscripts are apparently no longer extant.

Banchieri did not mention yet another Italian city that recognized Cecilia's Day with sacred music—probably because the performances began only two years before the publication of his book. In 1607 Marco da Gagliano established a musical society under Cecilia's patronage in Florence.[18] The Accademia degli Elevati gave a special role to composers. A section of the bylaws that deals with the selection of new members is entitled "Concerning the Admission of Composers."[19] The academy welcomed amateurs as well as professionals, who gathered once a week for the primary purpose of performing, hearing, and discussing music. The statutes required that each month a composer be chosen by lot to direct the performances, "to exercise the supervision of the concert with the authority to direct and choose at his pleasure that music which is to be sung or played during that time."[20] Here the Elevati differed from the musical groups referred

to by Banchieri, for whom Cecilia's Day seems to have been the only occasion on which they assembled.

The statutes referred to Cecilia as their patron, but almost casually—as if there were no choice in the matter. "*Concerning the Annual Feast*. Each year on the day of the festivities of Saint CECILIA, our protectress, a Mass will be sung by the academicians in which it is obligatory for everyone to participate; and those who might be absent without legitimate impediment will be fined four lire."[21] It was to such a performance that Cesare Tinghi, the Medici court diarist, referred when he wrote, in November 1609: "On the twenty-second day, on Sunday, his Highness went to Mass at San Giovanni with the Nunzio and the ambassadors for the feast of Saint Cecilia, and the *Accademia della Musica* performed splendid music."[22]

Despite the "splendid music," the Accademia degli Elevati flourished for only a few years. Its ambitious program, which demanded so much from its members, probably led to its decline after 1609 and to its eventual dissolution, probably in the mid-1620s.

CECILIAN ORGANIZATIONS IN NAPLES AND VENICE

We might expect the Compagnia dei musici di Roma, with the prestige of its papal blessing and the publicity generated by *Le gioie*, to have inspired similar organizations in other Italian cities; but in fact the groups of musicians in Milan, Siena, Ferrara, and Florence differed noticeably from the Compagnia. One of the main goals of the more recently founded groups was to celebrate Cecilia's Day with music. The members of the Compagnia, in contrast, had no obligation (as far as we know) to assemble for joint musical performances, on 22 November or at any other time.

Two musical organizations that emerged in Naples during the seventeenth century may have been founded in imitation of the Compagnia dei musici. In 1644 the Roman musician Giacomo Caproli brought together, at the church of S. Brigida in Naples, a group of nineteen musicians under the protection of Popes Gregory the Great and Leo, and St. Cecilia.[23] The adoption of three patron saints, including Gregory and Cecilia, was probably inspired by the triple dedication of the Compagnia—founded "under the invocation of the Visitation of the Blessed Virgin Mary, Pope St. Gregory, and St. Cecilia." The Neapolitan organization lasted only about five years; but that did not discourage other musicians in Naples from seeking the protection of Cecilia. A society of musicians in the employ of the royal chapel, with Cecilia as its patron, is recorded in documents from 1655 on.[24] We have no evidence of these groups using her feast as an opportunity to make music on a grand scale.

It was not until the 1680s that Venice formed a musical organization under Cecilia's protection. Giovanni Domenico Partenio, vice-maestro di cappella at S. Marco, also served as a priest in the church of S. Martino, the site of an altar

to St. Cecilia. In 1685 he organized an observance of Cecilia's Day at S. Martino, with music composed and directed by Giovanni Legrenzi, the doge's maestro di cappella, and performed by many of the city's finest musicians. The event's success led to its being repeated the following year and the year after that.[25]

In the hope of making it a permanent part of Venetian musical life, Partenio founded a *sovvegno* for the city's professional musicians. *Sovvegni*, charitable organizations resembling both guilds and confraternities, arose in Venice in the sixteenth century.[26] While the Sovvegno di Santa Cecilia had features typical of *sovvegni* in general—for example, it required its members to attend the funerals of their deceased brothers—its main function was to celebrate Cecilia's Day with a church service in which music featured prominently. Its bylaws began with a statement about "how and when the feast of Saint Cecilia should be solemnized" with an event evidently similar to those presented earlier in the century in Milan, Siena, Ferrara, and Florence: "The solemnity of Saint Cecilia must be sanctified with all the brothers singing the mass and vespers on 22 November at the usual hour in the church of San Martino; all of them should be used according to their abilities and in conformity with the need of the maestro or vice maestro, one of whom must organize the music."[27]

THE RISE OF CECILIA'S DAY MUSIC IN ENGLAND

Around the same time as Partenio was establishing the musical observance of Cecilia's Day as a tradition in Venice, Cecilia became a regular part of musical life in Restoration London.[28] Under the auspices of a loosely defined "Musical Society," musicians gathered in London on 22 November 1683 for the performance of an ode in honor of Cecilia newly composed by Henry Purcell—with a banquet to follow. In a Protestant country whose professional musicians had shown little interest in Cecilia, this turn of events might seem remarkable. Yet it may not have been the first musical celebration of Cecilia's Day in England.

Purcell's ode *Welcome to All the Pleasures* was published under a title page that reads: "A Musical Entertainment PERFORM'D On NOVEMBER XXII. 1683. IT BEING THE *Festival of St.* CECILIA, *a great Patroness of Music*; WHOSE MEMORY is ANNUALLY honour'd by a public *Feast* made on that Day by the MASTERS and LOVERS of Music, as well in *England* as in Foreign Parts."[29] The last phrase implies that the celebration of 1683 was not the first in England; and indeed a pamphlet published in 1655—in the middle of Oliver Cromwell's Commonwealth—describes a performance of music by Henry Lawes that took place on 22 November of that year.[30] According to Stacey Jocoy,

> the texts clearly indicate the inclusion of several of Lawes's more lavish symphony anthems, according a place for pieces that were inimical to the contemporary Puritan musical aesthetic. Reading these texts in light of their musical and social contexts yields a decidedly political message that used the allegorical

qualities of music and harmony to comment on the relative disharmony of the state: using music, and a musical holiday, as a means of performing cultural resistance against the Protectorate.[31]

Even before 1655 we find signs of English awareness of Cecilia as a symbol of music: as a muse rather than a saint. If we keep in mind that the part of Europe where musicians had most strongly associated Cecilia with music during the Renaissance and had honored her most warmly was also the part closest to London, and that cultural exchange between England on the one hand and northern France and the Netherlands on the other was constant and intense, the idea that English musicians should have thought of Cecilia's Day as an occasion for musical performances does not seem unreasonable.

What we might call the conceptual roots of the English celebration of Cecilia's Day are apparent already in a pair of engravings: the first published in the Netherlands around 1590, the second in London in 1612. Together, they show vividly how the musical culture of the Netherlands could influence that of England.

An engraving by Jacob Matham, based on a drawing by his stepfather Hendrick Goltzius, shows Cecilia making music with two angels (plate 72).[32] Matham and Goltzius were leading artists in Haarlem, and their print conveys a view of the saint that, as we saw in chapter 2, had been evolving among artists and musicians in the Netherlands since the late fifteenth century. As one of the angels, holding a partbook, directs the performance with an upraised hand, Cecilia plays the organ. Her hands, wide apart, command the entire keyboard. Her eyes focused on the keys, she is entirely absorbed in music-making. The direction of her gaze belies the four dactylic hexameters below the image (attributed to F. E., possibly the Flemish humanist poet Franco Estius), according to which she is preoccupied with thoughts of heaven and of her celestial bridegroom:

Caecilia ardenti dum caeli flagrat amore,
Organa sacra quatit modulans praeconia Christi;
Christum voce canens, hunc quaerens pectore toto
Gaudia stellantis secum meditatur Olympi.

While Cecilia glows with ardent love of heaven,
she strikes the organ keys, singing sacred praises of Christ;
singing of Christ with her voice, seeking him with her whole heart,
she meditates on the joys of starry Olympus.

The poetry makes no reference to Cecilia's virginity, martyrdom, or wedding, when according to Arnobius she "sang in her heart to the Lord alone." It accompanies an image in which her transformation into a musician, fully committed to her art, is complete.

About twenty years after the publication of Matham's engraving, the image crossed the English Channel. Part of it reappeared on the title page of an

anthology of keyboard music, *Parthenia or The Maydenhead of the first musicke that ever was printed for the virginalls. Composed by three famous masters: William Byrd, Dr. John Bull, & Orlando Gibbons* (plate 73).[33] The title is an ingenious tangle of wordplay. In ancient Greece, *parthenia* (plural noun, from *parthenos*, meaning "virgin") were songs sung by dancing maidens. In the alternate title, *The Maydenhead* (a word that Chaucer had used in his retelling of Cecilia's legend) could refer to female virginity in its most basic anatomical sense, but the following words quickly make clear that the publisher is speaking metaphorically. The music is "virginal" (adjective) not only in being of a kind never before printed in England, but also in being written for the virginal—the small harpsichord that Cecilia plays in the paintings of Coxcie and his workshop reproduced in plates 44 and 47.

The engraving by William Hole preserves Goltzius and Matham's Cecilia almost unchanged, but eliminates the angels and replaces the organ with a stringed keyboard instrument. (It goes without saying that the Latin verse, the only part of the original engraving that alluded to Cecilia's love of Christ and her anticipation of heaven, is also gone.) The young woman and the keyboard on which she plays were presumably meant to carry the title's wordplay into the visual realm; the instrument is a rectangular virginal or possibly a clavichord. We recognize the young woman advertising the music of Byrd, Bull, and Gibbons as Cecilia, but transformed for an English, largely Protestant audience. She is very much a muse, not a saint.

During the reign of Elizabeth I, English Catholics came under increasing pressure to renounce their faith. Many fled across the Channel to the southern Netherlands and northern France, the Catholic regions closest to their homeland, where they established schools, colleges, and convents. Around 1561 an English seminary was founded in Douai (where Jean Bogard published a steady flow of Cecilian motets beginning in 1578), and about thirty years later a school in Saint-Omer. Convents for English nuns proliferated in cities large and small.[34]

The English exiles included several professional musicians; others came from sophisticated musical backgrounds or developed musical interests and talents.[35] Among the best English musicians active in the Netherlands during the first half of the seventeenth century were Peter Philips, Richard Dering, and John Bull. Philips, born in 1560 or 1561, sang as a boy chorister at St. Paul's Cathedral in London. In 1582 the young Catholic musician left for the Continent. Years of travel took him to Rome, Madrid, Paris, and Antwerp. In 1597 he was appointed organist to the chapel of Albert VII, governor of the southern Netherlands, in Brussels, where he seems to have spent the rest of his life. Dering, born about twenty years after Philips, also visited Rome before settling in Brussels, where he served as organist for a community of English Benedictine nuns. In 1625 he returned to England, finding employment at the court of King Charles I and his Catholic consort Henrietta Maria.[36] Bull, a brilliant keyboard player and com-

poser who contributed to *Parthenia*, left England probably not for religious rea-
sons but because he faced charges of adultery; in 1617 he became the organist in
Antwerp Cathedral.

If Bull wrote any sacred vocal music in Antwerp, it has not survived. But
both Philips and Dering wrote works for Cecilia. Philips's five-voice *Cantantibus
organis* and eight-voice *Cecilia virgo, tuas laudes*, published in 1612 and 1613, re-
spectively, were the first Cecilian motets—as far as I know—by an Englishman.
Coinciding with the publication of *Parthenia*, they testify to the influence of mu-
sical traditions of the Netherlands on English composers living there. *Cecilia
virgo*, in which the eight voices are arranged in two four-voice choirs, is a setting
of a devotional text that acknowledges Cecilia as patron of musicians. The choir
represents all musicians in pleading for her intercession:

> Cecilia virgo, tuas laudes universa concinit musicorum turba, et tuis meritis
> supplices a Deo exaudiri possint, iuncta voce et una corde tuum nomen invo-
> cant, ut luctum mundi, in paradisi gloriam, mutare digneris, tuosque pupillos
> tutelaris, virgo aspicere velis, piam dominam, inclamantes, et semper dicentes:
> Sancta Cecilia, ora pro nobis.

> *Virgin Cecilia, the entire crowd of musicians sings your praises. And thanks to your
> merits supplicants may be heard by God. May they invoke your name with a unani-
> mous voice and a single heart, that you might deign to change the world's mourning
> into the glory of paradise, and that you might protect your disciples. May you wish,
> virgin, to look on those who plead for help from a merciful mistress, always saying:
> St. Cecilia, pray for us.*

Philips's two other Cecilian pieces, *Beata Cecilia* and another *Cantantibus
organis*, are more modern few-voice motets with basso continuo, published in
Antwerp in 1628 and probably written after those that appeared in 1612 and
1613.[37] He scored *Beata Cecilia* for soprano, tenor, and basso continuo; *Cantanti-
bus organis* for soprano, bass, and basso continuo. Dering's *Veni electa mea Cicilia*
[*sic*] is likewise a few-voice motet. Although he too may have written it in the
Netherlands, it did not appear in print until 1662, many years after his death:
apparently the first Cecilian motet published in England.[38]

During the English Civil War (1642–1651), the royal family joined the Cath-
olic exiles. Queen Henrietta Maria left England for Paris in 1644. After the
execution of her husband Charles I (1649) and the defeat of the Royalists at
the Battle of Worcester (1651), her sons King Charles II and James (later King
James II) also fled to the Continent. The young king passed a decade in Paris,
Cologne, and the Netherlands.[39] Both Charles II and his mother were intensely
interested in music; Henrietta Maria had employed Dering as her organist and
had fostered the performance of Latin sacred music in her private chapel dur-
ing the 1630s.[40] On the Continent they found a musical culture in which Ceci-

lia's Day continued to play the same role in musicians' lives as in the previous century.[41] The English royal family and its retinue were probably just as aware as the exiled musicians mentioned above of Cecilia's status as patron of musicians in many of the cities in which they lived during the 1650s. If so, they may have brought that knowledge back to England when Charles reclaimed the English throne in 1660.

During the Restoration (1660–1688), Charles II and his court helped make London a cosmopolitan musical center, in which the Catholic custom of observing Cecilia's Day with music could hardly have been unknown. The king sent the promising young Pelham Humphrey to study in Paris; he probably engaged Giovanni Battista Draghi (in London by 1667 at the latest) in the hope of establishing an Italian opera. The queen consort Catherine of Braganza named Draghi organist in her private Catholic chapel. John Playford issued the compilation of Latin sacred music by Dering that included *Veni electa mea Cicilia*. The playwright Thomas Killigrew, a royalist who had spent the 1650s on the Continent, alluded to the musical celebration of Cecilia's Day in his play *Thomaso, or The Wanderer*, published in 1664: "'Tis now St. Cecilia's Eve," says Serulina. "There's the great Musick tomorrow."[42] Although we have no reason to think that the Cecilia's Day concert that became a regular part of London's musical life in the 1680s (to which Draghi contributed with his setting of Dryden's "From Harmony, from Heav'nly Harmony") was directly instigated by the court, the cosmopolitanism that prevailed in the capital undoubtedly favored its establishment and success.

The musical festivity in London on 22 November 1683 established a tradition; but it was also the culmination of developments in music, poetry, and the visual arts that went back to the Middle Ages. In *Welcome to All the Pleasures*, Purcell set to music a text that—far from being Catholic in character—cannot even be called Christian. Apart from a reference to "this holy day," the ode, like the title page of *Parthenia*, is entirely secular.[43] It begins with an invocation not to Cecilia but to the Muses of Greco-Roman antiquity—"Hail, great assembly of Apollo's race"—reminiscent of the poetic appeals to the Muses in Gombert's *Ceciliam cantate pii* (1541), Pevernage's motets for the Cecilian confraternity in Kortrijk (1570–1577), the *Carmen Caecilianicum* (1575), and the *Convivium cantorum* (1585). Like those poems, Purcell's ode goes on to praise music—and not just sacred music: "For sorrow and grief find from music relief, / And love its soft charms must obey."

Cecilia, not even mentioned in the first few numbers, is finally named as the recipient of Purcell's ode:

Music that fancy employs
In rapture of innocent flame,
We offer with lute and with voice
To Cecilia, Cecilia's bright name.

EXAMPLE E.1. Henry Purcell, *Welcome to All the Pleasures*, "In a consort of voices," last five measures. Source: White, *Music for St. Cecilia's Day*, ex. 3.2 (pp. 97–99)

The music ends with acclamations using the word "Iô," a Greek exclamation of triumph, as if Cecilia were one of the Muses. But let us give Purcell the last word (ex. E.1). In the extraordinary final measures the violins drop out, then the sopranos and altos, then the tenors, leaving only the basses to declaim Cecilia's name one last time. As Purcell's chorus fades away, I will do so as well.

Acknowledgments

Three anonymous scholars read drafts of the manuscript at the request of the University of Chicago Press. I am most grateful to them for their constructive criticism and valuable suggestions. I would also like to thank Julie E. Cumming and Barbara Haggh-Huglo, who read parts of the manuscript and gave me the benefit of their extraordinary knowledge and experience.

The many other specialists in medieval, Renaissance, and Baroque music who have shared their expertise and in other ways made it possible for me to complete this project include Terence Bailey, Anna de Bakker, Rodolfo Baroncini, Bernd Becker, Ellen S. Beebe, M. Jennifer Bloxam, Ignace Bossuyt, Katherine Butler, Claudio Dall'Albero, Paola Dessì, Joseph Dyer, Scott L. Edwards, Mary Tiffany Ferer, Kristine K. Forney, Christine Getz, Martin Ham, David Hiley, Gerald Hoekstra, Erika Honisch, Aaron James, Eric Jas, Herbert Kellman, Edward L. Kottick, Reiner Krämer, Jeffrey Kurtzman, Debra Lacoste, Christian Thomas Leitmeir, Ruth Lightbourne, Patrick Macey, Lucia Marchi, Jorge Martín, Stefano Melloni, Antonella Nigro, Michael W. Nordbakke, Noel O'Regan, Keith Polk, John Powell, Wilfried Praet, Véronique Roelvink, Steven Saunders, Herbert Seifert, Christopher Shaw, Jason Stoessel, Jennifer S. Thomas, Daniele Torelli, Jonathan Wainwright, Sally Watt, Bryan White, Edward Wickham, and Emily Wuchner.

Art historians, cultural historians, and museum curators have been equally generous to a shameless interloper. My thanks to Peter Ackermann, Fiona Berry, Suzanne Boorsch, Jan Coppens, Nico De Brabander, Brigitte Dekeyzer, Virginie D'haene, Sophie Dutheillet de Lamothe, Tobias Kämpf, Alessia Lirosi, Aaron Macks, Hadewijch Masure, Bart Minnen, Louise Rice, Ann M. Roberts, Ruben

Suykerbuyk, Giovanni Travagliato, and Stanley E. Weed for information, advice, and other favors.

The librarians who made this book possible include the staff of the Rochester (Minnesota) Public Library, who obtained scholarly books and articles for me through interlibrary loan; Jessica Abbazio, head of the music library at the University of Minnesota; Roberto Marchi at the Museo Internazionale e Biblioteca della Musica di Bologna; Mirosław Osowski at the Wrocław University Library; and the designers of the marvelous website at the Bayerische Staatsbibliothek in Munich, which makes its vast collection of sixteenth-century music easily and pleasantly accessible to scholars the world over.

Such digital treasures were still far in the future when I began my work on St. Cecilia during graduate studies at the University of California, Berkeley, in 1981, with a paper on Cecilian motets by composers of the post-Josquin generation, written under the supervision of Anthony Newcomb. Tony, who died in 2018, did not see the fruit of our discussions long ago. I remember him with admiration and affection.

Homer Rudolf was one of the first scholars to write about the Franco-Flemish motets in honor of Cecilia, in his dissertation on Cornelius Canis (University of Illinois, 1977). When we met in 1984, Homer told me of his intention to write a book on the subject; but like me in the following decades he directed much of his intellectual energy in other directions. His death in 2018 left his book incomplete. I am particularly grateful to him for sharing with me two unpublished papers (cited in the introduction and elsewhere).

Going back even further, I remember with gratitude my mother and father, who loved European history, art, and music, and whose tastes and values shaped mine; and the winter and spring of 1975 that I, an impressionable teenager, spent with them in Trastevere, within a few hundred meters of the church of S. Cecilia. During the decades that followed, my sister Louise inspired and sustained my interest in Cecilia. Her gift to me many years ago of Beisson's engraving of Raphael's *Ecstasy of St. Cecilia* has never allowed me, despite the other projects that have claimed my attention, to forget St. Cecilia in the Renaissance.

Rochester, Minnesota
April 2021

Music for Cecilia Published or Copied before 1620

This list includes not only motets but also Masses based on Cecilian motets, works published under titles (such as *Antiphonae ad Magnificat*) that identify them as primarily liturgical in function, devotional songs in Italian or a combination of Latin and Dutch, music for a play, and musical notation in paintings of Cecilia.

Year of first publication (with RISM number) or year of earliest manuscript	Opening words (part 1 / part 2) or title	Number of voices	Composer	Modern editions(s) (for fuller citations see "Musical Editions" in bibliography)	Remarks
1492 or later	Cantantibus organis / Domine Jesu Christe / Nam sponsum	4	Heinrich Isaac	*DTÖ* 28; N. Greenberg, New York, 1963 (without Cecilian text)	Undated retexting (in I-Rvat, C. G. XIII. 27) of Isaac, *Quis dabit capiti meo aquam*; Cecilian texts subsequently erased and original text restored
ca. 1500	Puram Christo te dedisti	2	Anonymous	B. Bouckaert et al., Leuven, 2005	B-Br, MS II 270; devotional song
ca. 1500?	Fiat Domine cor meum	?	Anonymous		Treble line in mensural notation in painting attributed to Panetti; see plate 65

(continued)

Year of first publication (with RISM number) or year of earliest manuscript	Opening words (part 1 / part 2) or title	Number of voices	Composer	Modern editions(s) (for fuller citations see "Musical Editions" in bibliography)	Remarks
1520–30	Cantantibus organis / Fiat cor meum	?	Anonymous		I-Bc, Q.27/2; cantus only
ca. 1530	Inclita sanctae virginis Ceciliae / Ave virginum gemma	5	Jacquet of Mantua	*CMM* 54.5 (based on RISM J 6)	I-Bc, R.142; tenor only, another version addressed to St. Catherine in RISM J 6 (1539)
1532[11]	Sponsa Christi Cecilia / Biduanis ac triduanis	4	Loyset Piéton	*SCM* 9	Reprints: RISM 1539[12], 1545[4], 1564[6]
1532[11]	Gloriosa virgo Cecilia / Dum aurora finem daret	4	Nicolas Pagnier	*SCM* 9	Reprints: RISM 1539[12], 1540[6], 1545[4], 1564[6]
1539[10]	Cecilia virgo me misit ad vos / Tunc Valerianum	4	Hugier	*SCM* 10	
1539[10]	Cantantibus organis / Cecilia virgo gloriosa	4	Carette	*SCM* 10	
1539[10]	Laudemus Dominum / Creator omnium Deus	4	Carette	*SCM* 10	
1539[11]	Cantibus organicis / Fundite cantores	4	Hubert Naich or Nicolas Gombert	*CMM* 6.10, *CMM* 94	Reprint (under Gombert's name): RISM 1554[8]. Transcription for lute by Bakfark, RISM B 724 (1565)
1539 (J 9)	Cantantibus organis / Biduanis ac triduanis	4	Jacquet of Mantua	*CMM* 54.4	
1539 (M 269)	Cantantibus organis / Cecilia virgo gloriosa	4	Pierre de Manchicourt	*CMM* 55.1	Reprints: RISM 1539[10], 1545 (M 271)

Year of first publication (with RISM number) or year of earliest manuscript	Opening words (part 1 / part 2) or title	Number of voices	Composer	Modern editions(s) (for fuller citations see "Musical Editions" in bibliography)	Remarks
1541 (G 2984)	Ceciliam cantate pii / Concordes igitur	5	Gombert	*CMM* 6.8	Reprints: RISM 1546[5], 1550 (G 2985, 2986); contrafactum *Juravit Dominus* in I-TVd, MS 29 (not extant); basis for Mass by Gheerkin de Hondt
1541–49	Missa Ceciliam cantate pii	5	Gheerkin de Hondt		NL-SH MS 156; based on motet by Gombert
1542[7]	Ceciliam intra cubiculum / Cecilia virgo Almachium	4	Cornelius Canis	*CMM* 111 (forthcoming)	Reprint: RISM 1554[15]
1542 (C 1707)	Cantantibus organis / Benedico te	4	Pierre Certon	C. Shaw, Bath, 2019; *RRMR* (forthcoming)	Basis for parody Mass by Cléreau
1542 (C 1707)	Cecilia virgo gloriosa / Dum aurora finem daret	4	Certon	C. Shaw, Bath, 2019; *RRMR* (forthcoming)	Basis for parody Mass by Cléreau
1544 (B 4185)	Ceciliam intra cubiculum / Angelus Domini descendit	4	Simon Boyleau	S. Watt, Melbourne, 2009	
1545[2]	O beata Cecilia / Cecilia me misit ad vos	4	Canis	*CMM 111* (forthcoming)	
1545 (R 2474)	Cantantibus organis / Biduanis ac triduanis	5	Cipriano de Rore	*CMM* 14	Reprints: RISM 1573 (R 2477), 1595 (R 2478); contrafactum *O Gregori* in I-TVd, MS 29 (not extant)
1546 (M 3716)	Domine Jesu Christe / Dum aurora finem daret	5	Antoine de Mornable	*RRMR* (forthcoming)	
1546	Dum aurora finem daret	?	Christian Hollander		B-LVu MS 163 (altus partbook only, not extant)

(*continued*)

Year of first publication (with RISM number) or year of earliest manuscript	Opening words (part 1 / part 2) or title	Number of voices	Composer	Modern editions(s) (for fuller citations see "Musical Editions" in bibliography)	Remarks
1547[6]	Cecilia virgo gloriosa / Biduanis ac triduanis	4	Jacobus Clemens non Papa	*CMM* 4.9	Reprints: RISM 1559[2], 1559 (C 2698), 1562 (C 2699), 1567 (C 2700), 1569 (C 2701); also published as *Caro mea*
1548[2]	Virgo gloriosa / Cantantibus organis	4	Thomas Crecquillon	*CMM* 63.13	
1549	Domine Jesu Christe / Dum aurora finem daret	5	Crecquillon	*CMM* 63.7	NL-L MS 1438
ca. 1549	Dum aurora finem daret	8	Anonymous	*RRMR* (forthcoming)	B-Bc MS 27088
1550–75	O beata Cecilia / Cilicio induta dum viveres	5	Ludovicus Episcopius	*RRMR* (forthcoming)	A-Wn Mus. Hs. 19189
1551[1]	Domine Jesu Christe / Nam sponsum	4	Jean Maillard	*RRMR* 73	Reprints: RISM 1554[12], 1559[2], 1563[3], 1565 (M 185), 1588[3]
1552	Cantantibus organis	8	Petit Jean de Latre		GB WA, MS B. V. 23 (2 partbooks only)
1553[10]	Ave virgo Cecilia beata / Ave virgo prudens	4	Manchicourt	*CMM* 55.6	Also published (in RISM 1556[1]) with text *Ave virgo prudentissima*
1553[16]	Cecilia ex praeclaro genere / Cilicio vero ad carnem	5	Jean Crespel	*SCM* 18	Reprints: RISM 1557[4], 1558[3]
1554[1]	Dum aurora finem daret	5	Crecquillon	*CMM* 63.7	Reprint: RISM 1555[2]
1554[2]	Dum aurora finem daret	5	Jacob Bultel	*RRMR* (forthcoming)	Reprints: RISM 1555[3], 1564
1554[5]	Ave virgo gloriosa / Deprecare Jesum Christum	5	Crecquillon	*CMM*.63.6	Reprints: RISM 1558[5], 1576 (C 4410)

Year of first publication (with RISM number) or year of earliest manuscript	Opening words (part 1 / part 2) or title	Number of voices	Composer	Modern editions(s) (for fuller citations see "Musical Editions" in bibliography)	Remarks
1554[8]	Virgo gloriosa / Domine Jesu Christe	4	Crecquillon	*CMM* 63.13	Reprints: RISM 1559 (C 4406), 1576 (C 4410). MS: B-LVu 1050 (bassus only)
1554[15]	Virgo gloriosa / Cilicio Cecilia	4	Canis	*CMM 111* (forthcoming)	
1554[15]	Cecilia laudes celebremus / Praeses atrox illi ferrum	4	Antonius Galli	*RRMR* (forthcoming)	
1554 (C 3185)	Missa Cantantibus organis	4	Pierre Cléreau	C. Shaw, Bath, 2019	Based on motet by Certon
1554 (C 3185)	Missa Cecilia virgo gloriosa	4	Cléreau	C. Shaw, Bath, 2019	Based on motet by Certon
1555[8]	Cantantibus organis / Biduanis ac triduanis	5	Philippe Gheens	*SCM* 17	
1555 (M 179)	Cantantibus organis / Biduanis ac triduanis	4	Maillard	*RRMR* 73	Reprint: RISM 1565 (M 185)
1555 (M 179)	De fructu vitae	5	Maillard	*RRMR* 95	Text of cantus firmus, "Fiat cor meum." Reprint: RISM 1565 (M 184)
1556[6]	Virgo gloriosa Cecilia / Biduanis ac triduanis	6	Josquin Baston	*RRMR* (forthcoming)	
1557 (K 440)	Cantantibus organis / Biduanis ac triduanis	5	Jacobus de Kerle		Altus partbook only
1563[6]	I' sent' al cor conforto	2	Serafino Razzi	M. A. Mancuso, 1984	*Laude spirituale*. Reprint: RISM 1609[8]

(continued)

Year of first publication (with RISM number) or year of earliest manuscript	Opening words (part 1 / part 2) or title	Number of voices	Composer	Modern editions(s) (for fuller citations see "Musical Editions" in bibliography)	Remarks
1563	Dum aurora finem daret	4	Giovanni Pierluigi da Palestrina	R. Casimiri, 1939; D. V. Filippi, Pisa, 2003	Reprints: RISM 1564 (P 689), 1571 (P 690), 1574 (P 691), 1579 (P 692), 1585 (P 693), 1587 (P 694), 1590 (P 695), 1593 (P 696), 1595 (P 697)
1564[1]	Cantantibus organis	8	Daniel Torquet	C. Shaw, Bath, 2017; *RRMR* (forthcoming)	
1564	Cantantibus organis	5	Giulio Schiavetto (Julije Skjavetić)	L. Županović, Zagreb, 1996	
1565 (M 184)	Dum aurora finem daret / O beata Cecilia	4	Maillard	*RRMR* 73	
1566	Virgo gloriosa / Domine Jesu Christe	4	Geert van Turnhout		B-LVu MS 1050 (bassus only)
1566	Venit autem nox / Angelum Dei / Valerianus igitur	4	Turnhout		B-LVu MS 1050 (bassus only)
1568[4]	O virgo generosa / O virgo felix	7	Andreas Pevernage	*RRMR* 154	Reprint: RISM 1578 (P 1669)
1568[4]	Cecilia in corde suo	4	Jean de Chaynée	J. Quitin, Liège, 1987; C. Shaw, Bath, 2018; *RRMR* (forthcoming)	
1571 (C 1470)	Cantantibus organis / Biduanis ac triduanis	5	Jean de Castro	*DRM* 17	
1574 (S 3550)	Virgo gloriosa	5	Guglielmo Sitibundo		Title of collection, *Antiphonae ad Magnificat*, identifies it as liturgical in function
1575 (M 3314)	Cecilia virgo Almachium / O beata Cecilia	5	Philippe de Monte	C. van den Borren, Bruges, 1932 (reprint New York, 1965)	

Year of first publication (with RISM number) or year of earliest manuscript	Opening words (part 1 / part 2) or title	Number of voices	Composer	Modern editions(s) (for fuller citations see "Musical Editions" in bibliography)	Remarks
1575 (P 711)	Cantantibus organis / Biduanis ac triduanis	5	Palestrina	T. de Witt, Leipzig, 1881; R. Casimiri, Rome, 1940	Reprints: RISM 1581 (P 712), 1587 (P 713), 1589 (P 714), 1594 (P 715); organ tablature by Jacob Paix in RISM 1583[22]
1575–1600	Missa Cantantibus organis	12	Palestrina et al.	R. Casimiri, Rome, 1930	I-Rsg, Rari, ms. 52–54; based on motet by Palestrina
1577 (U 125)	Cantantibus organis	6	Alexander Utendal	T. Engel, Innsbruck, 2002; *RRMR* (forthcoming)	
1578	Ceciliam intra cubiculum	5	Etienne Testart		Won prize at Évreux; not extant
1578 (I 37)	Dum aurora finem daret	4	Fernando de las Infantas	J. Martín, Santa Cruz de La Palma, 2020	
1578 (I 37)	Gloriosa virgo Cecilia	4	Infantas	J. Martín, Santa Cruz de La Palma, 2020	
1578 (P 1669)	Dum aurora finem daret / Cecilia virgo, valedicens	6	Pevernage	RRMR 154	
1578 (P 1669)	Alma patrona veni / Princeps ecce	8	Pevernage	RRMR 155	
1578 (P 1669)	Ceciliae gaudete / Nam quae vel Charites	8	Pevernage	RRMR 155	
1578 (P 1669)	Ducite festivos Musae / Huic quoque tu faveas	8	Pevernage	RRMR 155	
1578 (P 1669)	Ecce triumphali revolutis / Nobilis est ortu	8	Pevernage	RRMR 155	
1578 (P 1669)	Nectite Ceciliae / Nam quos conjunxit	8	Pevernage	RRMR 155	
1578 (P 1669)	Plaudite: Cecilia / Nec secus	8	Pevernage	RRMR 155	

(continued)

Year of first publication (with RISM number) or year of earliest manuscript	Opening words (part 1 / part 2) or title	Number of voices	Composer	Modern editions(s) (for fuller citations see "Musical Editions" in bibliography)	Remarks
1578 (P 1669)	Solemnis redit ecce dies / Quem non obscuro	8	Pevernage	*RRMR* 155	
1580 (C 3945)	Cantantibus organis / Fiat cor meum	5	Séverin Cornet	*RRMR* (forthcoming)	
1580 (P 5181)	Cantantibus organis / Biduanis ac triduanis	6	Costanzo Porta	S. Cisilino, Padua, 1971	
1582 (L 939)	Cantantibus organis / Fiat Domine	5	Orlande de Lassus	*RRMR* 128	Won prize at Évreux
1585 (L 958)	Domine Jesu Christe	5	Orlande de Lassus	*RRMR* 130	
1585 (M 949)	Cantantibus organis	4	Luca Marenzio	*CMM* 72.2	Reprint: RISM 1603 (M497)
1585	Dum aurora finem daret	5	François Habert		Won prize at Évreux; not extant
1585 (P 5182)	Gloriosa virgo Cecilia	6	Costanzo Porta	S. Cisilino, Padua, 1971	
1585 (S 4201)	Cantantibus organis	8	Annibale Stabile	R. Lightbourne, Dunedin, 1994	
ca. 1585	Fiat cor meum	5	Daniel Raymundi	*RRMR* (forthcoming)	Picture motet; see plates 51 and 52
1586 (C 986)	Cantantibus organis	5	Jacopo Antonio Cardillo	C. Shaw, Bath, 2017	
1586 (G 164)	Benedicta es, virgo Cecilia / Nunc virgo te deprecamur	6	François Gallet	*RRMR* (forthcoming)	
1587	Dum aurora finem daret	5	Abraham Fourdy		Won prize at Évreux; not extant
1588 (L 753)	Dum aurora finem daret	6	Ferdinand de Lassus	*RRMR* (forthcoming)	

Year of first publication (with RISM number) or year of earliest manuscript	Opening words (part 1 / part 2) or title	Number of voices	Composer	Modern editions(s) (for fuller citations see "Musical Editions" in bibliography)	Remarks
1588 (C 1478)	Cantantibus organis / Biduanis ac triduanis	5	Castro	*DRM* 18; C. Shaw, Bath, 2017	
1588	Dum aurora finem daret	5	Nicolas Vauquet		Won prize at Évreux; not extant
1588	Dum aurora finem daret	5	Daniel Guichart		Won prize at Évreux; not extant
1589 (G 4875)	Dum aurora finem daret	4	Francisco Guerrero	J. Cisterò, Barcelona, 2003	
1589 (M 2196)	Cantantibus organis	6	Rinaldo del Mel	*RRMR* (forthcoming)	
1590 (H 1985)	Dum aurora finem daret / Cecilia valedicens	6	Jacob Handl (Gallus)	*DTÖ* 51–52	
1590 (M 1274)	Beata Cecilia dixit Tiburtio	5	Tiburzio Massaino		
1592 (M 1276)	Cilicio Cecilia membra domabat / Haec est virgo	4	Massaino	R. Montcrosso, Vienna, 1964	
1592 (S 1162)	Cantantibus organis	8	Damiano Scarabelli		
1593 (S 394)	Cantantibus organis / Biduanis ac triduanis	5	Franz Sales	C. Shaw, Bath, 2017; C. Wagemakers, Rijswijk, 2020; *RRMR* (forthcoming)	
ca. 1593	Domine fiant anima mea	6	Cornelis Schuyt	*RRMR* (forthcoming)	Picture motet; see plates 53 and 54
1594 (T 1436)	O virgo generosa / O virgo felix	8	Jan van Turnhout	*RRMR* (forthcoming)	
1595 (R 1936)	Cantantibus organis	6	Philippe Rogier	*RRMR* 2, *CMM* 61.3; C. Shaw, Bath, 2017	

(continued)

Year of first publication (with RISM number) or year of earliest manuscript	Opening words (part 1 / part 2) or title	Number of voices	Composer	Modern editions(s) (for fuller citations see "Musical Editions" in bibliography)	Remarks
1595 (R1085)	Domine Jesu Christe, pastor bone	5	Jacob Reiner		
1596 (B 2599)	Psallite cantantes Domino	6	Francesco Bianciardi	S. Cisilino and L. Bertazzo, Padua, 1974; *RRMR* (forthcoming)	
1596 (M 3325)	Cilicio Cecilia membra domabat	4	Philippe de Monte	M. Steinhardt, Leuven, 1986	
1597[3]	Cecilia virgo gloriosa	5	Ferdinand de Lassus	*RRMR* 147	
1597[3]	Cantantibus organis	5	Ferdinand de Lassus	*RRMR* 147	
1597 (L 366)	Cantantibus organis	4	Girolamo Lambardi		Title of collection, *Antiphonarium Vespertinum dierum festorum totitus anni*, identifies it as liturgical in function.
1597 (L 366)	Valerianus in cubiculo	4	Lambardi		
1597 (L 366)	Cecilia famula tua	4	Lambardi		
1597 (L 366)	Benedico Te Pater	4	Lambardi		
1597 (L 366)	Triduanis a Domino poposci	4	Lambardi		
1597 (L 366)	Est secretum Valeriane	4	Lambardi		
1597 (L 366)	Virgo gloriosa	4	Lambardi		
1598 (M 3642)	Cantantibus organis	5	Bernardino Morelli	C. Shaw, Bath, 2019	
ca. 1600	Fiat Domine cor meum	3	Antonio Goretti?	E. E. Lowinsky, Chicago, 1989; A. Valentini, Padua, 2012	Canon notated in altarpiece attributed to Filippi; see plates 66 and 67

Year of first publication (with RISM number) or year of earliest manuscript	Opening words (part 1 / part 2) or title	Number of voices	Composer	Modern editions(s) (for fuller citations see "Musical Editions" in bibliography)	Remarks
1600 (L 1036)	Dum aurora finem daret	6	Rudolph de Lassus		
1601 (BB 3431a)	Cantantibus organis	6	Valerio Bona		
1601 (B 2600)	Cantantibus organis	8	Bianciardi		
1601 (B 2600)	Domine Jesu Christe	6	Bianciardi		
1602 (RISM deest)	?	?	Bernardino Bertolotti		Published in *Motetti di diversi autori in lode di Santa Cecilia* (Rome, 1602); no copy extant
1602 (RISM deest)	?	?	Stefano Malescot		Published in *Motetti di diversi autori*
1602 (RISM deest)	?	?	Filippo Nicoletti		Published in *Motetti di diversi autori*
1603 (B 3469)	Dum aurora finem daret	9	Pierre Bonhomme	C. Shaw, Bath, 2017; *RRMR* (forthcoming)	
1603 (M1428)	Cantantibus organis / Sancta Cecilia, ora pro nobis	8	Piat Maulgred		
1603 (P 2392)	Cantantibus organis	5	Innocenzo Pini		Single surviving set of parts incomplete
1604 (B 1708)	Cantantibus organis	5	Lodovico Bellanda		
1604 (B 2697)	Cantantibus organis	3	Benedetto Binago		
1605 (R 737)	Dum aurora finem daret	8	Jacob Regnart		
1606 (B 2708)	Cantantibus organis		Giovanni Battista Biondi (Cesena)		Soprano, bass, b.c.

(continued)

Year of first publication (with RISM number) or year of earliest manuscript	Opening words (part 1 / part 2) or title	Number of voices	Composer	Modern editions(s) (for fuller citations see "Musical Editions" in bibliography)	Remarks
1606 (B 2984)	Choeurs de l'histoire tragique Saincte Cécile	4	Abraham Blondet	J. Powell, Tulsa, 2003	Music for Nicolas Soret's play *La Céciliade* (Paris, 1606)
1606 (C 807)	Dum aurora finem daret	3	Giovanni Antonio Cangiasi		
1606 (M 1285)	Cantantibus organis	9	Massaino	C. Shaw, Bath, 2020	
1607 (L 1437)	Cantantibus organis	8	Jan Lefebure	C. Shaw, Bath, 2019	
1607 (M 1000)	Cantantibus organis	4	Francesco Martini		
1607 (T 1013)	Cantantibus organis	3	Sebastiano Mangoni		
1608 (P 884)	Cantantibus organis	2	Francesco Pappo		Dedicated to Cardinal Paolo Sfondrato; single surviving set of parts incomplete
1609 (B 803)	Sancta Cecilia virgo gloriosa		Adriano Banchieri		Soprano, Tenor, b.c. Dedicated to Cardinal Sfondrato
1609 (C 1576b)	Cantantibus organis		Pietro Paolo Cavi		"Doi Contr'Alti," b.c.
1609 (D 3614)	Favus distillans / O tu, quae nunc beata	4	Eustache du Caurroy	M.-A. Colin, Paris, 1999	
1609 (D 3615)	Domine Jesu Christe / Virgo gloriosa	5	Du Caurroy	M.-A. Colin, Paris, 1999	
1609 (D 3615)	Dum ipsa fleret / Et extensis manibus	4	Du Caurroy	M.-A. Colin, Paris, 1999	
1609 (D 3615)	O diva quae dulces / Illic concilia	4	Du Caurroy	M.-A. Colin, Paris, 1999	
1609 (D 3679)	Beata Cecilia dixit Tiburtio	8	Giovanni Battista Dulcino		

Year of first publication (with RISM number) or year of earliest manuscript	Opening words (part 1 / part 2) or title	Number of voices	Composer	Modern editions(s) (for fuller citations see "Musical Editions" in bibliography)	Remarks
1610[1]	Cantantibus organis	6	Giovanni Battista Stefanini		
1610[1]	Cantantibus organis	6	Orfeo Vecchi		
1610 (C 2229)	Cantantibus organis		Giovanni Paolo Cima	A. Friggi, Milan, 2004	"Alto solo," b.c.
1610 (V 1551)	Cantantibus organis	16	Gasparo Villani	*RRMR* (forthcoming)	
1611 (F 1100)	Cantantibus organis	8	Giovanni Pietro Flaccomio		
1611 (RISM *deest*)	Officii divae Ceciliae	4–10	Blondet		Single surviving set of parts incomplete
1612 (N 17)	Dum aurora finem daret		Giovanni Bernardino Nanino		"Bassus, cum Basso"
1612 (P 1973)	Cantantibus organis	5	Peter Philips	J. Steele, Dunedin, 1992; R. Lyne, Oxford, 2002	
1613 (A 1104)	Cantantibus organis		Giovanni Francesco Anerio		"A due Soprani," b.c. Title of collection, *Antiphonae, seu Sacrae cantiones*, suggests a primarily liturgical function
1613 (A 1104)	Dum aurora finem daret		Anerio		"A 2. Bassi," b.c.
1613 (A 1104)	Est secretum Valeriane		Anerio		"A 2. Alti," b.c.
1613 (A 1104)	Virgo gloriosa		Anerio		"A due Tenori," b.c.
1613 (B 1771)	Cantantibus organis		Giulio Belli		"Canto, Alto & Tenore," b.c.
1613 (C 2194)	Cantantibus organis		Antonio Cifra		"Canto, e Tenore," b.c. Reprint: 1619 (RISM *deest*)
1613 (F 1813)	Cantantibus organis	8	Amante Franzoni	L. Colombo, Brescia, 2010	

(*continued*)

Year of first publication (with RISM number) or year of earliest manuscript	Opening words (part 1 / part 2) or title	Number of voices	Composer	Modern editions(s) (for fuller citations see "Musical Editions" in bibliography)	Remarks
1613 (L 2005)	Cecilia virgo gloriosa		Leone Leoni		"Alto, & due tenori," b.c. Reprints: RISM 1616 (L 2006), 1621 (L 2007)
1613 (P 3)	Cantantibus organis	4	Pietro Pace		
1613 (P 1976)	Cecilia virgo, tuas laudes	8	Philips	*MB* 61	
1613 (V 1557)	Missa Cantantibus organis	8	Gasparo Villani	C. Shaw, Bath, 2020	
1614 (M 1310)	Domine Jesu Christe, pastor bone		Domenico Massenzio	C. Dall'Albero and M. Bacherini, Milan 2009	"Doi Alti, & doi Bassi," b.c. Cecilia's name replaced with "N"
1614 (S 4730)	O beata Cecilia	8	Stefanini		
1615 (A 375)	Dum aurora finem daret		Andrea Raffaelli		"Canto, e tenore," b.c.
1616 (M 499)	Ceciliam cantate pii	5	Marenzio	*CMM* 72.1	
1616 (M 499)	Dum aurora finem daret / Virgo gloriosa	6	Marenzio	*CMM* 72.1	
1617 (F 503)	Cantantibus organis		Antonio Ferraro	R. Musumeci, Florence, 1999	"Duobus altis et Tenore," b.c.
c. 1617	Fiat cor meum et corpus meum		?		Musical notation for soprano and b.c. in Domenichino's painting of Cecilia playing a bass viol
1618 (A 552)	Cantantibus organis		Giovanni Battista Ala		"Canto, e Basso"
1618 (G 3436)	Cecilia virgo clarissima		Alessandro Grandi		"Doi Canti, & Basso"
1618 (G 3436)	Cilicio Cecilia sua membra domabat		Grandi		"Basso, Tenore, & Alto," b.c.
1619 (P 1181)	Cantantibus organis	4	Vincenzo Pellegrini		
1619 (U 34)	Cecilia famula Dei		Vincenzo Ugolini		"Ten. Bass. & Duo Cant," b.c.

Notes

INTRODUCTION

1. Encore que son Office ne soit que semidouble, neanmoins la Messe sera chantée en notes, et avec l'Orgue, à l'honneur de cette grande Sainte. Son histoire porte, qu'entre les innocens exercices de sa vie, elle passoit tous les jours quelques heures, à chanter les loüanges Divines, meslant sa voix avec les sons agreables de l'Orgue; et demandant à Dieu, que son cœur et son corps fussent toûjours purs en sa sainte presence (Pierre de Sainte-Catherine, *Cérémonial monastique des religieuses de l'abbaye royale de Montmartre lez Paris, Ordre de Saint Benoist* [Paris, 1669], 459–60).

2. Alban Butler, *The Lives of the Primitive Fathers, Martyrs, and Other Principal Saints*, 3rd ed., 12 vols. (Edinburgh, 1798–1799), vol. 11, 397.

3. Comme toutes choses sont sujettes à vicissitude sur la terre, et que tous les jours on avance dans la connoissance de l'Histoire, on a découvert que le choix de Sainte Cecile pour Patrone des Musiciens n'est appuyé que sur un fondement ruineux, c'est-à-dire, sur des Auteurs qui attribuent à cette Sainte des faits qu'il leur a plû d'imaginer pieusement, ou sur un texte historique mal entendu, et pris à contresens, en cas qu'il soit veritable ("Lettre de M *** à M. H. Chanoine de l'Eglise Cathedrale de *** sur le choix que les Musiciens ont fait de Ste. Cécile pour leur patronne," *Mercure de France*, January 1732, 21–45 [30]). The article is attributed to Lebeuf in L'Abbé Papillon, *Bibliothèque des auteurs de Bourgogne*, vol. 1 (Dijon, 1745), 394.

4. Charles Burney, *A General History of Music*, 4 vols. (London, 1776–1789), vol. 2, 377.

5. Jan Karel van der Haagen, *De heilige Caecilia in legende en kunst* ([The Hague], 1930); Albert P. de Mirimonde, *Sainte-Cécile: Métamorphoses d'un thème musical* (Geneva, 1974); Rodolfo Baroncini, "L'immagine di santa Cecilia prima e dopo Raffaello: percorsi iconografici e trasformazioni tematiche," in *Colori della musica: Dipinti,*

strumenti e concerti tra Cinquecento e Seicento, ed. Annalisa Bini et al. (Milan, 2000), 34–45; Nico Staiti, *Le metamorfosi di Santa Cecilia: L'immagine e la musica* (Innsbruck and Lucca, 2002); Lisa Ann Festa, "Representations of Saint Cecilia in Italian Renaissance and Baroque Painting and Sculpture," PhD diss., Rutgers University, 2004.

6. The *Passio sanctae Caeciliae*, after 1,500 years of anonymity, has finally found its author; see Cécile Lanéry, "Nouvelles recherches d'hagiographie arnobienne: la Passion de Cécile (*BHL 1495*)," in *"Parva pro magnis munera": Études de littérature latine tardo-antique et médiévale offertes à François Dolbeau par ses élèves*, ed. Monique Goullet (Turnhout, 2009), 533–59. Michael Lapidge, *The Roman Martyrs: Introduction, Translations, and Commentary* (Oxford, 2018), 143–44, summarizes Lanéry's arguments in favor of the attribution to Arnobius and accepts them as "powerful and incontrovertible."

7. On the iconography of Agnes, see Jan Vermeulen (Johannes Molanus), *De picturis et imaginibus sacris liber unus* (Leuven, 1570), fols. 111v–112r. On Jerome and the lion, see Eugene F. Rice Jr., *Saint Jerome in the Renaissance* (Baltimore, 1985), 37–45.

8. Bonnie J. Blackburn, "For Whom Do the Singers Sing?," *EM* 25 (1997): 593–609.

9. Jane D. Hatter, *Composing Community in Late Medieval Music: Self-Reference, Pedagogy, and Practice* (Cambridge, 2019), 208. See Hatter's bibliography for further literature on the changing self-image of professional musicians in the early Renaissance.

10. Rob C. Wegman, "From Maker to Composer: Improvisation and Musical Authorship in the Low Countries, 1450–1500," *JAMS* 49 (1996): 409–479 (472–74).

11. Hatter, *Composing Community*, 208.

12. Richard Luckett, "St. Cecilia and Music," in *Proceedings of the Royal Musical Association* 99 (1972–1973): 15–30.

13. Heinrich Hüschen, "Lob- und Preismotetten auf die Musik aus früheren Jahrhunderten," *Musicae scientiae collectanea: Festschrift Karl Gustav Fellerer*, ed. Heinrich Hüschen (Cologne, 1973), 225–42 (241).

14. Homer Rudolf, "The Life and Works of Cornelius Canis," PhD diss., University of Illinois, 1977, 149–59; "St. Cecilia, Patron Saint of Music" (1984); and "Cologne, Convents, Commissions, and the Cult of St. Cecilia," read at the spring meeting of the Capital Chapter of the American Musicological Society, April 1996, and the Annual Meeting of the Renaissance Society of America, Bloomington, IN, April 1996.

15. John A. Rice, "Palestrina's Saint Cecilia Motets and the Missa 'Cantantibus organis,'" in *Palestrina e l'Europa*, ed. Giancarlo Rostirolla et al. (Palestrina, 2006), 817–29.

16. Martin Ham, "Thomas Crecquillon in Context: A Reappraisal of His Life and of Selected Works," PhD diss., University of Surrey, 1998, 90–93; Mary Tiffany Ferer, "Thomas Crecquillon and the Cult of St. Cecilia," in *Beyond Contemporary Fame: Reassessing the Art of Clemens non Papa and Thomas Crecquillon*, ed. Eric Jas (Turnhout, 2005), 125–39.

17. Andreas Pevernage, *Cantiones sacrae (1578)*, ed. Gerald R. Hoekstra, 3 vols. (Middleton, WI, 2010); Megan K. Eagen, "The Articulation of Cultural Identity through Psalm Motets, Augsburg 1540–1585," PhD diss., University of North Carolina, 2016, 174, 184–85, 198–99.

18. . . . ex quo mos ille in Ecclesia profluxit, ut in eius manibus organa appingantur (Antonio Bosio, *Historia passionis B. Caeciliae* [Rome, 1600], 59).

19. Prosper Guéranger, *Histoire de Sainte Cécile vierge romaine et martyre*, 2nd ed. (Paris, 1853); in translation (used here) as *Life of Saint Cecilia Virgin and Martyr* (Philadelphia, 1866), 64–65.

20. Guéranger, *Life of Saint Cecilia*, 371.

21. Thomas Connolly, "The Legend of St. Cecilia: I, The Origins of the Cult," *SM* 7 (1978): 3–37; "The Legend of St. Cecilia: II, Music and the Symbols of Virginity," *SM* 9 (1980): 3–44; *Mourning into Joy: Music, Raphael, and Saint Cecilia* (New Haven, CT, 1994).

22. Connolly, *Mourning into Joy*, 6.

23. For example, Kathi Meyer-Baer, "Saints of Music," *MD* 9 (1955): 11–33 (21); and *Santa Cecilia martire romana: Passione e culto*, ed. Filippo Caraffa and Antonio Massone [Rome, 1983], 25–26.

24. Connolly, *Mourning into Joy*, 15.

CHAPTER ONE

1. Karen A. Winstead, *Virgin Martyrs: Legends of Sainthood in Late Medieval England* (Ithaca, NY, 1997), 5–6.

2. *The Old Norse-Icelandic Legend of Saint Barbara*, ed. Kirsten Wolf (Toronto, 2000); Katherine J. Lewis, *The Cult of St. Katherine of Alexandria in Late Medieval England* (Woodbridge, 2000); Christine Walsh, *The Cult of St. Katherine of Alexandria in Early Medieval Europe* (Aldershot, 2007); Eileen Marie Harney, "The Sexualized and Gendered Tortures of Virgin Martyrs in Medieval English Literature," PhD diss., University of Toronto, 2008; Scott B. Montgomery, *St. Ursula and the Eleven Thousand Virgins of Cologne: Relics, Reliquaries and the Visual Culture of Group Sanctity in Late Medieval Europe* (Bern, 2009); Paul Oldfield, "The Medieval Cult of St. Agatha of Catania and the Consolidation of Christian Sicily," *Journal of Ecclesiastical History* 62 (2011): 439–56; Anne Simon, *The Cult of Saint Katherine of Alexandria in Late-Medieval Nuremberg* (Farnham, 2012); *Writing Women Saints in Anglo-Saxon England*, ed. Paul E. Szarmach (Toronto, 2013); *The Cult of St. Ursula and the 11,000 Virgins*, ed. Jane Cartwright (Cardiff, 2016); Juliana Dresvina, *A Maid with a Dragon: The Cult of St. Margaret of Antioch in Medieval England* (Oxford, 2016); Dorottya Uhrin, "Rediscovering the Virgin Martyrs in Medieval Central Europe: The Case of the Cult of Saint Dorothy in Hungary," *Il capitale culturale* 21 (2020): 119–43.

3. Liesl Ruth Smith, "Virginity and the Married-Virgin Saints in Ælfric's *Lives of Saints*: The Translation of an Ideal," PhD diss., University of Toronto, 2000; Alison Gulley, *The Displacement of the Body in Ælfric's Virgin Martyr Lives* (Abingdon, 2014), chapter 7; Anne P. Alwis, *Celibate Marriages in Late Antique and Byzantine Hagiography* (London, 2011); and Dyan Elliott, *Spiritual Marriage: Sexual Abstinence in Medieval Wedlock* (Princeton, NJ, 1993).

4. CH-Zz, MS C 10i, fol. 228 r-v; online on the website e-codices—Virtual Manuscript Library of Switzerland (https://www.e-codices.unifr.ch). Modern editions of the *Passio sanctae Caeciliae* in Hippolyte Delehaye, *Étude sur le légendier romain: Les Saints de novembre et de décembre* (Brussels, 1936), 194–220; and (with English translation) in *Ælfric's Lives of the Virgin Spouses, with Modern English Parallel-Text Translations*, ed. Robert K. Upchurch (Exeter, 2007), 172–217; another English translation, with valuable commentary, in Lapidge, *The Roman Martyrs*, 138–64.

5. All biblical references in this book are to the online edition of the Latin Vulgate at www.drbo.org.

6. *Missale ad usum insignis ecclesiae Eboracensis*, ed. W. G. Henderson, vol. 1 (Durham, 1874), xiii–xv.

7. Valentijn Pacquay, "Breda, Bredanaars en de Onze-Lieve-Vrouwekerk: Religie, devoties en manifestaties voor 1590," *Jaarboek De Oranjeboom* 54 (2001), 1–89 (16–17), citing documents dated 1525–1531.

8. *Breviarium monasterii sancti Emmerami* (Munich, 1571), unpaginated. For another instance of the lighting of varying numbers of candles to indicate degree of solemnity, see Yossi Maurey, *Medieval Music, Legend, and the Cult of St. Martin* (Cambridge, 2014), 41–47.

9. Aaron Macks's website *Corpus Kalendarium* (https://www.cokldb.org) brings together and analyzes the calendars of hundreds of manuscript books of hours copied between 1000 and 1700 and is the source of all the data in this paragraph. I am grateful to him for advice in the interpretation of these calendars.

10. Cleveland Museum of Art, Hours of Isabelle of Castile, fol. 12r–v; online at https://www.clevelandart.org/art/1963.256.12.a and https://www.clevelandart.org/art/1963.256.12.b.

11. Geneviève's feast day was 3 January; 26 November was the date of the annual celebration (primarily in France) of the miraculous cure of Parisians afflicted by ergot poisoning that Geneviève's relics effected in 1129. See Brianna M. Gustafson, "*Miraculis Virgo*: The Abbey of Sainte-Geneviève and the Cult of Geneviève in the Twelfth and Thirteenth Centuries," *Journal of the Western Society of French History* 38 (2010), online at http://hdl.handle.net/2027/spo.0642292.0038.001.

12. Several calendars in the *Corpus Kalendarium* contain marginal notes marking 17 November "Sol in Sagittario"; see http://www.cokldb.org/cgi-bin/date_detail.pl?date_id=321&detailed=1. My thanks to Aaron Macks (email, 8 January 2021) for pointing this out.

13. Sherry L. Reames, "The Office for St. Cecilia," in *The Liturgy of the Medieval Church*, ed. Thomas J. Heffernan and E. Ann Matter (Kalamazoo, MI, 2001), 245–70.

14. *The Divine Office in the Latin Middle Ages: Methodology and Source Studies, Regional Developments, Hagiography*, ed. Margot Fassler and Rebecca A. Baltzer (New York, 2000).

15. For example, at Notre Dame in Paris during the Middle Ages, Matins was normally sung at midnight (Craig Wright, *Music and Ceremony at Notre Dame of Paris, 500–1550* [Cambridge, 1989], 267); but at Cambrai the choirboys woke up at 5:30 or 6 a.m. (depending on the season), then went to the cathedral to sing Matins (Sandrine Dumont, "Choirboys and *Vicaires* at the Maîtrise of Cambrai: A Socio-Anthropological Study [1550–1670]," *Young Choristers, 650–1700*, ed. Susan Boynton and Eric N. Rice [Woodbridge, 2008], 146–62).

16. M. Jennifer Bloxam discusses this variation in "Sacred Polyphony and Local Traditions of Liturgy and Plainsong: Reflections on Music by Jacob Obrecht," in *Plainsong in the Age of Polyphony*, ed. Thomas Forrest Kelly (Cambridge, 1992), chapter 6.

17. On the Beaupré Antiphonary (US-BAw, Ms. W.759–60), see the detailed entry on the manuscript in the Digital Walters (https://wwwthedigitalwalters.org), which includes a comprehensive bibliography and a complete facsimile.

18. Sean L. Field, "Marie of Saint-Pol and Her Books," *English Historical Review*

125 (2010): 255–78; on her breviary (GB-Cu, MS Dd.5.5), see *Cambridge Digital Library*: https://cudl.lib.cam.ac.uk.

19. Cantus ID numbers are assigned by Cantus: A Database for Latin Ecclesiastical Chant (http://cantus.uwaterloo.ca).

20. For a full set of nine Cecilia's Day lessons, as preserved in a manuscript copied in the later thirteenth century, with English translation, see "The Second Nun's Prologue and Tale," ed. Sherry L. Reames, in *Sources and Analogues of the Canterbury Tales*, vol. 1, ed. Robert M. Correale and Mary Hamel (Cambridge, 2002), 491–528 (517–26).

21. *Breviarium ad usum insignis ecclesie Eboracensis*, ed. Stephen Lawley, vol. 2 (Durham, 1882), cols. 706–12.

22. Some of these sources are listed in the *Cantus* database under Cantus ID 007902zb.

23. *Missale s[e]c[un]d[u]m ritum Augustensis ecclesie* (Augsburg, 1510), fols. 187r-v.

24. Robert L. Kendrick, *The Sounds of Milan, 1585–1650* (New York, 2002), 486, citing *Missale Ambrosianum* [1618], 311. For an earlier appearance of *Cantantibus organis* as "antiphona post Evangelium," see *Missale Ambrosianum Gasparis S. mediolanensis ecclesiae archiepiscopi iussu recognitum et editum* (Milan, 1594), fol. 185r.

25. Terence Bailey (email, 23 March 2020). I thank Bailey for valuable information on the double function of the antiphon *Cantantibus organis* in the Ambrosian liturgy for Cecilia.

26. No. 221 in Karl-Heinz Schlager, *Thematischer Katalog der ältesten Alleluia-Melodien* (Munich, 1965); transcribed in *Alleluia-Melodien I*, ed. Karl-Heinz Schlager (Kassel, 1968), 60–61.

27. *Missale secundum usum Byterii*, F-Pn, MS NAL 1690, fol. 316v.

28. *Hispania vetus: Musical-Liturgical Manuscripts from Visigothic Origins to the Franco-Roman Transition (9th–12th Centuries)*, ed. Susana Zapke (Bilbao, 2007), 400.

29. *Missale mixtum secundum ordinem almae primatis ecclesiae Toletanae* (Lyon, 1551), fol. 281r.

30. *Missale parvum secundum usum venerabilis ecclesie Cameracensis* (Paris, 1507), fol. 71v–72r; *Missale secundum usum ecclesiae Venetensis*, Paris, 1535 (unpaginated); *Missale ad usum insignis ecclesiae Eboracensis*, vol. 2, 128–29.

31. The York Gradual, GB-Ob, MS Lat. liturg. b. 5, facsimile edition by David Hiley (Ottawa, 1995).

32. The manuscript from Ireland, GB-Ob Rawlinson C 892; the manuscript from Acre, I-Nbn VI G 11. I am most grateful to David Hiley (email 3 November 2015 and 17 March 2019) for telling me of these sources for the *Alleluia Cantantibus organis*.

33. These melodies transcribed in *Alleluia-Melodien II*, ed. Karl-Heinz Schlager (Kassel, 1987), 101–2, with notes on pp. 607–8. Again, my thanks to Hiley for alerting me to the existence of these chants.

34. *Missale s[e]c[un]d[u]m ritum Augustensis ecclesie*, fols. 187r-v. In contrast, the Augsburg liturgy gave Catherine a sequence of her own: *Hac in die laudes pie* (fol. 188r).

35. *Analecta hymnica medii aevi 55: Die Sequenzen*, ed. Clemens Blume (Leipzig, 1922), no. 103.

36. [*Missale secundum usum ecclesiae Venetensis*] (Paris, 1535), copy, without title page and unpaginated, in F-Pn. In *Analecta hymnica medii aevi*, vol. 10: *Sequentiae*

ineditae. Liturgische Prosen des Mittelalters, ed. Guido Maria Dreves (Leipzig, 1891), 149, the first line is given as "Exsultemus cum jucundo."

37. On Anglo-Saxon accounts of Cecilia's life, see *Ælfric's Lives of the Virgin Spouses*, 3–19.

38. On Aldhelm, see George T. Dempsey, *Aldhelm of Malmesbury and the Ending of Late Antiquity* (Turnhout, 2015) and, on his accounts of Cecilia's wedding, Connolly, *Mourning into Joy*, 176–77.

39. *Aldhelmi opera*, ed. Rudolf Ehwald, Monumenta Germaniae Historica, Auctores antiquissimi 15 (Berlin, 1919), 292.

40. *Aldhelmi opera*, 424.

41. Vincent de Beauvais, *Speculum historiale* (Venice, 1494), fol. 132v.

42. Sherry L. Reames, *The Legenda Aurea: A Reexamination of Its Paradoxical History* (Madison, 1985).

43. Jacobus de Voragine, *Legenda aurea*, ed. Theodor Graesse, 3rd ed. (Breslau, 1890), 771–72. This translation from an abridged edition and translation of the story of Cecilia in the *Golden Legend* in "The Second Nun's Prologue and Tale," ed. Sherry L. Reames, in *Sources and Analogues of the Canterbury Tales*, 504–16.

44. *Passionael Winter Stuck* [Delft? No date], 33.

45. Translation by De Vignay, quoted in Bertha Ellen Lovewell, *The Life of St. Cecilia from Ms. Ashmole 43 and Ms. Cotton Tiberius E. VII* (Boston, 1898), 103.

46. Translation by Caxton, quoted in Lovewell, *The Life of St. Cecilia*, 103.

47. *Leggendario delle vite de' santi*, translated by Nicolo Manerbio (Venice, 1584), 668.

48. *Leyenda de los santos* (Toledo, 1554), fol. 169r.

49. *Der Heiligen Leben*, Winterteil (Strasbourg, 1521), fol. 68r.

50. For versions of the Cecilia legend in Middle English, see Lovewell, *The Life of St. Cecilia*, 71–102.

51. See Sherry L. Reames, "The Sources of Chaucer's 'Second Nun's Tale,'" in *Modern Philology* 76 (1978): 111–35, and her further research on related topics.

52. That is, her biography: a reference to the *Golden Legend*?

53. *Canterbury Tales*, modernized version by J. U. Nicolson (Garden City, NY, 1934), 430–31.

54. Juan Luis Vives, *De corruptis artibus*, Antwerp, 1531, book 2, as reprinted in *Ioannis Lodovici Vivis Valentini, de disciplinis libri XX in tres tomos distincti*, Cologne, 1532, 92.

55. *Cecilie viraginis romanae et merito castitatis et fortitudinis in martyrio incomparabilis agon: A. F. Baptista Mantuano Carmelita theologo et poeta cultissimo heroicis versibus dictus* (Paris, 1509), fol. 15v.

56. In Latin quantitative verse, a dactylic hexameter consists of six feet of two or three syllables each: dactyls (long-short-short), spondees (long-long), and—as an alternative to the spondee at the end of a line—trochees (long-short). The word *organis* cannot be used in this meter because it consists of a short syllable preceded and followed by long syllables.

57. Jean-Pierre Massaut, *Josse Clichtove, l'humanisme, et la réforme du clergé* (Liège, 1968).

58. Josse van Clichtove, *De laudibus sancti Ludovici regis Franciae. De laudibus sacratissimae virginis et martyris Ceciliae* (Paris, 1516), fol. 55r.

59. I am most grateful to Keith Polk for advice and information on the instruments depicted in the following illustrations and for insight into how they fit into the *bas / haut* dichotomy (email, 5 November 2019).

60. For more on the Lüneburg Retable, see Martin Voigt, *Die St. Johanniskirche in Lüneburg: Der Erzählschatz mittelalterlicher Kirchen* (Berlin, 2012), 59–106.

61. The musicians play a lute, an organ, and an instrument of which Keith Polk has written: "At first sight it would appear that the wind instrument is a shawm, but that is highly unlikely: shawms simply did not perform with soft instruments (*bas instruments*) such as the lute and portative organ at this time. It could possibly be a rather large recorder. Another possibility, and one which I find more intriguing, is that it might be a *douçaine*, a relative of the shawm, but with a gentler timbre" (email, 5 November 2019).

62. Connolly, *Mourning into Joy*, 221–23.

63. Ravenna, Archivio Storico Archivescovile, Antifonario II, fol. 122v. On the Ravenna image—one of the earliest known depictions of Cecilia in the presence of an organ—see Paola Dessì, *Cantantibus organis: musica per i Francescani di Ravenna nei secoli XIII–XIV* (Bologna, 2002), 91–109; and Staiti, *Le metamorfosi*, 18–21.

64. Studium Biblicum Franciscanum, Jerusalem, Antifonario 7 (H); see Nicola Bux, *Codici liturgici latini di Terra Santa / Liturgic Latin Codices of the Holy Land* (Fasano [Brindisi], 1990), 68–78.

65. Fitzwilliam Museum, Cambridge, MS McClean 201, fol. 26, reproduced and discussed in Connolly, *Mourning into Joy*, 222.

66. On the St. Cecilia Altarpiece, see Connolly, *Mourning into Joy*, 202–5; and Barbara Russano Hanning, "From Saint to Muse: Representations of Saint Cecilia in Florence," *Music in Art* 29 (2004): 91–103 (93–96). The final image of the naked Cecilia standing in a cauldron probably inspired Bernardo Daddi's *Martyrdom of St. Cecilia* (Pisa, Museo Nazionale di San Matteo); Lucia Marchi, "For Whom the Fire Burns: Medieval Images of Saint Cecilia and Music," *Recercare* 27 (2015): 5–22 (14–15), points out the similarity of the two images and reproduces the latter.

67. Laura Weigert, *Weaving Sacred Stories: French Choir Tapestries and the Performance of Clerical Identity* (Ithaca, NY, 2004), 1.

68. Philippe Guignard, *Mémoires fournis aux peintres chargés d'exécuter les cartons d'une tapisserie destinée à la Collégiale St-Urbain de Troyes, représentant les légendes de St Urbain et de Ste Cécile* (Troyes, 1851); Tina Kane, *The Troyes Mémoire: The Making of a Medieval Tapestry* (Woodbridge, 2010).

69. Transcription and translation from Kane, *The Troyes Mémoire*, 82–83. Passages in square brackets are emendations in the manuscript or in copy notebooks preserved with the manuscript.

70. Transcription and translation from Kane, *The Troyes Mémoire*, 82–83.

71. Transcription and translation from Kane, *The Troyes Mémoire*, 84–85.

72. On the Bologna frescoes, see David J. Drogin, "Art, Patronage, and Civic Identities in Renaissance Bologna," in *The Court Cities of Northern Italy*, ed. Charles M. Rosenberg (New York, 2010), 244–324 (271–73, with references to the earlier literature).

CHAPTER TWO

1. GB-Lbl Stowe MS 12, fol. 332r, online at https://www.bl.uk/catalogues/illuminatedmanuscripts/ILLUMIN.ASP?Size=mid&IllID=15835.

2. For example, the illustration of St. Etheldreda (fol. 256v) is almost identical.

3. Online at https://upload.wikimedia.org/wikipedia/commons/8/8c/Lamgods _open.jpg.

4. Julien Chapuis, *Stefan Lochner: Image Making in Fifteenth-Century Cologne* (Turnhout, 2004).

5. Philadelphia Museum of Art; online at https://www.philamuseum.org/collection/object/102554.

6. Art Institute of Chicago; online at https://www.artic.edu/artworks/16336/triptych-of-the-virgin-and-child-with-saints.

7. Ann M. Roberts, "The City and the Convent: *The Virgin of the Rose Garden* by the Master of the Legend of Saint Lucy," *Bulletin of the Detroit Institute of Arts* 72 (1998): 56–65, accepts the attribution, dates the painting "before 1483," discusses the depiction of Bruges in the background, and argues that it was painted for the Convent of St. Catherine in Bruges.

8. On the illustration of Cecilia in the Hours of Catherine of Cleves, see Joni M. Hand, *Women, Manuscripts and Identity in Northern Europe, 1350–1550* (Abingdon, 2013), 86–88. A closely related (but more crudely painted) image of Cecilia holding a falcon appears in the historiated initial *M* in *Me expectaverunt peccatores*, introit for the Cecilia's Day Mass in the Missal of Eberhard von Greiffenklau (Walters Art Museum, MS. W174, fol. 217v.), online at https://www.thedigitalwalters.org/Data/WaltersManuscripts/W174/data/W.174/sap/W174_000440_sap.jpg.

9. Illustrated and discussed in Connolly, *Mourning into Joy*, 214–17; and Staiti, *Le metamorfosi*, 20.

10. Rudolf, "Cologne, Convents, Commissions and the Cult of St. Cecilia."

11. William Martin Conway, *The Woodcutters of the Netherlands in the Fifteenth Century* (Cambridge, 1884), 117–21, 277, attributes this woodcut to "The Second Delft Woodcutter."

12. *La légende dorée en françois* (Paris, 1496), fol. cclvii; accessible online at https://gallica.bnf.fr/ark:/12148/btv1b8604292q/f523.item.r=légende%20dorée.

13. Joachim M. Plotzek, *Andachtsbücher des Mittelalters aus Privatbesitz* (Cologne, 1987), 219; "Chapitre noble de Sainte Gertrude, à Nivelles," in *Annuaire de la noblesse de Belgique* 3 (1849), 252–94 (254). Although this source places the abbess's death on 3 November 1480, the transcriber probably misread the last digit, since Marguerite's successor was elected on 14 January 1490.

14. British Library, Add. Ms. 18851, fol. 491v, online at http://www.bl.uk/manuscripts/Viewer.aspx?ref=add_ms_18851_fs001r. Isabella's ambassador Francisco de Rojas commissioned this manuscript and gave it to her in acknowledgment of the marriages of her children to those of Emperor Maximilian of Austria. Since the nuptial agreement was finalized in 1495 and the weddings took place in 1496 and 1497, the manuscript was probably made between 1495 and 1497. See Bodo Brinkmann, *Die Flämische Buchmalerei am Ende des Burgunderreichs: Der Meister des Dresdener Gebetbuchs und die Minaturisten seiner Zeit*, 2 vols. (Turnhout, 1997), *Textband*, 131–43; and Scot McKendrick et al., *The Isabella Breviary: The British Library, London, Add. Ms. 18851* (Barcelona, 2012).

15. On the Mayer van den Bergh Breviary (including discussion of its date, collaborating artists, and original owner), see Brigitte Dekeyzer, *Layers of Illusion: The Mayer van den Bergh Breviary* (Ghent, 2004). Dekeyzer (p. 87) attributes the miniature of Cecilia to the Maximilian Master, active between about 1475 and 1515.

16. Paula Pumplin, "The Communion of Saints: The Master of the Virgin inter Virgines' Virgin and Child with Saints Catherine, Cecilia, Barbara and Ursula," *The Rijksmuseum Bulletin* 58 (2010): 306–27.

17. According to Jan Piet Filedt Kok, Walter S. Gibson, and Yvette Bruijnen,

Cornelis Engebrechtsz: A Sixteenth-Century Leiden Artist and His Workshop (Turnhout, 2014), 59, Cecilia "must have been a popular saint in Leiden, for she often features among the saints in paintings connected with the Engebrechtsz workshop."

18. Online at https://www.wga.hu/frames-e.html?/html/e/engelbre/cecilia.html.

19. Gemäldegalerie, Berlin; online at https://commons.wikimedia.org/wiki/File: Cornelis_engebrechtsz,_incoronazione_di_spine,_1500-20_ca.JPG.

20. Stedelijk Museum de Lakenhal, Leiden; online at https://www.wga.hu/frames -e.html?/html/e/engelbre/index.html.

21. Davide Daolmi, "Jubal, Pythagoras and the Myth of the Origin of Music, with Some Remarks Concerning the Illumination of Pit (It. 568)," *Philomusica on-line* 16 (2017): 1–42. Online at http://dx.doi.org/10.13132/1826-9001/17.1894.

22. On Musica as iconographic precursor of Cecilia the organist, and a reproduction of another depiction of Musica playing the organ (in the Squarcialupi Codex), see Tilman Seebass, "Lady Music and Her *Protégés*: From Musical Allegory to Musicians' Portraits," *MD* 42 (1988), 23–61; and Marchi, "For Whom the Fire Burns," 19–20.

23. See Maryan W. Ainsworth's catalog entry on the website of the Metropolitan Museum at https://www.metmuseum.org/art/collection/search/437054.

24. On Memling's triptych, see Bernhard Ridderbos, "Objects and Questions," *Early Netherlandish Paintings: Rediscovery, Reception, and Research*, ed. Bernhard Ridderbos et al. (Los Angeles, 2005), 1–172 (136–44).

25. For more on Memling's depictions of musicians and instruments, see Jeremy Montagu, "Musical Instruments in Hans Memling's paintings," *EM* 35 (2007): 505–24.

26. Lesa Mason, "A Late Medieval Cologne Artistic Workshop: The Master of the Holy Kinship the Younger," PhD diss., Indiana University, 1991.

27. Berlin, Staatliche Museen, Kupferstichkabinett, KdZ 641, illustrated in Thomas Kren and Scot McKendrick, *Illuminating the Renaissance: The Triumph of Flemish Manuscript Painting in Europe* (Los Angeles, 2003), 382.

28. B-Gu, fol. 320v, online at https://lib.ugent.be/viewer/archive.ugent.be %3A082FD364-C35A-11DF-A9D6-99EF78F64438#?c=&m=&s=&cv=325&xywh= -176%2C-2224%2C11006%2C11813.

29. Online at https://en.wikipedia.org/wiki/Master_of_the_Saint_Bartholomew _Altarpiece.

30. Charles Dempsey, *Inventing the Renaissance Putto* (Chapel Hill, 2001).

31. *Genie ohne Namen: Der Meister des Bartholomäus-Altars*, ed. Rainer Budde and Roland Krischel (Cologne, 2001).

32. Rudolf, "Cologne, Convents, Commissions and the Cult of St. Cecilia."

33. Connolly, *Mourning into Joy*, 227. On the liturgical context of Massy's illumination (preserved in two duplicate manuscripts, B-Br MS 5646 and 5648), see J. van den Gheyn, *Catalogue des manuscrits de la Bibliothèque Royale de Belgique*, vol. 1 (Brussels, 1901), 398–99. This was not the first depiction of Cecilia with a turban; see plate 11, which also resembles Massy's illumination in its coloring and draftsmanship.

CHAPTER THREE

1. See Ronald F. E. Weissman, "Cults and Contexts: In Search of the Renaissance Confraternity," in *Crossing the Boundaries: Christian Piety and the Arts in Italian*

Medieval and Renaissance Confraternities, ed. Konrad Eisenbichler (Kalamazoo, 1991), 201–20.

2. For a recent survey with up-to-date bibliography, see Sheilagh Ogilvie, *The European Guilds: An Economic Analysis* (Princeton, NJ, 2019); on guilds in the Netherlands, see *Craft Guilds in the Early Modern Low Countries: Work, Power, and Representation*, ed. Maarten Prak et al. (Aldershot, 2006).

3. Paul Trio and Barbara Haggh, "Confraternities in Ghent and Music," in *Musicology and Archival Research*, ed. Barbara Haggh et al. (Brussels, 1994), 44–90 (46–47).

4. Kristine K. Forney, "The Role of Secular Guilds in the Musical Life of Renaissance Antwerp," in *Musicology and Archival Research*, 441–61; and Alfons K. L. Thijs, "Religion and Social Structure: Religious Rituals in Pre-Industrial Trade Associations in the Low Countries," in *Craft Guilds in the Early Modern Low Countries*, chapter 6, clearly document the preference of guilds in the Netherlands for male patron saints. On the role of women in medieval and Renaissance guilds, see Clare Crowston, "Women, Gender, and Guilds in Early Modern Europe: An Overview of Recent Research," *International Review of Social History* 53 (2008), supplement: 19–44; and Merry E. Wiesner-Hanks, "Guild Members and Guilds," in *Women and Gender in Medieval Europe: An Encyclopedia*, ed. Margaret Schaus (New York, 2006), 337–38.

5. J. G. R. Acquoy, "Een damesgild tot het houden van een jaarlijkschen maaltijd," in *Handelingen en mededeelingen van de Maatschappij der Nederlandsche Letterkunde te Leiden, over het jaar 1887* (Leiden, 1887): 72–83. During one of its "rice pudding feasts" in 1576, the Confraternity of Our Lady in Antwerp consumed 216 pounds of rice, 65 pounds of sugar, and 655 pots of milk, according to Hadewijch Masure, "'And Thus the Brethren Shall Meet All Together': Active Participation in Antwerp Confraternities, c. 1375–1650," in *Antwerp in the Renaissance*, ed. Bruno Blondé and Jeroen Puttevils (Turnhout, 2020), 107–29, fig. 6.

6. Anne-Laure van Bruaene and Sarah van Bouchaute, "Rederijkers, Kannenkijkers: Drinking and Drunkenness in the Sixteenth- and Seventeenth-Century Low Countries," *Early Modern Low Countries* 1 (2017): 1–29; online at http://hdl.handle.net/1854/LU-8526705.

7. Among many studies of the role of confraternities in Franco-Flemish music of the late Middle Ages and Renaissance, see Albert Smijers, "Music at the Illustrious Confraternity of Our Lady at 's-Hertogenbosch from 1330 to 1600," *Papers Read by Members of the American Musicological Society at the Annual Meeting*, 1939, 184–92; Albert Smijers, "Meerstemmige muziek van de Illustre Lieve Vrouwe Broederschap te 's-Hertogenbosch," *TVNM* 16 (1940–46): 1–30; Kristine K. Forney, "Music, Ritual, and Patronage at the Church of Our Lady, Antwerp," *EMH* 7 (1987): 1–57; Rob Wegman, "Music and Musicians at the Guild of Our Lady in Bergen op Zoom, c. 1470–1510," *EMH* 9 (1990): 175–249; Trio and Haggh, "Confraternities in Ghent and Music"; Véronique Roelvink, *Gegeven den sangeren: Meerstemmige muziek bij de Illustre Lieve Vrouwe Broederschap te 's-Hertogenbosch in de zestiende eeuw* ('s-Hertogenbosch, 2002); Robert Nosow, *Ritual Meanings in the Fifteenth-Century Motet* (Cambridge, 2012); Véronique Roelvink, *Gheerkin de Hondt: A Singer-Composer in the Sixteenth-Century Low Countries* (Utrecht, 2015), 195–217; and Sarah Ann Long, *Music, Liturgy, and Confraternity Devotions in Paris and Tournai, 1300–1550* (Rochester, NY, 2021).

8. Julie E. Cumming, "From Chapel Choirbook to Print Partbook and Back Again," in *Cappelle musicali fra corte, stato e chiesa nell'Italia del rinascimento*, ed. Franco Piperno et al. (Florence, 2007), 373–403 (388). See also Jonathan Glixon,

"Singing Praises to God: Confraternities and Music," in *Companion to Medieval and Early Modern Confraternities*, ed. Konrad Eisenbichler (Leiden, 2019), 329–44.

9. Forney, "The Role of Secular Guilds," 445.

10. Forney, "The Role of Secular Guilds," 445–48.

11. Reinhard Strohm, *Music in Late Medieval Bruges*, 2nd ed. (Oxford, 1990), 57; Nosow, *Ritual Meanings*, 127–28.

12. Barbara Haggh, "The Meeting of Sacred Ritual and Secular Piety: Endowments for Music," in *Companion to Medieval and Renaissance Music*, ed. Tess Knighton and David Fallows (London, 1992), 60–68; "Foundations or Institutions? On Bringing the Middle Ages into the History of Medieval Music," *Acta musicologica* 68 (1996): 87–128; "The Aldermen's Registers as Sources for the History of Music in Ghent," in *"La la la . . . Maitre Henri": Mélanges de musicologie offerts à Henri Vanhulst*, ed. Christine Ballman and Valérie Dufour (Turnhout, 2009), 27–54.

13. Andrew Brown, *Civic Ceremony and Religion in Medieval Bruges c. 1300–1520* (Cambridge, 2011), 105. On motets stipulated by endowments in Bruges, see Strohm, *Music in Late Medieval Bruges*; Douglas Salokar, "'Ad augmentationem divini cultus': Pious Foundations and Vespers Motets in the Church of Our Lady in Bruges," in *Musicology and Archival Research*, 306–25; Julie E. Cumming, *The Motet in the Age of Dufay* (Cambridge, 1999), 46–47; and Nosow, *Ritual Meanings*, 103–34.

14. Eric Jas, *Piety and Polyphony in Sixteenth-Century Holland: The Choirbooks of St. Peters Church, Leiden* (Woodbridge, 2018), 57–64.

15. Barbara Haggh, "Nonconformity in the Use of Cambrai Cathedral," in *The Divine Office in the Latin Middle Ages*, 372–97; and Nosow, *Ritual Meanings*, 167–200 (including table 7.1, a list of foundations established at Cambrai Cathedral between 1449 and 1476 for the performance of polyphony).

16. Kay Brainerd Slocum, "Confrérie, Bruderschaft and Guild: The Formation of Musicians' Fraternal Organisations in Thirteenth- and Fourteenth-Century Europe," *EMH* 14 (1995): 257–74 (257).

17. Slocum, "Confrérie," 258.

18. Slocum, "Confrérie," 262–74; Howard Mayer Brown: "Minstrels and Their Repertory in Fifteenth-Century France: Music in an Urban Environment," *Urban Life in the Renaissance*, ed. Susan Zimmerman and Ronald F. E. Weissman (Newark, DE, 1989), 142–64; on the guild's activities in the sixteenth century, see François Lesure, "La Communauté des joueurs d'instruments au XVIe siecle," *Revue historique de droit français et étranger* 1 (1953): 79–109.

19. Howard Mayer Brown and Keith Polk, "Instrumental Music, c. 1300–c. 1520," in *Music as Concept and Practice in the Late Middle Ages*, ed. Reinhard Strohm and Bonnie J. Blackburn (The New Oxford History of Music, vol. 3, part 1), 97–161 (104–5) (Oxford, 2001).

20. Trio and Haggh, "Confraternities in Ghent and Music," 58–59.

21. Trio and Haggh, "Confraternities in Ghent and Music," 54–58.

22. But this veneration took place almost completely outside the liturgy as codified in books of hours; of the hundreds of liturgical calendars accessible on the website *Corpus Kalendarium*, only two mention Job and his feast day.

23. Valentin Denis, "Saint Job, patron des musiciens," *Revue belge d'archéologie et d'histoire de l'art* 21 (1952): 253–98; Kathi Meyer-Baer, "St. Job as Patron of Music," *Art Bulletin* 36 (1954): 21–31; Bart Minnen, "De Sint-Martinuskerk van Wezemaal en de cultus van Sint-Job 1000–2000," and Steven Marien and Bart Minnen, "Sint-Job en het muziekleven te Wezemaal," in *Den heyligen Sant al in Brabant: De Sint-Martinuskerk*

van Wezemaal en de cultus van Sint-Job, 1000–2000, ed. Bart Minnen, 2 vols. (Averbode, 2011), vol. 1, 27–348, and vol. 2, 281–99. I am most grateful to Bart Minnen for sending me an English translation of passages related to music in his book.

24. M. Jennifer Bloxam, "In Praise of Spurious Saints: The *Missae Floruit egregiis* by Pipelare and La Rue," *JAMS* 44 (1991): 163–220 (198–212).

25. Minnen, "De Sint-Martinuskerk," chapter 3; Marien and Minnen, "Sint-Job en het muziekleven te Wezemaal."

26. Kristine K. Forney, "16th-Century Antwerp," in *The Renaissance: From the 1470s to the End of the 16th Century*, ed. Iain Fenlon (Basingstoke, 1989), 361–78 (372), citing Godelieve Spiessens, "Geschiedenis van de gilde van de Antwerpse speellieden, bijgenaamd Sint-Job en Sint-Maria-Magdalena (Deel 1: XVIde eew)," *RBM* 22 (1968): 5–50.

27. For the guild's statutes as revised in 1555 (in a French translation of the original Dutch), see Léon de Burbure, *Aperçu sur l'ancienne corporation des musiciens instrumentistes d'Anvers, dite de Saint-Job et de Sainte-Marie-Madeleine* (Brussels, 1862), 12–16.

28. Edmond vander Straeten, *La Musique aux Pays-Bas avant le XIX siècle*, vol. 2 (Brussels, 1872), 22–27; Gilbert Huybens, "Bronnen voor de geschiedenis van het muziekleven te Leuven in de 16e eeuw (1471–1594)," in *Muziek te Leuven in de 16e eeuw*, ed. Gilbert Huybens (Leuven, 1982), 34–37.

29. The translation is by Anna de Bakker, and the annotations are largely based on her comments. I am most grateful to her for her valuable contributions here and elsewhere in this chapter.

30. The passage concerning the non-professional members is obscure, but it seems to require them to pay for the privilege of socializing with the professional members of the guild. The *colve* that the non-professional members had to give annually was some kind of festive event (a banquet?), for which they paid fees to cover the costs of the food and drink; see van Bruaene and van Bouchaute, "Drinking and Drunkenness," 8. De Roose (The Rose) was Leuven's chamber of rhetoric, a lay confraternity devoted primarily to the production of Dutch poetry and drama, much of it probably written under the influence of alcohol.

31. Late medieval guild and confraternity statutes often specify payments and penalties in wax, to be made into candles for the adornment of the organization's altar; see J. Malet Lambert, *Two Thousand Years of Gild Life* (Hull, 1891), 107–17, 205–17.

32. Instrumentalists from Leuven occasionally participated in the Job's Day festivities in Wezemaal, meaning that they were not present in Leuven to celebrate the feast day; see Minnen, "De Sint-Martinuskerk van Wezemaal," chapter 3.

33. Trio and Haggh, "Confraternities in Ghent and Music," 59.

34. pour pryer Dieu et Madamme Saincte Cécile, pour les âmes des trespassez d'icelle connestablie (A. Lacroix, *Souvenirs sur Jacques de Guise, historien du Hainaut; la chambre de rhétorique; la confrérie de Sainte-Cécile, e l'Académie des Beaux-Arts de la ville de Mons* [Mons, 1846], 12–19 [12]; reprinted in Vander Straeten, *La Musique aux Pays-Bas*, vol. 2, 31–36).

35. *Item*, que les maistres de ceste connestablie feront aorner la chapelle de Saincte Cécile, en l'église Monsieur Sainct Germain, dont le jour de ladicte Saincte tous confrères se debveront trouver au logis de l'un des maistres, ou au lieu ordonné, pour par ensemble s'acheminer bien et honestement en ordre à l'église, oyr les vespre et salus, et au lendemain, jour de ladicte Sainte, samblablement se trouver

au lieu désigné, pour aller à la messe et à l'offrande, à peine de chacun deffaillant de deux solz, pour estre converty aux frais de ladicte chapelle et office divin (Lacroix, *Souvenirs*, 12–13).

36. *Item*, que au retour dudict office, ceulx qui voldront compaignier les maistres au disner le polront faire, sans touteffois y estre constrains, en payant leur escot également (Lacroix, *Souvenirs*, 13).

37. *Item*, advenant quelque compaignie de joueurs estrangiers pour jouer quelque nopce ou bancquet en la ville, debveront payer demy droict portant quattre livres chacun, et à leur deffaulte se polront lever leurs instrumens, pour les deux tierchs desdictes quattres livres appertenir à la chapelle, et l'autre aux paurvres de ladicte ville (Lacroix, *Souvenirs*, 14).

38. *Item*, que tous joueurs qui présentement sont demorans en ladicte ville y poldront demorer le reste de leur vie, sans estre subiectz de passer maistrise, saulf doresenavant y seront subiectz tous ceulx qui voldront gaignier leurs vies au jeu d'instrumens, et debveront sçavoir jouer des quattre sortes d'instrumens cy-après, si comme: haulbois, cornet, flutte et violon; et pour passer à maistre debveront sçavoir jouer deux pieces de musicque de chacun instrument susdict, de teles chansons que les maistre auront choisy, payant pour les droictz au proffict de la chapelle huict livres tournois, et à chacun desdictz maistre pour leurs peines, vingt solz tournois (Lacroix, *Souvenirs*, 13–14).

39. *Item*, que tous apprentiers joueurs debveront avant pooir passer maistre, ou jouer avecq maistre, estre deux ans apprenans sur maistres, saulf qu'ilz polront jouer restons et bancquetz avant avoir passé maistrice, et ce sur amende de soixante solz tournois pour chacune fois au profit de ladicte chapelle (Lacroix, *Souvenirs*, 14).

40. Albrecht Dürer, *Records of Journeys to Venice and the Low Countries*, ed. Roger Fry (Boston, 1913), 42.

41. Forney, "Music, Ritual and Patronage," 8–18, 30–40.

42. Léon de Burbure, "Correspondance," *Le Guide Musical* [Brussels] 6 (1860), no. 41 (6 December): [1–2]; Édouard Gregoir, "Notice sur le Carillon, avec des extraits des archives de la cathédrale et de la ville d'Anvers, concernant les ménétriers, les jeux de cloches, etc.," in *Messager des sciences historiques* (Ghent, 1870), 459–74.

43. Forney, "Music, Ritual, and Patronage," table 6 on pp. 30–31; Godelieve Spiessens, "*Zingende kelen moeten gesmeerd worden*: Stedelijke wijnschenkingen, drinkgelden en bieraccijnzen voor de zangers van de Antwerpse hoofdkerk (1530–1681)," in *Musicology and Archival Research*, 411–40.

44. Betaelt de coralen ende den sangers op Sinte-Sesylien dach voor haren wyn, te samen. VII sc. X den. Vleems (published in de Burbure, "Correspondance").

45. I am most grateful to Kristine Forney for sharing with me her unpublished transcriptions and for allowing me to publish them here (in table 3.2).

46. Pour la messe de Saincte Cécile se paie aux chantres 15 liv. t. et leur sont présentées cincq cannes de vin moyennant quoy ilz contentent le célébrant (Simon Le Boucq, *Histoire ecclésiastique de la ville et comté de Valentienne* [Valenciennes, 1844], 197).

47. De Burbure, "Correspondance"; Spiessens, "*Zingende kelen*," 421.

48. The "Feasts of O" ("de feeste van der oo" or "van der O"), on the last seven days of Advent, took their name from the antiphons for the Magnificat sung on those days, which all begin with the exclamation "O."

49. See Guido Marnef, *Antwerp in the Age of Reformation: Underground Protestantism in a Commercial Metropolis, 1550–1577* (Baltimore, 1996); and Peter Arnade,

Beggars, Iconoclasts, and Civic Patriots: The Political Culture of the Dutch Revolt (Ithaca, NY, 2008).

50. Spiessens, "*Zingende kelen*," 420–32.

51. Stadsarchief Antwerpen, Rekenkamer 1912 (Kwytbrieven 1578/1), 2 December 1578, transcribed in Spiessens, "*Zingende kelen*," 434–35, and discussed on p. 423.

52. English translation by Anna de Bakker.

53. Stadsarchief Antwerpen, Privilegekamer 558 (Collegiaal actenboek 1585–1588), fol. 39r-v, transcribed in Spiessens, "*Zingende kelen*," 435–36, and discussed on p. 425.

54. Translation by Anna de Bakker.

55. Cecilia's Day is absent from Appendix 5 ("List of Feasts in Delft") and Appendix 7 ("List of Feasts in Bruges") in Roelvink, *Gheerkin de Hondt*, but both lists include Catherine's Day.

56. Georges van Doorslaer, "Académie Ste-Cécile, société de musiciens amateurs, à Malines au début du XVIII^e siècle," *Bulletin du Cercle archéologique, littéraire et artistique de Malines* 12 (1903), 89–134 (92); later gifts documented in Georges van Doorslaer, *Notes sur les jubés et les maitrises des églises des SS. Pierre et Paul, de St-Jean, de Notre-Dame au dela de la Dyle et de St-Rombaut* (Mechelen, 1906), 22, 33, 57.

57. Roelvink, *Gheerkin de Hondt*, 75.

58. P. A. Leupe, "De sanghers van den Hove enz. in den Haag," in *Bouwsteenen: Eerste jaarboek der Vereeniging voor Nederlandsche Muziekgeschiedenis 1869–1872* ([Amsterdam], n.d.), 72–75; Marinus Godefridus Wildeman, *Aanteekeningen uit de rentmeestersrekeningen der Groote of St. Jacobs-kerk te 's-Gravenhage (1557–1567)* (The Hague, 1896), 114, 153.

59. C. S. Dessing, "De zeven getijden in de St. Jans-Kerk te Gouda," in *Bijdragen voor de Geschiedenis van het Bisdom van Haarlem* 35 (1913): 141–223 and 347–72 (185–86).

60. Smijers, "Meerstemmige muziek," 24; Roelvink, *Gegeven den sangeren*, 59, 73, citing documents published in Bijlage (Appendix) 2, and in Albert Smijers, "De Illustre Lieve Vrouwe Broederschap te 's-Hertogenbosch: Archivalia bijeengebracht door dr. A. Smijers," *TVNM* 13 (1932): 46–100, 181–237; 14 (1932–1935), 48–105; 16 (1940–1946), 63–106, 216; 17 (1948–1955), 195–230; and Roelvink, *Gheerkin de Hondt*, 216, 252.

61. Roelvink, *Gheerkin de Hondt*, 132–34.

62. NL-SH, MS 156, copied no later than 1549; see Roelvink, *Gheerkin de Hondt*, 337, 339–40.

63. Transcribed in Arthur Carolus de Schrevel, *Histoire du Séminaire de Bruges*, vol. 1 (Bruges, 1895), 209.

64. Frans de Potter, *Schets eener Geschiedenis van de Stad Rousselare* (Roeselare, 1875), 212.

65. Betaelt Jehan Sataeingne, nieuwe sanghmeester dezer stede, ende andere sanghers, omme hemlieden te recreerne up Ste Cecilien dach, V lib. par (*Audenaerdsche mengelingen*, ed. Lodewyk van Lerberghe and Jozef Ronsse, vol. 6 [Oudenaarde, 1854], 307).

66. Ruben Suykerbuyk, "The Matter of Piety: Material Culture in Zoutleeuw's Church of Saint Leonard (c. 1450–1620)," PhD diss., Universiteit Gent, 2017, 242, quotes the first mention of Cecilia's Day payments, dated 1559, as follows: "Betaelt den sanghers op Sinte Cecilien dach 15 st." See also Ruben Suykerbuyk, *The Matter*

of Piety: Zoutleeuw's Church of Saint Leonard and Religious Material Culture in the Low Countries (c. 1450–1620) (Leiden, 2020), 190–91.

67. Vander Straeten, *La Musique aux Pays-Bas*, vol. 1, 133, quotes the following from the "comptes communaux": "Betaelt de Cecilianisten, die up Ste Cecilien dach in recreatie van heerlieder feeste toegheleyt was, by scepenen, twee tonnen stoobancx vj lib. xvj s."

68. V. Fris, *Uittreksels uit de Stadsrekeningen van Geeraardsbergen, van 1475 tot 1658* (Gent, 1912), 59, 61, 96; see also Jan Coppens, "Cecilia in de Processie van Plaisance," *Gerardimontium* 2004, 24–33 (25). The documents are in Rijksarchief Gent, Oud Gemeentearchief; thanks to Jan Coppens (email, 21 September 2020) for this archival citation.

69. Betaelt den musiciennen up den dach van Ste Cecilie huerlider feestdach, hemlieden onderlinghe metten priesters recreerende (Fris, *Uittreksels*, 96).

70. Minnen, "De Sint-Martinuskerk," chapter 2.

71. Gustave Caullet, *Musiciens de la Collégiale Notre-Dame à Courtrai d'après leurs testaments* (Courtrai, 1911), 34.

72. Joannes van Loo, *Carmen Caecilianicum*, in *Iacobi Sluperii, Herzelensis, Flandri, poemata* (Antwerp, 1575), 310–13, cited in Pevernage, *Cantiones sacrae*, ed. Hoekstra, part 3, xv. Van Loo may have coined the unnecessary adjective *Caecilianicus*; I have found no other instance of its use.

73. The Cumaean Sibyl was a mythical priestess with oracular powers who, according to Ovid, lived a thousand years.

74. On van Roo's employment in Innsbruck, see Peter Tschmuck, "The Court's System of Incentives and the Socio-Economic Status of Court Musicians in the Late 16th Century," *Journal of Cultural Economics* 25 (2001): 47–62, table 3.

75. Van Roo chose this letter presumably to honor Cecilia, but also because more Latin words begin with *C* than any other letter. See the numbered word lists for each letter of the Latin alphabet on the website Latdict: https://latin-dictionary.net.

76. Gerard van Roo, *Convivium cantorum* (Munich, 1585), lines 22–26. The goat is the constellation Capricorn, which the sun entered in mid-December, about three weeks after Cecilia's Day; Clement and Chrysogonus are Cecilia's companions because their feast days (23 and 24 November) fall directly after hers. Bernard Joseph Docen, "Das Fest der Heiligen Cäcilia," *Münchener allgemeine Musik-Zeitung* 1828, cols. 633–34, quoted these and the following lines as evidence of an early musical celebration of Cecilia's Day.

77. Van Roo, *Convivium cantorum*, lines 192–99. In my translation I have been unable to account for the words "cantataque concio credi."

78. Julien Loth, *La Cathédrale de Rouen: Son Histoire, sa description* (Rouen, 1879), 53.

79. Amand Collette, *Histoire de la maîtrise de Rouen*, part 1 (Rouen, 1892), 76–77.

80. Dylan Reid, "Moderate Devotion, Mediocre Poetry and Magnificent Food: The Confraternity of the Immaculate Conception of Rouen," *Confraternitas* 7 (1996), 3–10; Dylan Reid, "The Virgin and Saint Cecilia: Music and the Confraternal Puys of Rouen." *Confraternitas* 8 (1997), 3–7; and Dylan Reid, "Patrons of Poetry: Rouen's Confraternity of the Immaculate Conception of Our Lady," *The Reach of the Republic of Letters: Literary and Learned Societies in Late Medieval and Early Modern Europe*, vol. 1, ed. Arjan van Dixhoorn and Susie Speakman Sutch (Leiden, 2008), 33–78.

81. Reid, "The Virgin and Saint Cecilia," 6, citing court documents dated 17 November 1574 in the Bibliothèque Municipale de Rouen.

82. Elizabeth C. Teviotdale, "The Invitation to the Puy d'Évreux," *CM* 52 (1993): 7–26 (7), citing documents earlier transcribed in *Puy de musique érigé à Évreux, en l'honneur de madame sainte Cécile*, ed. Théodose Bonnin and Alphonse Chassant (Évreux, 1837), 1–37. The contents of many of the documents published by Bonnin and Chassant are summarized in William Henry Husk, *An Account of the Musical Celebrations of St. Cecilia's Day in the Sixteenth, Seventeenth and Eighteenth Centuries* (London, 1857), 113–31.

83. Dieu le Créateur, premier autheur des sciences, ayant donné aux hommes l'invention de l'art de musique, a démonstré qu'il en vouloit estre servy et honoré, ayant eu agréable les louanges et cantiques chantez à son nom et touchez des instruments de musique par les enfans d'Israël deslivrez de la tyrannye de Pharaon. Ce que congoissant le Roy et prophète Dauid, il enhorte ung chacun des fidèles serviteurs de Dieu de la louer et magnifier par le son et armonye du psaltérion, de la harpe et des orgues. Et luy mesme, en a donné exemple, lorsque, marchant deuant l'arche de Dieu, il touchoit la harpe par le son de laquelle Dieu avoit plusieurs foys auparavant faict cesser les tourmentz que Saul souffroit du mauvays esprit, à l'imitation de luy et des peres aucuns, tant de la loy de nature, que de la loy escripte. Plusieurs sainctz personnages de la loy de grace, tant hommes que femmes, ont donné louange à Dieu et à son filz JÉSUS-CHRIST nostre Saulveur, par les armonieux accordz de la musique, tant instrumentalle que de la voix, et entre aultres madame saincte Cécille, vierge et martire, en l'honneur de Dieu, et soubz l'invocation de laquelle, en plusieurs endroitz de la chrétienté, ont esté faictes plusieurs belles fondations par les zélateurs du service de Dieu, amateurs de l'art de musique, qui, tous les ans au jour et feste de lad. vierge, chantent motetz, hymnes et louanges à Dieu le Créateur et à elle. Ce que considérans vénérables personnes, les chantres et clercz de sepmaine de l'église cathédral Nostre-Dame d'Euvreux, meuz de dévotion et du désir qu'ilz ont, que le service d'icelle église soit honorablement entretenu, comme il a esté cy devant, et pour inviter ceulx qui viendront aprèz eulx à mettre péne d'aprendre led. art de musique et se rendre dignes de servir en icelle église, en l'honneur de Dieu et édification du peuple, ilz ont aduisé et délibéré entre eulx et aulcun dévotz et notables habitans de cested. ville (soubz le bon plaisir toutesfoys de messieurs de chapitre), de fonder et establir, à tousiours par chacun an, ung service en l'honneur de Dieu, au jour et feste de lad. saincte, en la forme et manière et aux moyens qui ensuivent (*Puy de musique*, 1–2).

84. Le vingt-troisiesme jour de novembre, par chacune année à venir, lendemain de lad. feste et solemnité . . . sera célébré un Puy ou concertation de musique en la maison des enfantz de choeur dud. lieu. Auquel Puy seront receuz motetz latins, à cinq parties et deux ouvertures, dont le texte sera à l'honneur de Dieu ou collaudation de lad. vierge, et sera délivré au meilleur motet l'orgue d'argent, et au débatu qui et le meilleur d'après, la harpe d'argent. Item, seront receues chansons à cinq parties, à tel dict qu'il plaira au facteur, hors texte scandaleux partout. La meilleure aura pour loyer le lut d'argent; celle qui fera le débatu, la lyre d'argent. L'air à quatre parties trouvé le plus agréable, sera gratifié du cornet d'argent. La meilleure chanson légère-facescieuse, aussi à quatre parties seulement, emportera la flutte d'argent. Au plus excellent sonnet chrestien françoys, faict à deux overtures, sera donné le triomphe de la Cécile, enrichy d'or, qui est le plus grand prix (quoted in the original and in translation, used here, in Teviotdale, "Le Puy d'Évreux," 7–8, 23).

85. Item, affin que l'exercice dud. Puy ne soit ignoré des compositeurs musiciens, tant de ce royaume que de circonvoisins, sera, par led. prince et trésorier, faict

imprimer le nombre de deux cens attaches ou affiches, en la maison d'Adrian Le Roy, imprimeur du Roy, demeurant à Paris, au Mont Sainct-Hilaire, enseigne du Mont-Parnasse, lequel a pardevers luy le moulle de la figure de Scte. Cécille, ordonné à cest effect.

Et pour ce qu'il est très-séant et nécessaire pour la décoration dud. Puy, de faire, par chacun an, nouvelles invitations aux musiciens, le prince, en son année, aura Ie soing d'employer quelque gentil esprit à composer nouvelles semonces, en latin et françois, comme le motet est latin et la chanson françoise. Lesquelles il fera délivrer correctes et en temps opportun aud. Adrian Le Roy, pour de bonne heure les imprimer et les envoyer aux maistres musiciens des villes prochaines et eslongnées, qui par ce moyen seront advertis de la célébration et continuation dud. Puy (quoted in the original and in translation, used here, in Teviotdale, "Le Puy d'Évreux," 8–9).

86. Teviotdale, "Le Puy d'Évreux," 20–22, lists all prize-winning composers and works.

87. Bruno Petey-Girard, "Dorat, Henri III et la Confrairie de Saincte Cécile," in *Jean Dorat: Poète humaniste de la Renaissance*, ed. Christine de Buzon and Jean-Eudes Girot (Geneva, 2007), 95–113.

88. Chacun an le vingtuniesme jour de Novembre, vigille de saincte Cécile, s'assembleront lesdictz confreres, pour assister à vespres et complies qui se diront solonnellement en ladicte église des Augustins, avec la Musique et Orgues, et ainsi qu'il sera advis par le superintendant, qui en prendra la charge et conduicte.

Et le lendemain et feste saincte Cécile, se celebrera, aussi solonnellement, und grande Messe, avec la Musique et les Orgues, auparavant laquelle sera faicte procession autour dudit monastère des Augustins, et sera baillé à chacun desdictz confreres, un cierge blanc qui sera presenté a l'offrande, et se feront telles prières, et à mesme intention que dessus: comme aussi se diront le dict jour, Vespres et Complies solonnellement.

Après lesquels Vespres et Complies, se diront Vigiles de morts, speciallement à l'intention des confreres decedez, et le lendemain un obit solennel à mesme fin.

E pour obvier au desordre et confusion qui pourrait intervenir en ces prieres solennelles, mesme en la Musique, et Orgues: aucun Musicien, quel qu'il soit, ne sera receu pour chanter en ladicte assemblee, s'il n'est devant appellé et invité à ce faire par ledit superintendant, qui pareillement deleguera tel qu'il advisera pour toucher lesdictes Orgues ("Curiosités musicales (1): Confrairies de Sainte-Cécile," *Gazette Musicale de Paris* 2 [1835]: 133–35).

89. Nicolas Soret, *La Céciliade, ou Martyre sanglant de Saincte Cécile, patrone des musiciens* (Paris, 1606), unpaginated preface. The author and composer, addressing the dean and canons of Notre Dame, refer to Blondet's choruses as having been written "in place of the Cecilian concert, cancelled this year in your church because of the mortal danger posed by public gatherings during the epidemic" (au lieu du concert Cecilien: intermis cette année en vostre Eglise, à cause des assemblées publiques mortellement dangereuses en l'epidimic danger).

CHAPTER FOUR

1. Allan W. Atlas, "A Note on Isaac's *Quis dabit capiti meo aquam*," *JAMS* 27 (1974): 103–10, points out that in the manuscript I-Rvat, CG XIII.27, Isaac's lament on the death of Lorenzo de' Medici, who died in 1492, was retexted at an unknown date with the Cecilian responsories *Cantantibus organis* and *Domine Jesu Christe*; those

texts were subsequently erased and the original text restored. *Puram Christo te de-disti*, addressed to Cecilia and preserved in a manuscript copied around 1500, is not a motet but a devotional song in two voices, with homophonic texture and a refrain in which Latin and Dutch alternate.

2. On the advent of music printing in Venice and Paris, see Richard Freedman, *Music in the Renaissance* (New York, 2013), 158–63.

3. I-Bc, Q.27 part 2, fol. 10v–11r. On the manuscript, see *The Medici Codex of 1518*, ed. Edward E. Lowinsky, 3 vols. (Chicago, 1968), I, 151.

4. For a concise survey of music printing in the Netherlands in the sixteenth century, with many bibliographic citations, see Kristine K. Forney, "The Netherlands, 1520–1640," in *European Music, 1520–1640*, ed. James Haar (Woodbridge, 2006), 246–79 (250–52).

5. Guido Persoons, "Joannes I Bogardus, Jean II Bogard en Pierre Bogard als muziekdrukkers te Douai van 1574 tot 1633 en hun betrekkingen met de Officina Plantiniana," *De Gulden Passer* 66–67 (1988–1989): 613–66.

6. *Liber primus sacrarum cantionum quatuor et quinque vocum* (Leuven, 1568); see Henri Vanhulst, *Catalogue des éditions de musique publiées à Louvain par Pierre Phalèse et ses fils, 1545–1578* (Brussels, 1990).

7. *Mottetti de' diversi autori in lode di Santa Cecilia a 3, 4, 5, 6, e 7 voci*; see Cesarino Ruini, "Edizioni musicali perdute e musicisti ignoti nella *Notitia de' contrapuntisti e compositori di musica* di Giuseppe Ottavio Pitoni," in *Musicologia Humana: Studies in Honor of Warren and Ursula Kirkendale*, ed. Siegfried Gmeinwieser et al. (Florence, 1994), 417–42 (441).

8. Geneviève B. Bazinet, "Pierre Attaingnant's Encyclopedia of Sacred Music: The 1534–1539 Motet Series," PhD diss., McGill University, 2013.

9. M. Jennifer Bloxam, "Plainsong and Polyphony for the Blessed Virgin: Notes on Two Masses by Jacob Obrecht," *JM* 12 (1994): 51–75 (51).

10. Susan Kidwell, "*Gaude virgo Katherina*: The Veneration of St. Katherine in Fifteenth-Century England," *Explorations in Renaissance Culture* 25 (1999), 19–40; Gillian Lucinda Gower, "The Iconography of Queenship: Sacred Music and Female Exemplarity in Late Medieval Britain," PhD diss., University of California, Los Angeles, 2016, 173–241.

11. Cumming, *The Motet in the Age of Dufay*, 83, 187–89; Peter M. Lefferts, "Cantilena and Antiphon: Music for Marian Services in Late Medieval England," *CM* 45–47 (1990): 247–82; David J. Rothenberg, *The Flower of Paradise: Marian Devotion and Secular Song in Medieval and Renaissance Music* (Oxford, 2011); and Gower, "The Iconography of Queenship," 57–120.

12. Wegman, "From Maker to Composer"; Rothenberg, *The Flower of Paradise*, 163–71; Hatter, *Composing Community*. For a list of motets "for and about musicians" composed between 1450 and 1505, mostly addressed to Mary, and further discussion of Compère's *Omnium bonorum plena*, see Hatter, *Composing Community*, 54, 62–74.

13. On Mouton's motets for female saints, see Michael Alan Anderson, *St. Anne in Renaissance Music: Devotion and Politics* (Cambridge, 2014); and Aimee E. Gonzalez, "Piety, Patronage, and Power: Venerating St. Katherine of Alexandria and St. Margaret of Antioch in the Court of Anne of Brittany (1477–1514)," master's thesis, University of Florida, 2015.

14. Lowinsky, *The Medici Codex of 1518*.

15. Bazinet, "Pierre Attaingnant's Encyclopedia of Sacred Music," 71, 272.

16. On the motet's contested place between Catholicism and Protestantism, see

Patrick Macey, "Josquin as Classic: *Qui habitat, Memor esto*, and Two Imitations Unmasked," *JRMA* 118 (1993), 1–43; David Crook, "The Exegetical Motet," *JAMS* 68 (2015): 255–316; Aaron James, "Transforming the Motet: Sigmund Salminger and the Adaptation and Reuse of Franco-Flemish Polyphony in Reformation Augsburg," PhD diss., Eastman School of Music, 2016; Eagen, "The Articulation of Cultural Identity"; and Christian Thomas Leitmeir, "Beyond the Denominational Paradigm: The Motet as Confessional(ising) Practice in the Later Sixteenth Century," in *Mapping the Motet in the Post-Tridentine Era*, ed. Esperanza Rodríguez-García and Daniele V. Filippi (Abingdon, 2019), 154–92; for wider views, see Freedman, *Music in the Renaissance*, 193–215; and Chiara Bertoglio, *Reforming Music: Music and Religious Reformations of the Sixteenth Century* (Berlin, 2017).

17. Ellen S. Beebe, "The Repertoire of Brussels, Bibliothèque du Conservatoire Royal, MS 27088," in *Beyond Contemporary Fame*, 57–88.

18. On the date of the first edition of Palestrina's *Motecta festorum totius anni*, see chapter 7, note 4.

19. Jennifer Thomas, "The Core Motet Repertory of 16th-Century Europe: A View of Renaissance Musical Culture," in *Essays on Music and Culture in Honor of Herbert Kellman*, ed. Barbara Haggh (Paris, 2001), 335–76. I thank Jennifer Thomas (email, 4 March 2019) for her insightful comments on the place of works addressed to saints in the core repertory.

20. *Liber primus [secundus, tertius, etc.] ecclesiasticarum cantionum quatuor vocum [and quinque vocum] vulgo moteta vocant, tam ex Veteri quam ex Novo Testamento, ab optimis quibusque huius aetatis musicis compositarum* (Antwerp, 1553).

21. Crook, "The Exegetical Motet," 289.

22. Thanks again to Jennifer Thomas for directing my attention to this contrafactum.

23. Susan Jackson, "Berg and Neuber: Music Printers in Sixteenth-Century Nuremberg," PhD diss., City University of New York, 1998, 104–5.

24. Bonnie J. Blackburn, *Music for Treviso Cathedral in the Late Sixteenth Century: A Reconstruction of the Lost Manuscripts 29 and 30* (London, 1987), 8–9, 85–93

25. Stanley E. Weed, "Venerating the Virgin Martyrs: The Cult of the 'Virgines Capitales' in Art, Literature, and Popular Piety," *SCJ* 41 (2010): 1065–91. On the late medieval cults of Catherine and Barbara in the Netherlands and France, see Long, *Music, Liturgy, and Confraternity Devotions*, 14–106.

26. Bazinet, "Pierre Attaingnant's Encyclopedia of Sacred Music," 243.

27. Nosow, *Ritual Meanings*, 124–27.

28. I have identified 24 sixteenth-century motets for Barbara, 40 for Catherine, and 94 for Cecilia. (Not included in those numbers are works published or copied under liturgical designations such as introit or antiphon.) On motets for Catherine, see Edward Wickham's liner notes for his recording *O Gemma Clarissima: Music in Praise of St. Catherine* (Resonus Classics, 2019); for more on Barbara's cult and music written for her, see Anthony M. Cummings, "The Motet," in *European Music, 1520–1640*, 130–56 (148–56); and Aaron James, "*Salve regina Barbara*: The Adaptation and Reuse of Marian Motets," *EM* 45 (2017): 217–30. I am most grateful to Edward Wickham and Aaron James for help in assembling lists of motets in honor of Catherine and Barbara.

29. *Modulorum Ioannis Maillardi . . . primum volumen* [and *secundum volumen*] (Paris, 1565).

30. Ferer, "Thomas Crecquillon and the Cult of St. Cecilia," 129–30.

31. Ferer, "Thomas Crecquillon and the Cult of St. Cecilia," 132–33, focusing attention on the Netherlands, points to Leuven, Antwerp, and Kortrijk as cities characterized by "particular devotion to St. Cecilia."

32. On the chapel of Charles V, see Joseph Schmidt-Görg, *Nicolas Gombert, Kapellmeister Kaiser Karls V.: Leben und Werk* (Bonn, 1938); Homer Rudolf, "The Life and Works of Cornelius Canis," 80–153; *The Empire Resounds: Music in the Days of Charles V*, ed. Francis Maes (Leuven, 1999); Mary Tiffany Ferer, *Music and Ceremony at the Court of Charles V: The* Capilla Flamenca *and the Art of Political Promotion* (Woodbridge, 2012); and Mary Ferer, "Gombert, Thiebault, Crecquillon, Canis, Payen, and the Chapel of Charles V," *EM* 42 (2014): 191–206.

33. Ferer, *Music and Ceremony*, 108, 121.

34. Vi sono cantori, al numero forse di quaranta, la piu compita et eccelente cappella della Cristianità, eletti da tutti i paesi bassi, che sono hoggidì il fonte della musica (quoted in Leopold Ranke, *Fürsten und Völker von Süd-Europa im sechzehnten und siebzehnten Jahrhundert* [Hamburg, 1827], 141).

35. Antoine Lecocq (also spelled Antonius Coquus), listed as a singer in the Hapsburg chapel in 1547–1548, may be the musician elsewhere referred to as Antonius Galli (see Rudolf, "The Life and Works of Cornelius Canis," 126; and Ferer, *Music and Ceremony*, 108).

36. Ham, "Thomas Crecquillon in Context," 90–93; Ferer, "Thomas Crecquillon and the Cult of St. Cecilia."

37. For further discussion of the court of Charles V as an environment that favored the composition of Cecilian music, see Rudolf, "St. Cecilia, Patron Saint of Music," 7–9; and Ferer, "Thomas Crecquillon and the Cult of St. Cecilia," 110–11.

38. Rudolf, "The Life and Works of Cornelius Canis," 206–8; Rudolf, "Saint Cecilia, Patron Saint of Music," 8; Ferer, *Music and Ceremony*, 198.

39. Eagen, "The Articulation of Cultural Identity," 124.

40. Bruno Bouckaert, "The *Capilla Flamenca*: The Composition and Duties of the Music Ensemble at the Court of Charles V, 1515–1558," in *The Empire Resounds*, 37–45 (41). On Mary as patron of music, see Glenda Goss Thompson, "Mary of Hungary and Music Patronage," *SCJ* 15 (1984): 401–18; Péter Király, "Königin Maria von Habsburg und die Musik," in *Maria von Ungarn (1505–1558): Eine Renaissancefürstin*, ed. Martina Fuchs and Orsolya Réthelyi (Münster, 2007), 363–79.

41. Beebe, "The Repertoire of Brussels, Bibliothèque du Conservatoire Royal, MS 27088"; see also Douglas Kirk, "A Tale of Two Queens, Their Music Books, and the Village of Lerma," in *Pure Gold: Golden Age Sacred Music in the Iberian World*, ed. Tess Knighton and Bernadette Nelson (Kassel, 2011), 79–92. I thank Ellen S. Beebe for sending me a copy of the anonymous *Dum aurora* and her transcription of it.

42. Ferer, "Thomas Crecquillon and the Cult of St. Cecilia," 131.

43. On this manuscript, GB-WA B. VI. 23 (of which only two partbooks survive of an original set of eight), see Iain Fenlon, "An Imperial Repertory for Charles V," *SM* 13 (1984): 221–40; and Martin Ham, "The Stonyhurst College Partbooks, the Madrigal Society, and a Diplomatic Gift to Edward VI," *TVNM* 63 (2013): 3–64.

44. Beebe, "The Repertoire of Brussels, Bibliothèque du Conservatoire Royal, MS 27088," 68.

45. Ignace Bossuyt, *De componist Alexander Utendal (ca. 1543/1545–1581)* (Brussels, 1983).

46. Quoted in Vander Straeten, *La Musique aux Pays-Bas*, vol. 7, 183–86; and in Schmid-Görg, *Nicolas Gombert*, 340. For an English translation and commentary, see Rudolf, "The Life and Works of Cornelius Canis," 156–67.

47. F-VAL, MS 182 (*olim* 174), fol. 10v, transcribed in J. Mangeart, *Catalogue déscriptif et raisonné des manuscrits de la Bibliothèque de Valenciennes* (Paris, 1860), 161–62.

48. William F. Prizer, "Charles V, Philip II, and the Order of the Golden Fleece," in *Essays on Music and Culture in Honor of Herbert Kellman*, 161–88 (174–75); Ferer, *Music and Ceremony*, 203–12.

49. Ignace Bossuyt, "Charles V: A Life Story in Music," in *The Empire Resounds*, 83–160 (157–58). The date of composition of *Dum aurora* is unknown; it appeared in print for the first time in Venice in 1589. The other Spanish composer of Cecilian music was Fernando de las Infantas, who spent much of his adult life in Rome. His *Dum aurora finem daret* and *Gloriosa virgo Cecilia* were published in Venice in 1578.

50. Almudena Pérez de Tudela, "Michiel Coxcie, Court Painter," in *Michiel Coxcie 1499–1592 and the Giants of His Age*, ed. Koenraad Jonckeere (London, 2013), 100–115 (98).

51. Karel Philippus Bernet Kempers, "A Composition by Clemens non Papa in a 16th-Century Painting," *MD* 8 (1954): 173–77, first identified this music, as depicted in a related painting displayed at the auction house of Mack van Waay in Amsterdam in 1953.

52. Víctor J. Martínez, "Un virginal en la corte de Filipe," article dated 1 June 2015, online at https://www.instrumentosantiguos.es/un-virginal-en-la-corte-de-felipe-ii; and, on Karest's 1548 virginal, Edward L. Kottick, *A History of the Harpsichord* (Bloomington, IN, 2003), 37–44. I thank Kottick (email, 10 May 2019) for confirming that the instrument in the Prado's painting is indeed a Flemish virginal. The misidentification of the instrument may have resulted from confusion between it and the clavichord depicted in another painting of Cecilia, probably by the Coxcie workshop, likewise performing Clemens non Papa's *Cecilia virgo* but with just two boys, in the Musée des Beaux Arts in Liège, online at http://balat.kikirpa.be/object/10128874. This painting is extremely similar, but I think not quite identical, to the one published by Bernet Kempers in 1954.

53. The literature on this problem is vast. Important contributions include Anthony M. Cummings, "Toward an Interpretation of the Sixteenth-Century Motet," *JAMS* 34 (1981): 43–59; Blackburn, *Music for Treviso Cathedral*, 19–33; John T. Brobeck, "Some 'Liturgical Motets' for the French Royal Court: A Reconsideration of Genre in the Sixteenth-Century Motet," *MD* 47 (1993), 123–57; and Crook, "The Exegetical Motet," with extensive bibliography covering the scholarship on this subject since the publication of Cummings's article.

54. *Puy de musique*, 3.

55. Wright, *Music and Ceremony at Notre Dame of Paris*, 108.

56. In many of these motets, the setting of the text "Virgo gloriosa" constitutes one movement of a work in two parts; see table 5.3.

57. *Puy de musique*, 3.

58. Nosow, *Ritual Meanings*, 122–24; 168–75; Jeffrey Kurtzman, "Motets, Vespers Antiphons and the Performance of the Post-Tridentine Liturgy in Italy," in *Mapping the Motet in the Post-Tridentine Era*, 36–56.

59. *Puy de musique*, 4.

60. Cummings, "Toward an Interpretation of the Sixteenth-Century Motet," 43–59.

61. *Puy de musique*, 4.

62. *Puy de musique*, 4.

63. *Puy de musique*, 4.

64. On Clichtove's endowments (including the text of his will), see Jules-Alexandre Clerval, *De Judoci Clichtovei Neoportuensis . . . vita et operibus* (Paris, 1894), 51–52, 111, 118, 121–23. An early history of printing in Paris quotes the terms of the foundation that Clichtove established during his lifetime: "In Vigilia S. Caeciliae dicuntur Vesperae solemnes de S. Caecilia, ut in duplo unius Virginis & Martyr. Et in die Sanctae Caeciliae dicitur Missa solemnis de eadem, cum memoria pro Sacerdote vivente (Magistro nostro Judoco Clichtoveo) hujus obitus fundatore, Socio Sorbonico. Postquam vero fuerit vita functus (mutabuntur Vespera in) Vigilias novem Lectionum pro Defunctis, Missa eadem manente, &c" (André Chevillier, *L'origine de l'imprimerie de Paris*, [Paris, 1694], 416). The passage quoted by Chevillier does not specify the church in which the services endowed by Clichtove were to be celebrated.

65. Jas, *Piety and Polyphony in Sixteenth-Century Holland*.

66. *Puy de Musique*, 23–24.

67. Victor Coelho and Keith Polk, *Instrumentalists and Renaissance Culture, 1420–1600: Players of Function and Fantasy* (Cambridge, 2016), 173–77; Paul Wiebe, "To Adorn the Groom with Chaste Delights: Tafelmusik at the weddings of Duke Ludwig of Württemberg (1585) and Melchior Jäger (1586)," *Musik in Baden-Württemberg: Jahrbuch 6* (1999): 63–99.

68. Cummings, "Toward an Interpretation of the Sixteenth-Century Motet," 45–46.

69. Not prose, as stated by Don Harrán, whose edition (following Moderne) gives the first two words mistakenly as "Cantantibus organis": Hubert Naich, *Opera omnia*, ed. Don Harrán (Neuhausen, 1983).

70. F-VAL, MS 182 (*olim* 174), fol. 10v.

71. Cantus ID 001747; in many manuscripts the antiphon has "ovis" (sheep) instead of "apis."

72. 1546: lutinis.

73. 1546: ars queque.

74. 1546: drama.

75. 1546: Quidquid vel repperit clarorum ars illa sonorum.

76. 1546: clangere Caeciliae.

77. 1546: sponso.

78. Documents transcribed in Schrevel, *Histoire du Séminaire de Bruges*, 205.

79. This is apparently the first modern edition of this poem, based on Galli's setting as printed in *Motetti del laberinto a quattro voci libro terzo*, Venice, 1554.

80. Hatter, *Composing Community*.

81. On Barbe, see Forney, "Music, Ritual, and Patronage," 47–48.

82. Vissenaecken's *Quatuor vocum musicae modulationes numero xxvi* (RISM 1542[7]); see Forney, "Music, Ritual, and Patronage," 47.

83. B-LVu, MS 1050 (*olim* M4). Forney, in a review of Vanhulst's Phalèse catalog in *RBM* 46 (1992), 249–52, suggests that the works by Turnhout in this manuscript were among those in a printed book of Turnhout's motets published in 1568—an edition of which no copy is known to survive. Was that compilation perhaps a lost gold mine of Cecilian motets for the singers of Antwerp Cathedral?

84. Crecquillon's piece cites part of the Litany as documented in *Processionale*

insignis cathedralis ecclesiae Antverpiensis (Antwerp, 1574); see, in the following chapter, the discussion of Litany chants in Cecilian motets.

85. Auquel Puy seront receuz motetz latins, à cinq parties et deux ouvertures, dont le texte sera à l'honneur de Dieu our collaudation de lad. vierge (*Puy de musique*, 76).

86. *Puy de musique*, 81.

87. Pevernage, *Cantiones sacrae*, ed. Hoekstra, includes further bibliographic references. The following is based on Hoekstra's comprehensive and richly documented introductions to the three volumes. See also Gerald R. Hoekstra, "Andreas Pevernage's *Cantiones Sacrae* (1578) as a Counter-Reformation Statement of Confessional Loyalty in the Low Countries," *SCJ* 44 (2013): 3–24.

88. On the *Cantiones aliquot sacrae* see, in addition to Hoekstra's introductions, Crook, "The Exegetical Motet," 281–91.

89. Albert Dunning, *Die Staatsmottete, 1480–1555* (Utrecht, 1969).

90. On the Confraternity of St. Cecilia in Kortrijk and the music written for the annual election of its princes, see Pevernage, *Cantiones Sacrae*, ed. Hoekstra, part 3, xvii–xx.

91. Translation (slightly altered) from Pevernage, *Cantiones Sacrae*, ed. Hoekstra, part 3, xxxii.

92. Translation from Pevernage, *Cantiones Sacrae*, ed. Hoekstra, part 3, xxxii–xxxiii.

93. Translation from Pevernage, *Cantiones Sacrae*, ed. Hoekstra, part 3, xxxiv, slightly changed here.

94. Pevernage, *Cantiones sacrae*, ed. Hoekstra, part 3, xviii.

95. Translation from Pevernage, *Cantiones Sacrae*, ed. Hoekstra, part 2, xxii–xxiii. Crecquillon and Jan van Turnhout also set this text to music, the former with Saint Christine's name in place of Cecilia's.

96. On so-called *Bildmotetten*, see Thea Vignau-Wilberg, *Niederländische Bildmotetten und Motettenbilder: Multimediale Kunst um 1600* (Altenburg, 2013).

97. F. W. Hollstein et al., *Dutch and Flemish Etchings, Engravings and Woodcuts, ca. 1540–1700*, 32 vols., Amsterdam, 1949–2020, Jan Sadeler No. 305, Martin de Vos No. 1086.

98. The bird at least *looks* like an eagle (a symbol of St. John the Evangelist), though it appears to be feeding its young with its own blood, a practice usually attributed to the pelican (a symbol of charity and self-sacrifice) in Christian iconography.

99. On the place of Liège in the religious conflicts of the sixteenth century, see Henry Dieterich, "Liège in the Reformation: A City without Protestants?," paper read at the Sixteenth Century Studies conference, St. Louis, 1993, and published on Academia.edu.

100. The version attributed to Galle (Plantin-Moretus Museum, PK.OP.13042) is accessible online at https://search.museumplantinmoretus.be/Details/collect/256927; I thank Virginie D'haene, of the museum's print room, for valuable advice (email, 6 February 2019).

101. According to Vignau-Wilberg, *Niederländische Bildmotetten*; see also Hollstein, *Dutch and Femish*, Dolendo No. 45.

102. University of Louisville Library, Ricasoli Collection, Sacred 114.

103. On this diaspora, see Philippe Vendrix, "La tentation munichoise: Sur

l'émigration des musiciens flamands et liégeois durant la seconde moitié du 16e siècle," 2004, online at https://halshs.archives-ouvertes.fr/halshs-00982440/ document.

104. The music, republished in the posthumous *Magnum opus musicum* (Munich, 1604), is available in a scholarly edition in Orlando di Lasso, *The Complete Motets*, ed. Peter Bergquist et al., vol. 21 (Middleton, WI, 2006), 51. On the print, see Hollstein, *Dutch and Flemish*, Jan Sadeler No. 127.

105. A painting of the same image (oil on panel, with the same orientation as that of the print) in the Frans Hals Museum, Haarlem (online at https://commons .wikimedia.org/wiki/File:Peter_de_Witte_-_King_David's_Song_of_Praise_to_God .jpg), has been attributed to Candid, but there is no reason to assume that this is Candid's original; it could just as easily have been copied from the engraving.

CHAPTER FIVE

1. In addition to many studies of music for the Virgin Mary and the articles on Cecilian motets cited in the introduction, see Michael Alan Anderson, "The One Who Comes after Me: John the Baptist, Christian Time, and Symbolic Musical Techniques," *JAMS* 66 (2013): 639–708; Anderson, *St. Anne in Renaissance Music*; James Blasina, "Music and Gender in the Medieval Cult of St. Katherine of Alexandria, 1050–1300," PhD diss., Harvard University, 2015; Catherine A. Bradley, *Polyphony in Medieval Paris: The Art of Composing with Plainchant* (Cambridge, 2018), chapter 6 (on motets for St. Elizabeth of Hungary); Remi Chiu, *Plague and Music in the Renaissance* (Cambridge, 2017), chapter 4 (on motets for St. Sebastian); Mary Tiffany Ferer, "The Feast of St. John the Baptist: Its Background and Celebration in Renaissance Polyphony," PhD diss., University of Illinois, 1976; Gonzalez, "Piety, Patronage, and Power"; James, "*Salve regina Barbara*"; Kidwell, "*Gaude virgo Katherina*"; and Maurey, *Medieval Music, Legend, and the Cult of St. Martin.*

2. *Breviarium Romanum politissimis characteribus excusum*, Paris, 1531, unpaginated ("In festo Sancte Cecilie").

3. *Breviarium Romanum de camera* (Venice, 1550), fol. 408v. The shorter variant is also preserved in *Breviarium Romanum optime recognitum* (Venice, 1558), fol. 374v, *Breviarium alme ecclesie Compostellane* (Salamanca, 1569), fol. 532r, and *Breviarium secundum cursum ecclesiae Curiens[is]* (Augsburg, 1595, 849).

4. On Psalm 118 as a source of motet texts, see Eagan, "The Articulation of Cultural Identity," 166–203.

5. The early Cecilian motet *Gloriosa virgo Cecilia / Dum aurora finem daret* by Pagnier was reprinted several times, usually in the form of two separate single-movement motets. These reprints may have given other composers the idea of using the text *Dum aurora* for motets in one movement.

6. Katelijne Schiltz, *Music and Riddle Culture in the Renaissance* (Cambridge, 2015), 158–59, 448.

7. Although Cecilia's prayer paraphrases Psalm 118:80, Maillard's text is closer to Cecilia's words than to the Psalm; indeed, it is identical to a version of the prayer used in the *Alleluia Cantantibus organis*, as transcribed in ex. 1.6.

8. As pointed out by David Crook in the introduction to his edition (*RRMR* 147).

9. Cristle Collins Judd, "Modal Types and *Ut, Re, Mi* Tonalities: Tonal Coherence in Sacred Vocal Polyphony from about 1500," *JAMS* 45 (1992): 428–67, proposes a division of sixteenth-century polyphony into "three main tonal categories . . . defined and identified by hexachordal function of final" (usually the lowest pitch of a work's

final sonority). *Ut* tonality operates in works with a major third above the final, *Re* tonality in works with a minor third above the final, and *Mi* tonality in works with a minor second and a minor third above the final.

10. Stephanie P. Schlagel, "The *Liber selectarum cantionum* and the 'German Josquin Renaissance,'" *JM* 19 (2002): 564–615.

11. My thanks to Christopher Shaw for telling me of Gallet's *Benedicta es, virgo Cecilia.*

12. Ham, "Thomas Crecquillon in Context," 270–72. The litany chant is documented in *Processionale insignis cathedralis ecclesiae Antverpiensis B. Mariae* (Antwerp, 1574), which "appears to preserve the only surviving remnant of the plainsong tradition of Antwerp," according to Bloxam, "Plainsong and Polyphony," 55. The same formula is recorded in *Processionale, secundum ritum ecclesiae et ordinis Praemonstratensis* (Paris, 1574), fol. 86r–90r; and *Processionale, ritibus Romanae ecclesiae accomodatum* (Antwerp, 1629), 119–23.

13. B-LVu, MS 1050; on this manuscript, see chapter 4, note 83.

14. Crecquillon's work is yet another that uses Antwerp Cathedral's Litany formula; see Ham, "Thomas Crecquillon in Context," 90.

15. Sources for this Litany formula, beside the one used for example 5.10, include *Processionale juxta praxim et usum conventus Tornacensis* (1656), 125, F-Pn, RES VMD MS-59; *Processionale ordinis Cisterciensis* (Paris, 1674), 40; and *Processionale sacri ordinis Praedicatorum* (Paris, 1647), 275. Two slightly different versions of the formula are documented in *Processionale, secundum ritum ecclesiae et ordinis Praemonstratensis*, fol. 294r (beginning and ending on A) and *Processionale, ritibus Romanae ecclesiae accomodatum*, 108 (beginning and ending on C). I thank Barbara Haggh (email, 7 and 10 April 2019) for help in identifying this chant.

16. My thanks to Martin Ham (email, 5 November 2019) for calling my attention to Jan van Turnhout's motet.

17. On Utendal's *Cantantibus organis*, see Ignace Bossuyt, *De componist Alexander Utendal (ca. 1543/1545–1581)* (Brussels, 1983), 115–16; on *Andreas Christi famulus*, see Prizer, "Charles V, Philip II and the Order of the Golden Fleece," 177–78.

18. This third Litany formula is recorded in *Processionale, ritibus Romanae ecclesiae accomodatum*, 114–19.

19. The prevalence of movements with six points is consistent with Peter N. Schubert's findings in his analysis of the thirty-six works in Palestrina's first book of four-voice motets (all in one *pars*), in which he counted a total of 211 points: a mean of 5.86 points per work; see Peter N. Schubert, "Hidden Forms in Palestrina's First Book of Motets," *JAMS* 60 (2007): 483–556 (485).

20. Gallus Dressler, *Præcepta musicæ poëticæ*, edited, translated, and annotated by Robert Forgács (Urbana, IL, 2007).

21. Dressler, *Præcepta*, 173.

22. Dressler, *Præcepta*, 185.

23. Daniele V. Filippi, "Formal Design and Sonic Architecture in the Roman Motet around 1570: Palestrina and Victoria," in *Tomás Luis de Victoria: Estudios / Studies*, ed. Javier Suáres-Pajares and Manuel del Sol (Madrid, 2013), 163–98 (169–72).

24. For a discussion of how three early seventeenth-century composers in Milan responded to the shift to direct quotation in texts beginning "Cantantibus organis," see Kendrick, *The Sounds of Milan*, 173–86.

25. He may have been a relative of the Johannes Bultel who served as a choirboy in the chapel of Charles V; see Ferer, *Music and Ceremony*, 113.

26. Schubert, "Hidden Forms," 529.

27. Reiner Krämer, "The *Supplementum* in Motets: Style and Structure," paper given at the 9th European Music Analysis Conference (Euromac 9); abbreviated version accessible at http://euromac2017.unistra.fr/wp-content/uploads/2017/05/Ext.-Reiner-Krämer.pdf. I thank Krämer for allowing me to read a longer, not-yet-published version of the paper entitled "The *Supplementum* in Renaissance Motets: Style and Structure."

28. Krämer, "The *Supplementum* in Renaissance Motets: Style and Structure," 3.

29. Jessie Ann Owens, *Composers at Work: The Craft of Musical Composition, 1450–1600* (New York, 1997), 251. For a thorough demonstration of the usefulness of the module as a tool in the analysis of sixteenth-century motets, see Schubert, "Hidden Forms."

30. I use "caesura" freely here, in reference to any strongly felt break within a line of poetry. Using the term in a more technical sense, we would call the break between "patrios" and "religiosa" not a caesura but a diaresis. See Maurice Platnauer, *Latin Elegiac Verse: A Study of the Metrical Usages of Tibullus, Propertius and Ovid* (Cambridge, 1951), 4–24. For an insightful discussion of Gombert's response to poetic caesuras in setting elegiac couplets, see Brandi Neal, "The Multivoice Sacred Music of Nicolas Gombert: A Critical Examination," PhD diss., University of Pittsburgh, 2011, 46–52.

31. On the "red herring," see Schubert, "Hidden Forms," 510.

32. Galli's *finis* has some of the features of the galliards published by Attaingnant in his *Six gaillardes et six pavanes* (Paris, 1530), including the time signature ¢3 and the rhythmic group—dotted semibreve-minim-semibreve.

33. These celebratory melismas on *Cantantibus* were later taken over by Italian composers; see, for example, the settings of Bernardino Morelli (1598) and Giovanni Battista Stefanini (1610; excerpt in Kendrick, *Sounds of Milan*, 179–82).

CHAPTER SIX

1. Hanning, "From Saint to Muse," searched in vain for signs of interest (musical and otherwise) in Cecilia in sixteenth-century Florence. She attributed "the paucity of influence of St. Cecilia" to the "powerful male presence of the Medici," under whom "the Florentine pantheon was dominated by male saints." But Cecilia's role in the religious, artistic, and musical life of cinquecento Florence was no smaller than her role in the life of most other Italian cities, and thus requires no explanation based on special Florentine circumstances.

2. Giorgio Vasari, *Delle vite de' piu eccellenti pittori scultori et architettori*, part 3, vol. 1 (Florence, 1586), 67.

3. Linda Wolk-Simon, *Raphael at the Metropolitan: The Colonna Altarpiece* (New York, 2006), 29.

4. Francesco Morone, *Virgin and Child Enthroned between Saints Cecilia and Catherine of Alexandria*, ca. 1510–1515. Metropolitan Museum of Art, New York; online at https://www.metmuseum.org/art/collection/search/461043.

5. Sandra Hindman et al., *Illuminations in the Robert Lehman Collection* (New York, 1997), 182–84.

6. Anonymous triptych in the Museo del Castelvecchio, Verona, variously attributed to Francesco dai Libri and Antonio Badile; online at https://museodicastelvecchio.comune.verona.it/nqcontent.cfm?a_id=44412.

7. Stanisław Mossakowski, "Raphael's 'St. Cecilia': An Iconographical Study,"

Zeitschrift für Kunstgeschichte 31 (1968): 1–26 (19); Mirimonde, *Sainte-Cécile*, 17; Baroncini, "L'immagine di santa Cecilia," 35–45 (37–38); Staiti, *Le metamorfosi*, 30–31. Connolly, *Mourning into Joy*, 223, calls this painting "the best-known and most beautiful image of Cecilia enthralled by angelic music before Raphael's altarpiece."

8. Karl Baedeker, *Italy: Handbook for Travellers* (Third Part: Southern Italy and Sicily), 14th revised edition (Leipzig, 1903), 264; Van der Haagen, *De heilige Caecilia*, 12. Giovanni Travagliato and Mauro Sebastianelli, *Da Riccardo Quartararo a Cristoforo Faffeo: Un capolavoro del Museo Diocesano di Palermo restaurato e riscoperto* (Palermo, 2016), 13–44, marshaled more evidence in support of the same identification, arguing in addition that the painting is probably the work not of Quartararo but of Cristoforo Faffeo, an artist active in Naples at the end of the fifteenth century. (Mauro Sebastianelli recently restored the painting, and in the book he presents a fascinating and beautifully illustrated account of the restoration.)

9. Pinacoteca Comunale di Città di Castello; see Raffaele Caracciolo, "La *Pala di Santa Cecilia* di Luca Signorelli (e una proposta per l'*Incoronazione della Vergine* del Ghirlandaio)," *Pagine altotiberine* 51 (2013): 107–40; and Staiti, *Le metamorfosi*, 28–29.

10. Entry by Daniela Ferriani in *Galleria Nazionale di Parma: Catalogo delle opere del Cinquecento e iconografia farnesiana* (Milan, 1998), 169–70; image online at https://it.wikipedia.org/wiki/Madonna_col_Bambino_e_santi_(Agostino_Carracci).

11. On Raphael's Bolognese patrons and their commission, see Connolly, *Mourning into Joy*, 111–50. For thoughtful and learned analyses of Raphael's painting, with references to the extensive secondary literature, see Connolly, *Mourning into Joy*, 238–61; and Tim Shephard, Sanna Raninen, Serenella Sessini, and Laura Stefanescu, *Music in the Art of Renaissance Italy, 1420–1540* (Turnhout, 2020), 78–80.

12. Connolly, *Mourning into Joy*, 12, 257–58, 277.

13. Marzia Faietti, "La trascrizione incisoria," *L'Estasi di Santa Cecilia di Raffaello da Urbino nella Pinacoteca Nazionale di Bologna* (Bologna, 1983), 186–205; Connolly, *Mourning into Joy*, 238–61; Baroncini, "L'immagine di santa Cecilia," 41–42.

14. Judging from the number of keys and the number of visible pipes, this instrument might correspond to the portative organ with symmetrically arranged pipes described by the fifteenth-century organist Henri Arnaut; see Peter Williams, *The Organ in Western Culture, 750–1250* (Cambridge, 1993), 343.

15. Pier Virgilio Begni Redona, *Alessandro Bonvicino—Il Moretto da Brescia* (Brescia, 1988, 348); see also Staiti, *Le metamorfosi*, 61.

16. Stuart Lingo, *Federico Barocci: Allure and Devotion in Late Renaissance Painting* (New Haven, CT), 2008, 210–13; Peter Gillgren, *Siting Federico Barocci and the Renaissance Aesthetic* (Abingdon, 2011), chapter 11; Baroncini, "L'immagine di santa Cecilia," 42.

17. Baroncini, "L'immagine di Santa Cecilia," 42–43. For the last sentence of the paragraph, I am indebted to one of the anonymous reviewers who evaluated my manuscript for the University of Chicago Press.

18. Maria Cristina Guardata, catalog entry in *Colori della musica*, 226–27; see also Staiti, *Le metamorfosi*, 67–68.

19. I am grateful to Sophie Dutheillet de Lamothe of the Palais des Beaux-Arts in Lille (email, 4 February 2020) for information on the painting, briefly discussed in Shephard et al., *Music in the Art of Renaissance Italy*, 77–78. For bibliography, see AGORHA, Bases de données de L'Institut National d'Histoire de l'Art: https://agorha .inha.fr/inhaprod/ark:/54721/00312351.

20. Volker Scherliess, *Musikalische Noten auf Kunstwerken der italienischen Renaissance bis zum Anfang des 17. Jahrhunderts* (Hamburg, 1972), 77–78.

21. Edward E. Lowinsky, *Music in the Culture of the Renaissance and Other Essays* (Chicago, 1989), 346.

22. I thank Jason Stoessel (email, 23–24 January 2020) for information and insights; more details in his article "Canons in the Visual Culture of Renaissance Italy, c. 1480–c. 1530: Meanings, Materialities and Legacies," forthcoming in the proceedings of the conference *Il patrimonio musicale nella storia della cultura dall'Antichità alla Prima età moderna—Primo incontro* (Ravenna, October 2017).

23. On Bastianino's painting and Antonio Goretti as musical and artistic patron, see Anna Valentini, "Iconografia musicale a Ferrara tra XVI e XVII secolo," Tesi di dottorato, Università degli Studi di Padova, 2012, 19–67, 168–69.

24. Valentini, "Iconografia musicale a Ferrara," 64–67.

25. Lowinsky, *Music in the Culture of the Renaissance*, 344–46.

26. Adriano Banchieri, *Conclusioni nel suono dell'organo* (Bologna, 1609), 5–6. Connolly, *Mourning into Joy*, 15–16, and Baroncini, "L'immagine di santa Cecilia," 40–41, 43, quote from and comment insightfully on Banchieri's testimony.

27. Baroncini, "L'immagine di santa Cecilia," 43–44; see also Staiti, *Le metamorfosi*, 72–74.

28. Wilfried Praet, email, 12 April 2019.

29. For a view of the whole chapel, see http://www.360visio.com/wp-content/uploads/panoramas/CL2013/CR/chiese/sigismondo/navatap/output/index.html.

CHAPTER SEVEN

1. José M. Llorens, *Capellae sixtinae codices*, Vatican City, 1960, nos. 239–42 and 243–46; see also Eduardo Dagnigo, "I codici Sistini 239 a 242," *Note d'archivio* 10 (1933): 297–313; Mary S. Lewis, *Antonio Gardano, Venetian Music Printer, 1538–1569: A Descriptive Bibliography and Historical Study*, vol. 1 (New York, 2005), 152–53; and Bernhard Janz, *Der Fondo Cappella Sistina der Biblioteca Apostolica Vaticana* (Paderborn, 2000), 84, 97, 101, 106, 108, 137, 154.

2. I do not count as a motet *Virgo gloriosa* by Guglielmo Sitibundo, published in 1574 in a liturgically ordered collection of Vespers music under the title *Antiphonae ad Magnificat*.

3. Pappo's motet is *Cantantibus organis*; Banchieri's is *Sancta Cecilia virgo gloriosa*.

4. Although the earliest edition of Palestrina's *Motecta festorum totius anni* of which an exemplar survives was published by Antonio Gardano in Venice in 1564 (RISM P 689), it is likely that an earlier edition (of which no exemplar survives) appeared in Rome the previous year. See Daniele V. Filippi's introduction to his edition of *Motecta festorum totius anni* (Pisa, 2003), 3–7. On Palestrina's *Motecta festorum*, see also Schubert, "Hidden Forms"; David Crook, "Proper to the Day: Calendrical Ordering in Post-Tridentine Motet Books," in *Mapping the Motet in the Post-Tridentine Era*, 23–25; and Filippi, "Formal Design and Sonic Architecture."

5. Crook, "Proper to the Day," 17.

6. On Palestrina's 1575 publication, see Noel O'Regan, "Palestrina's Mid-Life Compositional Summary: The Three Motet Books of 1569–1575," in *Mapping the Motet in the Post-Tridentine Era*, 102–22.

7. On Kerle's 1557 motet book (of which only a single altus partbook survives), see Christian Thomas Leitmeir, *Jacobus de Kerle (1531/32–1591): Komponieren im*

Spannungsfeld von Kirche und Kunst (Turnhout, 2009), 135–93. I thank Leitmeir for sharing with me the text and (fragmentary) music of Kerle's *Cantantibus organis.*

8. Probably because "in corde suo" is missing from Palestrina's piece, O'Regan identified the texts of the two *partes* as independent antiphons (O'Regan, "Palestrina's Mid-Life Compositional Summary," 111).

9. Schubert, "Hidden Forms."

10. Palestrina was not the only composer for whom the ascending 5–6 sequence served almost as a pair of quotation marks for Cecilia's words: Pevernage, setting the phrase "Eia milites Christi" in *Dum aurora finem daret,* also used the schema for this purpose (see ex. 5.21).

11. Noel O'Regan, "Marenzio's Sacred Music: The Roman Context," *EM* 27 (1999): 608–20; Marco Bizzarini, *Luca Marenzio: The Career of a Musician Between the Renaissance and the Counter-Reformation,* trans. James Chater (Aldershot, 2003).

12. O'Regan, "Marenzio's Sacred Music," 618; Noel O' Regan, "The Organisation of Marenzio's *Motectorum pro festis totius anni cum communi sanctorum* of 1585," in *Miscellanea marenziana,* ed. Maria Teresa Rosa Barezzani and Antonio Delfino (Pisa, 2007), 49–70.

13. Michele Fromson, "A Conjunction of Rhetoric and Music: Structural Modelling in the Italian Counter-Reformation Motet," *JRMA* 117 (1992): 208–46.

14. O'Regan, "Marenzio's Sacred Music," 615.

15. The decree was published in Angelo De Santi, "L'antica Congregazione di S. Cecilia fra i musici di Roma ed un breve sconosciuto ed inedito di Sisto V del 1° maggio 1585," *La civiltà cattolica* 69 (1918), vol. 4: 482–94. The many editorial interventions by De Santi suggest that his source was corrupt. English translation (used here) in Robert F. Hayburn, *Papal Legislation on Sacred Music, 95 A.D. to 1977 A.D.* (Collegeville, MN, 1979), 70–72.

16. . . . omnibus et singulis utriusque sexus Christifidelibus vere penitentibus et confessis . . . Confraternitatem predictam deinceps pro tempore . . . *ingrederentur* et in illa reciperentur, die primi eorum [ing]ressus et receptionis hujusmodi, si sanctissimum Eucharistie sacramentum tunc sumpissent (De Santi, "L'antica Congregazione," 489).

17. William J. Summers, "The *Compagnia dei Musici di Roma,* 1584–1604: A Preliminary Report," *CM* 34 (1982): 7–25 (8). Much of the content of Summers's article was presented earlier in [Angelo De Santi], "La 'Vertuosa compagnia de i musici di Roma' nel secolo XVI," *La civiltà cattolica* 69 (1918), vol. 2: 514–31.

18. Bizzarini, *Luca Marenzio,* chapter 11, "Musici di Roma."

19. Augusta Campagne, *Simone Verovio: Music Printing, Intabulations and Basso Continuo in Rome around 1600* (Vienna, 2018).

20. Campagne, *Simone Verovio,* 108–9.

21. See Nino Pirrotta, "*Dolci affetti*: I musici di Roma e il madrigale," *SM* 14 (1985): 59–104.

22. For a thorough discussion of Sfondrato's life and artistic patronage, with references to the earlier scholarly literature, see Tobias Kämpf, *Archäologie offenbart: Cäciliens römisches Kultbild im Blick einer Epoche* (Leiden, 2015); see also Alessia Lirosi, "Il corpo di santa Cecilia (Roma, III–XVII secolo)," *Mélanges de l'École française de Rome* 122 (2010), 5–51, online at https://journals.openedition.org/mefrim/559?lang=en; and Clare Robertson, *Rome 1600: The City and the Visual Arts under Clement VIII* (New Haven, CT, 2015), 225–30. Although several scholars give Sfondrato's second Christian name as Emilio, Kämpf points out that documents from Sfrondrato's

lifetime—including those closely associated with the cardinal himself—mostly refer to him as Paolo Camillo. See Tobias Kämpf, "Framing Cecilia's Sacred Body: Paolo Camillo Sfrondrato and the Language of Revelation," *Sculpture Journal* 6 (2001): 10–20 (18), and Kämpf, *Archäologie offenbart*, 4.

23. fù anche grande il numero di musici primari di Roma, che concorsero à questa funzione, per applauderla con soaviss.[i]ma melodia (Giovanni Antonio Bruzio, *Della chiesa e del monasterio di Santa Cecilia*, BAV, Vat. lat. 11 88 4, quoted in Kämpf, *Archäologie offenbart*, 533).

24. La chiesa fu accomodata con superbissimi parati con molta argenteria, e vi furono soavissimi canti . . . Furono cantati alcuni motetti in lode sua (*Avvisi di Roma*, BAV, Vat. lat. 8026, 25 Jan. 1591, quoted in Kämpf, *Archäologie offenbart*, 588–89).

25. Passeri's engravings are briefly discussed, and two of them illustrated, in Suzanne Boorsch, "Cornelis Galle I and Francesco Vanni," in *Ein privilegiertes Medium und die Bildkulturen Europas: Deutsche, Französische und Niederländische Kupferstecher und Graphikverleger in Rom von 1590 bis 1630*, ed. Eckhard Leuschner (Munich, 2012): 163–76 (170, 172).

26. Raffaele Casimiri, "*I diari sistini*" in *Note d'archivio* 1 (1924)–17 (1940).

27. Lunedi alli 21 [novembre] . . . Di poi la messa il Cardinal Sfondrato ha mandato un cappellano ad invitare tutto il nostro Collegio, che voglia andar a cantar domani la messa et vespero alla Chiesa di Santa Cecilia suo titulo; glie fu reposto dal mastro di cappella, che alla Messa si anderà per servire a sua signoria Ill.ma, ma il vespero non è solito che la Cappella del papa collegialiter lo canti mai in nessun loco; et fu detto al detto Cappellano, che il Cardinal Mont'alto e il Cardinal Matthei hanno donato altre volte alla Cappella, cioè per li cantori scudi quindici per una messa sola; però con li padroni non si fa patti (Hermann-Walther Frey, "Das Diarium der Sixtinischen Sängerkapelle in Rom für das Jahr 1594 [Nr. 19]," *Analecta musicologica* 14 [Studien 9], 445–505 [497–98]).

28. Martedi alle 22, Santa Cecilia. Questa mattina ad instantia del Ill.mo et Rev .mo Cardinal Sfondrato siamo andati a cantar la messa a detta chiesa di Santa Cecilia suo titulo . . . Detto Ill.mo Sig.r Cardinal ci dette da pranzo a casa sua e di poi pregò il Collegio, che andasse a dir Vespero alla medesma chiesa, et per piú comodità ci mandò tutti in cochio, et cantammo Vespero . . . Il detto Ill.mo Cardinal questo medesmo giorno mandò al nostro Collegio scudi quindici di moneta (Frey, "Das Diarium der Sixtinischen Sängerkapelle," 497–98).

29. See Llorens, *Capellae Sixtinae codices*, nos. 88 and 229–34, and the other literature cited in note 1.

30. Kämpf, *Archäologie offenbart*, 75–76, argues persuasively of the importance of the approaching Jubilee in motivating Sfondrato to initiate his restoration of Santa Cecilia and subsequent archaeological investigation. For a lavishly illustrated survey of artistic developments in Rome before, during, and after the Jubilee, see Robertson, *Rome 1600*.

31. For instance, Cardinal Girolamo Rusticucci renovated and decorated the church of Santa Susanna (another virgin martyr); see Pamela M. Jones, *Altarpieces and Their Viewers in the Churches of Rome from Caravaggio to Guido Reni* (Aldershot, 2008), 20–38; and Robertson, *Rome 1600*, 237–39.

32. Robertson, *Rome 1600*, 225–30, discusses Sfondrato's renovations within the context of efforts throughout Rome during this period to investigate and call attention to its relics of early Christianity.

33. On these debates and Baronio's role in them, see Simon Ditchfield, *Liturgy, Sanctity and History in Tridentine Italy* (Cambridge, 1995).

34. Era grandissimo il desiderio che sua signoria illustrissima aveva di sapere se il corpo di santa Cecilia stava nella nostra chiesa et a' questo effetto spesse volte veniva in parlatorio et con istanza domandava alle madri maggiori se vi era alcuna di loro che gl'ne sapesse dar notitia (*Cronica del Venerabile Monasterio di Santa Cecilia di Roma*, Archivio del Monastero di S. Cecilia, fol. 41v, quoted in Lirosi, "Il corpo di santa Cecilia," 17). See also *Le cronache di Santa Cecilia: Un monastero femminile a Roma in età moderna*, ed. Alessia Lirosi (Rome, 2009); and, for another transcription of the nuns' chronicle, see Kämpf, *Archäologie offenbart*, 485–95.

35. Lirosi, "Il corpo di santa Cecilia," 17. See also Tomaso Montanari, "Una nuova fonte per l'invenzione del corpo di santa Cecilia: Testimoni oculari, immagini e dubbi," *Marburger Jahrbuch für Kunstwissenschaft* 32 (2005): 149–65.

36. Kämpf, "Framing Cecilia's Sacred Body," 14, refers to Bosio's *Historia* and Maderno's statue collectively as "an artistic and intellectual endeavor to perpetuate the excitement" (aroused by the discovery and reburial of Cecilia).

37. Bosio, *Historia*, 155–56.

38. An edition of Paschal's letter (with Italian translation by Norma Alfano) is in *Santa Cecilia martire romana: Passione e culto*, 85–93.

39. Bosio, *Historia*, 156–57.

40. The *avvisi* reporting the discovery of the body are quoted in Kämpf, "Framing Cecilia's Sacred Body," 19.

41. Cum nos ista de lignea arca non sine magna admiratione vidissemus: ad id quod intus detinebatur sacrum Martyris corpus intuendum devenimus. Ac plane, secundum illud Davidicum: Sicut audivimus ita et vidimus in civitate Domini virtutum, in civitate Dei nostri. Etenim ut a Paschali Papa inventum et reconditum fuisse legimus (et superius recitavimus) venerandum Caeciliae corpus, ita invenimus, nempe ad pedes eius quae fuerant madida sanguine vela; et serica fila auro obducta quae visebantur, iam vetustate solutae vestis illius auro textae, cuius idem Paschalis meminit, indices erant.

Alia vero supra Martyris corpus serica, levia tamen felamina posita, ipsaque depressa situm ipsum et habitudinem corporis ostendebant. Visebaturque (quod admiratione dignum erat) non ut assolet, in sepulchro resupinum positum corpus, sed ut in lecto iacens honestissima virgo supra dextrum cubare latus, contractis nonnihil ad modestiam genibus, ut dormientis imaginem redderet potius quam defunctae, ipso ita ad insinuandam in omnibus virginalem verecundiam composito situ corporis; adeo ut (quod aeque mirandum) nemo quamvis curiosus inspector, ausus omnino fuerit virgineum illud detegere corpus, reverentia quadam inenarrabili repercussus, perinde ac si caelestis sponsus asisteret vigilans custos dormientis sponsae, monens et minans: Ne suscitetis, neque evigilare faciatis dilectam donec ipsa velit (Cesare Baronio, *Annales ecclesiastici*, vol. 9 [Rome, 1600], 693; translation [used here, with some changes] in Guéranger, *Life of Saint Cecilia*, 275–76).

42. Bosio, *Historia*, 161–62.

43. Bosio, *Historia*, 162, quoted in English translation (used here) in Ditchfield, *Liturgy, Sanctity and History in Tridentine Italy*, 181.

44. Bosio, *Historia*, 163–64.

45. Gran cose si possono venir' ad imparar qui: come sarebbe a dire: con che studio si debba ricercare di risuscitare gli Santi delle Chiese loro, già andati in oblio: ritrovare le loro Sacre reilquie, trasferirle con solennissima pompa; collocare in pretiosi sepolcri, fare che da tutti gli Diocesani siano con particolar culto riveriti, solennizzate le feste loro (Giovambattista Possevino, *Vite de santi et beati di Todi*,

con la traslatione solenne di cinque corpi loro [Perugia, 1597], fol. 4r; translation [used here] in Ditchfield, *Liturgy, Sanctity and History in Tridentine Italy*, 148).

46. Bosio, *Historia*, 163–64.

47. Venuto il giorno di santa Cecilia furno per hordine dell'illustrissimo signor cardinale intimati tutti li cardinali, vescovi, prelati, ambasciadori, signori, in somma tutto il clero et tutta la nobilità di Roma per la capella che si doveva fare in detta chiesa; similmente furno intimati li più eccellenti musici che in Roma si trovassero (Lirosi, *Il corpo di Santa Cecilia*, 31; another transcription in Kämpf, *Archäologie offenbart*, 491).

48. In Rome on the night of 21–22 November 2019, 14 hours and 23 minutes elapsed between sunset and sunrise, according to timeanddate.com; my thanks to Austin Schneider for this information.

49. Bosio's description of the new silver coffin is omitted here.

50. Bosio, *Historia*, 164.

51. Bosio, *Historia*, 166–67.

52. On the artistic patronage of Farnese and Aldobrandini, see Robertson, *Rome 1600*, 57–121, 128–32, and passim.

53. For the full inscription, not included here, see Bosio, *Historia*, 169–70.

54. Bosio, *Historia*, 167.

55. Bosio, *Historia*, 173.

56. Connolly, *Mourning into Joy*, 35–37. On Maderno's sculpture, see Kämpf, *Archäologie offenbart*, 392–462.

57. On Galle's engraving, see Suzanne Boorsch, "Twelve Saints after Francesco Vanni by Philippe Thomassin," in *L'Estampe au Grand Siècle: Études offertes à Maxime Préaud*, ed. Peter Führing et al. (Paris, 2010): 37–47; Boorsch, "Cornelis Galle I and Francesco Vanni," 168–73; John Marciari and Suzanne Boorsch, *Francesco Vanni: Art in Late Renaissance Siena* (New Haven, CT, 2013), 182–84; Kämpf, *Archäologie offenbart*, 251–57.

58. Non tardò molto a' venire Sua Santità accompagnato da tutto il clero et in un istesso tempo fu ripiena tutta la chiesa, di maniera che fu cosa da stupire. Il pontifice, data che ebbe la beneditione al popolo, andò alla tribuna et disse bona parte dell'offitio. In questo istante fu portato il corpo della santa alla tribuna et fu accomodato dentro alla cassa d'argento, ivi standovi Sua Santità mentre si accomodava. Poi si parò per dir messa. Cominciorno i musici a' sonare et cantare con tanta suavità et eccellenza che veramente la nostra chiesa pareva l' Paradiso (*Cronica*, quoted in Lirosi, "Il corpo di Santa Cecilia," 31; Kämpf, *Archäologie offenbart*, 491, has a slightly different transcription).

59. Di Roma li X di Novembre 1599 . . . la domenica, che sarà il giorno della vigilia, terrà vespro solenne con la musica del Papa in honore di questa santa (*Avviso di Roma*, quoted in Kämpf, *Archäologie offenbart*, 562).

60. L'ill.[ustrissi]mo Sig.[no]r Cardinale la sollennizo magnifca.[men]te[;] vi furno tre cori di musici delli piu eccellenti di Roma . . . Vi venne il pontefice papa Clemente ottavo, il quale con grandiss.[im]a devotione celebrò messa . . . Quella matina non fu cantata la messa per rispetto che il pontefice haveva celebrato nell'altar maggiore, ma furno cantati alcuni mottetti, et li vesperi furno detti solleniss.[imamen]te con tanto concorso di popolo che era cosa da stupire. Vi venne il senato romano à portare il calice quale posorno sopra l'altare di S.[an]ta Cecilia con grandiss.[im]a devotione et riverenza[;] in quel istante li trombettieri sonavano le trombe con grandiss.[im]o strepito (Kämpf, *Archäologie offenbart*, 494–95).

61. ASR, CRF, StC, b. 4202, 1604, quoted in Emma Stirrup, "Time Concertinaed

at the Altar of Santa Cecilia in Trastevere," in *Rome: Continuing Encounters between Past and Present*, ed. Dorigen Caldwell and Lesley Caldwell (Farnham, 2011), 57–78 (78). According to Pompeo Ugonio, *Historia delle stationi di Roma che si celebrano la Quadragesima* (Rome, 1588), fol. 130v, stational day at Santa Cecilia was the third Wednesday in Lent.

62. According to Noel O'Regan, "The Performance of Roman Sacred Polychoral Music in the Late Sixteenth and Early Seventeenth Centuries: Evidence from Archival Sources," *Performance Practice Review* 8 (1995): 107–46 (109–10), the first archival reference to the singing of polyphony by three choirs in Rome is dated 1582; the practice spread rapidly after that. For a rich compilation of musicological literature on Roman polychoral music, see Filippi, "Formal Design and Sonic Architecture," 186.

63. Raffaele Casimiri, "La 'Missa: Cantantibus organis Caecilia' a 12 voci di Giov. P. da Palestrina e de' suoi scolari," in *Note d'archivio* 8 (1931): 234–44.

64. I-Rsg, Rari, ms. 52–54; see Giancarlo Rostirolla, *L'archivio musicale della Basilica di San Giovanni in Laterano: Catalogo dei manoscritti e delle edizioni (secc. XVI–XX)* (Rome, 2002), 893. On the sources for the *Missa Cantantibus organis* and other useful information and analytical insights, see Noel O'Regan, "Sacred Polychoral Music in Rome, 1575–1621," PhD diss., University of Oxford, 1988, 287–88; and Peter Ackermann, "Zur Frühgeschichte der Palestrinarezeption: Die zwölfstimmige *Missa Cantantibus organis* und die Compagnia dei Musici di Roma," *Kirchenmusikalisches Jahrbuch* 78 (1994): 7–25.

65. Quentin W. Quereau, "Aspects of Palestrina's Parody Procedure," *JM* 1 (1982): 198–216.

EPILOGUE

1. Hanning, "From Saint to Muse."

2. Artists active in Rome in the first half of the seventeenth century who made (or to whom are attributed) now familiar paintings of Cecilia making music include Domenichino, Orazio Gentileschi, Gramatica, Lanfranco, Pietro da Cortona, Poussin, Reni, Saraceni, and Vouet. The enormous topic of Cecilian iconography in the seventeenth century is beyond the scope of this book and deserves one of its own; for well-illustrated surveys, see Mirimonde, *Sainte-Cécile*; Staiti, *Le metamorfosi*, 76–117; Festa, "Representations of Saint Cecilia in Italian Renaissance and Baroque Painting and Sculpture"; and Charlotte Tanner Poulton, "The Sight of Sound: Resonances between Music and Painting in Seventeenth-Century Italy," PhD diss., University of York, 2009, 73–116.

3. Bernardino Bertolotti, Stefano Malescot, and Filippo Nicoletti; see Ruini, "Edizioni musicali perdute," 441.

4. On the sets of polyphonic antiphons to which these works belong, see Jeffrey Kurtzman, "Polyphonic Psalm and Canticle Antiphons for Vespers, Compline and Lauds Published in Italy in the Sixteenth and Seventeenth Centuries," *Barocco padano* 7, ed. Alberto Colzani et al. (Como, 2012), 583–644 (584–611); and Kurtzman, "Motets, Vespers Antiphons, and the Performance of the Post-Tridentine Liturgy in Italy."

5. In documenting the Cecilian motets of the early seventeenth century, I benefited greatly from the websites "Printed Sacred Music" (http://www.printed-sacred-music.org) and "A Catalogue of Motets, Mass, Office, and Holy Week Music printed in Italy, 1516, 1770," compiled by Jeffrey Kurtzman and Anne Schnoebelen (https://sscm-jscm.org/instrumenta/instrumenta-volumes/instrumenta-volume-2/).

I must also thank Kurtzman for sharing with me valuable information from his personal files.

6. On Amadino's motto and its implications (including possible connections with Cecilia's cult), see Elizabeth L. Lyon, "'Magis corde quam organo': Agazzari, Amadino, and the Hidden Meanings of *Eumelio*," *EM* 48 (2020): 157–76. Amadino published Cecilian motets by Morelli, Bona, Pini, Bellanda, Mangoni, Franzoni, Leoni, Raffaelli, and Marenzio.

7. A' tale applauso gli Musici, & Organisti Senesi ogn'anno per tradittioni à gli 22. di Novembre . . . concertano una Messa solenne nella Chathedrale . . . concertata con grandissimo concorso di virtuoso ridotto (Banchieri, *Conclusioni nel suono dell'organo*, 6).

8. Frank A. D'Accone, *The Civic Muse: Music and Musicians in Siena during the Middle Ages and the Renaissance* (Chicago, 1997), 371.

9. Copia dell'Orazione recitata a' Musici la sera di Santa Cecilia . . . l'anno 1588 (Curzio Mazzi, *La congrega dei rozzi di Siena nel secolo XVI*, vol. 2 [Florence, 1882], 365).

10. Essa ci dice nel bel principio come fosse stata "per li tempi adietro" usanza di celebrare quel giorno oltre che con musicali concerti, ancora col recitare in chiesa un'orazione delle lodi della santa protettrice (Mazzi, *La congrega*, 365).

11. Dacchè i Musici per onorare in Duomo la Santa loro con due vesperi e messa solenni "creano un Re della festa, il quale piglia pensiero et delle musiche e del banchetto che fa loro come corte bandita per quella notte, con qualche virtuoso trattenimento" (Mazzi, *La congrega*, 366).

12. *Francisci Bianciardi . . . sacrarum modulationum . . . liber primus* (Venice, 1596).

13. Daniele Torelli, *Benedetto Binago e il mottetto a Milano* (Lucca, 2004), 72, citing Cherubino Ferrari, *Oratione delle lodi di santa Cecilia vergine, e martire fatta, e recitata . . . il giorno della sua festa, con grandissima solennità celebrata da' sign. musici nella chiesa regia, ducale di Milano* (Milan, 1599).

14. Paolo Morigia, *Calendario volgare*, Milan, 1620, quoted in Kendrick, *The Sounds of Milan*, 487.

15. Kendrick, *The Sounds of Milan*, 174–86, 487.

16. 22 magnos fasciculos Musicae S. Ceciliae, quam pro vocibus et instrumentis ipse composuit, et totidem annis Ferrariae concini cum omnium admiratione curavit (*Novarum observationum physico-mathematicarum tomus III*, Paris, 1647, 166, quoted in Paolo Fabbri, "Collezioni e strumenti musicali dall'Italia: Due frammenti per la biografia monteverdiana," in *'In Teutschland noch gantz ohnbekadt': Monteverdi-Rezepzion und frühes Musiktheater im deutschsprachigen Raum*, ed. Markus Engelhardt [Frankfurt, 1996], 265–73; and in Valentini, "Iconografia musicale a Ferrara," 31).

17. Franz Waldner, "Zwei Inventarien aus dem XVI. und XVII. Jahrhundert über hinterlassene Musikinstrumente und Musikalien am Innsbrucker Hofe," *Studien zur Musikwissenschaft* 4 (1916): 128–47 (134).

18. This discussion of the Accademia degli Elevati is based on Edmond Strainchamps, "New Light on the Accademia degli Elevati of Florence," *Musical Quarterly* 62 (1976): 507–35; all translations here are by Strainchamps.

19. Del vincere i Compositori (Strainchamps, "New Light," 515, 534).

20. . . . il quale sia tenuto ad esercitare la maestranza del Concerto, con autorità di battere, & di eleggere a suo piacimento quelle Musiche, le quali si doveranno cantare, o sonare in quel tempo (Strainchamps, "New Light," 515, 535).

21. *Della Festa Annuale*. Ciascheduno Anno nel giorno della festività di s. CECILIA nostra protettrice, si canti da gl' Accad[emic]i una Messa, alla quale per obbligo intervenghino tutti, & e quelli che manchassero senza legittimo impedimento, Siano appuntati in lire quattro (Strainchamps, "New Light," 516, 535).

22. E adì 22 [novembre] detto in domenica S. A. andò alla messa a san Giovanni con Nunzio e Ambasciatori per esservi la festa di Santa Cicilia et *l'Academia della Musica* vi fece una musica grande (*Musica, ballo e drammatica alla corte Medicea dal 1600 al 1637: Notizie tratte da un* diario, ed. Angelo Solerti [Florence, 1905], 57; translation in Strainchamps, "New Light," 520).

23. Marta Columbro and Eloisa Intini, "Congregazioni e corporazioni di musici a Napoli tra Sei e Settecento," *Rivista italiana di musicologia* 33 (1998): 41–76; Dinko Fabris, *Music in Seventeenth-Century Naples: Francesco Provenzale (1624–1704)* (Abingdon, 2007), 21.

24. Columbro and Intini, "Congregazioni e corporazioni di musici"; Fabris, *Music in Seventeenth-Century Naples*, 21–22.

25. Jonathan Glixon, *Honoring God and the City: Music at the Venetian Confraternities, 1260–1807* [Oxford, 2003], 227–29.

26. Richard Mackenny, *Venice as the Polity of Mercy: Guilds, Confraternities, and the Social Order, c. 1250–c. 1650* (Toronto, 2019), chapter 5.

27. *Come, e quando si debba solennizare la Festa di Santa Cecilia*: Vada parte che la solennità di Santa Cecilia debba essere santificata da tutti li confrateli cantando la messa et il vespero li 22 novembre all'hora solita in chiesa di San Martino, e doveranno tutti impiegati secondo l'abilità sua, et in conformità del bisogno, che haverà il signor maestro o il signor vice maestro; uno de' quali doverà far la musica (transcription and translation [used here] in Glixon, *Honoring God and the City*, 227–29).

28. On the musical observance of Cecilia's Day in England, with comprehensive bibliography, see Bryan White, *Music for St. Cecilia's Day: From Purcell to Handel* (Woodbridge, 2019).

29. Facsimile of the title page in White, *Music for St. Cecilia's Day*, 9.

30. *Select Psalmes of a New Translation, to be Sung in Verse and Chorus of Five Parts, with Symphonies of Violins, Organ, and Other Instruments, November 22, 1655*. Edythe Backus first called attention to the copy of this edition (apparently an *unicum*) in the Huntington Library and pointed out that the date of publication or performance was Cecilia's Day; see Willa McClung Evans, *Henry Lawes, Musician and Friend of Poets* (New York, 1941), 211; for further bibliography, see White, *Music for St. Cecilia's Day*, 12.

31. Stacey Jocoy, "'Welcome to All the Pleasures': The Political Motivations of the St. Cecilia's Day Celebrations," paper read at the annual meeting of the American Musicological Society in 2013; abstract published in *AMS 2013, Pittsburgh, 7–10 November, Program & Abstracts*, ed. Dana Gooley, 188. For other musical performances in England before 1683 that might have served as precedents for the celebration of Cecilia's Day, see White, *Music for St. Cecilia's Day*, 11–28.

32. On Matham's engraving, see *The New Hollstein: Dutch and Flemish Etchings, Engravings and Woodcuts, 1450–1700* (Roosendaal, 1993–), Matham No. 317 and Goltzius No. 465.

33. Otto Erich Deutsch, "Cecilia and Parthenia," *Musical Times* 100 (1959): 591–92.

34. James E. Kelly, *English Convents in Catholic Europe, c. 1600–1800* (Cambridge, 2020).

35. On music among the Catholic exiles, see Kelly, *English Convents*, 105–6; Andrew Cichy, "Parlour, Court and Cloister: Musical Culture in English Convents during the Seventeenth Century," in *The English Convents in Exile, 1600–1800: Communities, Culture and Identity*, ed. Caroline Bowden and James E. Kelly (Farnham, 2013), 175–90; Peter Leech and Maurice Whitehead, "'Clamores omnino atque admirationes excitant': New Light on Music and Musicians at St. Omers English Jesuit College, 1658–1714," *TVNM* 66 (2016): 123–48; Jane Stevenson, "The Tixall Circle and the Musical Life of St. Monica's, Louvain," *British Catholic History* 33 (2017): 583–602.

36. See Jonathan P. Wainwright, "Richard Dering's Few-Voice 'Concertato' Motets," *Music and Letters* 89 (2008): 165–94 (165–66).

37. *Paradisus sacris cantionibus consitus, una, duabus et tribus vocibus decantandis, cum basso generali ad organum . . . prima pars* (Antwerp, 1628).

38. In *Cantica sacra ad duas & tres voces . . . authore Ricardo Deringo*, published in London by John Playford. Modern edition in *MB* 87, ed. Jonathan P. Wainwright (London, 2008).

39. Eva Scott, *The King in Exile: The Wanderings of Charles II from June 1646 to July 1654* (London, 1905); Eva Scott, *The Travels of the King: Charles II in Germany and Flanders, 1654–1660* (London, 1907).

40. Jonathan P. Wainwright, "Sounds of Piety and Devotion: Music in the Queen's Chapel," in *Henrietta Maria: Piety, Politics and Patronage*, ed. Erin Griffey (Aldershot, 2008), 195–213.

41. This is not the place for a detailed discussion; four examples must suffice. At the cathedral of Antwerp, as mentioned in chapter 3, the choir received Cecilia's Day gifts from the city council until 1681. At St. Martin's church in Ypres, the singers known as Cecilianisten received an annual present from the city council from 1603 until around the middle of the century (Vander Straeten, *La Musique aux Pays-Bas*, vol. 2, 320–22). The Confraternity of St. Cecilia in Rouen continued to meet during most of the seventeenth century (Collette, *Histoire de la maîtrise de Rouen*, 77–80). In 1633 a lavish Cecilia's Day celebration, with Mass sung by three choirs and a motet competition, was established in Le Mans; see Sylvie Granger, "La Feste de Madame Sainte Cécile (Le Mans, 1633)," in *Les Cérémonies extraordinaires du Catholicisme baroque*, ed. Bernard Dompnier (Clermont-Ferrand, 2009), 113–32.

42. Quoted in Husk, *An Account of the Musical Celebrations on St. Cecilia's Day*, 137.

43. On *Welcome to All the Pleasures*, see White, *Music for St. Cecilia's Day*, 93–99.

Bibliography

BOOKS, ARTICLES, AND DISSERTATIONS

Ackermann, Peter. "Zur Frühgeschichte der Palestrinarezeption: Die zwölfstimmige *Missa Cantantibus organis* und die *Compagnia dei Musici di Roma*." *Kirchenmusikalisches Jahrbuch* 78 (1994): 7–25.

Ælfric's Lives of the Virgin Spouses, with Modern English Parallel-Text Translations. Ed. Robert K. Upchurch. Exeter, 2007.

Aldhelmi opera. Ed. Rudolf Ehwald. Monumenta Germaniae Historica, Auctores antiquissimi 15. Berlin, 1919.

Alwis, Anne P. *Celibate Marriages in Late Antique and Byzantine Hagiography*. London, 2011.

Analecta hymnica medii aevi, vol. 10: *Sequentiae ineditae. Liturgische Prosen des Mittelalters*. Ed. Guido Maria Dreves. Leipzig, 1891.

Analecta hymnica medii aevi, vol. 55: *Die Sequenzen*. Ed. Clemens Blume. Leipzig, 1922.

Anderson, Michael Alan. *St. Anne in Renaissance Music: Devotion and Politics*. Cambridge, 2014.

Arnade, Peter. *Beggars, Iconoclasts, and Civic Patriots: The Political Culture of the Dutch Revolt*. Ithaca, NY, 2008.

[Arnobius the Younger]. *Passio sanctae Caeciliae*. Ed. Hippolyte Delehaye, in *Étude sur le légendier romain: Les Saints de novembre et de décembre*, Brussels, 1936, 194–220. Ed. and trans. by Robert K. Upchurch, in *Ælfric's Lives of the Virgin Spouses*, 173–217; trans. in Lapidge, *The Roman Martyrs*, 138–64.

Atlas, Allan W. "A Note on Isaac's *Quis dabit capiti meo aquam*." *JAMS* 27 (1974): 103–10.

Banchieri, Adriano. *Conclusioni nel suono dell'organo*. Bologna, 1609.

Baroncini, Rodolfo. "L'immagine di santa Cecilia prima e dopo Raffaello: percorsi iconografici e trasformazioni tematiche." In *Colori della musica: Dipinti, strumenti e concerti tra Cinquecento e Seicento*, ed. Annalisa Bini et al., 34–45. Milan, 2000.

Baronio, Cesare. *Annales ecclesiastici*, vol. 9. Rome, 1600.

Bazinet, Geneviève B. "Pierre Attaingnant's Encyclopedia of Sacred Music: The 1534–1539 Motet Series." PhD diss., McGill University, 2013.

Beebe, Ellen S. "The Repertoire of Brussels, Bibliothèque du Conservatoire Royal, MS 27088." In *Beyond Contemporary Fame*, 57–88.

Bernet Kempers, Karel Philippus. "A Composition by Clemens non Papa in a 16th-Century Painting." *MD* 8 (1954): 173–77.

Beyond Contemporary Fame: Reassessing the Art of Clemens non Papa and Thomas Crecquillon. Ed. Eric Jas. Turnhout, 2005.

Bizzarini, Marco. *Luca Marenzio: The Career of a Musician Between the Renaissance and the Counter-Reformation*. Trans. James Chater. Aldershot, 2003.

Blackburn, Bonnie J. *Music for Treviso Cathedral in the Late Sixteenth Century: A Reconstruction of the Lost Manuscripts 29 and 30*. London, 1987.

———. "For Whom Do the Singers Sing?" *EM* 25 (1997): 593–609.

Bloxam, M. Jennifer. "In Praise of Spurious Saints: The *Missae Floruit egregiis* by Pipelare and La Rue." *JAMS* 44 (1991): 163–220.

———. "Sacred Polyphony and Local Traditions of Liturgy and Plainsong: Reflections on Music by Jacob Obrecht." In *Plainsong in the Age of Polyphony*, ed. Thomas Forrest Kelly, chapter 6. Cambridge, 1992.

———. "Plainsong and Polyphony for the Blessed Virgin: Notes on Two Masses by Jacob Obrecht." *JM* 12 (1994): 51–75.

Boorsch, Suzanne. "Twelve Saints after Francesco Vanni by Philippe Thomassin." In *L'Estampe au Grand Siècle: Études offertes à Maxime Préaud*, ed. Peter Führing et al., 37–47. Paris, 2010.

———. "Cornelis Galle I and Francesco Vanni." In *Ein privilegiertes Medium und die Bildkulturen Europas: Deutsche, französische und niederländische Kupferstecher und Graphikverleger in Rom von 1590 bis 1630*, ed. Eckhard Leuschner, 163–76. Munich, 2012.

Bosio, Antonio. *Historia passionis B. Caeciliae virginis*. Rome, 1600.

Bossuyt, Ignace. *De componist Alexander Utendal (ca. 1543/1545–1581)*. Brussels, 1983.

———. "Charles V: A Life Story in Music." In *The Empire Resounds*, 83–160.

Bouckaert, Bruno. "The *Capilla Flamenca*: The Composition and Duties of the Music Ensemble at the Court of Charles V, 1515–1558." In *The Empire Resounds*, 37–45.

Breviarium ad usum insignis ecclesie Eboracensis. Ed. Stephen Lawley. Durham, 1880–1883.

Breviarium alme ecclesie Compostellane. Salamanca, 1569.

Breviarium monasterii sancti Emmerami. Munich, 1571.

Breviarium Romanum de camera. Venice, 1550.

Breviarium Romanum optime recognitum. Venice, 1558.

Breviarium Romanum politissimis characteribus excusum. Paris, 1531.

Breviarium secundum cursum ecclesiae Curiens[is]. Augsburg, 1595.

Brinkmann, Bodo. *Die flämische Buchmalerei am Ende des Burgunderreichs: Der Meister des Dresdener Gebetbuchs und die Miniaturisten seiner Zeit*, 2 vols. Turnhout, 1997.

Brobeck, John T. "Some 'Liturgical Motets' for the French Royal Court: A Reconsideration of Genre in the Sixteenth-Century Motet." *MD* 47 (1993): 123–57.

Brown, Andrew. *Civic Ceremony and Religion in Medieval Bruges c. 1300–1520*. Cambridge, 2011.

Brown, Howard Mayer. "Minstrels and Their Repertory in Fifteenth-Century France: Music in an Urban Environment." In *Urban Life in the Renaissance*, ed. Susan Zimmerman and Ronald F. E. Weissman, 142–64. Newark, DE, 1989.

Brown, Howard Mayer, and Keith Polk. "Instrumental Music, c.1300–c.1520." In

Music as Concept and Practice in the Late Middle Ages, ed. Reinhard Strohm and Bonnie J. Blackburn (The New Oxford History of Music, vol. 3, part 1), 97–161. Oxford, 2001.

Bruaene, Anne-Laure van, and Sarah van Bouchaute. "Rederijkers, Kannenkijkers: Drinking and Drunkenness in the Sixteenth- and Seventeenth-Century Low Countries." *Early Modern Low Countries* 1 (2017): 1–29. Online at http://hdl .handle.net/1854/LU-8526705.

Bux, Nicola. *Codici liturgici latini di Terra Santa / Liturgic Latin Codices of the Holy Land*. Fasano (Brindisi), 1990.

The Cambridge History of Sixteenth-Century Music. Ed. Iain Fenlon and Richard Wistreich. Cambridge, 2019.

Campagne, Augusta. *Simone Verovio: Music Printing, Intabulations and Basso Continuo in Rome around 1600*. Vienna, 2018.

Caracciolo, Raffaele. "La *Pala di Santa Cecilia* di Luca Signorelli (e una proposta per l'*Incoronazione della Vergine* del Ghirlandaio)." *Pagine altotiberine* 51 (2013): 107–40.

Casimiri, Raffaele. "I diari sistini." *Note d'archivio* 1 (1924)–17 (1940).

———. "La 'Missa: Cantantibus organis Caecilia' a 12 voci di Giov. P. da Palestrina e de' suoi scolari." *Note d'archivio* 8 (1931): 234–44.

Caullet, Gustave. *Musiciens de la Collégiale Notre-Dame à Courtrai d'après leurs testaments*. Courtrai, 1911.

Chaucer, Geoffrey. *The Canterbury Tales*, modernized version by J. U. Nicolson. Garden City, NY, 1934.

Cichy, Andrew. "Parlour, Court and Cloister: Musical Culture in English Convents during the Seventeenth Century." In *The English Convents in Exile, 1600–1800: Communities, Culture and Identity*, ed. Caroline Bowden and James E. Kelly, 175–90. Farnham, 2013.

Clerval, Jules-Alexandre. *De Judoci Clichtovei Neoportuensis . . . vita et operibus*. Paris, 1894.

Clichtove, Josse van. *De laudibus Sancti Ludovici regis Franciae. De laudibus sacratissimae virginis et martyris Ceciliae*. Paris, 1516.

Coelho, Victor, and Keith Polk. *Instrumentalists and Renaissance Culture, 1420–1600: Players of Function and Fantasy*. Cambridge, 2016.

Collette, Amand. *Histoire de la maîtrise de Rouen*, part 1. Rouen, 1892.

Columbro, Marta, and Eloisa Intini. "Congregazioni e corporazioni di musici a Napoli tra Sei e Settecento." *Rivista italiana di musicologia* 33 (1998): 41–76.

Connolly, Thomas. "The Legend of St. Cecilia: I, The Origins of the Cult." *SM* 7 (1978): 3–37.

———. "The Legend of St. Cecilia: II, Music and the Symbols of Virginity." *SM* 9 (1980): 3–44.

———. *Mourning into Joy: Music, Raphael, and Saint Cecilia*. New Haven, CT, 1994.

Conway, William Martin. *The Woodcutters of the Netherlands in the Fifteenth Century*. Cambridge, 1884.

Corley, Brigitte. *Painting and Patronage in Cologne, 1300–1500*. Turnhout, 2000.

Craft Guilds in the Early Modern Low Countries: Work, Power, and Representation. Ed. Maarten Prak et al. Aldershot, 2006.

Le cronache di Santa Cecilia: Un monastero femminile a Roma in età moderna. Ed. Alessia Lirosi. Rome, 2009.

Crook, David. "The Exegetical Motet." *JAMS* 68 (2015): 255–316.

———. "Proper to the Day: Calendrical Ordering in Post-Tridentine Motet Books." In *Mapping the Motet in the Post-Tridentine Era*, 16–35.

Crowston, Clare. "Women, Gender, and Guilds in Early Modern Europe: An Overview of Recent Research." *International Review of Social History* 53 (2008), supplement: 19–44.

The Cult of St. Ursula and the 11,000 Virgins. Ed. Jane Cartwright. Cardiff, 2016.

Cumming, Julie E. *The Motet in the Age of Dufay*. Cambridge, 1999.

———. "From Chapel Choirbook to Print Partbook and Back Again." In *Cappelle musicali fra corte, stato e chiesa nell'Italia del rinascimento*, ed. Franco Piperno et al., 373–403. Florence, 2007.

Cummings, Anthony M. "Toward an Interpretation of the Sixteenth-Century Motet." *JAMS* 34 (1981): 43–59.

———. "The Motet." In *European Music 1520–1640*, 130–56.

"Curiosités musicales (1): Confrairies de Sainte-Cécile." *Gazette Musicale de Paris* 2 (1835): 133–35.

D'Accone, Frank A. *The Civic Muse: Music and Musicians in Siena during the Middle Ages and the Renaissance*. Chicago, 1997.

Dagnigo, Eduardo. "I codici Sistini 239 a 242." *Note d'archivio* 10 (1933): 297–313.

Daolmi, Davide. "Jubal, Pythagoras and the Myth of the Origin of Music, with Some Remarks Concerning the Illumination of Pit (It. 568)." *Philomusica on-line* 16 (2017): 1–42. Online at http://dx.doi.org/10.13132/1826-9001/17.1894.

De Burbure, Léon. "Correspondance." *Le Guide Musical* [Brussels] 6 (1860), no. 41 (6 December): [1–2].

———. *Aperçu sur l'ancienne corporation des musiciens instrumentistes d'Anvers, dite de Saint-Job et de Sainte-Marie-Madeleine*. Brussels, 1862.

[De Santi, Angelo]."La 'Vertuosa compagnia de i musici di Roma' nel secolo XVI." *La civiltà cattolica* 69 (1918), vol. 2: 514–31.

De Santi, Angelo. "L'antica Congregazione di S. Cecilia fra i musici di Roma ed un Breve sconosciuto ed inedito di Sisto V del 1° maggio 1585." *La civiltà cattolica* 69 (1918), vol. 4: 482–94.

Dekeyzer, Brigitte. *Layers of Illusion: The Mayer van den Bergh Breviary*. Ghent, 2004.

Delehaye, Hippolyte. *Étude sur le légendier romain: Les Saints de novembre et de décembre*. Brussels, 1936.

Dempsey, George T. *Aldhelm of Malmesbury and the Ending of Late Antiquity*. Turnhout, 2015.

Denis, Valentin. "Saint Job, patron des musiciens." *Revue belge d'archéologie et d'histoire de l'art* 21 (1952): 253–98.

Dessì, Paula. *Cantantibus organis: Musica per i Francescani di Ravenna nei secoli XIII–XIV*. Bologna, 2002.

Deutsch, Otto Erich. "Parthenia and Cecilia." *Musical Times* 100 (1959): 591–92.

Ditchfield, Simon. *Liturgy, Sanctity and History in Tridentine Italy*. Cambridge, 1995.

The Divine Office in the Latin Middle Ages: Methodology and Source Studies, Regional Developments, Hagiography. Ed. Margot Fassler and Rebecca A. Baltzer. New York, 2000.

Docen, Bernhard Joseph. "Das Fest der heiligen Cäcilia." *Münchener allgemeine Musik-Zeitung* 1828, cols. 633–34.

Doorslaer, Georges van. "Académie Ste-Cécile, société de musiciens amateurs, à Maline au début du XVIIIᵉ siècle." *Bulletin du Cercle archéologique, littéraire et artistique de Malines* 12 (1903): 89–134.

———. *Notes sur les jubés et les maitrises des églises des SS. Pierre et Paul, de St-Jean, de Notre-Dame au dela de la Dyle et de St-Rombaut*. Mechelen, 1906.

Dressler, Gallus. *Præcepta musicæ poëticæ*. Ed. and trans. Robert Forgács. Urbana, IL, 2007.

Drogin, David J. "Art, Patronage, and Civic Identities in Renaissance Bologna." In *The Court Cities of Northern Italy*, ed. Charles M. Rosenberg, 244–324. New York, 2010.

Dumont, Sandrine. "Choirboys and *Vicaires* at the Maîtrise of Cambrai: A Socio-Anthropological Study (1550–1670)." In *Young Choristers, 650–1700*, ed. Susan Boynton and Eric N. Rice, 146–62. Woodbridge, 2008.

Dunning, Albert. *Die Staatsmottete, 1480–1555*. Utrecht, 1969.

Economopoulos, Harula. *Stefano Maderno scultore, 1571 ca.–1636: I maestri, la formazione, le opere giovanili*. Rome, 2013.

Eagen, Megan K. "The Articulation of Cultural Identity through Psalm Motets, Augsburg 1540–1585." PhD diss., University of North Carolina, 2016.

Elliott, Dyan. *Spiritual Marriage: Sexual Abstinence in Medieval Wedlock*. Princeton, NJ, 1993.

The Empire Resounds: Music in the Days of Charles V. Ed. Francis Maes. Leuven, 1999.

Essays on Music and Culture in Honor of Herbert Kellman. Ed. Barbara Haggh. Paris, 2001.

L'Estasi di Santa Cecilia di Raffaello da Urbino nella Pinacoteca Nazionale di Bologna. Ed. Andrea Emiliani et al. Bologna, 1983.

European Music, 1520–1640. Ed. James Haar. Woodbridge, 2006.

Evans, Willa McClung. *Henry Lawes, Musician and Friend of Poets*. New York, 1941.

Fabbri, Paolo. "Collezioni e strumenti musicali dall'Italia: Due frammenti per la biografia monteverdiana." In '*In Teutschland noch gantz ohnbekandt': Monteverdi-Rezeption und frühes Musiktheater im deutschsprachigen Raum*, ed. Markus Engelhardt, 265–73. Frankfurt, 1996.

Fabris, Dinko. *Music in Seventeenth-Century Naples: Francesco Provenzale (1624–1704)*. Abingdon, 2007.

Faietti, Marzia. "La trascrizione incisoria." In *L'Estasi di Santa Cecilia*, 186–205.

Fenlon, Iain. "An Imperial Repertory for Charles V." *SM* 13 (1984): 221–40.

Ferer, Mary Tiffany. "The Feast of St. John the Baptist: Its Background and Celebration in Renaissance Polyphony." PhD diss., University of Illinois, 1976.

———. "Thomas Crecquillon and the Cult of St. Cecilia." In *Beyond Contemporary Fame*, 125–39.

———. *Music and Ceremony at the Court of Charles V: The Capilla Flamenca and the Art of Political Promotion*. Woodbridge, 2012.

———. "Gombert, Thiebault, Crecquillon, Canis, Payen, and the Chapel of Charles V." *EM* 42 (2014): 191–206.

Ferrari, Maria Luisa. *Il tempio di San Sigismondo a Cremona: Storia e arte*. Milan, 1974.

Festa, Lisa Ann. "Representations of Saint Cecilia in Italian Renaissance and Baroque Painting and Sculpture." PhD diss., Rutgers University, 2004.

Field, Sean L. "Marie of Saint-Pol and Her Books." *English Historical Review* 125 (2010): 255–78.

Filedt Kok, Jan Piet, et al. *Cornelis Engebrechtsz: A Sixteenth-Century Leiden Artist and His Workshop*. Turnhout, 2014.

Filippi, Daniele V. "Formal Design and Sonic Architecture in the Roman Motet around 1570: Palestrina and Victoria." In *Tomás Luis de Victoria: Estudios / Studies*, ed. Javier Suárez-Pajares and Manuel del Sol, 163–98. Madrid, 2013.

Forney, Kristine K. "Music, Ritual, and Patronage at the Church of Our Lady, Antwerp." *EMH* 7 (1987): 1–57.

———. "16th-Century Antwerp." In *The Renaissance: From the 1470s to the End of the 16th Century*, ed. Iain Fenlon, 361–78. Basingstoke, 1989.

———. "The Role of Secular Guilds in the Musical Life of Renaissance Antwerp." In *Musicology and Archival Research*, 441–61.

———. Review of Henri Vanhulst, *Catalogue des éditions de musique publiées à Louvain par Pierre Phalèse et ses fils, 1545–1578*. *RBM* 46 (1992): 249–52.

———. "The Netherlands, 1520–1640." In *European Music, 1520–1640*, 246–79.

Freedman, Richard. *Music in the Renaissance*. New York, 2013.

Frey, Hermann-Walther. "Das Diarium der Sixtinischen Sängerkapelle in Rom für das Jahr 1594 (Nr. 19)." *Analecta musicologica* 14: 445–505.

Fris, V. *Uittreksels uit de Stadsrekeningen van Geeraardsbergen, van 1475 tot 1658*. Ghent, 1912.

Fromson, Michele. "A Conjunction of Rhetoric and Music: Structural Modelling in the Italian Counter-Reformation Motet." *JRMA* 117 (1992): 208–46.

Genie ohne Namen: Der Meister des Bartholomäus-Altars. Ed. Rainer Budde and Roland Krischel. Cologne, 2001.

Gillgren, Peter. *Siting Federico Barocci and the Renaissance Aesthetic*. Abingdon, 2011.

Glixon, Jonathan. *Honoring God and the City: Music at the Venetian Confraternities, 1260–1807*. Oxford, 2003.

———. "Singing Praises to God: Confraternities and Music." In *Companion to Medieval and Early Modern Confraternities*, ed. Konrad Eisenbichler, 329–44. Leiden, 2019.

Gonzálvez Ruiz, Ramón. Commentary on the antiphonary E-Tc 44-1. In *Hispania vetus: Musical-Liturgical Manuscripts from Visigothic Origins to the Franco-Roman Transition (9th–12th Centuries)*, ed. Susana Zapke, 400. Bilbao, 2007.

Granger, Sylvie. "La Feste de Madame Sainte Cécile (Le Mans, 1633)." In *Les Cérémonies extraordinaires du Catholicisme baroque*. Ed. Bernard Dompnier, 113–32. Clermont-Ferrand, 2009.

Gregoir, Édouard. "Notice sur le Carillon, avec des extraits des archives de la cathédrale et de la ville d'Anvers, concernant les ménétriers, les jeux de cloches, etc." In *Messager des sciences historiques*, 459–74. Ghent, 1870.

Guéranger, Prosper. *Histoire de Sainte Cécile vierge romaine et martyre*. 2nd ed. Paris, 1853. English translation: *Life of Saint Cecilia Virgin and Martyr*. Philadelphia, 1866.

Guignard, Philippe. *Mémoires fournis aux peintres chargés d'exécuter les cartons d'une tapisserie destinée à la Collégiale St-Urbain de Troyes, représentant les légendes de St Urbain et de Ste Cécile*. Troyes, 1851.

Gulley, Alison. *The Displacement of the Body in Ælfric's Virgin Martyr Lives*. Abingdon, 2014.

Haagen, Jan Karel van der. *De heilige Caecilia in legende en kunst*. [The Hague], 1930.

Haggh, Barbara. "The Meeting of Sacred Ritual and Secular Piety: Endowments for Music." In *Companion to Medieval and Renaissance Music*, ed. Tess Knighton and David Fallows, 60–68. London, 1992.

———. "Foundations or Institutions? On Bringing the Middle Ages into the History of Medieval Music." *Acta musicologica* 68 (1996): 87–128.

———. "Nonconformity in the Use of Cambrai Cathedral." In *The Divine Office in the Latin Middle Ages*, 372–97.

———. "The Aldermen's Registers as Sources for the History of Music in Ghent." In *"La la la . . . Maitre Henri": Mélanges de musicologie offerts à Henri Vanhulst*, ed. Christine Ballman and Valérie Dufour, 27–54. Turnhout, 2009.

Ham, Martin. "Thomas Crecquillon in Context: A Reappraisal of His Life and of Selected Works," PhD diss., University of Surrey, 1998.

———. "The Stonyhurst College Partbooks, the Madrigal Society, and a Diplomatic Gift to Edward VI." *TVNM* 63 (2013): 3–64.

Hand, Joni M. *Women, Manuscripts and Identity in Northern Europe, 1350–1550.* Abingdon, 2013.

Hanning, Barbara Russano, "From Saint to Muse: Representations of Saint Cecilia in Florence." *Music in Art* 29 (2004): 91–103.

Harney, Eileen Marie. "The Sexualized and Gendered Tortures of Virgin Martyrs in Medieval English Literature." PhD diss., University of Toronto, 2008.

Hatter, Jane D. *Composing Community in Late Medieval Music: Self-Reference, Pedagogy, and Practice.* Cambridge, 2019.

Hayburn, Robert F. *Papal Legislation on Sacred Music, 95 A.D. to 1977 A.D.* Collegeville, MN, 1979.

Hesbert, René-Jean. *Corpus antiphonalium officii,* 6 vols. Rome, 1963–1979.

Den heyligen Sant al in Brabant: De Sint-Martinuskerk van Wezemaal en de cultus van Sint-Job, 1000–2000. Ed. Bart Minnen. 2 vols. Averbode, 2011.

Hindman, Sandra, et al. *Illuminations in the Robert Lehman Collection.* New York, 1997.

Hoekstra, Gerald R. "Andreas Pevernage's *Cantiones Sacrae* (1578) as a Counter-Reformation Statement of Confessional Loyalty in the Low Countries." *SCJ* 44 (2013): 3–24.

Hollstein, F. W., et al. *Dutch and Flemish Etchings, Engravings and Woodcuts, ca. 1450–1700.* 32 vols. Amsterdam, 1949–2010.

———. *The New Hollstein: Dutch and Flemish Etchings, Engravings and Woodcuts, 1450–1700.* Roosendaal, 1993–.

Hüschen, Heinrich. "Lob- und Preismotetten auf die Musik aus früheren Jahrhunderten." In *Musicae scientiae collectanea: Festschrift Karl Gustav Fellerer,* 225–42. Cologne, 1973.

Husk, William Henry. *An Account of the Musical Celebrations of St. Cecilia's Day in the Sixteenth, Seventeenth and Eighteenth Centuries. To which is appended a collection of Odes on St. Cecilia's Day.* London, 1857.

Huybens, Gilbert. "Bronnen voor de geschiedenis van het muziekleven te Leuven in de 16e eeuw (1471–1594)." In *Muziek te Leuven in de 16e eeuw,* ed. Gilbert Huybens, 34–37. Leuven, 1982.

Jackson, Susan. "Berg and Neuber: Music Printers in Sixteenth-Century Nuremberg." PhD diss., City University of New York, 1998.

Jacobus de Voragine. *Legenda aurea,* ed. Th. Graesse. 3rd ed. Breslau, 1890. English translation, London, 1900.

James, Charles Aaron. "Transforming the Motet: Sigmund Salminger and the Adaptation and Reuse of Franco-Flemish Polyphony in Reformation Augsburg." PhD diss., Eastman School of Music, 2016.

———. "*Salve regina Barbara*: The Adaptation and Reuse of Marian Motets." *EM* 45 (2017): 217–30.

Jas, Eric. *Piety and Polyphony in Sixteenth-Century Holland: The Choirbooks of St. Peters Church, Leiden.* Woodbridge, 2018.

Jocoy, Stacey. "'Welcome to All the Pleasures': The Political Motivations of the St. Cecilia's Day Celebrations." Paper read at the annual meeting of the American Musicological Society, 2013; abstract published in *AMS 2013, Pittsburgh, 7–10 November, Program & Abstracts,* ed. Dana Gooley, 188.

Jones, Pamela M. *Altarpieces and Their Viewers in the Churches of Rome from Caravaggio to Guido Reni*. Aldershot, 2008.

Kämpf, Tobias. "Framing Cecilia's Sacred Body: Paolo Camillo Sfondrato and the Language of Revelation." *Sculpture Journal* 6 (2001): 10–20.

———. *Archäologie offenbart: Cäciliens römisches Kultbild im Blick einer Epoche*. Leiden, 2015.

Kane, Tina. *The Troyes Mémoire: The Making of a Medieval Tapestry*. Woodbridge, 2010.

Kelly, James E. *English Convents in Catholic Europe, c. 1600–1800*. Cambridge, 2020.

Kelly, Henry Ansgar. "How Cecilia Came to Be a Saint and Patron (Matron?) of Music." In *The Echo of Music: Essays in Honor of Marie Louise Göllner*, ed. Blair Sullivan, 3–18. Warren, MI, 2004.

Kendrick, Robert L. *The Sounds of Milan, 1585–1650*. New York, 2002.

Kidwell, Susan. "*Gaude virgo Katherina*: The Veneration of St. Katherine in Fifteenth-Century England." *Explorations in Renaissance Culture* 25 (1999): 19–40.

Király, Péter. "Königin Maria von Habsburg und die Musik." In *Maria von Ungarn (1505–1558): Eine Renaissancefürstin*, ed. Martina Fuchs and Orsolya Réthelyi, 363–79. Münster, 2007.

Kirk, Douglas. "A Tale of Two Queens, Their Music Books, and the Village of Lerma." In *Pure Gold: Golden Age Sacred Music in the Iberian World*, ed. Tess Knighton and Bernadette Nelson, 79–92. Kassel, 2011.

Kolve, V. A. "Chaucer's *Second Nun's Tale* and the Iconography of Saint Cecilia." In *New Perspectives in Chaucer Criticism*, ed. Donald M. Rose, 137–74. Norman, OK, 1981; reprinted in V. A. Kolve, *Telling Images: Chaucer and the Imagery of Narrative II* (Stanford, CA, 2009), chapter 7.

Kottick, Edward L. *A History of the Harpsichord*. Bloomington, IN, 2003.

Krämer, Reiner. "The *Supplementum* in Motets: Style and Structure." Paper given at the 9th European Music Analysis Conference (Euromac 9); abbreviated version online on the conference website. Longer unpublished version: "The *Supplementum* in Renaissance Motets: Style and Structure."

Kren, Thomas, and Scot McKendrick. *Illuminating the Renaissance: The Triumph of Flemish Manuscript Painting in Europe*. Los Angeles, 2003.

Kurtzman, Jeffrey. "Polyphonic Psalm and Canticle Antiphons for Vespers, Compline and Lauds Published in Italy in the Sixteenth and Seventeenth Centuries." In *Barocco padano* 7, ed. Alberto Colzani et al., 583–644. Como, 2012.

———. "Motets, Vespers Antiphons and the Performance of the Post-Tridentine Liturgy in Italy." In *Mapping the Motet in the Post-Tridentine Era*, 36–56.

La Bella, Carlo, et al. *Santa Cecilia in Trastevere*. Rome, 2007.

Lacroix, A. *Souvenirs sur Jacques de Guise, historien du Hainaut; la chambre de rhétorique; la confrérie de Sainte-Cécile, e l'Académie des Beaux-Arts de la ville de Mons*. Mons, 1846.

Lambert, J. Malet. *Two Thousand Years of Gild Life*. Hull, 1891.

Lanéry, Cécile. "Nouvelles recherches d'hagiographie arnobienne: la Passion de Cécile (*BHL 1495*)." In "*Parva pro magnis munera*": *Études de littérature latine tardo-antique et médiévale offertes à François Dolbeau par ses élèves*, ed. Monique Goullet, 533–59. Turnhout, 2009.

Lapidge, Michael. *The Roman Martyrs: Introduction, Translations, and Commentary*. Oxford, 2018.

[Lebeuf, Jean]. "Lettre de M *** à M. H. Chanoine de l'Eglise Cathedrale de *** sur

le choix que les Musiciens ont fait de Ste. Cécile pour leur patronne." *Mercure de France*, January 1732, 21–45.

Leech, Peter, and Maurice Whitehead. "'Clamores omnino atque admirationes excitant': New Light on Music and Musicians at St. Omers English Jesuit College, 1658–1714." *TVNM* 66 (2016): 123–48.

Lefferts, Peter M. "Cantilena and Antiphon: Music for Marian Services in Late Medieval England." *CM* 45–47 (1990): 247–82.

Leggendario delle vite de' santi. Translated by Nicolo Manerbio. Venice, 1584.

Leitmeir, Christian Thomas. *Jacobus de Kerle (1531/32–1591): Komponieren im Spannungsfeld von Kirche und Kunst.* Turnhout, 2009.

———. "How Many Keys Are There to a Lock? Contextualizing a 16th-Century Motet." In *Uno gentile e subtile ingenio: Studies in Renaissance Music in Honor of Bonnie J. Blackburn*, ed. M. Jennifer Bloxam and Gioia Filocamo, 441–52. Turnhout, 2009.

———. "Beyond the Denominational Paradigm: The Motet as Confessional(ising) Practice in the Later Sixteenth Century." *Mapping the Motet in the Post-Tridentine Era*, 156–95.

Lesure, François. "La Communauté des joueurs d'instruments au XVIe siecle." *Revue historique de droit français et étranger* 1 (1953): 79–109.

Ley, Klaus. *Caecilia, Tosca, Carmen: Brüche und Kontinuitäten im Verhältnis von Musik und Welterleben.* Tübingen, 2006.

Leyenda de los santos. Toledo, 1554.

Lightbourne, Ruth. "Annibale Stabile: A Man of No Little Repute among the Masters of Music." PhD diss., University of Otago, 1994.

Lincoln, Harry B. *The Latin Motet: Indexes to Printed Collections, 1500–1600.* Ottawa, 1993.

Lingo, Stuart. *Federico Barocci: Allure and Devotion in Late Renaissance Painting.* New Haven, CT, 2008.

Lirosi, Alessia. "Il corpo di santa Cecilia (Roma, III–XVII secolo)." *Mélanges de l'École française de Rome* 122 (2010): 5–51.

Llorens, José M. *Capellae Sixtinae codices.* Vatican City, 1960.

Lo Bianco, Anna. *Cecilia: La storia, l'immagine, il mito. La scultura di Stefano Maderno e il suo restauro.* Rome, 2001.

Long, Sarah Ann. *Music, Liturgy, and Confraternity Devotions in Paris and Tournai, 1300–1550.* Rochester, NY, 2021.

Lovewell, Bertha Ellen. *The Life of St. Cecilia from Ms. Ashmole 43 and Ms. Cotton Tiberius E. VII.* Boston, 1898.

Lowinsky, Edward E. *Music in the Culture of the Renaissance and Other Essays.* Chicago, 1989.

Luckett, Richard. "St. Cecilia and Music." *Proceedings of the Royal Musical Association* 99 (1972–1973): 15–30.

Lyon, Elizabeth L. "'Magis corde quam organo': Agazzari, Amadino, and the Hidden Meanings of *Eumelio*." *EM* 48 (2020): 157–76.

Macey, Patrick. "Josquin as Classic: *Qui habitat, Memor esto*, and Two Imitations Unmasked." *JRMA* 118 (1993): 1–43.

MacGregor, Neil. *A Victim of Anonymity: The Master of the Saint Bartholomew Altarpiece.* London, 1993.

Mackenny, Richard. *Venice as the Polity of Mercy: Guilds, Confraternities, and the Social Order, c. 1250–c. 1650.* Toronto, 2019.

Mancuso, Margaret A. "Serafino Razzi's *Libro primo delle laudi spirituali* (Venice, Rampazetto for Giunti, 1563)." MA thesis, California State University, Long Beach, 1984.

Mantuanus, Baptista. *Cecilie viraginis romanae et merito castitatis et fortitudinis in martyrio incomparabilis agon*. Paris, 1509.

Mapping the Motet in the Post-Tridentine Era. Ed. Esperanza Rodríguez-García and Daniele V. Filippi. Abingdon, 2019.

Marchi, Lucia. "For Whom the Fire Burns: Medieval Images of Saint Cecilia and Music." *Recercare* 27 (2015): 5–22.

Marciari, John, and Suzanne Boorsch. *Francesco Vanni: Art in Late Renaissance Siena*. New Haven, CT, 2013.

Marien, Steven, and Bart Minnen. "Sint-Job en het muziekleven te Wezemaal." In *Den heyligen Sant al in Brabant*, vol. 2, 281–99.

Marnef, Guido. *Antwerp in the Age of Reformation: Underground Protestantism in a Commercial Metropolis, 1550–1577*. Baltimore, 1996.

Martínez, Víctor J. "Un virginal en la corte de Felipe II." Article dated 1 June 2015, online at https://www.instrumentosantiguos.es/un-virginal-en-la-corte-de-felipe-ii.

Mason, Lesa. "A Late Medieval Cologne Artistic Workshop: The Master of the Holy Kinship the Younger." PhD diss., Indiana University, 1991.

Massaut, Jean-Pierre. *Josse Clichtove, l'humanisme, et la réforme du clergé*. Liège, 1968.

Masure, Hadewijch. "'And Thus the Brethren Shall Meet All Together': Active Participation in Antwerp Confraternities, c. 1375–1650." In *Antwerp in the Renaissance*, ed. Bruno Blondé and Jeroen Puttevils, 107–29. Turnhout, 2020.

Maurey, Yossi. *Medieval Music, Legend, and the Cult of St. Martin*. Cambridge, 2014.

Mazzi, Curzio. *La congrega dei rozzi di Siena nel secolo XVI*. Florence, 1882.

McKendrick, Scot, et al. *The Isabella Breviary: The British Library, London, Add. Ms. 18851*. Barcelona, 2012.

Meyer-Baer, Kathi. "St. Job as Patron of Music." *Art Bulletin* 36 (1954): 21–31.

———. "Saints of Music." *MD* 9 (1955): 11–33.

Minnen, Bart. "De Sint-Martinuskerk van Wezemaal en de cultus van Sint-Job, 1000–2000." In *Den heyligen Sant al in Brabant*, vol. 1, 27–348.

Mirimonde, Albert P. de. *Sainte-Cécile: Métamorphoses d'un thème musical*. Geneva, 1974.

Missale ad usum insignis ecclesiae Eboracensis. Ed. W. G. Henderson. 2 vols. Durham, 1874.

Missale Ambrosianum Gasparis S. Mediolanensis ecclesiae archiepiscopi iussu recognitum et editum. Milan, 1594.

Missale mixtum secundum ordinem almae primatis ecclesiae Toletanae. Lyon, 1551.

Missale parvum secundum usum venerabilis ecclesie Cameracensis. Paris, 1507.

Missale s[e]c[un]d[u]m ritum Augustensis ecclesie. Augsburg, 1510.

[*Missale secundum usum ecclesiae Venetensis*]. Paris, 1535.

Montagu, Jeremy. "Musical Instruments in Hans Memling's Paintings." *EM* 35 (2007): 505–24.

Montanari, Tomaso. "Una nuova fonte per l'invenzione del corpo di santa Cecilia: Testimoni oculari, immagini e dubbi." *Marburger Jahrbuch für Kunstwissenschaft* 32 (2005): 149–65.

Montgomery, Scott B. *St. Ursula and the Eleven Thousand Virgins of Cologne: Relics, Reliquaries and the Visual Culture of Group Sanctity in Late Medieval Europe*. Bern, 2009.

Mossakowski, Stanisław. "Raphael's 'St. Cecilia': An Iconographical Study."
 Zeitschrift für Kunstgeschichte 31 (1968): 1–26.

Musicology and Archival Research. Ed. Barbara Haggh et al. Brussels, 1994.

Neal, Brandi A. "The Multivoice Sacred Music of Nicolas Gombert: A Critical Ex-
 amination." PhD diss., University of Pittsburgh, 2011.

Nosow, Robert. *Ritual Meanings in the Fifteenth-Century Motet.* Cambridge, 2012.

Ogilvie, Sheilagh. *The European Guilds: An Economic Analysis.* Princeton, NJ, 2019.

O'Regan, Noel. "Sacred Polychoral Music in Rome 1575–1621." PhD diss., University
 of Oxford, 1988.

———. "The Performance of Roman Sacred Polychoral Music in the Late Sixteenth
 and Early Seventeenth Centuries: Evidence from Archival Sources." *Performance
 Practice Review* 8 (1995): 107–46.

———. "Marenzio's Sacred Music: The Roman Context." *EM* 27 (1999): 608–20.

———. "Italy, 1560–1600." In *European Music, 1520–1640,* 75–90.

———. "The Organisation of Marenzio's *Motectorum pro festis totius anni cum com-
 muni sanctorum* of 1585." In *Miscellanea marenziana,* ed. Maria Teresa Rosa Barez-
 zani and Antonio Delfino, 49–70. Pisa, 2007.

———. "Palestrina's Mid-Life Compositional Summary: The Three Motet Books of
 1569–1575." In *Mapping the Motet in the Post-Tridentine Era,* 102–22.

Owens, Jessie Ann. *Composers at Work: The Craft of Musical Composition, 1450–1600.*
 New York, 1997.

Pacquay, Valentijn. "Breda, Bredanaars en de Onze-Lieve-Vrouwekerk: Religie, devo-
 ties en manifestaties voor 1590." *Jaarboek De Oranjeboom* 54 (2001): 1–89.

Passio sanctae Caeciliae. See under Arnobius the Younger.

Persoons, Guido. "Joannes I Bogardus, Jean II Bogard en Pierre Bogard als mu-
 ziekdrukkers te Douai van 1574 tot 1633 en hun betrekkingen met de Officina
 Plantiniana." *De Gulden Passer* 66–67 (1988–1989): 613–66.

Petey-Girard, Bruno. "Dorat, Henri III et la Confrairie de Saincte Cécile." In *Jean
 Dorat: Poète humaniste de la Renaissance,* ed. Christine de Buzon and Jean-Eudes
 Girot, 95–113. Geneva, 2007.

Pirrotta, Nino. "*Dolce affetti*: I musici di Roma e il madrigale." *SM* 14 (1985):
 59–104.

Platnauer, Maurice. *Latin Elegiac Verse: A Study of the Metrical Usages of Tibullus,
 Propertius and Ovid.* Cambridge, 1951.

Plotzek, Joachim M. *Andachtsbücher des Mittelalters aus Privatbesitz.* Cologne, 1987.

Pogue, Samuel. *Jacques Moderne: Lyons Music Printer of the Sixteenth Century.* Geneva,
 1969.

———. "A Sixteenth-Century Editor at Work: Gardane and Moderne." *JM* 1 (1982):
 217–38.

Poulton, Charlotte Tanner. "The Sight of Sound: Resonances between Music and
 Painting in Seventeenth-Century Italy." PhD diss., University of York, 2009.

Powers, Harold S. "Tonal Types and Modal Categories in Renaissance Polyphony."
 JAMS 34 (1981): 428–70.

Prizer, William F. "Charles V, Philip II, and the Order of the Golden Fleece." In *Es-
 says on Music and Culture in Honor of Herbert Kellman,* 161–88.

Processionale insignis cathedralis ecclesiae Antverpiensis B. Mariae. Antwerp, 1574.

Processionale ordinis Cisterciensis. Paris, 1674.

Processionale, ritibus Romanae ecclesiae accomodatum. Antwerp, 1629.

Processionale sacri ordinis Praedicatorum. Paris, 1647.

Processionale, secundum ritum ecclesiae et ordinis Praemonstratensis. Paris, 1574.

Puy de musique érigé à Évreux, en l'honneur de madame sainte Cécile. Ed. Théodose Bonnin and Alphonse Chassant. Évreux, 1837.

Quereau, Quentin W. "Aspects of Palestrina's Parody Procedure." *JM* 1 (1982): 198–216.

Reames, Sherry L. "The Sources of Chaucer's 'Second Nun's Tale." *Modern Philology* 76 (1978): 111–35.

———. "The Cecilia Legend as Chaucer Inherited It and Retold It: The Disappearance of an Augustinian Ideal." *Speculum* 55 (1980): 38–57.

———. *The Legenda Aurea: A Reexamination of Its Paradoxical History.* Madison, 1985.

———. "A Recent Discovery Concerning the Sources of Chaucer's 'Second Nun's Tale.'" *Modern Philology* 87 (1990): 337–61.

———. "The Office for St. Cecilia." In *The Liturgy of the Medieval Church*, ed. Thomas J. Heffernan and E. Ann Matter, 245–70. Kalamazoo, MI, 2001.

Reid, Dylan. "Moderate Devotion, Mediocre Poetry and Magnificent Food: The Confraternity of the Immaculate Conception of Rouen." *Confraternitas* 7 (1996): 3–10.

———. "The Virgin and Saint Cecilia: Music and the Confraternal Puys of Rouen." *Confraternitas* 8 (1997): 3–7.

———. "Patrons of Poetry: Rouen's Confraternity of the Immaculate Conception of Our Lady." In *The Reach of the Republic of Letters: Literary and Learned Societies in Late Medieval and Early Modern Europe*, vol. 1, ed. Arjan van Dixhoorn and Susie Speakman Sutch, 33–78. Leiden, 2008.

Rice, Eugene F., Jr. *Saint Jerome in the Renaissance.* Baltimore, 1985.

Rice, John A. "Palestrina's Saint Cecilia Motets and the Missa 'Cantantibus organis.'" In *Palestrina e l'Europa*, ed. Giancarlo Rostirolla et al., 817–29. Palestrina, 2006.

Roberts, Ann M. "The City and the Convent: *The Virgin of the Rose Garden* by the Master of the Legend of Saint Lucy." *Bulletin of the Detroit Institute of Arts* 72 (1998): 56–65.

Robertson, Clare. *Rome 1600: The City and the Visual Arts under Clement VIII.* New Haven, CT, 2015.

Roelvink, Véronique. *Gegeven den sangeren: Meerstemmige muziek bij de Illustre Lieve Vrouwe Broederschap te 's-Hertogenbosch in de zestiende eeuw.* 's-Hertogenbosch, 2002.

———. *Gheerkin de Hondt: A Singer-Composer in the Sixteenth-Century Low Countries.* Utrecht, 2015.

Roo, Gerard van. *Convivium cantorum.* Munich, 1585.

Rostirolla, Giancarlo. *L'archivio musicale della Basilica di San Giovanni in Laterano: Catalogo dei manoscritti e delle edizioni (secc. XVI–XX).* Rome, 2002.

Rothenberg, David J. *The Flower of Paradise: Marian Devotion and Secular Song in Medieval and Renaissance Music.* Oxford, 2011.

Rudolf, Homer. "The Life and Works of Cornelius Canis." PhD diss., University of Illinois, 1977.

———. "St. Cecilia, Patron Saint of Music." Unpublished paper, 1984.

———. "Cologne, Convents, Commissions, and the Cult of St. Cecilia." Unpublished paper read at the spring meeting of the Capital Chapter of the American Musicological Society, April 1996, and the Annual Meeting of the Renaissance Society of America, Bloomington, IN, April 1996.

Ruini, Cesarino. "Edizioni musicali perdute e musicisti ignoti nella *Notitia de' contrapuntisti e compositori di musica* di Giuseppe Ottavio Pitoni." In *Musicologia*

Humana: Studies in Honor of Warren and Ursula Kirkendale, ed. Siegfried Gmein-wieser et al., 417–42. Florence, 1994.

Santa Cecilia Martire Romana: Passione e culto. Ed. Filippo Caraffa and Antonio Mas-sone. [Rome, 1983].

Salokar, Douglas. "'Ad augmentationem divini cultus': Pious Foundations and Vespers Motets in the Church of Our Lady in Bruges." In *Musicology and Archival Research*, 306–25.

Schiltz, Katelijne. *Music and Riddle Culture in the Renaissance*. Cambridge, 2015.

Schlagel, Stephanie P. "The *Liber selectarum cantionum* and the 'German Josquin Renaissance.'" *JM* 19 (2002): 564–615.

Schlager, Karl-Heinz. *Thematischer Katalog der ältesten Alleluia-Melodien*. Munich, 1965.

Schmidt-Görg, Joseph. *Nicolas Gombert, Kapellmeister Kaiser Karls V.: Leben und Werk*. Bonn, 1938.

Schrevel, Arthur Carolus de. *Histoire du Séminaire de Bruges*, vol. 1. Bruges, 1895.

Schubert, Peter N. "Hidden Forms in Palestrina's First Book of Motets." *JAMS* 60 (2007): 483–556.

Scott, Eva. *The King in Exile: The Wanderings of Charles II from June 1646 to July 1654*. London, 1905.

———. *The Travels of the King: Charles II in Germany and Flanders, 1654–1660*. London, 1907.

"The Second Nun's Prologue and Tale." Ed. Sherry L. Reames. In *Sources and Ana-logues of the Canterbury Tales*, vol. 1, ed. Robert M. Correale and Mary Hamel, 491–528. Cambridge, 2002.

Seebass, Tilman. "Lady Music and Her *Protégés* from Musical Allegory to Musicians' Portraits." *MD* 42 (1988): 23–61.

Shephard, Tim, Sanna Raninen, Serenella Sessini, and Laura Stefanescu. *Music in the Art of Renaissance Italy, 1420–1540*. Turnhout, 2020.

Slocum, Kay Brainerd. "Confrérie, Bruderschaft and Guild: The Formation of Musi-cians' Fraternal Organisations in Thirteenth- and Fourteenth-Century Europe." *EMH* 14 (1995): 257–74.

Smijers, Albert, "De Illustre Lieve Vrouwe Broederschap te 's-Hertogenbosch: Ar-chivalia bijeengebracht door dr. A. Smijers." *TVNM* 13 (1932): 46–100, 181–237; 14 (1932–1935): 48–105; 16 (1940–1946): 63–106, 216; 17 (1948–1955): 195–230.

———. "Music at the Illustrious Confraternity of Our Lady at 's-Hertogenbosch from 1330 to 1600." *Papers Read by Members of the American Musicological Society at the Annual Meeting*, 1939, 184–92.

———. "Meerstemmige musiek van de Illustre Lieve Vrouwe Broederschap te 's-Hertogenbosch." *TVNM* 16 (1940–1946): 1–30.

Smith, Liesl Ruth. "Virginity and the Married-Virgin Saints in Ælfric's *Lives of Saints*: The Translation of an Ideal." PhD diss., University of Toronto, 2000.

Spiessens, Godelieve. "Geschiedenis van de gilde van de Antwerpse speellieden, bijgenaamd Sint-Job en Sint-Maria-Magdalena (Deel 1: XVIde eew)." *RBM* 22 (1968): 5–50.

———. "*Zingende kelen moeten gesmeerd worden*: Stedelijke wijnschenkingen, drink-gelden en bieraccijnzen voor de zangers van de Antwerpse hoofdkerk (1530–1681)." In *Musicology and Archival Research*, 411–40.

Staiti, Nico. *Le metamorfosi di Santa Cecilia: L'immagine e la musica*. Innsbruck and Lucca, 2002.

Stevenson, Jane. "The Tixall Circle and the Musical Life of St. Monica's, Louvain." *British Catholic History* 33 (2017): 583–602.

Stirrup, Emma. "Time Concertinaed at the Altar of Santa Cecilia in Trastevere." In *Rome: Continuing Encounters between Past and Present*, ed. Dorigen Caldwell and Lesley Caldwell, 57–78. Farnham, 2011.

Straeten, Edmond vander. *La Musique aux Pays-Bas avant le XIX siècle*. 8 vols. Brussels, 1867–1888.

Strainchamps, Edmond. "New Light on the Accademia degli Elevati of Florence." *Musical Quarterly* 62 (1976): 507–35.

Strohm, Reinhard. *Music in Late Medieval Bruges*. 2nd ed. Oxford, 1990.

Summers, William J. "The *Compagnia dei Musici di Roma*, 1584–1604: A Preliminary Report." *CM* 34 (1982): 7–25.

Suykerbuyk, Ruben. "The Matter of Piety: Material Culture in Zoutleeuw's Church of Saint Leonard (c. 1450–1620)." PhD diss., Universiteit Gent, 2017.

———. *The Matter of Piety: Zoutleeuw's Church of Saint Leonard and Religious Material Culture in the Low Countries (c. 1450–1620)*. Leiden, 2020.

Tanzi, Marco. *I Campi*. Milan, 2004.

Teviotdale, Elizabeth C. "The Invitation to the Puy d'Évreux." *CM* 52 (1993): 7–26.

Thijs, Alfons K. L. "Religion and Social Structure: Religious Rituals in Pre-Industrial Trade Associations in the Low Countries." In *Craft Guilds in the Early Modern Low Countries*, chapter 6.

Thomas, Jennifer. "The Core Motet Repertory of 16th-Century Europe: A View of Renaissance Musical Culture." In *Essays on Music and Culture in Honor of Herbert Kellman*, 335–76.

Thompson, Glenda Goss. "Mary of Hungary and Music Patronage." *SCJ* 15 (1984): 401–18.

Torelli, Daniele. *Benedetto Binago e il mottetto a Milano tra Cinque e Seicento*. Lucca, 2004.

Travagliato, Giovanni, and Mauro Sebastianelli. *Da Riccardo Quartararo a Cristoforo Faffeo: Un capolavoro del Museo Diocesano di Palermo restaurato e riscoperto*. Palermo, 2016.

Trio, Paul, and Barbara Haggh. "Confraternities in Ghent and Music." In *Musicology and Archival Research*, 44–90.

Tudela, Almudena Pérez de. "Michiel Coxcie, Court Painter." In *Michiel Coxcie 1499–1592 and the Giants of His Age*, ed. Koenraad Jonckeere, 100–115. London, 2013.

Uhrin, Dorottya. "Rediscovering the Virgin Martyrs in Medieval Central Europe: The Case of the Cult of Saint Dorothy in Hungary." *Il capitale culturale* 21 (2020): 119–43.

Valentini, Anna. "Iconografia musicale a Ferrara tra XVI e XVII secolo," tesi di dottorato. Università degli Studi di Padova, 2012.

Vanhulst, Henri. *Catalogue des éditions de musique publiées à Louvain par Pierre Phalèse et ses fils, 1545–1578*. Brussels, 1990.

Vendrix, Philippe. "La tentation munichoise: Sur l'émigration des musiciens flamands et liégeois durant la seconde moitié du 16e siècle." 2004. Online at https://halshs.archives-ouvertes.fr/halshs-00982440/document.

Vignau-Wilberg, Thea. *Niederländische Bildmotetten und Motettenbilder: Multimediale Kunst um 1600*. Altenburg, 2013.

Voigt, Martin. *Die St. Johanniskirche in Lüneburg: Der Erzählschatz mittelalterlicher Kirchen*. Berlin, 2012.

Vos, Dirk de. *Hans Memling: The Complete Works*. London, 1994.

Wainwright, Jonathan P. "Richard Dering's Few-Voice 'Concertato' Motets." *Music and Letters* 89 (2008): 165–94.

———. "Sounds of Piety and Devotion: Music in the Queen's Chapel." In *Henrietta Maria: Piety, Politics and Patronage*, ed. Erin Griffey, 195–213. Aldershot, 2008.

Waldner, Franz. "Zwei Inventarien aus dem XVI. und XVII. Jahrhundert über hinterlassene Musikinstrumente und Musikalien am Innsbrucker Hofe." *Studien zur Musikwissenschaft* 4 (1916): 128–47.

Wegman, Rob. "Music and Musicians at the Guild of Our Lady in Bergen op Zoom, c. 1470–1510." *EMH* 9 (1990): 175–249.

———. "From Maker to Composer: Improvisation and Musical Authorship in the Low Countries, 1450–1500." *JAMS* 49 (1996): 409–79.

Weigert, Laura. *Weaving Sacred Stories: French Choir Tapestries and the Performance of Clerical Identity*. Ithaca, NY, 2004.

Weissman, Ronald F. E. "Cults and Contexts: In Search of the Renaissance Confraternity." In *Crossing the Boundaries: Christian Piety and the Arts in Italian Medieval and Renaissance Confraternities*, ed. Konrad Eisenbichler, 201–20. Kalamazoo, MI, 1991.

White, Bryan. *Music for St. Cecilia's Day: From Purcell to Handel*. Woodbridge, 2019.

Wiebe, Paul. "To Adorn the Groom with Chaste Delights: Tafelmusik at the Weddings of Duke Ludwig of Württemberg (1585) and Melchior Jäger (1586)." *Musik in Baden-Württemberg: Jahrbuch 6* (1999): 63–99.

Wiesner-Hanks, Merry E. "Guild Members and Guilds." In *Women and Gender in Medieval Europe: An Encyclopedia*, ed. Margaret Schaus, 337–38. New York, 2006.

Williams, Peter. *The Organ in Western Culture, 750–1250*. Cambridge, 1993.

Winstead, Karen A. *Virgin Martyrs: Legends of Sainthood in Late Medieval England*. Ithaca, NY, 1997.

Wolk-Simon, Linda. *Raphael at the Metropolitan: The Colonna Altarpiece*. New York, 2006.

Wright, Craig. *Music and Ceremony at Notre Dame of Paris, 500–1550*. Cambridge, 1989.

Writing Women Saints in Anglo-Saxon England. Ed. Paul E. Szarmach. Toronto, 2013.

MUSICAL EDITIONS

Alleluia-Melodien. Ed. Karl-Heinz Schlager. 2 vols. Kassel, 1968, 1987.

Anonymous. *Dum aurora finem daret*. Ed. John A. Rice (*RRMR*, forthcoming).

———. *Puram Christo te dedisti*. In *Collection of Middle Dutch and Latin Sacred Songs, ca. 1500: Brussels, Royal Library, MS II 270*. Ed. Bruno Bouckaert et al. Leuven, 2005.

Baston, Josquin. *Virgo gloriosa Cecilia*. Ed. John A. Rice (*RRMR*, forthcoming).

Bianciardi, Francesco. *Opera omnia*. 6 vols. Ed. Siro Cisilino and Lodovico Bertazzo. Padua, 1973–1978.

———. *Psallite cantantes Domino*. Ed. John A. Rice (*RRMR*, forthcoming).

Blondet, Abraham. *La Céciliade*. Ed. John S. Powell. Tulsa, OK, 2003.

Bonhomme, Pierre. *Dum aurora finem daret*. Ed. Christopher Shaw. Bath, 2017. Ed. John A. Rice (*RRMR*, forthcoming).

Boyleau, Simon. *Motetta quatuor vocum (1544)*. Ed. Sally Watt. Melbourne, 2009.

Bultel, Jacob. *Dum aurora finem daret*. Ed. John A. Rice (*RRMR*, forthcoming).

Cardillo, Jacopo Antonio. *Cantantibus organis*. Ed. Christopher Shaw. Bath, 2017.

Carette. *Cantantibus organis*. Ed. Richard Sherr. New York, 1999 (*SCM*, vol. 10).

———. *Laudemus Dominum*. Ed. Richard Sherr. New York, 1999 (*SCM*, vol. 10).

Castro, Jean de. *Sacrarum cantionum liber unus*. Ed. Harald Kümmerling. Düsseldorf, 1974 (*DRM* 17).

———. *Novae cantiones sacrae*. Ed. Harald Kümmerling. Düsseldorf, 1975 (*DRM* 18).

Certon, Pierre. *Cantantibus organis*. Ed. Christopher Shaw. Bath, 2019; ed. John A. Rice (*RRMR*, forthcoming).

———. *Cecilia virgo gloriosa*. Ed. Christopher Shaw. Bath, 2019; ed. John A. Rice (*RRMR*, forthcoming).

Chaynée, Jean de. *Ceciliae in corde suo*. Ed. Christopher Shaw. Bath, 2018. Ed. John A. Rice (*RRMR*, forthcoming).

———. *Dix motets à 4 et 5 voix du Novi thesauri musici, Venise 1568*. Ed. José Quitin. Liège, 1987.

Cima, Giovanni Paolo. *Concerti ecclesiastici*. Ed. Andrea Friggi. Milan, 2004.

Clemens non Papa, Jacobus. *Opera omnia*. Ed. Karel Philippus Bernet Kempers. 21 vols. Rome, 1951–1976 (*CMM* 4).

Cléreau, Pierre. *Missa Cantantibus organis*. Ed. Christopher Shaw. Bath, 2019.

———. *Missa Cecilia virgo*. Ed. Christopher Shaw. Bath, 2019.

Cornet, Séverin. *Cantantibus organis*. Ed. John A. Rice (*RRMR*, forthcoming).

Crecquillon, Thomas. *Opera omnia*. Ed. Barton Hudson et al. 20 vols. Neuhausen and Middleton, WI, 1974–2011 (*CMM* 63).

Crespel, Jean. *Cecilia ex praeclaro genere*. Ed. Richard Sherr. New York, 1997 (*SCM*, vol. 18).

Dering, Richard. *Motets for One, Two or Three Voices and Basso Continuo*. Ed. Jonathan P. Wainwright. London, 2008 (*MB* 87).

Du Caurroy, Eustache. *Preces ecclesiasticae*. Ed. Marie-Alexis Colin. Paris, 1999.

Episcopius, Ludovicus. *O beata Cecilia*. Ed. John A. Rice (*RRMR*, forthcoming).

Ferraro, Antonio. *Mottetti concertati*. Ed. Rosalba Musumeci. Florence, 1999.

Fiat Domine cor meum (canon in Bastianino's *St. Cecilia Holding an Organ*). In Lowinsky, *Music in the Culture of the Renaissance and Other Essays*; Anna Valentini, "Iconografia musicale a Ferrara tra XVI e XVIII secolo," tesi di dottorato, Università degli Studi di Padova, 2012.

Franzoni, Amante. *Apparato musicale*. Ed. Luca Colombo. Brescia, 2010.

Gallet, François. *Benedicta es, virgo Cecilia*. Ed. John A. Rice (*RRMR*, forthcoming).

Gheens, Philippe. *Cantantibus organis*. Ed. Richard Sherr. New York, 1996 (*SCM*, vol. 17).

Gombert, Nicolas. *Opera omnia*. Ed. Joseph Schmidt-Görg. 11 vols. Rome and Neuhausen, 1951–1975 (*CMM* 6).

Guerrero, Francisco. *Opera omnia*. Barcelona, 1955–.

Handl (Gallus), Jacob. *Opus musicum*. Ed. Emil Bezecny and Josef Mantuani. 7 vols. Vienna, 1899–1919 (*DTÖ* 12, 24, 30, 40, 48, 51–52).

Hugier, *Cecilia me misit ad vos*. Ed. Richard Sherr. New York, 1999 (*SCM*, vol. 10).

Infantas, Fernando de las. *The Complete Motets*. Ed. Jorge Martín. Santa Cruz de La Palma, 2020.

Isaac, Heinrich. *Weltliche Werke*. Ed. Johannes Wolf. Vienna, 1907 (*DTÖ* 28).

———. *Quis dabit capiti meo aquam*. Ed. Noah Greenberg. New York, 1963.

Jacquet of Mantua. *Opera omnia*. Ed. Philip Jackson and George Nugent. 7 vols. Neuhausen, 1971–2013 (*CMM* 54).

Lassus, Ferdinand de. *Cantiones quinque vocum*. Ed. David Crook. Middleton, WI, 2007 (*RRMR* 147).

———. *Dum aurora finem daret*. Ed. John A. Rice (*RRMR*, forthcoming).

Lassus, Orlande de. *The Complete Motets*. Ed. Peter Bergquist et al. 22 vols. Madison and Middleton, WI, 1995–2006 (*RRMR* 102–148S, passim).

Lefebure, Jan. *Cantantibus organis*. Ed. Christopher Shaw. Bath, 2019.

Maillard, Jean. *Modulorum Ioannis Maillardi*. Ed. Raymond H. Rosenstock. 3 vols. Madison, WI, 1987–1993 (*RRMR* 73, 95, 96).

Manchicourt, Pierre de. *Opera omnia*. Ed. John D. Wicks and Lavern Wagner. 7 vols. Holzgerlingen, 1971–1999 (*CMM* 55).

Marenzio, Luca. *Opera omnia*. Ed. Bernhard Meier and Roland Jackson. 7 vols. Neuhausen and Holzgerlingen, 1978–2000 (*CMM* 72).

Massaino, Tiburzio. *Cantantibus organis*. Ed. Christopher Shaw. Bath, 2020.

———. *Liber primus cantionum ecclesiasticarum*. Ed. Raffaello Monterosso. Vienna, 1964.

The Medici Codex of 1518. Ed. Edward E. Lowinsky. 3 vols. Chicago, 1968.

Mel, Rinaldo del. *Cantantibus organis*. Ed. John A. Rice (*RRMR*, forthcoming).

Missa Cantantibus organis. Ed. Raffaele Casimiri. Rome, 1930.

Monte, Philippe de. *Opera omnia*. Ed. Charles van den Borren et al. Bruges, 1927–1939 (reprint New York, 1965).

———. *Opera*. Ed. René Bernard Lenaerts et al. Leuven, 1975–1986.

Morelli, Bernardino. *Cantantibus organis*. Ed. Christopher Shaw, Bath, 2019.

Mornable, Antoine de. *Domine Jesu Christe*. Ed. John A. Rice (*RRMR*, forthcoming).

Naich, Hubert. *Opera omnia*. Ed. Don Harrán. Neuhausen, 1983 (*CMM* 94).

Oxford Bodleian Library MS. Lat. liturg. b. 5 (facsimile of the York Gradual). Ed. David Hiley. Ottawa, 1995.

Pagnier, Nicolas. *Gloriosa virgo Cecilia*. Ed. Richard Sherr. New York, 1998 (*SCM*, vol. 9).

Palestrina, Giovanni Pierluigi. *Werke*. Ed. Theodor de Witt et al. 33 vols. Leipzig, 1862–1907.

———. *Le opere complete*. Ed. Raffaele Casimiri and Lino Bianchi. 35 vols. Rome, 1939–1999.

———. *Motecta festorum totius anni cum communi sanctorum quaternis vocibus*. Ed. Daniele V. Filippi. Pisa, 2003.

Palestrina, Giovanni Pierluigi, et al. *Missa Cantantibus organis*. Ed. Raffaele Casimiri. Rome, 1930.

Pevernage, Andreas. *Cantiones sacrae*. Ed. Gerald R. Hoekstra. 3 vols. Middleton, WI, 2010 (*RRMR* 153–55).

Philips, Peter. *Cantantibus organis*. Ed. Richard Lyne. Oxford, 2002.

———. *Cantiones sacrae quinis vocibus, Antwerp, 1612*. Ed. John Steele. Dunedin, 1992.

———. *Cantiones sacrae octonis vocibus (1613)*. Ed. John Steele. London, 1992 (*MB* 61).

Piéton, Loyset. *Sponsa Christi Cecilia*. Ed. Richard Sherr. New York, 1998 (*SCM*, vol. 9).

Porta, Costanzo. *Opera omnia*. Ed. Siro Cisilino. 25 vols. Padua, 1971.

Raymundi, Daniel. *Fiat cor meum*. Ed. John A. Rice (*RRMR*, forthcoming).

Razzi, Serafino. "I' sent' al cor conforto." Ed. Margaret A. Mancuso. In Mancuso, "Serafino Razzi's *Libro primo delle laudi spirituali*," vol. 2, 368–69 (text), 370 (music).

Rogier, Philippe. *Cantantibus organis*. Ed. Christopher Shaw. Bath, 2017.

———. *Eleven Motets*. Ed. Lavern Wagner. New Haven, CT, 1966 (*RRMR* 2).

———. *Opera omnia*. Ed. Lavern Wagner. 3 vols. Neuhausen, 1974–1976 (*CMM* 61).

Rore, Cipriano de. *Opera omnia*. Ed. Bernhard Meier. 8 vols. Rome and Neuhausen, 1959–1977 (*CMM* 14).

Sales, Franz. *Cantantibus organis*. Ed. Christopher Shaw. Bath, 2017. Ed. John A. Rice (*RRMR*, forthcoming).

———. *The First Book of Motets for 5–6 Voices*. Ed. Cees Wagemakers. Rijswijk, 2020.

Schiavetto, Giulio (Julije Skjavetić). *Moteti u pet i sest glasova, 1564*. Ed. Lovro Županović. Zagreb, 1996.

Schuyt, Cornelis. *Domine fiant anima mea*. Ed. John A. Rice (*RRMR*, forthcoming).

Stabile, Annibale. *Cantantibus organis*. Ed. Ruth Lightbourne. In Lightbourne, "Annibale Stabile," vol. 2, 100–108.

Torquet, Daniel. *Cantantibus organis*. Ed. Christopher Shaw. Bath, 2017. Ed. John A. Rice (*RRMR*, forthcoming).

Turnhout, Jan van. *O virgo generosa*. Ed. John A. Rice (*RRMR*, forthcoming).

Utendal, Alexander. *Cantantibus organis*. Ed. John A. Rice (*RRMR*, forthcoming).

———. *Sacrarum cantionum . . . liber tertius*. Ed. Thomas Engel. Innsbruck, 2002.

Villani, Gasparo. *Cantantibus organis*. Ed. John A. Rice (*RRMR*, forthcoming).

———. *Missa Cantantibus organis*. Ed. Christopher Shaw, Bath, 2020.

ONLINE RESOURCES

This list does not include articles published on websites and in online journals or open-access books and dissertations (included in the first section of the bibliography), or the websites of libraries, museums, and music publishers.

Cantus, database for Latin ecclesiastical chant: http://cantus.uwaterloo.ca/home

ChoralWiki, Choral Public Domain Library: https://www.cpdl.org/wiki/

Corpus Kalendarium: www.cokldb.org

Digital Image Archive of Medieval Music (DIAMM): https://www.diamm.ac.uk

e-codices, Virtual Manuscript Library of Switzerland: https://www.e-codices.unifr.ch/en

Internet Culturale, catalogues and digital collections of Italian libraries: www.internetculturale.it

International Music Score Library Project (IMSLP): https://imslp.org/wiki/Main_Page

JSCM Instrumenta, vol. 2: A Catalogue of Motets, Mass, Office, and Holy Week Music Printed in Italy, 1516–1770, compiled by Jeffrey Kurtzman and Anne Schnoebelen: https://sscm-jscm.org/instrumenta/instrumenta-volumes/instrumenta-volume-2/

Motet Database Catalogue Online, compiled by Jennifer Thomas: http://www.arts.ufl.edu/motet

OPENN, repository of primary digital resources: https://openn.library.upenn.edu

Oxford Music Online, including Grove Music Online: https://www.oxfordmusiconline.com

Printed Sacred Music Database, bibliography of printed sacred music in Europe, 1500–1800: http://www.printed-sacred-music.org

Répertoire International des Sources Musicales (RISM): https://opac.rism.info

Themefinder.org allows searches of Harry B. Lincoln's *The Latin Motet: Indexes to Printed Collections, 1500–1700*: www.latinmotet.themefinder.org

Index